KENTUCKY TRAVELER

itbooks

AN IMPRINT OF HARPERCOLLINS PUBLISHERS

KENTUCKY TRAVELER

My Life in Music

RICKY SKAGGS

With
EDDIE DEAN

*it*books

KENTUCKY TRAVELER. Copyright © 2013 by Ricky Skaggs. All rights reserved. Printed in the United States of America. No part of this book may be used or reproduced in any manner whatsoever without written permission except in the case of brief quotations embodied in critical articles and reviews. For information address HarperCollins Publishers, 195 Broadway, New York, NY 10007.

HarperCollins books may be purchased for educational, business, or sales promotional use. For information please e-mail the Special Markets Department at SPsales@harpercollins.com.

Lyrics to "Somebody's Prayin'" by John G. Elliot. Copyright: © 1985 Universal Music—Brentwood Benson Music Publishing (ASCAP). All Rights Reserved. Used By Permission.

A hardcover edition of this book was published in 2013 by It Books, an imprint of HarperCollins Publishers.

FIRST IT BOOKS PAPERBACK PUBLISHED 2014.

Designed by Sunil Manchikanti

The Library of Congress has catalogued the hardcover edition as follows:
Skaggs, Ricky.
 Kentucky traveler : my life in music / Ricky Skaggs with Eddie Dean. — First edition.
 pages cm
 ISBN 978-0-06-191733-2 (hardcover)—ISBN 978-0-06-191734-9 (pbk.) 1. Skaggs, Ricky. 2. Bluegrass musicians—United States—Biography. I. Dean, Eddie, 1964- II. Title.
 ML420.S5866A3 2013
 782.421642092—dc23
 [B]
 2013013572

ISBN 978–0–06–191734–9 (pbk.)
14 15 16 17 18 OV/RRD 10 9 8 7 6 5 4 3 2 1

This book is dedicated
to my mother, Dorothy Skaggs,
my father, Hobert Skaggs,
and my musical father, Bill Monroe.

They taught me how to pick and sing and honor God.

Prologue

Martha, Kentucky: Summer 1960

Then Samuel took the horn of oil and
anointed him in the midst of his brethren.

—First Book of Samuel, Chapter 16, Verse 13

Somehow we heard that Bill Monroe was coming through east-ern Kentucky. In those days, musicians advertised shows with handbills stuck to electric poles, posters in grocery-store windows, and promos on local radio stations, but word still traveled fastest by mouth. And word got around Lawrence County that the great Bill Monroe and His Blue Grass Boys were going to play a show at the high school in Martha, just up the road.

Martha was a little town a few miles toward the county line be-tween Blaine and Sandy Hook, Kentucky, not far from where we lived in a hollow called Brushy Creek, near Cordell. It was named after my eighth-great-grandmother, Martha Cothron Skaggs, a Cherokee from Wilkes County, North Carolina. She married my eighth-great-grandfather, old Peter Skaggs, in 1788, in Fincastle, Vir-ginia. They moved to Floyd County, Kentucky, in 1802 and then to the head of Blaine Creek in Lawrence County in 1812. Peter Skaggs was a Baptist preacher. There's an old cave near there that my dad used to play in when he was a kid, and it was called Peter Cave. The way the story's come down is that Peter and Martha were considered the elders in that area; they had a lot of kids and did a lot for the community. A cave is one thing, but it took some doing to have a town named after you, especially with Martha being of Indian blood and married to a white settler from Virginia, so she must have been quite a woman to receive such an honor.

Cordell was even smaller than Martha, but it didn't matter how

small your hometown was or how far out in the sticks you lived, because back then, everybody in our corner of the world knew who Bill Monroe was. He was a big star on the Grand Ole Opry, broadcast on WSM radio every Saturday night from Nashville. Mom and Dad loved his music, and I did, too. I'd never seen a picture of him, so I didn't know what he looked like. All I knew was that he sung real high and he played mandolin, just like me. I was so excited to hear how he'd sound singing "Blue Moon of Kentucky" in person. I was six years old and this was my first live country-music show. Heck, I'd never been anywhere more exciting than the county fair in Louisa.

The weeks dragged on until the big night finally came. We all packed into Dad's Ford Fairlane 500—Mom, Dad, my brother, my sister, and me—and made the drive on Route 32 into Martha, passing the little general store run by Gar Ferguson and pulling up to the ol' stone high school. We joined the crowd milling around outside and waiting for the band. It started getting close to sunset, and I was wondering if Mr. Monroe had decided not to show up after all.

Then up went a shout, "There he comes!" and an old Cadillac eased into the gravel parking lot. It was a big black stretch limousine, not like any car you'd see in Lawrence County. There was a wooden box on top with stenciled letters: "BILL MONROE AND HIS BLUE GRASS BOYS." The Cadillac was fancy all right, but it was dusty from so many hard miles spent on the back roads that had brought the band here to our town. This was before there were many interstate highways, before a lot of things we take for granted now.

The Blue Grass Boys climbed out of the dirty limo first, and I could hardly believe my eyes. They looked as if they'd just stepped right out of the dry cleaners. No wrinkles on their suits, not a speck of road dust. How they managed it, I'll never know. There weren't any motels or rest stops for miles around. I was amazed at how great they looked after so much hard traveling. I thought that was so cool!

Next, a back door of the Caddy swung open and I could see the tip of a blond beehive hairdo poke out. Come to find out, the bass man for the Blue Grass Boys was really a girl! Not a girl, actually, but

a woman older than my mom. She swung her legs out and found a spot on the gravel to plant her high heels, and she slowly stepped out of the limo, careful not to mess up her stage dress. Then she walked 'round back and got her bass fiddle out of the trunk.

Finally, a man got out of the other side and stood straight as an arrow, looking over the crowd. I knew right off it was Mr. Monroe. You could tell he was the bandleader and boss man. He was dressed real sharp in his suit and hat, and he was carrying his mandolin case. The crowd rushed at him, and he didn't move an inch, just let 'em come and gather round. He was head and hands above everybody else, as big as an oak tree. Imagine it! The Father of Bluegrass right here in little Martha!

I didn't know that Mr. Monroe was in lean times then, just trying to survive by barnstorming the country for fifty cents a head at schoolhouses and fire halls and theaters—wherever he could draw a crowd when he wasn't on duty at the Opry. I didn't know rock and roll had nearly put him out of business. I didn't know that the woman in the fancy dress was Bessie Lee Mauldin, and that she was not only Mr. Monroe's bass player, she was his girlfriend, too.

There was a whole lot I didn't know back then. I was just a pup, and I was awestruck. There were three other Blue Grass Boys: a banjo man, a guitar player, and a fiddler riding in the front seats. They were dressed to the nines, same as Mr. Monroe. The sound system was in the box on the limo roof—two speakers and a couple of microphones, along with the instruments. They loaded all the gear into the building, and in no time they were set up and ready to go.

Out in the parking lot, I watched Mr. Monroe tip his hat and say his howdies to fans as he tried to make his way through the crowd. Finally, he got to the school door and ducked inside. Everybody piled in after him. We quickly found seats on the folding metal chairs set up on the gym floor. The place was packed with a few hundred people.

What a show! The band was louder and better than any record or radio broadcast. You could feel the force of the music in your chest. Dad and Mom were loving it, and so was I. The crowd was going

crazy. After about thirty minutes, some neighbors from our neck of the woods started shouting out, "Let little Ricky Skaggs get up and sing!"

Now, these people, they'd seen me pick and sing around Cordell—at our church, at Butler's grocery store, and on the front steps of the bank. I'd got a little pawnshop mandolin as a present from my dad, and I'd been playing for about a year. Wherever I could, I'd go out and play, mostly with Dad and his guitar. We had us our own little duet, and sometimes, especially on Sundays at church, Mom sang with us, too.

The crowd was hollering for me to do my thing on stage, in the middle of the Bill Monroe show. They wanted to brag on Hobert and Dorothy's boy, and they got carried away. Mr. Monroe didn't pay 'em any mind, ignoring all the commotion. But that was like throwing gasoline on a fire, 'cause mountain people can be stubborn. They weren't gonna give up, and they kept at it hollering, "Let little Ricky sing one!"

Finally Mr. Monroe got tired of hearing it. He stepped up to the microphone and said, "Where is this little Ricky Skaggs? Where's he at? Get him on up here!"

Well, now it was plain to see that he meant business, and I surely wasn't gonna chicken out and let everybody down. But I was a little nervous, so Dad got up to walk me down the aisle to the stage. Just before I got out of earshot, Mama said, "Now, Ricky, don't you sing that pinball song!"

"Pinball Machine" was a novelty hit by Lonnie Irving in the summer of 1960, a song about a truck driver who loses all his money playing pinball. My mom knew how much I loved it, and she also knew that Mr. Bill Monroe wouldn't want that tune played anywhere near his stage. She was always looking after me.

Well, when I reached the edge of the stage, I just froze. When Mr. Monroe looked down to see a little towheaded boy, he wasn't amused. I think he was expecting a teenager. And here I was, looking up at this mountain of a man. On stage, he was even bigger than he looked in the parking lot.

The stage was only a few feet above the gym floor, so Mr. Monroe just stooped over and grabbed me by the arm and pulled me up like a sack of feed. He stood me right next to him. He towered beside me, but I tried to stand up straight like he was.

"What do you play, boy?" he barked into the mic.

"I play the mandolin!"

Well, he just laughed and said, "You do?"

Slowly, he took his great big F-5 Lloyd Loar Gibson mandolin off his shoulder, carefully wrapping the old leather bootstrap around the curl of the instrument's body until it fit me just right, and then he hung it on my shoulders. It was the first time I'd ever seen a mandolin that big, much less held one. My pawnshop mandolin was a pint-sized model. This mandolin of Mr. Monroe's seemed as big as a guitar. I had to think about where to put my fingers on it.

"What do you want to sing, boy?" he said.

"'Ruby!'"

I was so excited I sort of yelled it out. The song just popped into my head. The Osborne Brothers' "Ruby, Are You Mad at Your Man?" was a huge bluegrass hit at the time. The band knew it well. Bessie Lee and the rest of the Blue Grass Boys were smiling, kinda amused at my choice. The lyrics were pretty salty for a six-year-old to be singing on stage. I know Mom must have been mortified! To me, though, it was just a catchy tune I heard on the radio, so I'd learned it and played it around the house.

Somehow, I found E and started chunking rhythm on that big ol' mandolin. The band joined in, and we were in the right key. I didn't know much about musical notes and keys back then—I just copied the way Bobby Osborne had done it on the record. I sung my verses, the banjo player took a solo, and I sung the rest of the verses. We rode it till the end.

The crowd was cheering us on as Mr. Monroe stood off to the side, his big arms folded against his barrel chest. I thought I saw him grinning, but I couldn't be sure.

When the song was over, everybody in the place let us know we'd pulled it off. Thinking back on it now, our rendition of "Ruby" was

probably just average, but I was the hometown kid, so the crowd was with me all the way. Maybe a little too much. Mr. Monroe came right over, took the mandolin off me, and slung it back on his shoulder. He grabbed me by the arm just like before and set me back down off the stage.

He didn't say a word. He just kicked into his most famous tune, "Mule Skinner Blues." That was his first big hit, the song he'd been featuring on the Opry since 1939, and the Blue Grass Boys really tore it up. I think it was Mr. Monroe's way of reminding the crowd who they'd paid to see that evening.

There wasn't much more to it. I went back to my folks and sat down, and we watched the rest of the show. Afterward, people came up and said, "Son, you done a good job." It felt good to hear that, but I knew they were just being neighborly and nice. We didn't go backstage and meet Mr. Monroe that night. I kinda wished we had, 'cause it turned out I didn't see him again for another ten years.

It was fun to share the stage with the Father of Bluegrass, and I enjoyed the applause. As much as I had played and sung in church, people there didn't roar and shout and clap for you. At our Free Will Baptist church that would have been irreverent. So the crowd response that night in Martha felt good ringing in my ears, but what I enjoyed most was playing with a real band. It was the first time I'd ever played with a bunch of musicians instead of just my dad. I liked the big, loud sound of the full band with a bass player, banjo player, fiddler, and a guitar player, too—all the instruments blending together into something powerful. I loved feeling part of that.

That night in Martha was the biggest thing that had ever happened to me up till then, and I sure was glad it did. Mostly, though, I was just glad I didn't mess up. It was late by the time we piled into Dad's Ford and headed back to Brushy Creek. All the excitement had just worn me plumb out. I slept the whole way home.

KENTUCKY TRAVELER

Chapter 1

ROOTS OF MY RAISING

Lay down, boys, and take a little nap,
fourteen miles to Cumberland Gap.
Cumberland Gap, Cumberland Gap,
way down yonder in Cumberland Gap

—"Cumberland Gap," Appalachian folk song

I was young when I left my home back in the mountains, but the mountains never left me. It don't matter how many years I've been gone or how many miles I've traveled. Where I come from is who I am, head to toe. It's there in the way I sing and the way I talk and the way I pray. Country as a stick!

I grew up in the hills of eastern Kentucky in a hollow called Brushy Creek. My mom and my dad were spiritual people, and we went to a little Free Will Baptist church where I grew up hearing gospel music and old-time preaching. Real fire-and-brimstone stuff, where they preached so loud you grew up thinking the Lord must surely be hard of hearing.

We were a community of mountain folks who didn't have much. But we worked hard and cared for family and neighbors. We all cried together and we all laughed together and we all sang together. We all hurt together when there was a tragedy. We all pulled together, 'cause about all we really had *was* each other.

Mom and Dad raised me to be proud of my mountain roots and who I am. Everything I do in my life today reflects on how I was brought up by Hobert and Dorothy Skaggs. They instilled beliefs and values that took root early on, and stayed strong enough to help me through rough times. I've had a few.

My folks knew that a little mountain pride went a long way. They warned me not to get too full of myself. They taught me to be thankful for what I had and where I came from. "Son," they told me, "always be humble and stay down to earth."

Now, when I was a young musician seeing the world for the first time, I was as headstrong as they come. There was a time in my life when you couldn't have paid me enough to stay in the hills where I was born and raised. I'm older now, and I hope a lot wiser. I can tell you now that I wouldn't take all the money in the world to be from anyplace else.

When I was coming up in the business, the only way to get a record deal was to go to Nashville. It was a dream I'd had since I was a little boy and first heard the country stars on the Grand Ole Opry. I used to go to sleep on my Papaw Skaggs's lap listening to the Opry on an old tube radio in his Ford pickup. To get a clear signal, we'd pull the truck away from the house where all the electric lines were hooked up and park down by the barn. He'd turn on the radio and work the knob to pick up the Opry broadcast on WSM. The radio frequency out of Nashville would come and go up in those mountains, so you had to sit there real quiet and wait for the music to break through the static. And then we'd hear Roy Acuff and Bill Monroe and it was the greatest sound in the world.

There came a time when I had to leave home and go to Nashville and try to make my boyhood dream come true. I wanted to carry Kentucky music out of Kentucky, take it out into the world, and deposit it wherever I could. These hills poured music into me from the time I was a child, and I've tried to honor that tradition. I'm a carrier of this music. It's in my DNA.

Well, I went to Nashville and had a good run in country music, and I was lucky enough to live out my dreams. By the mid-'90s,

though, I was over forty years old and the hits were starting to dry up. In 1996, my father, Hobert, and my musical father, Bill Monroe, both passed away. I prayed about what I should do next. It just seemed right in my heart to go back to the old foundation stones of bluegrass, which is what my country career had been built on. I felt a calling to revisit my musical roots again.

So I went back to the bluegrass I was raised on, the sound that had inspired me to become a musician in the first place. I decided I wanted to play the music I learned as a kid in the mountains, whether I made a good living or not. You know you're doing the right thing when there's peace in your heart, and I couldn't find that in country music anymore.

My old boss Ralph Stanley made a prediction to an interviewer years ago, when I was having all those number-one records and touring with a tractor-trailer and two buses. "Ricky's making a name for himself, but you just wait a while," he said. "I think he'll come back to bluegrass music."

Ralph knew something about me that I didn't know myself. It makes me think of the Scripture from Proverbs where it says, "Train up a child in the way he should go, and even when he is old, he will not depart from it." If you pour the foundation into a person and point them to the right path, they may stray from that in their younger years, but they'll return to it when they mature. That happened to me with bluegrass.

For me, going back to bluegrass and mountain music was like giving water to a thirsty man. That traditional Appalachian music is part of the wide rolling river of American roots music. No matter how many years pass, or how the place itself changes, that music is a constant flow of fresh water from a deep mountain spring. There are different creeks and tributaries; some flow into the old-time current, and some flow into more commercial waters. But there's something about that pure mountain stream that still connects us to the old. It's our musical heritage, and it keeps me nourished. I needed to take a drink of that fresh water straight from the source.

* * *

For thirty years now I've lived not far outside Nashville, a long way from Brushy Creek. Somehow, I was able to find a house on a hill north of town, where the land is mostly flat. I found my own little mountain right here in the middle of Tennessee. They call it Cherry Hill, after the man who first built up here. It's nowhere near as high as the mountains you'd find in eastern Kentucky, but it's got fifteen acres of elbow room and an awesome view for miles around. We've got nice neighbors, too, and it feels like home.

There's always a breeze blowing up here, so the wind chimes on the front porch go all the time. It's real peaceful.

A few years ago, I was driving around not far from my house, and I ended up in a beautiful wooded area called Mansker's Fort. It's the site of the first permanent pioneer settlement in this area. It's got a reconstructed fort and some old log buildings from those days, back when Nashville was called French Lick.

I was out looking around, and I came upon a sign, one of those historical markers you pass by and never think about stopping to check out. Well, this time I did, and would you believe that the sign tells all about my family and what they did here more than two centuries ago? Come to find out, some of my ancestors were out this way a long time before I was. It reads:

> Henry Skaggs, his brothers, Charles and Richard, and Joseph Drake and a group of other long hunters were the first Anglo-Saxons to explore this area. They made their campsite at Mansker's Lick, opening the doorway for the future settlement of Goodlettsville and Middle Tennessee.

Henry, Charles, and Richard Skaggs were the older brothers of my eighth-great-grandfather Peter Skaggs. Reading those words, I felt proud, and humbled, too. My forefathers were already here hundreds of years before I ever made it out this way to Music City.

My ancestors came out of old Virginia and migrated into the

area that later became Kentucky. They were nosing around in these mountains in the 1760s, even before Daniel Boone. They were explorers, and they were instrumental in blazing the trail through the Cumberland Gap and into the eastern part of Kentucky. They had a route they traveled on called Skaggs Trace, and it was used as much, if not more, than the Wilderness Trail.

Neither is around today, but they were two of the main routes that started as hunting trails and backwoods horse paths and were traveled by pioneers settling the early American frontier. The Wilderness Trail was better known, and it went from Cumberland Gap up north through Somerset to Boonesborough. But Skaggs Trace also became an important route for pioneer families making their way with wagons and supplies into Kentucky, and it went up through Harrodsburg and turned west toward the falls at Louisville by the Ohio River.

My ancestors belonged to a group of sharpshooting explorers called long hunters, and they went on expeditions in bands of twenty or thirty men, sometimes for as long as two years, hunting, mapmaking, and charting the waterways and the tributaries. Back then, Kentucky was Indian country, and the long hunters went to places no white men had been before. They traveled light, with just their long rifles and the buckskin they were wearing. They kept on the move and hunted whatever they needed to eat.

From what I've researched on the long hunters, I know they suffered a lot of hardship. They had to leave their families behind in Virginia, and they never knew when they'd be home. Henry Skaggs was gone so long that his wife thought he'd been killed, and so she took another husband. Then Henry came back and ran the fellow off. He and his wife went on to raise a family together. Now, ain't that something? Come on, Henry!

Henry Skaggs was probably the most famous of the Skaggs brothers who came into this territory, and he left a long line of descendants where my family comes from. Eight generations back, there were some who fought at the Battle of Kings Mountain, one of the

decisive battles of the American Revolution. John Skaggs, who was
Henry's brother, was wounded there. The Skaggses have an amazing
family lineage in Kentucky and throughout the Appalachian region.
When you have ancestors who gave their blood for America and for
freedom, it's very humbling to think about the sacrifices they made.
Nobody ever loved liberty more than those hardy mountaineers.
They're always among the first to serve in every war we've had, and
we owe them a debt of gratitude.

This frontier heritage of exploring and rambling is something I've
always connected with, even when I was a boy. I was always drawn to
the long rifle and coonskin caps and stories about Daniel Boone. My
favorite gun, an old flintlock rifle I've got back at the house, belonged
to a man named Lance Skaggs. It had been in his family for years.

Lance ran a store up around Keaton, Kentucky, which is over in
Johnson County, where my great-grandfather Cornelius Skaggs and
my grandfather John M. Skaggs were born. The old store caught
fire many years ago and burned the wood stock off the gun, but the
barrel was still good. A friend of Dad's, Mort Mullins, got his hands
on the barrel somehow, and that's how it came to me.

One night when I was fourteen years old, we were up at Mort's
house playing music and talking about guns and hunting tales and
family stories. I told him I loved old flintlock rifles like Daniel Boone
had on TV. Mort said, "Son, your ancestors was in this country
before Daniel Boone was." Well, hearing that just blew me away. He
left the room and came back with a rusty old gun barrel in his hand.

"Here, take this home with you," he told me. "It's an old gun
barrel from the Skaggs clan. Don't know how old it is, but it's a lot
older than me and your dad put together. It will make you a good
gun that will last you all your life."

I kept that barrel safe and in storage, and along about thirty-five
years later, I found the right man for the job of restoring it. Robert
Eisenhower, from around Boone, North Carolina, is an antique gun
refurbisher, and he got a wood stock for my rifle and returned it to its
original long-hunter style. Ever since I got it back from him, it's been

my favorite flintlock. He said the barrel dates back to the mid to late 1700s. That's about the time Henry Skaggs and his brothers crossed into the mountains of southeastern Kentucky from Virginia.

I didn't know until later on that Henry Skaggs had hunted with Daniel Boone. I've got it chronicled in lots of history books, how the whole thing went down, and I'm still studying it and learning about it.

Brushy Creek, where my family comes from, is a hollow that gets its name from the stream that empties into Blaine Creek, which really oughta be called Blaine River, given its size. To be designated a river, a waterway has to be at least one hundred miles long, and when they measured Blaine, it turned out to be ninety-nine miles and some spare change, so that's why it's called a creek.

We lived up a dirt road, up the holler in the woods about five miles from the main highway. Your average holler might be ten miles long. Brushy is longer than most, and if you go all the way to the head of the holler, you go clear over into the next county.

My dad, Hobert, was born in Relief, Kentucky, in Morgan County. His father, John M. Skaggs, moved the family to Brushy when my dad was a teenager. There was better farmland there than what they had before. They lived on about seventy acres, with a big white clapboard country house and a great big front porch, and fields to grow corn and other crops. It was a step up in the world.

Dad and his younger brother Okel were brought up hunting and fishing and farming. Being Kentucky boys, they were singing and playing music together early on. Dad sang lead and played guitar, and Okel sang tenor and played mandolin. This was the brother-duet style made popular by Charlie and Bill Monroe.

They favored the brother-harmony songs that were all the rage back then: "Blues Stay Away from Me" by the Delmore Brothers, and Monroe Brothers records like "What Is a Home Without Love." They performed at pie suppers and house parties and local events and get-togethers, any chance they got to make music. They were pals and musical partners, too.

Dad and Okel were the new kids on the creek, but they quickly got to know the neighbors. The Thompson family lived up the holler a ways, and some of the Thompson brothers played fiddle and guitar. Dad and Okel would walk the mile or so up the creek to the Thompson house to play music and have a good time. The Thompson boys had a kid sister by the name of Dorothy May. She had brown hair and blue eyes and a sweet smile. She was a beautiful mountain girl, and Dad was knocked out the first time he saw her. He also liked that she could sing as good as she looked.

Both Skaggs brothers got drafted for service in World War II. Dad failed his Army entry because he'd had rheumatic fever as a child and it had left spots on his lungs. But Okel passed with flying colors. He was strong and enterprising, a fine example of a young mountain boy fresh off the farm. He entered the service June 17, 1942 and shipped overseas to the Pacific Theater when things were really heating up. His regiment was part of the huge landing operation on the island of Guam in August 1944. They came under heavy fire when they hit the beach. Okel had a buddy who caught a bullet. He ran to get him out of harm's way, and he got killed trying to save him. His bravery earned him a Purple Heart. He was twenty years old.

Dad was devastated. He'd lost his best friend. I don't think he ever got over it. He made a vow to himself that if he ever had a son who showed any musical ability, he was going to get him a mandolin and teach him how to play it and sing tenor with him. Then they could play all the old songs he loved to sing with Okel.

Though my dad lost his singing partner when Okel died, he didn't let his grief kill his love for music, and he played whenever he could. Around about 1947, Dad was working for a while at the Holston Army Ammunition Plant down in Kingsport, a town in east Tennessee. He found out Bill Monroe was coming through Kingsport with a new outfit that had just about tore the roof off the Opry. There were a couple of new Blue Grass Boys: Lester Flatt, who sang lead, and Earl Scruggs, who played a banjo that sounded like a tommy gun.

Well, Dad paid a quarter to get in, and he later said it was the most incredible show he'd ever seen in his whole life, before or since. For years afterward, whenever he talked about that night, his eyes would light up. I'd give anything to have been there with him. What my dad got to see was the classic lineup of the Blue Grass Boys. Once they got to playing, they turned the stage into a battle-field. It was a competition between Bill and Earl, trying to outdo each other on their instruments. With Bill and Lester nailing those great duets, I'm sure Dad was wishing his brother Okel could have been there to hear it. I asked Dad one time if he'd gotten his money's worth at that show. He said, "Son, I'd a-paid a dollar to a-seen them!"

Let me tell you about a bunch of young bucks in their prime. They had a one-microphone setup. They didn't need nothing else. The whole band worked around the mic as smooth as silk. They stepped in and out to take solos and hit the harmonies and never broke stride or missed a note. And then Chubby Wise would wedge his two hundred fifty pounds through the scrum to play a fiddle breakdown, with Bill behind him chopping his mandolin, Howard Watts in back slapping on that big bass, and Lester and Earl blazing away, making the impossible seem easy as pie.

I knew another guy who saw the Blue Grass Boys that same year. He was a farm boy in Turkey Scratch, Arkansas, and his name was Levon Helm. When I saw him at a festival a few years before he passed away, Levon told me the show had changed his life. He got as excited as a kid just talking about that night, same way my dad used to get. "Monroe had put together the dream band, and they really tattooed my brain for good," he said. "I loved the mandolin and the fiddle and the bass and Earl's banjo—I loved everything about that show. When I got home, I knew right then I wanted to play music for the rest of my life."

Levon meant it, too. He died in 2012, playing his music right up till the end, same way that I hope to do. In his late sixties, he went back to his roots and cut bluegrass and traditional country albums

full of Stanley Brothers songs and old-time hymns. It was a few years after he'd whipped cancer, and he had a resurgence of popularity, bringing a new generation of fans into the fold with his singing and drumming and mandolin picking. I believe certain things happen for a reason, and the last time I saw Levon I told him the Lord wasn't done with him yet. He busted out in a big grin and said, "Son, I believe you're right!"

After his stint at the ammunition factory, Dad left Kingsport and came back to Brushy Creek. There wasn't much work around, but he found jobs welding, which is what his uncles Calvin and Homer did. Lawrence County has never been a major coal-mining region, but the area has huge underground reserves of natural gas; the natural-gas pipes were everywhere, and they needed fitters and welders.

There was something else, too, that drew Dad back home to the holler. The Thompson sister Dorothy May was there, and he'd been thinking a lot about her. When he wasn't welding, he started hanging out at the Thompson place. Sometimes he brought his guitar and played music with the Thompson brothers. Most of the time, though, he was just there to see Dorothy May. It wasn't long before they got pretty serious about each other.

Dad and Mom were married on July 1, 1947, and moved into a little one-bedroom house on Brushy Creek. My sister Linda was born the next year, so now Dad had a wife and baby girl to support. Work was hard to find in eastern Kentucky at that time. He heard about a job opening at a large farm in Urbana, Ohio, just north of Springfield. The great thing was, the job paid a steady salary and provided housing for the family. Dad liked the work and the owner of the farm so much that he stayed there for a couple of years. My brother Garold was born there in 1950.

With a growing family and the Kentucky hills calling, Dad moved back to Brushy Creek and built a house. That was the house we called the homeplace. That's where the family lived in 1954, when I was born, in 1959, when my brother Gary came along. No matter where Dad's work would take us, we always had the homeplace to

go back to. That was a comforting thought for Dad and, as the years went by, for all of us.

When I was born, I was a handful from the first breath I ever took. Leastways that's how my mom remembered it. I was born on July 18, 1954, at Riverview Hospital in Louisa, Kentucky, the closest sizable town to our holler and the county seat of Lawrence. They said that when the doctor slapped my butt, I squalled out so loud the doctor told my mom, "Well, you've got a healthy boy, and he's got a healthy set of lungs. He's either gonna be a preacher or a singer." Mom replied right quick, "Well, I want both!" My given name is Rickie Lee Skaggs. Rickie wasn't a nickname for Richard or anything like that. I wasn't named for a relative or a friend of the family or even a real person. Strange as it may sound, I was actually named after Ricky Ricardo.

The thing was, my folks didn't know what to call me at first. My grandfather knew they were having trouble coming up with a name. In the early '50s, *I Love Lucy* was the biggest show going on TV, and Ricky Ricardo, played by Desi Arnaz, was about the most famous man in America. You had Lucille Ball hollering "Ricky! Ricky!" at Desi every episode, and the name was very popular, even way out in Brushy Creek, where most people like us didn't even have television sets yet. So one day my grandfather said, "Why don't you name him Ricky?" and Dad and Mom were sold. I was named Rickie Lee Skaggs. On my birth certificate it says R-I-C-K-I-E because that's what looked right to my dad and mom. One thing's for sure. The doctor sure was right about the singing, and the signs came early. Right from the start, I was a little different from my sister and brothers.

My mother didn't play an instrument, but she was a great, natural-born singer, probably the first singing voice I ever heard. She had an old mountain voice, pure and powerful. You'd never guess such a big voice could come from such a small woman. She sang all the time, tunes she wrote herself, gospel songs, and whatever country hits she

heard on the radio. Before she knew it, she had herself a little singing partner, and that was me.

Mama would sing while she did her chores around the house, and I'd be off at the other end of the house playing with my toys. She was all the time singing in the kitchen while she was cooking, and she'd hear me singing harmony along with her. I took my dad's part when I sang with her. I guess it was because I'd heard them sing together so often that I knew how to fit just right with mom's voice.

This was early on, around the time I was three years old. Being so young, I didn't know it was called harmony and that the part I was singing was called tenor and that it was a third above the lead and so forth. But it must have sunk into me deep, 'cause that's the only singing lessons I ever had!

Chapter 2

PREACHERS AND PROPHETS

*I learned more about Christianity from my mother
than from all the theologians in England.*

—John Wesley, 18th-century evangelist and circuit rider

It wasn't too long before I was singing on Sundays with my mom
and dad. Our church was called Low Gap Free Will Baptist
Church. It was about five miles down from where Brushy Creek
hollow ends at Highway 32. It was a little whitewashed one-room
church house with a potbellied wood stove in the middle, same as so
many around that part of eastern Kentucky. Our church had congre-
gational singing out of hymnbooks, with everybody joining in and
singing together and praying out loud at the same time.

A lot of mountain churches, like the primitive Baptists and the
old-time Baptists and the Church of Christ, didn't allow musical in-
struments in their services, and some still don't. They only sing a cap-
pella. But the Free Will Baptists welcomed guitars and banjos and
mandolins and whatever you brought to make a joyful noise unto the
Lord. We didn't have choirs because everybody was expected to join
in and sing.

There was a little Holiness Church not far from where we lived,

just a few miles down an old back road, and they had electric guitars in their services. They got down with it. It was real foot-stomping, wall-shaking music, and I think God loves that as much as any other gospel music. When I was a little older, I'd go by there and hear the worship music coming from inside, and I'd be thinking, "Oh, man, playing electric guitar in church! That must be somethin'!"

Our church wasn't quite as raucous, but it was a sweet, holy place. Some hymns were mournful, but most were joyous. There were a lot of songs about the wonder of God and the gloriousness of God and the love of Jesus. And we sang hymns about the price He paid on the Cross for the forgiveness of sin.

After the congregation sang a few hymns and got things warmed up, the preacher would usually call me and Mom and Dad out of the pews up by the altar to sing a few songs. One of my earliest memories is my mom holding me up in her arms in front of the congregation. I wasn't more than three years old. She'd carry me down the aisle and set me on the pulpit with my little ol' legs dangling down, and I'd sing harmony with her and my dad, who'd play guitar. We'd do our gospel numbers and lead the service for a while, just the three of us.

I remember a hymn we loved to sing called "Prince of Peace." It dated back to the 1870s, and the words were printed in one of the old Baptist hymnbooks they had at our church. It was a favorite of Mom and Dad. Some of the verses were so pretty, and they stay with me even after all these years: "I stand all bewildered in wonder and gazed on God's ocean of love, and over its waves to my spirit came peace like a heavenly dove." These were what they called praise hymns, and there was an awe-struck quality in the music and it really touched my heart.

Singing with my parents in church was great. But there were some things I didn't much like. I was sort of shy at that age, and I didn't want to be the center of attention. That was one thing. Another was that I didn't like having to give up my chewing gum. Just before we'd go up to sing at the pulpit, my mom would make me spit out my

gum, and I hated that. It was always right about the time the flavor got real good and tasted the best. My brother and sister, they got to keep theirs. I had to go up front and sing, while they got to sit back in the pews enjoying their bubble gum.

We were Free Will Baptist, also known as foot-washing Baptists, named after the foot washing Jesus and his disciples did at the Last Supper. Certain Baptist denominations follow that very ritual at Easter time, usually after the service. The men wash the men's feet and the women wash the women's feet. If you've never had an eighty-year-old man kneel down and wash your feet, well, I can tell you, it's a very humbling experience. Especially when you're much younger. Foot washing is a church tradition going back generations, but now it's mostly a thing of the past. You hardly ever hear about it anymore. It's a shame, because it's something very precious that binds the old and the young. It's humbling for the washer and for the washed; it's a breaking of the hardened heart. Like the verse in Malachi 4:6 says, "He shall turn the hearts of the Fathers to the children, and the hearts of the children to their Fathers."

After the services, these old preachers—the same ones preaching with fire all morning long—would come up to me outside the church house and they'd prophesy and speak the word of God over me. They'd lay hands on me and pray: "God's going to use you someday, young man. He's going to use your gift and your talent to bring people to the Kingdom. Always give the glory to the Lord!" Being just a little kid, my mind couldn't comprehend what it all meant. It kind of rattled me to hear how serious they were. Deep down inside, though, my spirit was saying "yeah and amen" to every one of those preachers' words. It took years for the seeds to bear fruit, but it's amazing to see how the prophecies came true.

Church was where I got my first taste of the old-time hymns, and where I heard about heaven and hell. But the place I learned the most about living the Christian faith was at home. That was on account of my parents, but especially my mother. We went to church

on Sundays, but that was only part of our life. It was how my parents lived the rest of the week that taught me most.

My mom prayed a lot. She wasn't a very educated person. About all the education she had in the way of formal schooling was through the fourth grade, while Dad went through the eighth grade. But they both had so much know-how, common sense, and faith. Mom knew the Scriptures. The word of God was so important to her, and she used it in prayer.

Prayer is such a powerful thing. I saw my folks and other neighbors praying for a man who lived on our creek. He was an alcoholic and he beat his wife and he was just full of meanness. But his friends and neighbors didn't give up on him. They kept on earnestly and prayed for him. Then one day the man walked down the aisle of our church and gave his heart to Jesus. I knew God was real when I saw how his life changed.

Mom was a real prayer warrior, and she was always doing battle for us. I'll never forget one day when I came inside the house after playing, went looking for my mom, and couldn't find her. I was calling her name and there was no answer. I finally walked down the hallway to my parents' bedroom. The door was cracked open and I peeked in and I saw my mom down on her knees, praying.

She was praying for my dad and my brother and my sister. And then I heard her call out my name, too. She was asking the Lord to watch out for me and to keep His hand on me. And she was praying that someday I would accept the Lord Jesus for myself.

Her face had a beautiful, radiant glory. It was lit up with the prettiest light, like sunshine on her cheeks, only it was shining from the inside. And she had tears running down her sweet face. The sight of her stunned me. It was powerful to see my mother doing business with God for her family. She was our intercessor before the Lord. That moment stayed with me and is forever etched in my memory. It's like a precious leaf frozen in the ice, always there to draw on for strength when I need to.

Of course, Mama showed her faith in other ways, too. She was

kind and gentle, and she had a warm heart. But she was firm and unbending in her discipline. She was a strong mountain woman to the core. She had to be strong to raise us kids and do all the cooking, washing, and cleaning, as well as farm work. In those early years, Dad was away from home on welding jobs most of the time. It was usually my mom who had to lay down the law, and I'll tell you what, my mom meant business. If you done wrong, she made sure you knew it. She'd knock you through a door and make you fix it!

There was one time I got in big trouble and ended up getting my hide tanned. I was about five years old, way too young to shoot a real gun like the rifles and shotguns my dad had for hunting and target practice. I had gotten a toy squirt gun and was just realizing how I could hit things from a pretty fair distance. So I was always on the lookout for fresh targets. It was just a piddly lil' ol' plastic water pistol, but it sure made me feel like a hotshot.

One morning I slipped down to the barn around milking time. I wasn't looking for trouble. I just wanted to have some fun with my new squirt gun. My mom was in the stall sitting on a stool milking the cow. She'd put some corn in the feed trough for the cow to munch on. I snuck down on the side of the barn where the stall was, and it so happened that there were cracks, little spaces between the sideboards, to let some fresh air inside the barn.

I was outside the stall and looked through a crack at where the cow was feeding. Mom didn't know I was there, and I didn't want her knowing. But the cow heard me and was curious to see what was out there. So now here was this great big ol' eyeball staring from that crack in the wall, and I thought, *Man, what a good target!* I got up close and personal with my squirt gun and shot that cow right smack in the eye. Well, the cow went ballistic. She wheeled around and kicked over the milk bucket and my mother, too. It was chaos, with my mom's foot hung up in the bucket. Then the cow stepped on my mom's leg. I heard my mother groan and the cow having a fit trying to get out of that stall.

I took off running as hard as I could, scared to death and knowing I had really messed up bad.

Well, Mom came stomping back up to the house, and she was drenched—not just in cow's milk, either. She had mud and everything that a cow excretes splattered all over her. She wasn't a bit happy about it, and she wore my butt out over what I'd done. I'm telling you what, she really spanked me good, and I deserved it, too. It wasn't just that she was mad; she had to teach me a lesson about consequences. As much as she prayed for me and as much as she loved me, she was never easy on me. She always taught me right from wrong, good from bad. She'd make sure to correct me whenever I strayed from the path, even when I got older and was a husband and a father with kids of my own.

One time in the 1980s, when I was past thirty years old and had made my name in Nashville, I was visiting at her house near Brushy Creek, and I had my little kids with me, Andrew and Mandy. Mom and I were alone in the kitchen just like old times, fixing up something good to eat, when I said a word I shouldn't have said. I wasn't saying it to her, and the kids weren't even around to hear it. I just blurted it out without thinking. I'll tell you this much: It starts with an *s* and ends with a *t*! Not too strong for some people, but for Mama it was a bad word.

As soon as the *t* came off my tongue, her hand came at me, quick as a cat. She popped me good, and my lip swelled out. Boy, did I feel small. I said, "Mom!" I was more surprised than I was hurt. I thought maybe she'd realized she'd overreacted. But she wasn't sorry one bit for what she'd done. "Don't you talk like that in my kitchen!" she said. "You know better than to say that!" She scolded me something fierce. My ears were burning. Here I was a grown man with kids, and I felt like I was four years old again.

I thank God for the consistency of her love and her firm hands that brought correction. (Those same firm hands could wring the necks of two chickens at once, too. I saw her do it out in the yard early one morning from my bedroom window!)

We're always our parent's children, don't matter how old we get. I was lucky to have a good Christian mother up until the day she died. I know a lot of people who never had that. It's a hard life when you haven't had a good family and a strong Christian upbringing. If you raise your kids up with a solid Christian foundation, they won't ever forget it no matter what happens. It will always be in the back of their minds. I know it was that way for me.

My mother's gone, but what she taught me I put to use every day. That includes using some of her recipes for fried chicken with fried cornbread and pinto beans, and pork and sauerkraut. They weren't real recipes like you see in a cookbook, 'cause she never wrote none of it down. She'd prepare all this stuff from scratch, off the top of her head. She was a great down-home-style cook—she saw cooking as a joy, not a drudgery—and most of what I know in the kitchen comes from my mama. I learned to cook the same way I learned to play music, just by watching and doing, trial and error.

When I was growing up, we mostly lived off of what we raised ourselves. Everything was so fresh and tasted so good, like milk and butter and all kind of garden vegetables. My dad raised a vegetable garden every year. He raised potatoes and watermelons and cucumbers and beans and tomatoes and corn and cabbage, all sort of things. Sometimes, he'd raise sweet potatoes, too, in an area down by the creek where the sandy soil was. We grew just about everything we needed, and we always had plenty and then some. Dad gave away a lot to neighbors who didn't have fresh produce of their own, especially older couples and widows who weren't able to work their own gardens anymore. It sort of spoils you in a way, being able to go out in the garden and pick tomatoes off the vine, instead of having to go to the supermarket. I didn't even know you could buy tomatoes at a store until I was seven and we moved to Tennessee, and I didn't like store-bought compared to the ones we raised.

Ours had a rich, earthy taste. I used to go out in the tomato patch early in the morning with a saltshaker in my back pocket and get a

big ol' ripe one and bite into it. Oh, man! It was the best. Like the old saying goes, you can't buy true love or homegrown tomatoes. That's the truth. And with what was left over, Mama would can the lot and those tomatoes would last us through the winter, along with kraut and pickled beans and sweet corn.

It was a great way to grow up, helping out in the garden or down at the barn. I didn't have to hoe very much since I cut too many plants and vines with the hoe blade. I would mostly help out by gathering vegetables from the garden and picking fruit from our orchard. I learned that having chores, learning responsibility, was a big part of life. Nothing tastes better or sweeter than corn you've hoed and brought in yourself from the field to the table. That was real satisfaction, and it made you feel part of the land and the earth. You felt like you belonged.

Dad always got the Stark Brothers catalog, and he knew a lot about grafting apple trees from his Uncle Calvin. They were men who just loved making things grow. Dad would take a Red Delicious apple tree and graft it with a Rome Beauty. He carried a real sharp pocketknife, and he'd make a slit in the sapling and tie the graft together with string, and then he'd put on sticky resin to keep the sap from running out and the bugs from getting in. He was very meticulous.

A year or two later, the hybrid would mature to give us a great harvest in the fall. We'd pick apples by the bushel. Mom would fry up some of the apples for breakfast, and she'd make fried apple pie. Oh, my God! If you've never eaten fried apple pie like my mom fixed it you've missed something wonderful. I can't find any words to describe it.

We used to butcher a hog every winter, too. We didn't have a freezer. My dad would cut up the pig and lay out all the meat on a great big table in the smokehouse. He'd salt it down with real coarse salt. That hog fed our whole family for months. You know, it's like Bill Monroe said, "You can't hurt ham!" I will explain what he meant later on, if you stick with me.

Nowadays some people think hog-killing was cruel. How could you raise an animal, go to the barnyard and feed it every day of its life, see it grow up, and then just kill it? But that hog or chicken was our food, and none of it got wasted. It was the way things were in the mountains, the way we lived, and we didn't think anything about it.

There wasn't a lot of beef around in those days, but we didn't miss it much. We had plenty of pork and chicken and caught our own fish, and my mom made it all taste good. One of my favorites was when mama would fix pork tenderloin, hot biscuits, and gravy. To this day, I can tell you, there ain't nothing like the way she did it. She kept a bucket of lard under the sink, and she'd take a scoop and fry up some pork chops real crisp in an iron skillet. Then, right before they were done, she'd throw in a spoonful of water and cover it with a heavy lid and the scalding-hot steam would tenderize those pork chops just right.

And the way she fixed her kraut and pork chops! She'd cook up the sauerkraut and pork together and layer it all with sliced potatoes and carrots and onions. Then of course, there were her fried potatoes and onions, and I can't forget to mention her fried corn, where she'd scrape the cob clean and make this fried cream corn that was to die for. Frying was her specialty, and she even made her own fried potato chips from razor-thin potato slices sizzling in Crisco.

But let's not forget her fried chicken. Oh, my Lord, Mama's fried chicken could bring peace to the Middle East. She fried her chicken three ways at once: in lard, with the skin on it, in a black iron skillet. Are there any questions? Her special ingredient, though, was in the refrigerator. When she got her lard good and hot and smoking just a little, she'd go for the secret weapon. She'd open the refrigerator door, grab a whole stick of butter, and lay it in that sizzling hot lard. That was when the Holy Ghost showed up! Then Mama would tell me, "Honey, the butter is what makes it so brown and crispy." Eat your heart out, Paula Deen.

I believe if the Arabs and the Jews could sit down at a table with a great big plate of Mama's fried chicken, they could have some peace

for a while. Well, at least until the last piece of chicken was up for grabs, and then they'd probably get to fighting again.

All this time my mom was cooking, she'd be singing, and her little kitchen was the best-sounding, best-smelling place you can imagine. It was heaven for a boy like me who loved to eat and sing both. I guess that's how I got such a big, big appetite for food and music. Thanks, Mama! She knew as many great songs as she did great-tasting recipes. One of her favorites was "Cut Across Shorty." I'd always be rooting for Shorty to outrun the city boy named Dan in the race so he could win Miss Lucy's hand. Shorty was a country boy same as I was, and it made me happy that he beat out Dan.

I loved singing around the house with my mom, it's some of my best childhood memories, but when Dad came home from work on the weekends, that's when the real fun began. We always had picking and singing at the house on weekends. My folks always made music fun, and that's why I'm still having fun playing music fifty years later—because it never got too serious for me. You know, the music business is serious sometimes, but it never robs me of my joy for music. I'm grateful that I have that precious gift from Mom and Dad.

I've been exposed to music all my life, and it all started by singing with my family and feeling the joy of music. For me, singing went along with whatever I was doing. Then along came something totally new, and it sure took my mind off singing for a while. My life was about to change forever.

Chapter 3

BOY MEETS MANDOLIN

Singing families have been a part of American life since colonial times.

—*The Country Music Store*, by Robert Shelton

A thing that especially pleased country folk was that the Carters were a family.

—Tom T. Hall, quoted in *Will You Miss Me When I'm Gone?: The Carter Family and Their Legacy in American Music*, by Mark Zwonitzer with Charles Hirshberg

One cold Saturday morning, when I was five years old, I woke up to a mandolin on my bed. It was the best surprise I ever got, before or since.

Dad had made good on the promise he'd made to himself. I think he had been holding out until the right time, when I was big enough to hold an instrument properly. If I had gotten the mandolin too soon, I might have gotten frustrated. The timing had to be just so, and my dad figured out when the right time was. I guess it's one of those things dads know.

Dad was a really good welder. Things were pretty tough in east-

ern Kentucky at that time, but we had more than most, because Dad could always find work.

But construction welding jobs were usually a good long ways from Lawrence County, so my dad had to travel. Some were up in Ashland, Kentucky, where they had the big Armco steel factory. Some were further north, in Louisville, Cincinnati, or Columbus. Dad had a good work record and was in demand. Foremen with job assignments from all over the area would call the local union and ask for Hobert Skaggs, because they knew he'd get the job done right. When Dad got word of a job, he'd be gone in a few hours and stay at the work site all week. He'd come home on Friday nights and spend Saturdays with us. Then he'd get up at three or four o'clock on Sunday mornings and make the long drive back to his job site. It could be a ten-hour drive on crooked two-lane roads just to get back to wherever he was working. It was a tough commute, before there were interstates. But that long journey was worth it to him just to be with Mom and us kids for a day or two. It was a good thing Dad had Glair Mullins to travel with and help make the miles go by. Glair was a piper-fitter and welder, too, and he and dad loved to work together. Glair was my dad's first cousin, and they were like brothers.

Anyhow, during the winter of '59, Dad was at a welding job in Lima, Ohio. There he found a little secondhand mandolin in a pawn shop. I think he paid five dollars for it. He came in from work real early on Saturday morning and put the mandolin in the bed next to me while I was sleeping.

I woke up the next morning, and there was the little mandolin, just my size. I put my hands around the neck, my first feel of wood and steel together. I've never forgotten that feeling. In a way, it was almost spiritual. It's like I connected to it immediately. Dad showed me three basic chords—G, C, and D. That was about all he knew on mandolin. Then he stepped aside and just let me go to it, and I took to it right from the start. When I first heard the sound I could make, my heart leapt inside me. Once I held that mandolin in my hands, nothing was ever the same.

That Sunday, Dad went back to his job in Lima, where he got snowed in and couldn't come home for two weeks. When he finally made it back to Kentucky, I was playing and singing and changing the chords in the right place, all at the same time. I'd worked hard on that mandolin for those two weeks, and it showed. When Dad saw me playing and singing, he was blown away. He got so excited he went out and bought himself a new guitar, a 1959 Martin D-28. Drove all the way to a music store in Ashland to get it. Now my dad had a reason to play music again, and that's what we did. I sang tenor to his lead and played mandolin with his guitar, just as he'd done with his brother Okel. For my dad, this was a dream come true.

I'll tell you what—I fell in love with that little mandolin. It pulled me away from my toys. I kept it with me all the time. I didn't have an instrument case and didn't need one. I just laid the mandolin on the floor or the bed when I wasn't playing, and that wasn't too often. I had plenty of time to practice. There wasn't much television in those days, and I made up my own entertainment with my mandolin. I was happy to play and sing for anybody who was willing to listen.

I had a gift, but it was my dad who nurtured it so it could grow. He saw something in me that I didn't see myself. I'm so thankful to God that he was my dad. A good father is someone who sees potential in his children. He pays attention to what they like and what they excel at. I had a father who was also a musician, and he knew he had a son who was a natural-born musician with raw talent. Raw talent needs a guiding hand, and that's what my dad gave me. He was a patient man, and he was willing to spend the time with me. He never had to force me to practice. I loved my dad, and I loved to do things with him. So he made me *want* to practice, because practicing meant we could play music together.

Dad's love for country music was infectious, and I caught it real bad. He was a huge fan of Jimmie Rodgers, the Singing Brakeman; he loved his yodeling and those hot, bluesy runs on the guitar. He loved Roy Acuff and Floyd Tillman and Clyde Moody—all these

great voices from the past. And I came to love them all, too. He'd sit around the porch in the evening playing their songs.

But Red Foley was probably his favorite. You don't hear much about Red Foley nowadays, maybe because he didn't sing many cheating and drinking songs. Back in the '40s, he was a country superstar, with hit records like "Old Shep," "Chattanooga Shoeshine Boy" and "Peace in the Valley." He was a fellow Kentucky boy, from a place called Blue Lick near Berea, and Lord, did he have a beautiful storyteller's voice!

Then there were all the brother acts Dad and my uncle Okel loved—Alton and Rabon Delmore, Ira and Charlie Louvin, Bill and Charlie Monroe.

Last but not least, by any means, there were the Stanley Brothers. Carter and Ralph were from the mountains of Virginia, not too far from where we lived. The Stanleys were special. They had a high, lonesome sound that went through me like a March wind, especially their early recordings with Pee Wee Lambert. Their singing just grabbed me by the throat. Their song "The Lonesome River" had a chorus that made me cry. I guess it was the harmony that touched me. It was so different, and oh so good.

Dad had a collection of old 78-rpm records that predated blue-grass, rockabilly, and Elvis Presley. Not just Jimmie Rodgers and Roy Acuff, but Uncle Dave Macon and Sam and Kirk McGee and all kinds of wild string bands that blew my mind. I'm so glad those records gave me such a solid foundation. It is an easy jump from that early hillbilly music to bluegrass or gospel or country, or even to traditional Irish music like the Chieftains. My Daddy's old records were a springboard for me, and those influences are what inspire me and keep music fun, more now than ever.

For Dad, music was a joy. He'd lay us kids on the floor after dinner and sing to us. We loved hearing him sing one called "I Had But Fifty Cents." It went back to the Civil War and the minstrel-show days, and the words were so funny. We'd hound him, "C'mon, Dad, do that fifty-cent song!" It's about a guy who takes his girl out on a date to a restaurant, and though she says she isn't very hungry,

she eats a whole big bunch of food. I can still hear my dad sing: "A dozen raw, a plate of slaw, a chicken and a roast, parsnips and some apple sauce, with soft-shell crabs on toast, an oyster stew, some crackers too, her appetite was immense. When she called for pie, I thought I'd die—for I had but fifty cents."

There were a lot more verses and a lot more food she ate. Dad just leveled us kids with that song. He'd sing, and we'd just laugh and laugh.

Sometimes he was in the mood for a gospel song. There was one he loved, "The City That Lies Foursquare." He'd close his eyes and sling his head back and holler out, "I'm going to a city where my Jesus is the light." And boy, you could tell he believed it. That's the way he sang and played—I don't think there's anybody I've ever met who loved music more than my dad. He never played for a living, but he could have easily sung with Mr. Monroe or any of 'em.

I told you before how my dad had incredible patience, and this was real important. Learning music, you make a lot of mistakes. It takes time—and he gave me his time—and it also takes a certain character. Dad had an easy-going nature; he had one steady pace and he kept at it. You could set your watch by the way he did things. My great-grandfather Cornelius Skaggs was the same way, and Dad must have inherited it from him.

All my life I've had a good sense of pitch. Playing out of tune or singing off-key just doesn't sound good. I've never liked it. When Dad and I would play, I just couldn't stand to be out of tune, so I was constantly fooling around with my mandolin, trying to get my eight strings in tune with the six on my dad's guitar.

As I've said, Dad was usually a very patient man. I'd seen him sit and wait for hours for a groundhog that had been getting into his tomato patch to come out of his hole so he could pop him with a .22 rifle. I'd seen him fish all day and not catch a thing and barely get a bite, and he'd be happy as can be. But to give me five minutes to tune up, you'd a-thought I'd asked him for a million dollars.

One day I was busy tuning my mandolin, twiddling with those tuning pegs. After a few moments, he couldn't take it anymore. He yelled out, "Son, if you're a little out of tune, it's all right. It just sounds like there's more of us playin'!" Well, let me tell you, sometimes me and Dad sounded like a whole band.

Dad had a great ear. He could always hear when a song wasn't played the right way. He couldn't necessarily tell me exactly what was wrong or show me by playing, but he could always hear the wrong notes or ones that didn't fit. So he'd sit there patiently while I kept playing a song over and over again until I got it right. When he heard me get it right, he'd say, "That's it, that's it!" and then I was able to hear the difference, too. That is what you call learning it by ear, and in this case, two sets of ears, me and Dad's both. He never got frustrated, so I didn't, either. We just kept at it until we got it right.

When I think of kids today learning music, I feel bad for 'em, because of all the distractions out there. If I could tell 'em one thing I know, it would be this simple advice: Just keep playing and get to know your instrument like it's your best friend. Turn off the computer and the video games and things that drain your brain and find inspiration in your instrument. If you're going to be a great player, you've got to spend a great amount of time practicing. When you're not doing your chores or your schoolwork, you oughta be playing!

Now, I ain't gonna lie to you. There were plenty of times when I didn't feel like practicing anymore. After hours of playing, I'd really get tired. My hands and fingers would get so sore. Sometimes, I'd even try to break a string when my dad wasn't looking. If I broke a string, we'd have to call it quits and put the instruments up for the night. We didn't have the luxury of going down the road for new strings.

Well, one night, I'd been playing so hard for so long that I was dying to take a break. I saw my dad's head turn, and I knew this was my big chance. I pressed down on the string behind the bridge, and since the string was worn out and ready to go, it snapped. I said, "Oh, sorry, Dad, I broke a string!" He looked sad, but quietly said, "Aw right, let's put 'em up." Mama saw me pull that stunt, but she didn't

say a word. She never did tell Dad. I guess she understood that I was tired and didn't want to hurt Dad's feeling by letting him know I had wanted to stop. If I hadn't had my mom on my side, I don't know what I'd have done. She was very sympathetic to my cause. Mom knew I was blessed with a lot of talent, but she also wanted me to have some fun and be a regular kid, too. And so she'd stand up for me when I wanted to stop playing for a bit. If she'd been as dedicated and driven as my dad, I am sure I would have worn my fingers down to bloody nubs.

Mom was very understanding, and she knew when I'd had enough. She'd say, "Now, Daddy, just do one more and then let him rest." And he'd say, "Let's do one more and then you can quit." But that one more always turned into more than one. He just loved music so much; there was always one more he wanted to do. Eventually I'd holler for help. "Hey, Mama, Dad is one-moring me to death!" and she'd finally put her foot down and make us stop.

Most of the time, though, I was as raring to play as he was. He saw something in me and encouraged me. He pushed me to get better, and he pressed me to practice. He saw that I had the talent to go far with my music.

One of the first audiences I played for was in Blaine at Butler's Grocery, a general store a few miles from home where we'd go for sugar, coffee, and anything we couldn't grow. The woman who ran the store was named Lorraine Butler Burton, and she was a precious, sweet lady. She loved everybody, and everybody loved her. You could buy food at Butler's on credit, which came in handy later when Dad hurt his back and couldn't work.

Blaine had a post office, a gas station, a bank, a barbershop, and a couple of grocery stores. That was it. Butler's was the oldest store in town and the one we always went to. The Butlers loved music, and the store was a local gathering place for years.

Sometimes when Dad and I went over to Butler's to buy groceries, we'd take our instruments with us. We'd play for hours and draw a big crowd. I'd sit with my mandolin on the old Coca-Cola cooler

in the middle of the room. That cooler was the old horizontal kind with the two doors that opened on top. It stayed plenty cold for the pop they kept inside, all the Nehi Orange, root beer, 7-Up, RC Cola, grape soda, and ginger ale you could drink.

After I'd played a while, Miss Lorraine would let me pick out whatever soda I wanted. I'd grab me a bottle, and it would taste so good. Sometimes there were even little icy crystals in that ice-cold pop. Dad would play all day long at Butler's, drawing a big crowd into the little store. The only problem was that my little skinny butt would get so cold on that freezer that I couldn't stand it for more than fifteen or twenty minutes at a time.

Dad taught me how to listen to music, how to really hear what the words were saying, and how to feel those words with my heart. When we sang "What Is a Home Without Love," he'd help me understand the story of the song afterward. "Now that man is really hurting," he'd say. "Did you listen to what was troubling him there in the words? How he don't have nobody?" When you open your heart that-a-way, music is more than a bunch of notes.

Beyond the music, Dad was a big influence as a role model. He was quiet in his ways. He was a godly man, but he didn't preach it. He walked the faith, he lived it every day of his life. To me, he was everything, 'cause it seemed there was nothing he couldn't do. He was a Christian, he was a musician, he was a welder, he was a farmer, he was a coon and squirrel hunter, he was a ginsenger, he was a fisherman.

And he was a real Mr. Fix-It, too. Dad could fix anything with a pair of pliers, wire, and duct tape. A neighbor would call him on the phone and say, "Hobert, our cook stove is tore up. Could you come fix it?" He'd say, "Yeah, be over there in a little bit." He'd grab some tools out of his toolbox and go over and get the stove fired up. It didn't matter if it was ten below zero and the wind was howling, he'd crawl under somebody's house and work on their frozen gas lines. Before we go any further and before I forget, I oughta tell you what

a "ginsenger" is, because some of you may not have heard that term before. In the mountains, there's a lot of ginseng growing wild, but it's hard to find. It has green leaves and red berries, but it's the root everybody's after. You have to know where to look, and you have to walk around a lot to get to it, because it grows in small patches deep in the woods. My dad knew the secret places, and he was a fine ginseng hunter.

Now, the reason people go out hunting for ginseng is because it's worth a lot of money. It's highly prized in Asia, where people use it for all sorts of remedies, especially over in China. There, a lot of people use ginseng as an aphrodisiac. When I was real little and curious about everything in the world, especially about whatever my dad was doing, I asked him, "Dad, what do they do with the ginseng you get out in the woods?" For a long time, he wouldn't tell me. Finally, when I was a few years older, I asked him again, and this time he was ready for me: "Well, son," he said, real serious. "China uses it to strengthen their nation!"

Dad loved a lot of things, but above everything came music—well, music and family. He really cherished that night in Martha when I got to sing on stage with Mr. Monroe; he told the story to friends and family and anyone who'd listen. Part of the reason was fatherly pride—his own son playing on stage with his hero Bill Monroe was a big moment for my dad. That night confirmed his deep desire to see me become a real musician. It seemed like the natural thing to do was start a family band—Dad could continue to teach me and nurture what he loved most, his family and his music. So we started our own group, the Skaggs Family. Most of the time, it was just the three of us: Dad on guitar, me on mandolin, and Mom singing and clapping her hands.

Sometimes our friend Elmer Burchitt joined us on banjo. Walter Adams and Dad's cousin Euless Wright joined us on fiddle. Euless was a big influence on me. He taught me a lot about how to play music and how *not* to live. Family bands were a dime a dozen in those days,

but we had a secret weapon, and that was my Dad. Thanks to his energy and his friendly ways, people started hearing a lot about the Skaggs Family. He had faith in me 'cause I was so young and I had talent, and he played it to the hilt. He got some cool-looking hand-bills printed up with a group photo that said, "The Skaggs Family Featuring Little Rickie Skaggs, World's Youngest Mandolin Player." I don't know if that was really true or not, but Dad sure hadn't heard of anybody younger. Even if I wasn't the youngest mandolin player, I may have been the littlest, 'cause I wasn't even four foot tall.

Ours wasn't much of a stage show. We didn't do comedy, and we didn't do a lot of talking. We just played and sang the same songs we did around the house, family favorites by Red Foley and Molly O'Day and radio hits like "Cup of Loneliness" and "Window up Above" by George Jones. Mom and I sang a lot of duets, and Dad would sing lead or sometimes bass, in the same way A.P. Carter used to back up Sara and Maybelle on those old Carter Family records. When Dad sang lead, Mom would sing tenor, and I'd sing high tenor like Pee Wee Lambert did with the Stanley Brothers, and it gave us a real haunting sound.

It was the kind of entertainment that had been around for many years and went back to the days before radio, when vaudeville and medicine shows traveled the back roads. We sang a good share of old-fashioned toe-tappers, mountain ballads, and sentimental songs. One pretty number was called "River of Memory." Onstage, we were from the tradition of the Carter Family and so many other family groups that came before and after us, in that we didn't put on any airs or try to be something that we weren't. Like it says in the biography of the Carters, *Will You Miss Me When I'm Gone?*: "They didn't play hillbillies or hayseeds or cowpokes. They were just regular folks making their own music." That was us, all right.

I usually took a break on my mandolin in the middle of a song—nothing fancy, just little turnarounds I'd heard on records—and the folks really loved to see the little boy play. But it was mostly the family singing that carried the show, and most of the crowd favorites were

gospel tunes like those we'd sing at the Free Will Baptist Church. We got a lot of our songs from the Baptist hymnals, especially the old Stamps-Baxter hymnbooks that people knew so well. These were little paperbacks published in a town called Lookout, Kentucky, and they were popular in the mountains. They printed the words, not the music, because most people couldn't read music.

There was one beautiful hymn, "Jesus Spoke to Me One Day," that my mom and me used to sing as a duet. It was an old call-and-response hymn, and it was always one we could sing to get the audience involved. I'll never forget the time when that hymn got hold of a woman out in the crowd, and she got to shouting!

It was at the big Fourth of July shindig in Louisa, not too long after we first started playing in public as the Skaggs Family band. This was a huge celebration every year, and all kinds of local home-grown performers like us would show up to help celebrate Independence Day. It was held outside on the grounds of the Lawrence County courthouse. They had lots of music, hamburgers, hot dogs, cotton candy, caramel apples, and custard. It was the biggest event all year, and you'd have folks from miles around come to Louisa to get in on the celebration. There was an old band-shell amphitheater, built back in the Civil War days. It was poured concrete with a curved roof, and you could stand in this round shell and talk to a thousand people without a microphone. It had perfect acoustics, and the music sounded great when you played inside. On the afternoon of the big bash, we were in the amphitheater, just us three, performing our little family-music program. It was the largest crowd we'd ever entertained, and I was getting a real thrill hearing our voices bounce off that band shell into the open air. After a few songs, people started coming up and throwing money at my feet. They'd run up and toss a nickel or a quarter or a silver dollar or whatever change they had. I got so much money in my pockets that my pants came down that day, and it embarrassed me to death. But I was awfully happy to see that people liked the music we were playing. After I got my britches hitched back up, me and Mom started singing "Jesus Spoke to Me."

I was chiming my response parts with my squeaky tenor. There was an old woman out in the crowd, and she stood up and threw her arms up in the air and started shouting hallelujah, as if she were in church. This hymn was really touching her heart, and she was praising the Lord out there in public in front of the drunks and the street people and whoever happened to be passing by. It was just her and Jesus. That was the first time I'd ever seen anyone shout like that outside of church.

I look back at that now, and I think that God was using my music—these old-time hymns I was singing with Mom—to reach out and touch the audience long before I knew there was an audience to be touched. I was just a kid singing with my mom, but our music could carry the message of the Gospel out into the public square. Sometimes a song can take people to a place where a preacher can't. I believe Jesus really was speaking to that old woman on that Fourth of July so long ago, and we were somehow being used to help her hear His voice crying out across a crowded park in downtown Louisa.

At the time, though, the shiny coins those people threw at me made a bigger impression. And there was more of that coming. I started entering a lot of talent contests on my own about this time. There was a contest over in West Virginia where I won fifty silver dollars. I felt like I'd won the lottery.

There's an old photo of me sitting on the floor in the living room with all those silver dollars stacked up on the coffee table. It's one of those family pictures where everybody's pulling a goof. I've got my mandolin, and I'm wearing a cowboy hat cocked sideways. Dad's got his guitar, and his hair is pulled way down on his forehead like Moe from the Three Stooges. Mom is sitting behind us, and she's holding a banjo and making a funny face. She loved banjo, but she couldn't play a lick! It still makes me laugh when I think of that photo. There was another competition at the Pan Theater in Portsmouth, Ohio, where the Skaggs Family band played sometimes. The top prize was a brand-new red Marvel transistor radio, and I beat out a lot of

kids to win one and was thrilled. This was when transistors were as cutting-edge and high-tech as an iPod is nowadays. It was an incredible thing to have at that age, especially during that era of American music. Here I was, a kid from the mountains who lived up a dirt road back in the woods, five miles from the main highway, and now I could hear the sounds of every kind of music being made, from places I couldn't even find on a map.

For my seventh birthday, I got my first Gibson mandolin, an A-40 model. It was the first good mandolin I ever had, one that was professional quality. I'd never have dreamed that one day that little Gibson would end up in the Country Music Hall of Fame. It almost didn't survive past my tenth birthday.

The Skaggs Family band kept mighty busy, and not just with talent shows. We worked a little radio station in Ashland, Kentucky, called WTCR, where they'd set me up on a box in the studio so I could reach the great big microphone. One time we were guests on a big package show headlined by Roy Acuff over in Huntington, West Virginia. There we were, the Skaggs Family band playing with the likes of Kitty Wells and Johnnie & Jack. It was somethin' else.

But the best was when we went to Nashville for a guest spot on the Ernest Tubb Midnite Jamboree. We had traveled down from Kentucky to go to the Grand Ole Opry for the Saturday night show. My dad figured that we'd find a place to play somewhere, so we had the car packed with instruments. Elmer came with us, as did Euless, who played his fiddle to help the long drive go by.

Then we pulled up to the Ryman Auditorium in downtown Nashville. I remember my first time at the Ryman like it was yesterday. We bought our tickets and went in and sat down in the old woodenpew seats. I can still see the rainbow colors of the stage clothes that all the performers wore—the bright blues and yellows and purples and greens—it was so amazing.

In those days, it was important for stars to look like stars, and the theatrical presentation and the fancy costumes were a big part of it.

When hardworking people went to the Opry and paid their money to see the show, they wanted a show. Even if you were sitting forty or fifty rows from the stage, you could still get a good look at one of those sparkling rhinestone Nudie suits, the flashy, eye-popping outfits designed by tailor Nudie Cohn, whose country music clients ran the gamut from Gene Autry to Gram Parsons.

Porter Wagoner had an incredible blue Nudie suit with sparkling rhinestone wagon wheels and cactus on it. Here were all the voices I knew from the radio, right in front of us. Shining like true stars. There was Hank Snow, the Singing Ranger; ol' Ernest Tubb; Lester Flatt and Earl Scruggs; Webb Pierce; Patsy Cline; Kitty Wells; Jean Shepard; and Hawkshaw Hawkins.

At the time, Jean was married to Hawk, and that night they were scheduled to host the Midnite Jamboree show at the Ernest Tubb Record Shop, down the street from the Ryman. At the end of the Opry show, Hawkshaw invited everyone to come by the Jamboree. Well, that was the invitation Dad was waiting for. We walked down Lower Broadway to the record shop. It was packed elbow-to-elbow, and somehow Dad worked his way through the crowd and made his way back to see Hawk.

Next thing I knew, Dad was telling us to get ready and grab our instruments from the car; sure enough, Hawkshaw and Jean were going to give us a spot to play a few songs that night.

It was a truly kind gesture, and it turned out great. There was only one hitch. Euless didn't show up to the gig, so we didn't have a fiddler. We found out later he got a case of stage fright and drank too much and missed out on our big moment. But Elmer was there with us on banjo, and I got to do a mandolin solo. The legendary Opry announcer Grant Turner was beside us, rooting us on and exhorting the crowd. It wasn't the Opry, but it was pretty darn close.

I'm so glad my cousin Barbara Sue Skaggs was with us that night. She took a picture of that appearance, and you can see all four feet of me at the microphone.

That was early 1961. Two years later, on March 5, 1963, Hawk-

shaw was killed in the same plane crash that took the lives of Patsy Cline, Cowboy Copas, and his son-in-law Randy Hughes. It was a very sad time in Nashville, especially for Jean. In the years since, I've thanked Miss Jean Shepard many times for letting us play as guests on the Midnite Jamboree. It meant so much to our family.

Mostly, though, the Skaggs Family was a local act. We used to work a lot of churches, pie suppers, theaters, and schools, in towns all over eastern Kentucky. We played from Prestonsburg to Paintsville, near Butcher Hollow, where Loretta Lynn's from. Every now and then, we'd get a paying gig. But we didn't make any real money. It was just a hobby, and good practice for me.

The Skaggs Family band also gave my mom a chance to step out and sing her own songs. She had a bunch of things she'd written around the house. One was called "All I Ever Loved Was You," a song that Ralph Stanley later recorded. Mom didn't play an instrument, but she'd write out what she could and Dad would help her work out the melody on his guitar. She wrote a lot of love songs when Dad was away working and she was missing him. He'd be on her mind, and she'd wake up in the middle of the night thinking of lyrics. She'd jump out of bed and jot down the words before she'd forget. She said the songs would just come to her.

I was thinking about my mom the other day when I was listening to "Mother's Only Sleeping" by Bill Monroe, one of his most popular records. It was one of her favorites. Not having my mother now makes me realize how this song touches people when they hear it. Mama was such a powerful influence: Her singing and songwriting inspired me, her words encouraged me, and her prayers always kept me safe.

The songwriting gift my mom had, I didn't get. I haven't been blessed that way, not so far, anyhow. I keep believing that one day I'm gonna get real inspired to write songs. I don't think you can force it; at least I can't. It may never happen for me, but I'm hoping it will.

Music is a calling, and I mean that literally, too. I remember I'd be out goofing around in the woods, and Mom would stand on the

front step of our house and holler, "Lester and Earl's on!" Her voice could travel a mile, and no matter where I was, I heard her loud and clear. The Flatt & Scruggs TV show was sponsored by Martha White flour. It was syndicated on television stations all over the South. The show brought Lester and Earl and their red-hot band, the Foggy Mountain Boys, into the living rooms of millions, and it had helped make Flatt & Scruggs the most popular bluegrass act in the country. I'd take off as hard as I could run, on back to the house. The music had a pull on me like nothing else, not even the call of the woods.

At the time, I didn't know what "child prodigy" meant, and nobody ever said it. Prodigy was not a word we threw around in Kentucky back then. People would just smile and say, "That boy's got a lot of talent. God's given him a gift." And those words stuck with me. You'd be surprised how much a child is influenced by words. My mom always reminded me that the Lord had given me my gifts, but she didn't make me feel like I had to pay Him back by only playing gospel. As if I could ever pay back the Lord's kindness to me.

My mother said those words to me to remind me that my talent didn't come out of nowhere; it came from the Creator. Her words were full of joy and blessing, and they poured into me. I knew I had to use the gift the best I could and not let it go to waste.

See, Dad gave me the mandolin and love for music, but my mom gave me a faith. Through her example I learned the importance of praying and trusting in God. Without those pillars, the gift of music, though wonderful, would not be enough to uplift my spirit and satisfy my heart. Mom taught me only Jesus can have that place. I always remembered what my mother taught, even when I wasn't all the way living up to it. Mama was doing what she always did: preparing me for the road I'm on now, the road I've been traveling for most of my life.

Chapter 4

CHASING A DREAM

*Like a sinner's penance, the Ryman was austere, its wooden benches harsh,
its roof offering no respite from the sapping summer heat. It was the week-
end home of the Grand Ole Opry, a country radio show regarded as a sacred
monument. . . . The Opry was revered by all who loved country music for its
authority and grandeur.*

—*Are You Ready for the Country,* by Peter Doggett

*A night at the Opry is a concoction of color, confusion, country culture, and
corn. To observe the show is to see a spectacle rooted in the American grain.
. . . "New York advertising people just don't believe it when they see it," said
Ott Devine, general manager of the Opry, in an interview in Nashville in
1961. "They just don't understand the informality."*

—*The Country Music Story,* by Robert Shelton

In 1962, Dad took a job at the Tennessee Valley Authority plant
near Paradise, in the southwestern part of Kentucky. It was at the
atomic energy plant, and they needed skilled welders. This was no

ordinary job for hire, done in a few weeks and on to the next. It was full-time employment, so the whole family was moving with him. But the TVA welding job wasn't the only reason he uprooted the family to leave the hollow. It was mostly on account of me and my mandolin.

Paradise was only a few hours' drive from Nashville. And Nashville was home to the Grand Ole Opry, where all the country stars played. Dad moved us close to Nashville so I could have a decent shot at the country-music business, and so we could give it a go with the Skaggs Family band, too. His greatest dream was to get me on the Opry. The only way to get on the Opry, he figured, was to be in Nashville.

So we moved to Goodlettsville, Tennessee, a suburb north of town. It was a big change for us. It was probably hardest on my oldest brother, Garold, because he loved hunting and fishing and running the woods so much. The rest of us were excited. And we wouldn't be leaving everyone behind at Brushy Creek. My dad's cousin Glair Mullins got hired at the TVA plant, too, and he and his wife also moved to Goodlettsville, living two doors down from us in our new neighborhood.

It was a brand-new subdivision: tidy little three-bedroom houses all lined up and straight driveways down to the paved street, complete with a street sign for Fannin Drive. Roads back home curved like a copperhead, and most were simple dirt paths cut into the land. We were a long way from Brushy.

I still had a lot of Kentucky in me, though, and it didn't take much for me to put it on full display. One of the first things that happened after we moved in was me getting in a fistfight with a boy in the neighborhood. We'd barely even met, and I busted his nose.

The stupid fight was over a mulberry tree, if you can believe it. We got into a crazy argument over this tree that grew along our street. I don't remember how it even started, just him saying, "It's my tree!" and me saying, "No, it ain't!" Something in me snapped, and I reared back and popped him right in the nose. It was a hard punch, too, and

I knew his nose was broken. I still don't know what triggered it. I guess this boy had pushed me to the limit.

When I saw his nose spewing out blood, I was as surprised as he was. I immediately felt terrible and ashamed of what I'd done. I started to tell him how sorry I was and tried to hug him, but I just got his blood all over me, too. Now we were both a bloody mess standing there under the mulberry tree.

He went home screaming to his mom, and I went home crying to mine. This wasn't a very good way to make a new friend. The boy's mother came to our house and told my mom what had happened. Mom said, "When your dad gets home, you're gonna get it." I dreaded to see Dad pull into the driveway, and when he did I really got my butt busted. He didn't want me growing up fighting, especially over something piddly like that. If that boy had challenged me, or said something about my family, there may have been a little more justification. But to get into a fight over a mulberry tree that didn't belong to either one of us? That was pretty senseless.

After that I never got into another fight. One was enough. Now, I did learn to spit and whistle and do all the other things boys my age did back then. I was a regular kid except when it came time for sports, and that's when I wished I didn't play music so much.

Dad didn't let me try out for any team sports, because he thought I'd hurt my mandolin hands. He never wanted me playing baseball, because he was afraid I'd get a bad hop on a ground ball or get nailed by a line drive and mash my fingers. Same with basketball and football.

Garold was on the Little League baseball team they had in Goodlettsville. We didn't have organized sports or anything like that in Kentucky, which of course made the idea seem even cooler to me. I mean, Garold had a uniform, so by gosh, I wanted to have me a uniform and play on the team, too! Well, Dad wasn't gonna let that happen.

I was really upset. I wanted to be in on the fun the other kids were having. He said music was too important to let a freak accident on a

ball field ruin my chances. He wouldn't budge. My mom talked him into letting me be the batboy. It gave me a role to play and I got to have a uniform, so I was happy. Before you get to feeling too sorry for me, I can tell you now that Dad was absolutely right on this point. Looking back on it, I'm glad he didn't let me get involved with team sports, because I believe I'd probably have lost my focus on music if I played, and it would have cost me in the long run. I could have ended up being okay as an athlete and being good as musician—but not being great at anything.

The way it turned out, batboy was plenty enough organized athletics for me, 'cause I realized music was gonna be my true sport. When most kids were discovering other pursuits and peers to keep them occupied, I sort of hunkered down for the long haul with my little mandolin, with my Dad as my guide. I'd found something I was good at, something I could count on.

It wasn't too long after we moved to Tennessee before Dad's plans to get me on the Opry hit a snag. The management said I was too young to play their stage because of child labor laws. But Dad wasn't going to let a little setback like that stop him.

This was back when the Opry was in downtown Nashville at the Ryman Auditorium, which is an old brick building that started as a church called the Union Gospel Tabernacle in 1892. It wasn't much to look at from the outside, but you could hardly believe what a mecca it was then and what it meant to country music fans. In the afternoons, before show time, you'd see families eating fried-chicken dinners on the curb in front of the Ryman, while we scooted down the alley to the back entrance behind Tootsie's bar.

Things were more casual back then when it came to meeting celebrities. Dad made friends with the backstage guard at the Opry, a man named Mr. Bell. Here again, we're talking about my dad, who just made things happen. Mr. Bell took a shine to this kindly mountain man and his little mandolin boy.

Mr. Bell alone decided who could come and go backstage, a sacred

area that was off-limits to the general public. He was the law, but he was not puffed up by his station. He had compassion and good old common sense, and he decided that we were as earnest as they come and that we didn't give a hoot about autographs. So he told Dad and me, "Okay, I'll let y'all back in here. But remember: We've got a live show going on. So don't be pestering people, and whatever you do, make sure you don't touch nobody's instruments! Y'all know how to be." It was really nice of Mr. Bell, and I'll always remember what he did for us, because I know he helped a dad and his son chase a dream.

One day in the late fall of 1962, we were backstage at the Ryman as all the country greats were coming and going, getting ready for the show. We were standing off to the side, away from all the hustle and bustle. I was strumming my mandolin when Earl Scruggs happened to walk by, and he stopped to listen. Earl was so casual and down-home, and he was in no hurry at all. It might seem strange that he was so willing to pay attention to little a kid, but he had boys my age, Randy and Gary, who were learning to play, too.

I started in on one of the little breaks I'd been working on, and Earl stood there and listened for a bit. When he'd heard enough, he said, in his easy-going way, "The boy's a fine little picker. Why don't you bring him down for an audition next week for our television show? I'd like to get him on." Earl didn't make any promises. He told my dad it was up to the producers of the show. But we were over the moon.

An appearance on the Flatt & Scruggs TV show! My dad didn't need half a second to tell Earl we'd be there at the studio ready to go.

The audition was a big success, and the producers put me on the schedule. I got a chance to meet Lester and all the Foggy Mountain Boys that day. They were real nice men like Earl, and they made me feel welcome. We did a rehearsal, working up an instrumental, "Foggy Mountain Special," and running through my old stand-by, "Ruby."

Come show time I was ready. I was freshly shorn with my flattop

haircut, and Mom dressed me in a Kentucky Colonel string tie just like the Foggy Mountain Boys wore. Right before I went out, Lester came over to give me some last-minute instructions. He said that just before they announced me he'd be doing a commercial for the sponsor, and at that moment, he wanted me to go tug on his coat and tell him I want to play with the band.

That may seem simple enough, but it had me worried to death. I was saying, "Yes, sir," but in the back of my mind I was thinking, *I'm supposed to go out on stage to interrupt somebody when they're speaking, with my mother sitting right there in the studio audience, seeing me do that?* I knew my mother would never approve. She never let me interrupt anybody when they were talking, especially a grown-up and surely not an Opry star like Lester Flatt. I was not comfortable with the situation. It wasn't singing and playing that worried me. I was nervous about interrupting Lester Flatt in front of my mom.

There was no way out except to get it over with. I sort of sidled out on stage and snuck up behind him while he was busy on the mic plugging Martha White biscuits. I tugged on his coattail, and Lester whirled around as if he were startled. He was an old pro, and he played it perfect.

"What do you want, son?"

"I want to pick!"

"Didja hear that boys? He wants to pick!"

The first one I played was "Foggy Mountain Special," and I got to do a nice little break on my mandolin, and I didn't even crack a smile I was so focused on getting every note right. The Foggy Mountain Boys stayed behind me all the way. When the song ended, Lester really whooped it up for the studio crowd, and he said, "By dog, he wasn't kidding, was he, fellas, when he said he wanted to pick!"

Then it was back on stage for the second part of the show. We lit into "Ruby," and I really bore down to stay with the band, like steering a freight train from the engineer's seat. I didn't even think about the fact that I was sharing my little microphone with Earl Scruggs's banjo.

After we finished up, we milled around backstage, and everybody in the band congratulated me; everyone was so nice to this little mountain boy. I didn't know there was a long-standing feud between Lester and Earl and their old boss, Bill Monroe, and this was probably the worst it had been since the split. Flatt & Scruggs were on top of the world with a hit TV show and the Martha White sponsorship, and meanwhile, poor ol' Mr. Bill was just scraping by. There was bad blood in both camps, and I was about to get a taste of it.

At that time, Curly Seckler was singing tenor and playing mandolin for the Foggy Mountain Boys. He was on a lot of their classic records like "Roll in My Sweet Baby's Arms" and "Salty Dog." Well, Curly's mandolin caught my eye. It had a scroll on the neck just like Monroe's, but the body had a round hole that was different than the F-5 model Mr. Bill played. I was curious about it, so I went up and asked Curly, "Is that mandolin like Bill Monroe's?" It was an innocent question from a seven-year-old. Everybody got quiet, and you coulda heard a pin drop. "Well, son," Curly said. "I sure hope it ain't!"

Curly started laughing, and all the Foggy Mountain Boys joined in, especially Lester and Earl. I had no idea what was going on, and it didn't feel too good, either. I didn't laugh along with them. It didn't seem a bit funny to me. I had no notion of the hard feelings between Mr. Monroe and Flatt & Scruggs. I just knew I loved Mr. Monroe, and I was thinking they must have said something nasty about him.

Not too long after the taping, the producers called to let us know when the show was gonna air. When the day finally came, we all gathered around the TV to hear the announcer say "special guest Ricky Skaggs." I watched myself come out on the stage, and I felt this burning excitement in my gut. I ran into my room and hid under the bed and wouldn't come out. I didn't want to watch it. I was so shy and backward, I couldn't watch it. Being from the mountains, I just couldn't understand the whole concept of TV, really. My sweet little grandmother Carrie Skaggs was watching the show on her television back home in Kentucky. She went up to her TV set and kissed me on

the screen, thinking I could feel it. TV was still kinda new to us folks from the mountains.

It was more than thirty years before I finally got another chance to see myself on that Martha White TV show. I tried to find a tape of it for years, asking all around Nashville, but nobody had one. One day I was on the road, and my wife, Sharon, called and said she'd got a copy. When I got home, I sat down to watch it, and this time, I didn't run into the bedroom. I had my youngest children, my daughter Molly, who was 10, and my son Luke, who was about five, there with me. More than three decades later, my eyes filled with tears to see my seven-year-old self again. It's funny, because I look at myself on that tape and can see a self-assurance there that I wasn't aware of at the time. I've got this fierce determination on my face, and a very stern expression. I don't look nervous at all. So I had something in me right then, even at seven years old. I had a real inner drive. Some might call it arrogance, and maybe I was arrogant, but I would have never thought of myself that way. I just was so focused on playing music the best I could, and I still try to do that today. I guess I was already Picky Ricky, long before Emmylou Harris gave me that nickname.

That appearance on the Flatt & Scruggs TV show was my highest-paying gig yet. I remember I got a check for $52.50, and in 1961 that was a lot of money, especially for a kid! I guess I thought I was pretty hot stuff. It wasn't always easy on my sister and brothers, with me getting most of the attention. But they were accepting of the situation, least as far as I could tell. We've never talked much about it in the years since, but they never showed jealousy or ugliness toward me. I know they probably felt Dad was spending a lot of time with me, practicing and playing. But he spent a lot of time with Garold, too, hunting and fishing. My sister and my mom spent a lot of time together, and she was already involved in lot of school activities. My younger brother, Gary, he was the baby, and he got plenty of love. We all did. It was such a blessing to grow up in a house full of peace.

Dad's job at the TVA plant in Paradise kept him busy. He and Glair would usually stay there during the week. This job was government-regulated with the highest safety standards. Dad might do a half day of welding, and then the federal inspectors would x-ray the work he did. If there was a crack in the pipe bigger than one-sixty-fourth of an inch, they'd have to grind it out and re-weld the joint. They couldn't afford to take a chance on one of those welds breaking and causing an accident. It was a high-pressure situation for my dad, and it really wore on him.

So when Dad came back home on weekends, it was such a joy for him to be able to see his family and to sing and play music like we did back in Kentucky. He looked forward to these picking parties all week long. We'd usually have friends and neighbors come by and play. We'd scoot all the furniture back against the wall so we'd have a clear place in the center of the room. Mom, Dad, and I would play, along with whoever brought along their instrument. Usually we'd have a fiddler and a banjo player, too. Inevitably, a few folks would jump out of their chairs and get to dancing in the middle. And we'd do our best to keep 'em dancing till they were wore out, which usually wasn't till way past my normal bedtime.

Sometimes my Dad would have to tell people it was getting late and time to leave, with hints like, "Well, if I wasn't home, I'd go!" Or he'd say, "If y'all are setting up just for me, I'm feeling better!" If they still wouldn't budge, he'd finally holler, "Dorothy, I guess we oughta go on to bed, or these people might wanna go home!" That one usually did the trick.

These pickings were the most wonderful fun. In Ireland, they're called a ceili, and I went to several over there when I was on tour in the late '70s. On those nights on Fannin Drive, I saw what music did to people. You'd see the folks coming through the door, and they'd be worn out from the workweek. Then, after a few songs, you'd see the change in their faces. That is the only way I can describe it. I saw how music can truly bring joy, and joy kills sorrow.

I try to remember that whenever I play. I know some people come

to a show and they're stressed out from work or they're depressed over problems at home or finances. Whatever the case may be, there's something in the music we play that can help bring peace and joy to people, at least for a little while. They may not get out of their seats and dance, but they sure do get their feet tapping.

One of the musicians who really encouraged me at that time was Benny Martin. He'd come over to pickings at our house in Goodletts-ville. Dad had met him backstage at the Opry, and it turned out he lived nearby. Benny was an incredible fiddler, and he'd pulled stints with Monroe and Flatt & Scruggs, playing on some of their greatest recordings. He was on his own by then as a solo artist.

My dad invited Benny a few times, and he brought his wife and children. Benny was one of those musicians who could do it all. I've got a recording of my mother singing "Mule Skinner Blues" with Benny backing her on fiddle. Talk about a dynamic duo. Tell you what, it's something to hear your mom get as wild as that. Benny could hardly keep up with her. Benny was very supportive of my musical development. He listened to me play and offered advice and tips. He even wrote a song for me, something he thought would be perfect for a little kid musician like me. It was called "Changing Playmates." Benny knew I'd moved to Tennessee from the only place I'd known back in Brushy Hollow, and he figured I was lonesome and missing my little mountain pals. He thought it'd do me some good to sing a song from a child's perspective about leaving your old friends behind and making new ones.

To tell the truth, it was a little soft for me. I sort of turned my nose up at it. He was just trying to be helpful, but the whole idea behind a song like that seemed kind of silly and childish. The odd thing was that Benny's own kids were mean as snakes, and they didn't make good playmates at all. They just ran wild while Benny fiddled.

So while he was trying to teach me the song, I was thinking to myself, you know, I can't handle this, Mr. Benny. I mean, my favor-ite songs were real-life, grown-up, sad-as-all-get-out country records like "Pinball Machine," the hit from 1960 by Lonnie Irving. It was

about a truck driver who lost everything he loved because he loved pinball more than anything. It was one of those tragic recitations you heard on country radio back then, and I knew every word. From the time I started playing, I wasn't singing kids' songs at all. I think some people probably thought it was a little strange for me to sing "Ruby, Are You Mad at Your Man?" And it was pretty salty for a kid my age, when you think about it. But it didn't seem strange to me. I'd grown up loving the old songs from the mountains, the ones my dad was teaching me. I just sort of absorbed them like coal dust on a miner's child; they just seeped into me.

One song really had me spooked. It was called "The Little Girl and the Dreadful Snake," a bluegrass tune Bill Monroe and Jimmy Martin sang in the late '50s. It was about this girl who wanders out in the woods, gets bit by a snake, and dies. Her father hears her screaming, but he gets there too late. That song made me so afraid of snakes that I avoid them to this day. By and large, most of the music that us mountain kids heard back then was the same music that grown-ups listened to, songs that came into the mountains with Scots-Irish immigrants in the eighteenth and nineteenth centuries—songs of loss and sorry like "Little Bessie" and "Pretty Polly" and "Little Rosewood Casket." It could be about the death of a loved one—the passing of your mother or the killing of your uncle—or hope for the afterlife, or what happens if you don't have salvation. Songs were about life and death.

Those old songs never lose their power. They have lasted because they're about real things and real emotions and they helped people face hard truths. They put something in the back of your mind to ponder. They would challenge you to think, and prepare you for things that could happen. Because life was as sad as it was happy. There was death, sickness, accidents, tragedies.

We got our own taste of trouble when my dad got hurt real bad at the job in Paradise. He and another man were carrying a section of heavy pipe, and the guy slipped on a small piece of pipe lying in the walkway. He dropped his end, and all the weight of the pipe crushed

my dad's back. He went down to the ground all twisted up, ruptur-ing two vertebrae in his lower back.

Boy, poor Dad was in a mess. He just rolled up in a ball and couldn't hardly move for days. His legs got numb, his feet got numb. Finally he had an operation to ease the pain, but there wasn't much they could do in the way of repair in those days. He could walk, but he was never the same strength-wise or stamina-wise after the acci-dent. He had to get a lawyer and sue to get his workers' compensa-tion. But it took years to get all that together.

I felt so bad for my Dad. He was in so much pain. He was hurt-ing not just in his body, but also in his mind. He had always been a provider, and now he was disabled. It hurt his pride, but he tried not to let it get him down. He had music to help keep his spirits up. His injury was bad for his work, but it didn't keep him from playing guitar. To tell the truth, I was glad to have him around the house more. It gave us more time to practice together, and he could teach me more songs. Singin' and playin' with Dad; that was my paradise.

Chapter 5

SAINTS AND SINNERS

What is a home without sunshine
To spread its bright rays from above?
You may have wealth and its pleasures
But what is a home without love?

—"What Is Home Without Love," by the Monroe Brothers, 1936

Not long after Dad's accident, we left Goodlettsville and moved back to the old home place where I was born. Mom gave her okay after making Dad promise he'd renovate the old house so we'd have some of the modern conveniences we'd gotten used to in Tennessee. Our home on Brushy Creek was very small, and Mom gave Dad her list of renovation needs. Dad got busy making plans and recruiting folks to help out. He got some help from Papaw Skaggs and a few of his uncles and cousins, and they built us some more bedrooms and put in a new bathroom and a nice kitchen for mom.

Goodlettsville had been pretty good to us. A lot of good things happened while we were in Tennessee, especially music-wise, and not just for me, but for the Skaggs Family band as well. We'd made some good friends, and we made some contacts in the music business, like Benny Martin. Despite our good fortune there, I think Dad was kinda disappointed bigger things didn't happen. Still, he knew it was time to get back to Kentucky, and I think he was as homesick as the rest of us.

Me and my brothers and sister, well, we were more than fine with heading back to the holler. I remember seeing the top of the ridges come into view when we got close to Brushy, and how good it felt to be home. I was at an age now when I was old enough to run the woods, and the mountains gave us plenty more space than the suburbs in Nashville. It was great to have freedom to roam the hills and run barefoot with your shirttail flappin' in the wind, and to stay outside all day long exploring, getting chigger-bites on your legs, and skinning your knees. We kids would come home at night dirty and plumb wore out!

Back on Brushy Creek, it really didn't matter how much money you had. People around us were a lot poorer than we were, just scraping by. We had neighbors and relatives right down the creek from us who were as poor as church mice. In those days, we were all poor so we didn't even notice.

All the while Dad was trying to get the settlement money for his accident. For a time he had a job down at the Ashland Oil refinery, but the pain became too much to bear. He just couldn't work anymore. We had to get some government assistance—there was even a time when we were on welfare—and we bought our groceries on credit. I remember my mom wanted to buy us some new clothes and couldn't, because there was next to nothing coming in moneywise.

I had just two pair of pants that I could wear to school, so my mom was always washing one or the other so I'd have clean pants for the next day. It was a hard time for us, but we always had plenty to eat, never missed a meal, and if we really needed something we'd go out in the woods and hunt it or raise it in the garden. We could always live off the land.

Mom's prayers really increased during this trying time. She knew the Lord would provide what we needed. But that period was awful tough on her. It got to where things were so lean, I'd catch her crying. One Christmas, we kids got one gift each. Mine was a toy Give-a-Show projector, which let you display pictures on the wall or ceiling.

Mom was so sorry she couldn't give us more. We didn't mind going without, but I know it hurt Mom and Dad.

One day, trying to be helpful, I suggested, "Well, Dad, can't you just write a check?" He laughed, and replied, "Son, you've got to have something in the bank before you can write a check!" But we always had enough, really. Every Christmas, my mom's folks up in Ohio, Grandpa and Grandma Thompson, would send us a big basket of fruit with nuts and candy and oranges. It was a lot more than Dad usually got at Christmastime when he was growing up—a piece of hard candy and a pack of firecrackers!

To be honest, I was too busy being a kid to worry too much about the finances. Besides, I had my own troubles, like the time I faced my first real tragedy—almost losing my Gibson A-40.

We were over at a neighbor's house up the road, the Baileys. We played music till real late at night, and by the end, we were all wore out. Dad loaded his guitar in the back trunk, but he'd set my mandolin down and forgot to put it in; it was dark and he was very tired. I was sitting up in between my folks in the front seat. My dad put our Ford Galaxie in reverse. Soon we felt a thumping sound under the car, and we knew we'd run over something.

I heard Dad whisper, "Oh, my God," and I knew something bad had happened, but I wasn't sure just what. He knew, though. Dad shut off the motor and got out. He looked down and saw he'd backed the car right over the mandolin, smashing it pretty bad. I saw it lying on the ground, and I just lost it. Dad never did curse, and he didn't this time, either. But he saw me bawling like he'd killed my best friend. It's not that I was mad at him. It was just that my heart was crushed worse than my mandolin. For me, my mandolin was more than my friend. It was my whole life.

Dad felt so bad he got back in the car, put his head in his hands, and just sat there. He looked at me crying and got hold of himself. "Son, I'm so sorry! We'll get it fixed, don't you worry. We'll send it back to Gibson and get it fixed up like it was before." It seemed pretty hopeless to me, but my dad always kept his promises.

He mailed it off the next day to the Gibson manufacturers in Kalamazoo, Michigan. It sure sounded like it was a long way from Cordell, Kentucky. I still don't know how he managed to pay for the repair. Bad as it looked, it turned out it was only the broken neck that needed fixing. But I wasn't counting on how long it would take, which wasn't days or weeks but months.

Back then, if you got a package too big for the mailbox, they kept it at the post office. So every day for a few months, I'd walk the mile or so from my house to the post office and ask about my mandolin. Every time, the postmaster, Grace Cordel, would say, "Honey, it's not here today. I'm sorry." I'd walk the mile back home, and the next day I'd make the same round trip. When the package finally did come, that was one happy day, I'm here to tell you. The wait was worth it. I couldn't believe they'd put it back together like new.

Backing over my mandolin was about as upset as Dad ever got, 'cept for one other time, and that was when I saw him when he was scared 'bout half to death. Garold and I were riding home on the school bus one day around Halloween, and we saw big thick clouds of smoke down the road near our place. The bus dropped us off, and we ran around back. Come to find out, my dad was on the hill behind the house fighting a wildfire. He'd been burning piles of brush and debris, part of the usual fall clean-up work he always did, but that afternoon, the autumn wind had picked up and blown the flames out of control toward our house.

Well, Dad was freaked out, running around and shouting for help. I never saw him so rattled before or after that; he was always solid as a rock, no matter what. Seeing that look of fear on his face, that scared Garold and me real bad. Dad was afraid the house was gonna catch fire with the next big gust of wind. Dad was so upset that he hollered out, "We need some fifarters!" instead of saying "firefighters." We tried not to laugh at that but it sounded so funny. Garold and I did our best to help, 'cause there wasn't a fire truck for miles around. We were grabbing blankets and coats and whatever we could find to smother the fire, and after a lot of work, we finally put it out!

We got the fire put out, but the most important thing in my world was that my little Gibson mandolin had made it back to Brushy Creek good as new, and just in the nick of time, too, because I soon found out the Stanley Brothers were coming to eastern Kentucky! They were booked for shows one weekend in Olive Hill and Prestonsburg, a few counties over and an easy drive from our place. I brought my mandolin along for the first night in Olive Hill, the little town where Tom T. Hall is from and where country music's "Storyteller" got so much material for his classic songs like "The Year That Clayton Delaney Died." The show was at a movie theater that sometimes had live entertainment.

We pulled into the theater, went backstage, and met Carter and Ralph. My dad wasn't loud or pushy. He could get into those places because of his humility, the same way he got us backstage at the Opry. Dad and Carter hit it off like old pals, and Dad told him, "My boy played mandolin with Bill Monroe when he was six, and last year he played on the Flatt & Scruggs TV show. If y'all could get him on the show, I think he'd do a good job for you." Friendly as could be, Carter said, "Let's hear you play, son." I picked a tune, and he nodded. "Yeah, that's mighty fine, son. We'll use you tonight. Can you come to Prestonsburg tomorrow night?"

And so I played the next night's show, too. Dad was thrilled, and so was I. Afterward, Carter laid his hand on my shoulder and said, "Son, one of these days Bill Monroe will have to take a backseat to you!" Everybody had a good laugh, and Dad was beaming. At the same time, though, it kinda stung me. Being literal-minded like any kid that age, I thought, *Hold on, Mr. Monroe is the Father of Bluegrass. He'll never take a backseat to anybody, especially some little kid from east Kentucky.* And of course, he never did. But we sure became good friends years later.

It was great to hear Carter say that, even in a joshing way, but I knew he was just being nice. It was the Stanleys' playing, not mine, that sticks in my mind after all these years. Especially that first show. I remember they opened with "Pig in a Pen," and it was blazing. It's

a great opening number for any bluegrass band. Even now I some-times use it to kick off my shows, and it's a tune you can count on to get things started with a bang. One time I even performed "Pig in a Pen" with the Boston Pops Orchestra, and it went over as big in that fancy concert hall as when the Stanleys did it nearly fifty years ago in that little movie theater in Olive Hill.

The Stanleys only had the one fiddler instead of a whole violin section like the Boston Pops, but boy, he tore it up. The fiddler that night was Ralph Mayo, one of the finest they ever had, and Curly Lambert was on mandolin. I always kept my eye out for the mando-lin player, looking for tips on how to pick better. Curly could pick, but he was also an incredible harmony singer who blended beauti-fully with Carter and Ralph. The Stanleys had a great trio sound, as always.

A year later, Carter and Ralph were traveling through our area again, this time closer to home, at the high school down the road in Blaine. 'Course, my dad was waiting right there with me when they got out of their old Buick, and he let the Stanleys know they were in our hometown and how much we'd been looking forward to the show.

Carter remembered me from Olive Hill and Prestonsburg. He asked if I'd brought my mandolin. Well, of course I had. I didn't go anywhere without it. Sure as anything, Carter said, "We'll put you on tonight," and he smiled at me like we were buddies for life. "Go on backstage, son, and set and wait and we'll call you out."

Even though I'd already met him twice, I was still so awestruck I could barely look him in the eye. Carter Stanley was as tall as the ceiling to me, bigger than life. He was so sharp and cool, more like a movie star than a country singer. His suit fit just right, with perfect creases and not a speck of lint. He was wearing these black leather boots buffed up so shiny you could just about see your reflection in them. I remember thinking, *I want to be like that when I grow up.*

The dressing area backstage was the high school boys' locker room. I went on back there and sit by myself on a long wooden bench

while my dad and mom and everybody were out in the auditorium watching the show.

I was alone in the locker room, but I could hear the music and the crowd loving it. Every so often, one of the boys in the band came through in a big hurry. They went right past the commodes to the shower stalls back in the corner. None of 'em stayed long, though, and I never did hear a thing. They'd finish whatever they were doing and make a beeline back out to the stage. First came the fiddler, then Curly, then Ralph, and finally Carter, everyone hitting the same shower stall. I kept wondering what they were coming back for so often and why nobody was using the toilet or faucet.

Well, I couldn't figure it out, so I went over and peeked out the door and listened to the show for a little while, kind of wondering when I'd be getting to go on stage. Carter came in again and saw me up off the bench. I guess he could tell I was getting antsy, so he said, "We'll call you out in just a minute, son."

The curiosity finally got to me, and I decided I was gonna find out what they were doing in those shower stalls. I waited for Carter to leave and slipped back there and poked around. At first I didn't see anything. Then I happened to look up at the ledge where you put the soap and shampoo and what not. There I saw whiskey bottles lined up, little pint bottles they'd hid up there out of sight and out of reach. That's when I realized they'd been making their little trips to the stall during their breaks to take a little nip or two, or three.

It was awfully strange to stumble on the Stanley Brothers' stash of booze. I felt like I'd done something wrong. I don't think I'd ever seen a real bottle of whiskey before, not up close, anyhow. All I knew was that it was bad for you, and that my mother wouldn't let Euless bring any whiskey in the house when he came by with his fiddle. I thought to myself, *Oh, God, if my mother knew what they were doing back here, she'd be so mad! She'd yank my little ten-year-old Kentucky butt right outta here!*

I knew there were many musicians who drank. Whiskey and the fiddle sort of followed each other. But the Stanley Brothers were

heroes to me, and it was an eye-opener when I saw those whiskey bottles in the shower stall. It made me think of them in a different light. Why were my heroes doing this stuff you're not supposed to do? I had heard the Stanleys sing so many gospel songs and hymns about Jesus and salvation. I thought to myself, *Do they really believe those songs?* It gave me plenty of doubts.

I didn't say anything about it at first, but it weighed on my mind. When we went back home, I finally told Mom and Dad what I'd seen. "I wish they wouldn't do that," I said. "That's not good for them." My folks said it was a shame I'd had to see it, but they told me there was a lesson in it, which was not to judge them.

And that was true. I was looking at things from the eyes of a ten-year-old kid, and kids can be pretty unforgiving sometimes. I'd never walked in their shoes, so I didn't know what it was like for them to travel all those miles and be away from their families for so long. I do now. The whiskey was like a painkiller for them.

Even so, it was a painful moment for me. I lost some innocence that night. I can't even relate to that innocence now, after all I've seen of life and the things people do and the suffering some go through. I've come to realize my parents were right, and it wasn't my place to judge. I understand more what the Stanleys were up against now. Those nips of whiskey helped keep 'em going. It wasn't partying, it was maintenance.

In any case, finding those whiskey bottles in the shower stall didn't stop me from loving the Stanleys and their music, and I was still a loyal fan.

Not long after that, my teenage sister Linda came home with a couple of new 45-rpm singles by the Beatles. She put 'em on the turntable, and the house filled with a kind of music I'd never heard before. It was fresh, exciting, and new. But there was something in the harmonies and the singing structure that wasn't foreign to me.

When I heard John and Paul sing together, I said to myself, *There's another brother duet!* I could hear the Everly Brothers in their har-

monies. Now where did that apple fall from? Not far from the tree. 'Cause I knew there was something in the Beatles' way of singing that was kin to the Everlys and Ira and Charlie Louvin and the Stanleys, and even all the way back to Bill and Charlie Monroe.

So when I heard the Beatles, I heard my British cousins. They were an updated brother harmony team. Turns out they were huge fans of Phil and Don Everly. John and Paul sounded like Phil and Don, and Phil and Don sounded like Ira and Charlie, and Ira and Charlie sounded like Ralph and Carter, and Ralph and Carter sounded like Bill and Charlie. It was a cycle come full circle.

There was so much country in early rock and roll, with roots in that old brothers-style, close-harmony singing. It's a special vocal sound that has inspired so many people through the years. All this music is just one big family, in a way. My son Luke has turned me on to a lot of new acoustic modern folk music, like Mumford & Sons, Fleet Foxes, and Iron & Wine. Some of that isn't too different from the mountain music I was raised on.

I thank God I had an older teenage sister. I owe a lot to Linda for introducing me to the Beatles so early on and bringing the British Invasion into our house on Brushy Creek. If she hadn't bought "Love Me Do" and "Please Please Me," I might not have been exposed to the Beatles till much later. She cranked those 45s from her bedroom, and my parents were playing the Stanley Brothers in the living room.

Mom and Dad at first just put up with the Beatles, but soon they came to like them. Now, Dad certainly liked Red Foley better than he liked Ringo Starr, but he had a fine old ear no matter what type of music, and he appreciated their talent. He even told me one time, "Them boys are good!"

I remember the night the Beatles were on *The Ed Sullivan Show*. At our house we could get Channel 13, the ABC affiliate, and Channel 3, the NBC affiliate, out of Huntington, West Virginia, where Flatt & Scruggs's and Porter Wagoner's shows were broadcast. Grandpa Skaggs lived across the bottomland, and he could pick up Channel 5, the CBS affiliate out of Charleston, West Virginia that

aired the Sullivan show every Sunday night. It was wintertime, so we got ourselves bundled up and walked through the snow to my grandpa's house after dinner that evening.

The Beatles came on the TV, and my sister went wild. She was screaming and pulling her hair out and going nuts, hollering, "Aren't they great? They're the best group I ever saw in my whole life!" She wouldn't let up until my Dad finally said, "Well, they're pretty good." I punched Dad in the arm and said, "The Beatles ain't as good as the Stanley Brothers, though, right, Dad?" I was smart-mouthing my older sister, but Dad let it go because he was on my side of the argument.

Truth be told, I loved the Beatles right along with my Stanleys. Just like I loved the Rolling Stones and the Hollies along with my Flatt & Scruggs and Bill Monroe. One of my favorite records was "Look Through Any Window" by the Hollies. I was such a huge harmony freak, and the Hollies floored me with their vocal arrangements. I feel blessed to have grown up in that era, because it was such a great time for all kinds of music.

The day after *The Ed Sullivan Show*, all the kids came to our school with their hair combed down like the Beatles. It was unbelievable. With my vacation Bible school flattop, I didn't have any bangs to pull down, but I sure would have! The Beatles had a look that was new and kinda strange, but it made its way to Brushy Creek. When you think about it, it wasn't any stranger than when Bill Monroe walked onto the Opry stage in 1939 dressed like a Kentucky fox hunter, with riding pants and jodhpurs and hat.

Anyhow, it wasn't just the Beatles' singing I loved. I'd heard that backbeat on some old country records. The Beatles were influenced by Elvis and Buddy Holly and Bill Haley, who were all influenced by Bill Monroe. So I was hearing all these connections, and I loved it. But I was even more intrigued by the Beatles and their electric guitars.

E ver since we'd lived in Tennessee, I'd wanted to learn to play guitar. I'd been trying to play Dad's D-28 Martin, but it wore me

out trying to pick his big guitar with my little mandolin hands. And good Lord, the Mapes-brand strings my dad used were sure big for a kid raised on a mandolin. Dad heard me struggling, and I started asking him if he'd get me a guitar that played easier. He said he'd look for one, and this old fella we knew, Mr. Upchurch, had an ol' beautiful black Gibson guitar that played like butter. It had a nice small neck, and the strings were low on the fretboard and easy to hold down with my little fingers. Mr. Upchurch let us keep it for a while, and I started practicing mandolin tunes on guitar. It was my second instrument. But after seeing the Beatles, I wanted to plug in.

Back in the Kentucky mountains, there weren't too many electric guitar players. You'd see them in the Holiness churches, but that was about it. But there was one guy, Clyde Ball, and he had a cool-looking electric guitar. I wanted more than anything to play it. Clyde was a family friend, and he had an old black Silvertone with a Bigsby tailpiece on it. Clyde let me borrow it, and I'd play the instrumental hits by Duane Eddy and by the Ventures that were all over the radio at the time. I was also learning Chet Atkins stuff like "Yakety Axe" then. At school, I had some friends who had a little rock and roll band. I would show up with that Silvertone and play Ventures songs, and sometimes I'd even play bass or drums for laughs. We had a few gigs at school events, but we didn't even stay together long enough to have a name.

Me and another friend named Darrell Boggs entered this little talent show right after the Beatles hit Lawrence County. He had a big ol' Les Paul Gibson electric guitar, and I had my Dad's acoustic D-28 Martin. We did a sort of two-teenager rendition of "I Want to Hold Your Hand," and we won. Then we tried to go for a bigger prize on a talent show on television in Huntington, West Virginia. It turned out pretty terrible. We came in something like thirtieth place, I think, but it sure was fun.

My mind was always open when it came to music. I always wanted to learn something new and try something different. I liked the challenge of it. Rock and roll was a lot of fun to play and fool around

with, but I never felt it was right for me. It was just a gut feeling that my calling was with the music I was raised on. My parents didn't seem to mind that I wanted to experiment. They didn't call rock and roll the Devil's music, the way so many parents did back then. They seemed to know that mountain music was what was closest to my heart.

I guess it was a time when a lot of kids rebelled against their parents with sex and drugs and rock and roll, but I was always taught to obey my folks, and so I did as best I could. Besides, I never had any good reason to rebel against them.

When I look back now, I think my driving force at that time was the musical partnership I'd had with Dad and Mom. I still enjoyed playing with them so much, and that was what I wanted to keep doing, no matter what. In the back of my mind, I knew that if I went off playing rock or some other kind of music as a serious pursuit, then we wouldn't be able to play together anymore. And I didn't want that to end.

HILLBILLY ROCK OF AGES

Lord, I ain't no stranger now
I've been introduced to the Father and the Son,
And I ain't no stranger now.

—"Cryin' Holy Unto My Lord" by the New South, 1975

Now, I want to tell you about when I left behind my boyhood and became a man. Two big events happened then around the same time. One was when I shot a gun for the first time, and the other was when I got saved. I was a lot more sure of myself when it came to shooting a gun than I was with getting saved, but that wasn't nobody's fault but the Devil's.

There was a revival down the road at Blaine Free Will Baptist Church. These revivals lasted for a few days and sometimes a few weeks. My mom and dad and me would usually help with the service and play a few gospel songs. The preachers who held the revivals were John Pelfry and Emerson Collier, and my folks knew them well. They did some fiery preaching every night. At this particular revival, you could feel the Spirit moving.

One night during the altar call, I saw Dad go forward and rededicate his life to the Lord. He had already gotten saved as a young man, and he'd been baptized, too. He and my mom had always walked the faith. I don't know if his disability had anything to do with how he

was feeling, or where he was on his spiritual journey. He didn't talk about those things, and I never did ask. All I know for sure is that on this night, he got convicted in the Spirit and wanted to make a recommitment to his faith.

The Lord had been dealing with me already. I'd been feeling conviction from Pastor Pelfry's preaching, and I was feeling a conviction in the Holy Spirit, too. I'd been around good preaching since I was a little kid, but I'd never felt the urge to go forward.

But now I was thirteen years old, and I was hearing the message in a different light. I'd gotten to a new place. Mom and Dad always talked about the age of accountability, when you're old enough to make your own decision about your faith, when you're accountable to God. I had gotten to an age where I realized I needed to make a decision—was I going to accept Christ, or reject Him?

For the first couple nights of the revival, I'd been white-knuckling during the altar call. I was holding onto those pews so tight. It was the time of reckoning. I knew I needed to go and give my heart to the Lord, and I felt the Holy Spirit drawing me to make a decision. But being just a kid, I thought to myself, *What could I have done so bad that I really needed to be saved? Was I really ready?*

I wanted to go, but I was so fearful. One of the things I was most fearful of was that God would make me a preacher and I'd have to give up my music to be in the ministry. I was still too immature and unsure, even after those old men had prophesized over me years before and said God was going to use my gift to minister to people. I didn't know what that meant. I was so afraid, and I let fear keep me from the very thing that God wanted to bring to my life, the joy of accepting Christ. And really, that is the story of a whole lot of people's lives.

But when I saw Dad go forward that night, it made an impact on me. It was the nudge I needed. I realized that if it was important enough to him to take that altar walk and make his commitment publicly, then it was important enough to me, too. Seeing my dad go down the aisle opened my eyes and my heart. It was like a shot of courage.

A few nights later, we were singing at the revival service again. Every time I sang those old hymns about the Lord, my heart felt warm and full, and my spirit just burned inside. Then came the altar call. I was standing there white-knuckling same as before, but this time both my hands came off the back of the pew. It just happened. I remember I put my left foot out and took a step and my right foot followed. And I started walking down the aisle.

Nobody had come and started pulling on me or persuading me or anything. There were preachers known to do that sometimes. Bully pulpit preachers who'd yank you right out of your pew and drag you down the aisle. Some people called that sort of thing "holding people over hell with a rotten stick."

If you've never been to a revival, you have to realize how overwhelming it can be. There were Holiness revivals going on down Highway 23 in Whitesburg, Kentucky, led by the singing preacher and musician Brother Claude Ely. He made 78-rpm records of his services, and fifty years later you can hear for yourself how intense and wild the music and the preaching and the praying could get.

I'm thankful that in my case it was the spirit of God working on me, and I knew I just had to obey His will. My feet started moving, and I followed. When I made it down the aisle, I dropped down on my knees in front of the altar and repented to God, pouring my heart out to Him. I told Him I was sorry for my sins. I asked Him to come into my heart and I told Him I wanted to be saved. I knelt at the altar and couldn't stop sobbing. I cried and cried like I'd murdered someone.

Now, let me tell you straight. It wasn't this magnificent experience you hear about. There was no night-and-day difference. It wasn't Paul on the road to Damascus. It didn't happen to me like that. But I knew in my heart I had made a commitment to Christ. That was all that mattered.

A few days later, I ran into a neighbor who'd been to the revival and seen me down at the altar. He asked, "So you're saved. How do you feel now?" All I could say was, "Well, it's all so new and so different, I'm just not sure how I feel."

His question had me stumped. I'd never really studied the Bible or been to Sunday school, so I didn't know how I was supposed to feel. Was I supposed to feel like a totally new person and not like the old Ricky Skaggs anymore? Was I supposed to never think a bad thought or do anything wrong again? This neighbor then said to me, "If you don't know how you feel, you must not have got saved, then." He'll never know how strong those words were, but the weight of them crushed me. That was all it took to sow a little seed of doubt in my heart. And my heart was so tender at that age, so freshly plowed by the Lord. That seed of doubt got in and took root and started to grow. I started to believe I probably hadn't been saved at all.

Those words are what Satan used against me for years. Being born again is asking Christ into your heart, and that's what I did. Emotions come and go, but salvation is forever. So I really did get saved at the revival. I'm not anymore saved now, at fifty-eight, than I was at thirteen, just a lot more understanding; my faith has grown, and I understand so much more. But my commitment to Christ has never changed. God accepted it then, and it was real.

The Devil wanted to steal my peace and joy, though, and he came real soon after I was saved and planted that doubt in me. For a good while, until I was almost twenty, I lived with a whole lot of doubt in my heart. I was mostly a good kid. I wasn't living bad, really. I just wasn't sure of my salvation, and it haunted me.

In eastern Kentucky, shooting a gun is a skill that just runs in your blood. Or at least, it did when I was coming up. Shooting your first gun wasn't some kind of formal rite of passage, but it was an important part of growing up. And it was something you had to learn, too, just like learning to play a banjo or throwing a baseball.

When Dad handed me a rifle for the first time and said, "Okay, you can shoot now," man, that was something I'll never forget. Up until that moment, guns were something strictly for the men and the teenagers who were old enough to handle them. And now I was one

of them. Not necessarily a man yet, you understand, but I wasn't a boy anymore, either.

There were always guns in my house, and the Skaggs men were always out hunting and shooting. My dad was a good shot and so was his father, John M., and so was *his* father, Cornelius. Dad's uncle Calvin could hit quail flying and rabbits running with a .22 rifle. It was what a mountain boy needed to know, in the old days, at least—learning how to shoot, to take care of the hunting gear, and to hunt and fish. That way, they could provide for their families when they were grown-ups.

At Thanksgiving, Christmas, Easter, and any big family gatherings, the men would go out back after dinner, set up targets, and shoot. It was really a social thing as much as a competition. Shooting is a real skill, same as playing music. It may take some natural ability, too, but you have to practice. You have to understand how to take proper aim. Sighting a rifle in is an art, and the old-timers knew how to sight theirs in at twenty-five yards, fifty yards, or a hundred yards. And these old Skaggs men were such fine marksmen they could shoot the eye out of a groundhog at fifty yards.

My great-uncle Calvin was a gunsmith. If a part broke on a gun, he could make the replacement piece, or at least get hold of one, to fix it. He had diabetes, and that forced him to quit his welding job, but he stayed busy repairing guns in his later years. I wish Uncle Calvin were still around today, so he could help me maintain all the old flintlocks I have.

Guns are weapons, make no mistake, and they're not anything to play around with. My dad was real cautious about us kids being around guns, and he supervised us and taught us good gun safety. We learned to respect guns. Dad always kept his guns locked up, 'cause he didn't want us getting in the gun case and getting into trouble.

Dad had a few shotguns and a few rifles he really loved. One day, not too long after I was saved at the revival, he handed me a Remington Model 24 semiautomatic .22 rifle and said it was time I learned

how to use it. I quickly put it on my left shoulder, and he said, "No, son, you're putting it on the wrong shoulder." I said, "Dad, it feels right over here on this shoulder." "Well," he said, "you're supposed to shoot from the right shoulder!" Thing was, it *was* right for him, but I'm left-eye dominant, so it was gonna be the left shoulder for me.

It was kind of a rough start on my road to becoming a Skaggs dead-shot marksman. Once I started knocking the snot out of a can at forty yards, though, Dad realized I really was a lefty shooter. He said, "Son, as long as you can hit what you're aiming at, go ahead and shoot from whatever side you want to!"

Shooting cans is one thing. Hunting is another, and it wasn't just sport for us. Growing up, we hunted groundhogs, squirrels, and rabbits, as well as game birds like quail and grouse. As I've told you, we didn't just hunt 'em, we ate 'em. It was part of our food supply, and we put 'em in the freezer so we could have meat through the wintertime.

Mom would get a knife, take the time to get the pellets out of a squirrel, and then fry 'em up with biscuits. If you've never had fried squirrel and biscuits, you don't know what you're missing. If the squirrels were older and the meat was tougher, my mom would boil 'em in a big pot and use the juice for squirrel gravy and dumplings.

In the fall, me, Dad, and my older brother Garold would go out on squirrel hunts with those .22 rifles. We had a great squirrel dog named Lassie, and she loved to go hunting and chase them up a tree. To her it was all fun.

Coon hunting was a whole different deal. For one thing, you didn't cook and eat raccoons. You hunted 'em for their hides. They were still the fashion back then, coonskin caps for kids and coonskin coats you'd see at college football games. My dad would sell them for twenty or twenty-five dollars a hide, and you could haul in thirty or forty in a season fairly easy, so that was pretty good extra money in those days.

Coon hunting also takes a different kind of dog. Dad's best hunting dog, the one he loved most, was a hound named Ol' Pal. He was a black-and-tan, but his mother was a shepherd. Because of that

shepherd blood, his nose wasn't as sensitive as a full-blooded hound, but he got the job done. With Pal, you didn't have to go out there all night long and sit, waiting for a warm scent. You could get a great coon hunt going with Pal, because he'd pick up a fairly recent scent and start running the coon. And Ol' Pal was so fast on the run that when the coons heard him, they'd have to take a tree pretty quick.

Dad had some friends who lived in Paintsville, and they'd come up and coon hunt with us a lot. But there were times we wished they'd a-stayed in Paintsville. Their coon dogs made a hunt into a marathon. These were registered, 100-percent, pure-bred hounds, and they could pick up a coon scent a day old. Running with them was like a wild goose chase. We'd be out there all night following every coon scent for miles around, and I had to be up at 6 a.m to get ready for school.

One thing about coon hunting with Dad was that he didn't show a lot of etiquette, not by my reasoning, anyhow. I'd be following him through the woods, and he'd just let all those limbs and branches brush off his legs and swat me right in the face. He'd tell me, "Son, don't follow so close! If you back off just a little those branches won't hit you." But I was just bad to follow my Dad, almost right on his butt. I had to keep up no matter how them branches stung. I didn't want to miss out on anything, or get left behind.

I still cherish memories of coon hunting with Dad. We'd be high up on a ridgetop, and the hounds would be down in the valley barking. When the trail got cold, everything got real quiet, and the only sound was the wind through trees. The bare branches would rub up against each other, and you'd swear it was the sound of fiddles playing. Around eastern Kentucky, we also had a lot of grouse to hunt. Grouse are the Ferraris of the game birds—totally wild and extremely fast. They also seemed to know just where to fly to make sure there was a tree between you and them. I shot a lot more tree bark than birds when I was hunting grouse. But on those lucky hunting trips when we did bring home a mess of grouse, there was nothing that tasted better. Dorothy Skaggs sure owned the kitchen!

* * *

Shooting and hunting was fun, but I still got my biggest kicks from music. There was nothing like that feel of wood and steel on an instrument, and when I was thirteen, I got a new thrill when another instrument came into my life. It was my third musical companion, and number three was a handful. It was a fiddle that was up on the wall in our living room. It was a cheap ol' German model that Dad had got at a pawnshop, same as he did my first mandolin. He bought it for my youngest brother, but Gary didn't take much interest in it. So Dad just hung it on the wall.

One Christmas Eve, that fiddle caught my eye for some reason or another. I took it down, dusted it off, and started playing it. Well, I tried to, anyhow. I didn't know a thing about fiddles. I can tell you one thing, the fiddle didn't come as natural to me as the mandolin did. It was awfully hard to learn. Forty-five years later, I'm still learning how to play the fiddle.

The left hand came pretty easy because a fiddle is tuned in fifths, exactly like a mandolin, though without frets. I already knew where to put my fingers. The trick was getting the bowing down. It took months. The hardest part was figuring out how to handle the bow itself. That means, for a beginner, trying to avoid the sharp and flat notes, and to work the bow smooth without squeaking the strings. Then you have to learn how to use the proper amount of tension on the bow. Not too little, not too much. The bow has to be handled just right to get a fiddle sounding good.

I'd practice a lot around the house, and it used to drive Mom crazy. "Honey," she'd say, in her sweetest-sounding voice, "why don't you go over yonder on the bridge and sit down and play there? And I can get supper ready and watch you from here. Okay?" This was her way of saying "Get that thing out of this house!" without destroying my confidence.

I'd take my fiddle out in the woods and find an old stump or bed of moss where I could sit and play. It was so peaceful under the trees, with the wind blowing through the branches. Out there I had my own secret place where nobody cared how many mistakes I made. It was the perfect place to learn.

Alone or not, learning fiddle was hard work. Now I realize how smart Dad was to start me out on the mandolin. If he'd bought me a fiddle first, I would have screeched on it so bad I'd probably have given up on music for good.

Dad wasn't bothered a bit by my fumbling on the fiddle. He was fired up that I'd taken to another instrument. He grabbed his guitar, and we started playing together. I was old enough to know it'd take a lot longer to get decent on fiddle, and I didn't get discouraged. I was too busy studying and learning new songs. I soon found out that I could play a lot of tunes on fiddle that I couldn't play very well on the mandolin, like "Orange Blossom Special," "Grey Eagle," and "Cumberland Gap."

I started to understand the science of the fiddle and how it fits into the music. I learned how it fits with the singing, how it handles backup and works in a breakdown. I was connecting with it, but it just took a little longer to make the connection than it did with the mandolin. So many things in life happen for a reason, at least I believe they do, and I call it God's providence. I've been really blessed in this regard, meeting people at certain times or, in this case, meeting a new instrument at just the right time. The fiddle came into my life when I was a shy teenager and needed a new buddy I could pal around with, one who could protect me in a new environment, because our family was on the move again, this time up north to Ohio. It wasn't for long, but it sure was a big change for me. We were going from the hollow to the city of Columbus.

Grandpa and Grandma Thompson were still living up there, and they were getting up in years, especially Grandpa, who had some health problems, so my mom thought it'd be good to spend time with them. Grandpa Walter was a night watchman at Darby Dan Farm, where they raised thoroughbred racehorses. We moved up to be with them in West Jefferson, a suburb of Columbus.

I arrived in Ohio fresh out of the mountains with my fiddle and my accent. At first, it wasn't easy. I felt awkward and out of place, especially when the teacher called on me in class. My English teacher would cringe whenever she heard me talk. Not because of what

I said, but because of the way I said it. Of course, I thought I was talking just fine!

I told my mom that the teacher didn't like how I sounded when I talked. Mom didn't downplay it, but she didn't blow it up, either. She took the humble road. She didn't get mad at the teacher or call the school to complain. I was kinda disappointed, to be honest, because I thought the teacher had done wrong. "Honey," Mom said, "don't you ever be ashamed of how you talk or where you come from. You just stand up there, and you be proud to be a hillbilly."

But support and encouragement at home can only take you so far. At that age, it's what the other kids think that really matters. It's one thing to be told to be proud and another to have something to be proud of. Well, I found I did have something to be proud of. My fiddle!

I'd take it to school and play at lunch break and at recess. I'd keep it in my locker during class. My nickname in school became "Hillbilly." I was okay with it because they were okay with it—and that's what I was, a hillbilly in the city.

I got help early on from some buddies who sort of took care of me when I was the new kid in town. Ron Sloan and his brothers were first-generation Buckeyes, but their folks were from Kentucky. They loved bluegrass and the old country I played, but they loved loud rock and roll and the party life, too.

The Sloans took a liking to me, and nobody messed with the Sloans at school. They protected me—a few words from Ron was all it took. "Don't mess with Hillbilly," he'd say. "Now, you'll have to go through me to mess with Hill—he's my buddy."

After school, the Sloan boys would come over to my house. We'd play basketball and goof around for a bit, but after a while they'd get bored. It was music that they really came over for. They'd say, "Hey, Hill, is your dad home? Why don't y'all play a little for us?"

Dad would come outside on the front stoop with his guitar and I'd get my fiddle and we'd play for them. These kids didn't necessarily understand what we were playing, but they liked what they heard.

Sometimes one of the boys would grab a guitar and try to play along. It meant even more to get support out in public. Whenever there was any kind of local event, like an ox roast, carnival, or fair, sure enough, Dad and I were the musical entertainment. We'd be playing on stage, and the Sloan boys would come by and point me out to their friends. "Hey, Hillbilly!" they'd holler. I swelled with pride.

Things like that made me feel like I was different, but different in a good way. I had something I was good at, and people liked it. Music never let me down.

Up in Ohio, I was around a lot more rock music than in Kentucky. The West Jeff kids liked rock and soul, especially the harder stuff.

Jimi Hendrix had come out with his blazing cover of Dylan's "All Along the Watchtower." I loved the sound of it. I told my friend from up the street, Danny McCraig, that I could learn how to play it. Danny bet me five dollars I couldn't. Well, now I'd got myself in a bind. This was bigger than the five dollars: My reputation was on the line. I went down to the record store and bought the single. I listened to it and practiced, and I finally figured out the intro and the chords on Dad's D-28 Martin guitar. He let me take it to school, and I showed Danny and the other kids I could play it. My fingers hurt for a week from bending those strings, but I got my money.

Rock and roll was cool, but it couldn't hold up to hearing a band like Earl Taylor and the Stoney Mountain Boys in person at the Astro Inn on High Street in downtown Columbus. I remember the first time I saw Earl Taylor playing there, and my God, was it great. It was this really high, lonesome, screaming bluegrass music right in your face. Earl on mandolin and Jim McCall on guitar and singing lead, just blowing it out, big ol' jugular veins jutting out of their necks.

Some teenagers went to the Monterey Pop Festival. Well, I spent the Summer of Love with Dad at the Astro Inn. You hear about "clubs" and "venues" nowadays. They were called "beer joints" back then, and the Astro Inn was definitely a beer joint. Forget "Purple Haze" and free love, the Astro was all about dim lights, thick smoke,

and loud, loud music. At the Astro, the only décor I can recall was gray wallpaper that had the look of prison cinderblock. The Astro Inn was one of those places where if you went through the front door and didn't have a knife in your pocket, they'd give you one. Not really, but it was sure a rough spot.

Dad didn't bring a knife, just a fourteen-year-old boy. That may seem a little bit reckless, but remember this was Hobert Skaggs, and he could always find the good in any situation. He said, "Son, don't pay attention to nothing 'cept the music." He told me there were plenty of good things happening on stage and no reason to fool with whatever was happening in the crowd. The good outweighed the bad, you know, and I was so focused on music that I was able to do what Dad told me. I just ignored the fistfights and craziness all around us. It was just background noise to me. I was too busy studying Earl Taylor on his mandolin and watching how the Stoney Mountain Boys worked their one-mic setup without knocking each other down on the tiny stage.

It made a difference that Dad was as innocent as I was in a lot of ways. He didn't drink, didn't curse, didn't carouse or tomcat around. We'd just sit there at our table with a couple of sodas and enjoy the music. We didn't bother with the patrons, and they didn't bother with us. Looking back, I'm so glad my dad walked the line. If Dad had been in there drinking and getting rowdy, it would have changed my whole future. It would have injured my innocence at a time when I wasn't quite ready. We were there for bluegrass and nothing else.

I don't want to give too bad an impression of the Astro Inn. It was rough, maybe, but it was real. It was what it was. It was a place in the city for all the homesick mountain people to hear bluegrass and the music from back home. They'd come here the same way we did, 175 miles north up Route 23, the one they call Hillbilly Highway, and out of every carload you could find a bluegrass picker. A lot of 'em told themselves and their families that the move to Ohio was only for a while, that the next year they'd be back home in Kentucky. Then years would go by, and they never did make it back for good.

I counted us the lucky ones. For us, it really was just for a few years.

Sometimes we'd see our cousin Euless Wright at the Astro Inn, and sometimes he'd come by our place in West Jefferson. We didn't see much of Euless after we folded the Skaggs Family band, but when we were living in Columbus he started coming around again. Euless was an incredible natural-born musician. He had a ton of raw talent, and he soaked up any sound he liked. He played bluegrass, country, old-time, and jazz, too. Euless could do it all and make it look so easy. He was tall and skinny, with long arms and long fingers. When he'd stand up to play, he'd rest the fiddle down on his body—not under his neck like some do—put it against his upper torso, and play it that-a-way.

I learned classic tunes from Euless that every fiddler needs to know, like "Billy in the Low Ground," "Florida Blues," and "Whitesburg." He knew old-time Kentucky traditional songs like "Blackberry Blossom," and he did a version of "Grey Eagle" that was great. He always added his own personal touch, but he never abandoned the melody. One of his heroes was Georgia Slim, a well-known fiddler from Tifton, Georgia. Like him, Euless was very smooth and very constructed in his bowing. It was Euless who really got me excited about playing the fiddle.

Euless was generous with his time and everything else. What was his was yours. He had an old wind-up record player and a bunch of bluegrass records, lots of Monroe and Flatt & Scruggs, those red-label Columbia records from the late 1940s and early 1950s, beat-up old 78s like "Raw Hide" and "Flint Hill Special." He let me borrow the whole stash. I'd turn the knob from 78 to 45 rpm, slowing the record down so I could hear how a solo was put together and practice at my own pace. I'd spend the afternoon studying Benny Martin's fiddle breaks on "Dear Old Dixie," and I wouldn't quit till I'd figured out how he played it.

I wish Euless had been as good to himself as he was to me. About all he ever really did in life was play the fiddle and drink. He was a great fiddler, but he had a bad drinking problem. To put it plain, he

was an alcoholic. I saw how it slowly destroyed his life and finally ruined him as a musician. He was as good as a professional, and he could have gone pro if he'd wanted it bad enough. But he didn't have the drive it takes, because the drinking took the drive away.

The fiddler Buddy Spicher lived for a while with Euless and my aunt Estie. Buddy really liked Euless's fiddling, too. Buddy did a lot of session work in Nashville and played fiddle for some of the all-time greats, from Hank Snow to Bob Dylan. Euless could have been right there in the thick of it, cutting records with the legends. By rights, Euless should have been one of the best fiddlers Bill Monroe ever had, but he couldn't quit drinking. It just dogged him. He probably lost his chance to be part of Bill's band after Monroe had to come to Ashland and bail Euless out of jail. With Monroe, one time was all you got when it came to something like that.

Alcoholism sort of runs in my family, on both sides, a long ways back. That's one of the reasons my mom didn't keep any alcohol in the house and didn't allow anyone to bring it in, either. Not even Euless. "Now don't you be bringing that stuff in my house!" she'd say. "You know I love you, boy, but uh-uh." Euless would just leave his whiskey in the car and go outside to take him a nip. Sometimes he'd even be straight when he came by the house. Didn't matter if he was drinkin' or not, though—when it came to fiddling, he was smooth as could be, and we'd pick for hours and hours. A lot of times, I'd just sit there and listen to Euless play.

Euless had a great heart till he had too much to drink. I believe things could've turned out different if he'd had somebody early on to give him the kind of encouragement I got from my parents. If he could have learned to lean on Jesus and found acceptance in Him, Euless would never have had to lean on the bottle. It makes me think about this great ol' hymn:

My hope is built on nothing less
Than Jesus' blood and righteousness.

I dare not trust the sweetest frame,
But wholly lean on Jesus' name.
On Christ the solid rock I stand.
All other ground is sinking sand.

The first time I met Keith Richards, we were working on the George Jones tribute *The Bradley Barn Sessions*. Marty Stuart and I had gotten to the studio early in the morning, and we were talking about heaven. I don't know how we got to talking about it, but we were. Keith came in the room, and he'd been drinking vodka since the sun came up. He was so nervous about having to sing with George, one of his idols, that he was bombed. Here's the coolest guy in the world, who plays guitar in the coolest, most famous rock and roll band on the planet. And here he was in this tiny studio in Nashville at 9 a.m. trying to find his nerve.

Well, Keith walked in swigging his vodka. He looked pretty rough. Kinda reminded me of what Waylon Jennings once said: "If I knew I was going to live this long, I'd have took better care of myself." Now, Keith's a great guy; he's friendly and funny as heck, too. Marty and me were talking about the afterlife, and I was telling him that I don't fear death because I know that my last breath on this earth will be my first breath in heaven.

Well, Keith heard me, and he couldn't help chiming in. "When I die," he said, "if I ever get into heaven, God's gonna be really angry with me, 'cause I've been a really bad boy." Then he took another swig and said, "When I see God, He's going to give me a big spanking!"

"Do you really think so, Keith?" I said.

"Oh, yeah, I'm dead serious."

"Keith," I told him, "God has a whole lot more mercy for you than you think He does."

Now here's the deal: If Keith has been able to survive living the way he has, it's been by the grace of God. But a lot of musicians

who've tried to imitate his lifestyle, they didn't survive. It don't matter if it's rock and roll or country, some people believe you have to be like Hank Williams or Keith Richards to make it. I can tell you that's a lie from the pits of hell. That's what Satan wants you to believe! He says that you'll never be good enough or creative if you don't live dangerous or get wasted. That's the biggest lie ever told.

I hate to say it, but my poor cousin Euless was pretty much drunk all the time. I guess you could say he wasted his life, throwing all that talent away. When I think about how much I learned from him, though, I know it wasn't a total waste. What Euless threw away, I've tried to pick up. I have his fiddle and play a lot of his tunes. I loved him, and I think about him a lot.

Chapter 7

THE LONESOME MOUNTAIN BOYS

We sang together constantly, night and day. Our voices just had a natural
blend. People who heard us often thought we were brothers. And the fact is, I
ended up being closer to Ricky than I was to my own brothers.

—Keith Whitley, "Country at the Core," *Country Music* magazine, 1984.

In early '69, we moved back to Kentucky. Part of the reason we left
Ohio was financial, to ease the burden of making payments on two
houses. But the biggest reason was that Dad didn't like living in the
city. He was a mountain guy, just a farm boy all growed up, and he
wanted to get back to his fruit trees and his ginseng and his squirrel
hunting. He was too set in his ways and the life he knew back home,
and he couldn't adapt to being cooped up in a subdivision in West
Jefferson, Ohio.

Thing was, he'd only agreed to move up north for my mom, so
that she could be close to her folks at a time when her dad was ailing.
But Grandpa Walter was doing better health-wise, so Mom felt it
would be okay to go back to Brushy. She knew Dad was restless and
uneasy up there in Ohio, with all the concrete and the commotion.
She knew how much he missed all the things that go with having
your own farm, like raising a hog every year and harvesting the

garden. The mountains always drew Dad back home, and us right along with him.

Like always, I was glad to be back at Brushy Creek. Every time we came back to the old home place, I appreciated it more. It was peaceful, it was lovely, and it was a place that never seemed to change. I thought maybe the post office in Cordell would fall in the creek while we were in Ohio, but it didn't. You could always count on things being pretty much the same back home.

The only thing I didn't look forward to was school. I enrolled at Louisa High School for my junior year, taking the bus there, but I never really liked much about it. The 4-H club was all right, I guess. Truth was, I was more interested in fiddling than reading, writing, or 'rithmetic. And as far as that went, my real education was just beginning.

Euless gave me a real solid foundation, but that was just the start of my apprenticeship. Dad started introducing me to old fiddlers in our area, so I got sit at the feet of the old masters. I was cutting my teeth with the best around these parts. Some were up in their seventies and eighties, and the music they played was old-time mountain music. It wasn't just old, it was ancient.

In those days, the hills and hollows of eastern Kentucky were heaven for a boy with a fiddle, and it was that way for generations. Folklorists have been flocking here since the early 1920s, flushing out old-time musicians to hear ballads and breakdowns handed down for generations, and it was the fiddlers who made Kentucky such a gold mine for the early record companies looking for the real-deal hillbilly music.

"As the Mississippi delta is to blues, Kentucky is to fiddle music," say the notes to the compilation *Kentucky Mountain Music: Classic Recordings of the 1920 & 1930s.* "No other state comes even close in both terms of fascinating diversity of styles and prodigious amounts of great performances. The explanations for this musical embarrassment of riches are lost to time."

That's kind of a fancy way of saying we've had some incredible fid-

dlers over the years in Kentucky. And the region with the most was eastern Kentucky. The place was crawlin' with 'em! These old guys never got famous or made any money. They did it for the love of the music, and that was all they needed. They'd come to the courthouse square on Saturdays and pull out a fiddle and entertain the people. If some folks threw money in the case, that'd be fine. But they were going to play anyway. In the little towns where they lived, they were big names, and to me they were bigger than life.

There were three fiddlers I remember best, and they all had an influence on how I play. You've already met Euless Wright, who was the first teacher I had. There was also Paul Johnson, a friend of my dad's from the early days. They used to play together when they were kids. He lived a few miles over in Johnson County, outside the town of Paintsville, in coal country. And he was known all around the area.

Paul was short and chubby—matter of fact, about the same size and shape as Chubby Wise. But Paul played more in the style of Fiddlin' Arthur Smith, who with his group the Dixieliners was a star on the Opry in the 1930s and 1940s. Arthur was a very smooth fiddler, a killer for the melody, and one of the finest in country music, ever. Paul knew all the classic Arthur Smith tunes like "Red Apple Rag," "Florida Blues," and "Sugar Tree Stomp."

Well, Paul Johnson was a very smooth fiddler, too. He would use the full length of his bow when he played, every inch. My dad and I would go visit Paul at his old wood-frame house, and I learned a lot from watching him play. I recorded "Red Apple Rag" on an album back in the '80s, and I played it same as Paul used to—with a style that smooth and perfect, there ain't no need to embellish.

Paul and Euless were both great fiddlers, but the guy who really blew my mind, the one who really tightened the screw down for me as far as old-time mountain music, was Santford Kelly. He was one of the greatest barn-dance fiddlers who ever lived.

Santford was from a town called West Liberty, about thirty miles

away in Morgan County. You could usually find him Saturdays at
the courthouse, fiddling on the steps, and he'd always draw a crowd.
He was one of those musicians who just got better with age. He was
a farmer by trade, I guess you could say, but he was a fiddler down to
his fingertips. He'd been around for years and years; Dad had played
with him when he was younger.

When I first started playing fiddle, Dad would say, "I want you
to hear Santford Kelly some time. There ain't nobody like him!" It
wasn't until we moved back to Kentucky that I finally got the chance,
and I can tell you, it was worth the wait. I don't think Santford had
a telephone, but somehow Dad tracked him down and they recon-
nected. They made a good team, and they'd play together whenever
they could.

Most times, Santford would contact us by letter or postcard. He'd
get word that a square dance was coming up, and he'd want Dad to
back him on guitar. It took forever to get a message to people in those
days, but they made the effort because they had such a love for the
music.

Santford was a walking, talking history of mountain fiddling, and
he could give you a story with every song. It was all in his head and
in his hands. He even knew the Irish fiddle tunes the early settlers
brought over to this country in the 1700s and 1800s. When he was
young, he learned from people who'd passed them down for gener-
ations. He had some incredible styles of bowing, and I would try to
copy what he did. I learned a lot of old, old tunes from Santford, an-
cient ones like "Forked Deer" that went back centuries.

Some were rarities, local tunes tucked away in the mountains
Santford kept alive. You coulda made a map from the song titles
alone and found your way around eastern Kentucky. He played a
thing called "Halfway to Morehead," along with "Whitesburg," and
another called "Up Tug Fork and Down Sandy River." There was
this one song with a pretty melody, "Colonel Prentiss," that I recorded
on my solo album, *Songs My Dad Loved*. Euless played that tune too,
and he did it fine, but I played it the old-time way that Santford did.

Santford was past seventy when I knew him, and he knew hundreds of songs. His signature tune was "Flannery's Dream." He said it went all the way back to the Revolutionary War, when Irish settlers brought it here from the old country. Years later, I was a guest performer on an album by the traditional Irish band the Chieftains. At one point during the recording session in Nashville, when we had a little down time in between takes, I was fooling around on my fiddle and playing "Flannery's Dream" the way Santford had taught me. Sean Keane, one of the fiddlers for the Chieftains, was sitting nearby and listening intently. When I finished, he said, "That's how they play in Donegal!" It shows how deep those Celtic roots took hold in our mountain music.

My God, Santford died with so many fiddle tunes in his head, and many died with him. Luckily, his playing was recorded at the end of his life. Dad even got him on tape, too. One Sunday, Santford came over to our house and Dad got out his big ol' Wollensak reel-to-reel recorder and taped hours of Santford playing whatever struck his fancy. I'm just now getting around to having these tapes transferred to digital. But I knew then that a Santford Kelly only comes through your life once, and I tried to learn all I could from him while he was still around. Thank God Dad taped him, so generations to come can hear how amazing he was!

Company showed up unexpectedly all the time at our house in Brushy. Sometimes it was Santford. Sometimes Euless. We never knew when somebody was coming by the house. Folks just don't drop in unannounced like they used to. Back then, though, if somebody drove up, we'd drop everything and Dad would tell 'em to come on in. Most of the time, neighbors would drop by out of the blue because they wanted to hear me play and sing. Mom and Dad welcomed them inside, and they'd stay the afternoon or evening. It was Southern hospitality, was what it was. It wouldn't be long till our company would want a little show, so we'd get out the instruments and play for them.

That could be an aggravation for me, because there were times I

wanted to go fishing or hunting instead of having to play. Sometimes I felt like a piece of antique furniture, something to show off. Even though it put me out, I never did let my parents know I felt that way. I didn't want to hurt their feelings. And usually, I was more than happy to oblige.

Now, when Santford came by unannounced, that was different. It was a surprise I looked forward to. We never knew when he was coming. Sometimes he showed up on Sunday afternoon after church. He didn't drive and didn't even have a license, so his son Ralph would pull up in his car with Santford riding shotgun. Mom would right away start fixing something to eat. It was always good to see Santford get out of the car with his fiddle case under his arm.

Santford was a sight. He was in his seventies, tall and lanky—even taller than Euless was. And he wore these old overalls, probably the longest ones he could find, and they were still four or five inches too short for him. He'd have to duck his head down as he came through the doorway. As soon as he walked in the house, man, oh, man! It was time to get busy, time to get down with it. Dad would get his guitar, I'd grab my mandolin, and we'd play for hours. Mom and Dad would let me stay up even though it was a school night, 'cause they knew this was part of my education.

For most tunes, Santford would hold the fiddle up under his chin, in the classic old-time style. He had a long bony face and these heavy, dark horn-rimmed glasses that sat on the tip of his nose. He'd look at me over the top of the glasses, almost in a trancelike state. It was hard for me to keep my eyes on his hands and watch what he was doing while he was staring me down like that.

Santford was a heckuva showman, too. He was as much fun to watch as he was to listen to. Even right there in our living room, he'd put on a little show and do wild tricks with his fiddle bow. When he played "Turkey in the Straw," he'd take the bow and go *pop-pop-pop-pop!* on Dad's head, tapping out the beat right along with the tune. He was always on stage, even when I was the only audience he had. I thought he was the coolest thing.

One day Dad said, "Santford, did you bring your banjo with you?" He said, "No, sir, I didn't." Dad said, "Son, go get your banjo."

Dad had traded a shotgun for a banjo. I was trying to learn the three-fingered bluegrass style, taking on yet another instrument. So I went and got it from under the bed and brought it to Santford. What I was about to see and hear would change my life.

The second his long, leathery ol' hands hit the strings on that banjo, I was hooked. He played the old drop-thumb clawhammer style that was very popular in the mountains of North Carolina, Virginia, eastern Tennessee, and eastern Kentucky. He would do these droning instrumentals like "Charlie's Sweet" and, of course, songs like "Yeller Gal" that were old as dirt and full of mystery.

His technique stunned me. I couldn't believe the sound he could get from that same banjo I'd been plunking on, trying my little forward rolls. In his hands it was a whole new animal. Santford's playing was as smooth and solid as oak. It was something I'd never heard before. I'd heard Uncle Dave Macon and Grandpa Jones play banjo in a frailing, sorta clawhammer style, but they used it as more of a comical prop than a serious instrument. All I knew was that their banjo-playing was different from the three-finger bluegrass style Earl Scruggs and Don Reno had popularized.

I didn't know what it was that made clawhammer so different-sounding until I saw Santford do it up close. It was also the first time I'd seen someone play drop-thumb-style banjo. Playing that second string with the thumb—that was a strange new configuration for me. It blew my mind. Lord, it had some bite to it! I had to learn that style.

I would sit and practice, visualizing Santford's hands and trying to get the rhythm of that clawhammer sound. I didn't get frustrated, I didn't get bored. I just kept searching for that sound.

I think I'm still like that today. When I get a particular sound in my head, or at least the notion of a particular sound, I have to find it. That's part of why, as I get older, I've come to enjoy the recording studio so much. It's where I can experiment with sounds. When I was younger, the studio seemed too sterile, and I was too much of a

perfectionist to have much fun. Nowadays, I take my time to explore. I feel like a scientist in a white lab coat, mixing voices and instruments and discovering new sounds.

I wasn't as patient with a banjo as I was with a fiddle. I wanted right away to make that sound Santford had made, to conjure it up. So I holed up in my room with Santford in my head until I did. I remember one shining moment when I finally got it, when I got the drop-thumb rhythm and it just clicked into place. The song was "Yeller Gal." That sound I was after, ringing out loud and clear, was coming from my hands. I could hear me playing just like Santford. When I got that down, it was like heaven opened up for me. I was so excited I couldn't stop. Good thing for me, my mom loved the old-time banjo—she'd grown up hearing it in her house. Let's just say she never sent me out of the house over to the bridge like she did when I was learning to play the fiddle.

Santford's fiddle and clawhammer banjo really lit that fire in me for old-time mountain music for good. His fiddle and banjo styles are the sounds of the hills where I come from. Now, the fiddle is as old-time as it gets. For Appalachian string music, the fiddle ties all kinds of things together. It was a classical instrument first, of course, coming out of Europe. Then it got in the hands of Irishmen and Scotsmen, and they brought it over with them to America in the 1700s when they settled in these mountains. And it got deep into the hills and hollers, with people changing the sound to suit the way they felt. They were far away from their families and homesick.

That's when the well-known high, lonesome sound came about in the mountains of Appalachia. A lot of the loneliness you hear comes from the isolation of the region. These Scots-Irish immigrants were far from home and far from civilization. The lonesomeness they felt started to enter into the music, something you don't hear a lot in Celtic music. That yearning seeped in for two hundred years. Those old songs like "Little Bessie" or "Snow-Covered Mound" or "Omie Wise" have droning mountain melodies with a Victorian or even Gothic feel.

The lonely sound I heard in Santford's music helped me understand why I was drawn to the music of the Stanley Brothers. They too had that high, lonesome ol' stank from the Virginia hills where they were raised. I could hear how their music was a fulfillment of a tradition. They mixed in some of Bill Monroe's energy, sure, but it was still raw mountain music. I could hear it in their gospel singing and in their trio harmonies with Pee Wee Lambert singing that high, lonesome tenor. Or on stage, when Ralph featured "Little Birdie" and other old clawhammer tunes his mother had taught him. It was a special part of the show when he'd take off his banjo picks and play the five-string in that old-time clawhammer style like Santford played.

Santford and the Stanleys and the other mountain musicians taught me more than licks on a banjo or fiddle or mandolin. They gave me a precious gift, and that was a tradition I was a part of. It gave me solid ground to stand on at a time I needed it. When you're a teenager, solid ground can save you from falling down or getting lost.

But I was just about to meet someone who was not only my own age, but a prodigy, too—someone who was gonna help put the mandolin back at center stage in my life.

In early 1970, me and Dad went to a talent show at the Ezel High School in Ezel, Kentucky. It was a little town not far from West Liberty, Santford Kelly's stomping grounds. We didn't know it beforehand, but ol' Santford was there, and I was so excited to get to see him again. Santford was in his element, and he asked Dad to play with him that night.

The talent show was a highlight of the school's annual Fall Festival. Richard Jett was the principal of Ezel High School, and he made music and dance a big part of the school's arts program. There was a local dance troupe called the Ezel Shindiggers, and they'd clog to bluegrass and mountain music; the Shindiggers were guests on the Grand Ole Opry many times. They were by far the biggest act at the talent show.

Me and Dad did our usual routine, some old tunes we'd picked
up from Santford and favorites we'd worked out as a fiddle-guitar
combo. We played "Sally Goodin," "Pig in a Pen," and a few other
old-time numbers. Afterward, we checked out the rest of the com-
petition, and it wasn't much. There was a teenage baton-twirler who,
for her showstopper, lit the batons on fire.

I was heading down to the dressing room when a voice belting out
a Stanley Brothers song caught my attention. I looked up on stage
to see who it was. It was a scrawny kid with big, thick glasses. He
was playing guitar, backed by an older boy on banjo and a couple
other guys. The song was "My Deceitful Heart," one of the last rec-
ords Carter and Ralph cut for the King label. It was a real sad song.
This boy sung it like he meant every word. I loved the way he sang,
and I just stood there and watched. He was about my age, maybe a
little younger, but there was a maturity in his voice. He knew what
he was doing. In between songs, he knew how to talk to the crowd,
and he could handle himself in front of a mic. He was comfortable
up on stage, but he wasn't a show-off. His voice touched you; he had
something special.

They called themselves the East Kentucky Mountain Boys. I won-
dered where they were from and why I'd never heard of them. They
did some more mossy old bluegrass numbers, like "My Little Girl in
Tennessee" by Flatt & Scruggs. But it was "My Deceitful Heart" that
stayed with me. I couldn't believe another boy my age knew a Stanley
Brothers song and was able to pull it off like a pro. He sure won me
over, and the crowd, too. But the judges went for the razzle-dazzle.
We all got put down by the little ponytailed twirler and her flaming
batons. She took top prize.

Afterward, I went to the dressing area down in the basement. Me
and this boy ended up down there at the same time, and we started
talking. I was happy, since I wasn't sure I'd ever see him again. I
wanted him to know he wasn't the only kid in eastern Kentucky who
loved old-time, honest-to-God mountain music.

"Man," I said. "I really like your singing."

His face just lit up. For such a small kid he had as big a grin as he did a voice.

"Well," he said. "I love your fiddle playing and the singing you did with your Dad."

"Who do you like?"

"I like the Stanley Brothers," he said. "Who do you like?"

"I *love* the Stanley Brothers! Ralph and Carter are my favorites!"

We were practically shouting we were so excited. You have to understand how unusual this was. It'd never happened to me before. I'd never met anyone my age with such a deep love and knowledge for the music of the Stanleys. Turned out we were both fifteen, even though he sang like someone much older. We were excited to find out we both had our sixteenth birthdays coming up in July. That meant we'd soon get our driver's licenses!

"Well, do you know this song?" he said, and started singing Carter's lead: *"Darlin', do you really love me?"* And I jumped right in on Ralph's tenor part: *"Are you the girl I used to know?"* We sang like we'd been singing together our whole lives, and we kept at it, song after song, for close to an hour. We were in our own world. We were like brothers, at least it felt that way.

That's how I first met Keith Whitley, and we got to be great friends. Me and Keith hit it off right from the start. It really clicked that quick. Some things happen that way. You feel it in your bones, and you just know. There was a bond between us. We stayed that way from then on, right up until the day he died.

It turned out that Keith lived only thirty miles or so down Route 32, in Sandy Hook, a little crossroads just over the line in Elliott County. The more we talked, the more we realized how much we had in common. He was a child prodigy, too. He was only four when he started playing music in public. That's when he won his first talent show, singing a Marty Robbins song in a cowboy outfit. By eight he was a guest on the Buddy Starcher TV show in Charleston, West Virginia, and now he had a band with his brother Dwight, the older boy I'd seen playing banjo.

I guess it shows how closed off and isolated we were out in the country back then. Brushy Creek was only a half hour away by car from Keith's place, door to door, but it could have been halfway around the world. I'd never met Keith, and I'd never heard of the East Kentucky Mountain Boys. He'd never heard of me or the Skaggs Family band, either. And here we were singing like long-lost brothers. He loved the fact that he now had a like-minded friend who knew the old songs. And when he found out I played mandolin, too, he got even more fired up.

Well, we didn't waste any time. I invited Keith and Dwight over to my house that weekend. We figured, hey, we sung pretty good together, so let's get to know each other and see what happens. Mom fixed supper, and we had a great time picking and singing, with Dad adding his guitar to our little band.

The next weekend, I went over to Keith's house in Sandy Hook and had supper with the Whitleys. They were a lot like our family, even down to the home-cooked meals. I loved his mom, Faye, and his dad, Elmer. Miss Faye sure knew how to cook. We were sitting at the dinner table, and I was on my best behavior. When you are eating supper at someone else's house for the first time, you don't say much unless you're spoken to first.

Well, I took one bite of the green beans, and I just blurted out, "Oh, gosh, Miss Faye, you cook with lard just like my mama!" I didn't mean nothing by it, really, it just came out. I was worried maybe I'd said something that could offend. Miss Faye didn't mind a bit, and in fact she thought it was funny and started laughing. "I sure do, honey," she said. "And I'm glad to hear you like it." I was so relieved she took what I said in the right way, and it really made me feel welcome.

Meeting Keith was a milestone for a lot of reasons. One of the most important was it sent me back to my first love, the mandolin. I'd kind of put it away and concentrated on fiddle for a few years, but the mandolin was key to the sound me and Keith wanted

to create. It was the sound the Stanley Brothers had in the early days, when Pee Wee Lambert played mandolin in their band.

With the singing, we had a blend that came natural. Keith sang lower than me in a baritone, and he took lead vocals and played rhythm guitar. I sung real high back then, as much as I'd grown, so I took tenor harmonies and played mandolin. When we did the high trio songs, Keith's brother Dwight would join in, and I'd jump up to the high tenor.

The Stanleys played with an old-time lonesome sound, more pure mountain style. Me and Keith were just drawn to that lonesomeness. The way Carter and Ralph sang was the highest expression of what was already inside us. We wanted to make music that was pure and beautiful, too. When you're at an impressionable age like me and Keith were, you get fixated on a sound. That's the way you learn music and hone your skills, by imitating the old masters and learning from them. And for us, it was Bill Monroe, Flatt & Scruggs, and, most of all, the Stanley Brothers.

There was a lot of material for us to learn, 'cause I'd hit the jackpot with a stash of Stanley Brothers records. Not long before our family had left Columbus to come back to Kentucky, I'd gone to a record store with my dad. This store had a bunch of albums of reissued early Stanley Brothers records I didn't even know existed. I went through the stack like I'd struck pirate's gold, and I asked Dad if he'd let me get the ones I didn't have. There must have been near a dozen, and back then records were about five bucks apiece.

Dad didn't say a word. He pulled from his wallet a folded-up hundred-dollar bill that he'd stuck down in there in case of an emergency. I don't know if he really thought this was a bona fide emergency or not, but he took out that creased bill and gave it to the cashier. He got back some change, but I know he must have spent sixty dollars or more on Stanley Brothers records that day. He didn't waste a dime, though, I can tell you that! That stack of records was a gold mine. This was vintage material that had been out of print for years. It was incredibly rare stuff I'd never heard before.

With Keith, I had somebody my age to share this precious trea-
sure with. We'd listen to the albums and play along for hours on end.
We knew every vocal phrase and instrumental break, even the mis-
takes. Back then, it was straight to disc in the studio: These were live
performances, no overdubs. Hearing those rare Columbia recordings
was like falling in love with music all over again. I especially loved
Pee Wee's mandolin, which was straight from the heart and always
on the mark. It was all feel, so delicate, so bittersweet. Kinda haunt-
ing, too, like moonlight in a hollow. Most important to me at the
time, Pee Wee's playing was simple, straightforward stuff, technique-
wise. *Now that's a mandolin I can aspire to*, I thought to myself. So I
just practiced till I got it. Like Dad used to say, "One more." I'd drop
the needle again and again and wear out the vinyl. Fifty years on, I
never get tired of hearing this music. I still get inspiration from it. I
have it all on my iPhone and listen to it almost every day.

Keith and I studied the album covers, pictures, and liner notes: We
knew who played and sang what. Our favorite was the reissue of their
earliest 78-rpm records made for the legendary Rich R Tone label,
which had a photo of the band in 1946. This was probably the first
group shot ever taken: Ralph and Carter and Pee Wee and the fiddler
Leslie Keith. They're in an old house in Bristol, Virginia, holding
their instruments and striking a formal pose behind a microphone
in this room with old-fashioned wallpaper. What stood out was their
intensity. No airs, no attitude, no foolishness, just pure focus. Just
mountain kids crazy about music, same as us. They looked so young
and so serious, and we could totally identify with them.

Music was everything to us. Keith came from a musical family,
too. His mom Faye played piano and organ in church. His brother
Dwight learned banjo from his grandpa. It was Miss Faye who got
Keith started on guitar, and she said he didn't need much help. She
noticed he had the knack. He only had to hear a song but once and
he could play it beautifully.

When we met, all we wanted to do was play and sing. We didn't
have a fallback plan or notions of doing anything else. Now, the thing

was, in little places like Blaine and Sandy Hook, singing with your family or by yourself could only get you so far.

Once we got together, though, it sure speeded up things for us. Now we had something together that we didn't have on our own: a duet. Those harmonies took two voices blending together to do it right. We were a brother team, not by blood but by the bond of the music. When we sang, it felt that strong.

There was a kid named Jimmy Burchitt, cousin of our friend Elmer Burchitt who played with the Skaggs Family band. Jimmy would come up to the house and we'd all play together, me and Keith and Dad, too. We called Jimmy "The White Dove" because he was so pale. He had stark white hair and light pink complexion. He played in the old-time mountain style of Ralph Stanley, and Keith and I just loved that kind of picking. Give him Ralph's "Clinch Mountain Backstep" and he could blister it!

It wasn't long before Keith and I formed a band, along with Dad on guitar and Dwight on banjo. We got a weekly show at a radio station, WGOH, in Grayson, Kentucky, not too far from home. We had to come up with some sort of a name for ourselves. Keith had the idea for the Lonesome Mountain Boys, and it stuck. You hear about all the garage bands in the '60s that sprung up after the British Invasion. Well, we were a garage band, too. Every Wednesday night we'd get together in the garage at Keith's house. His dad, Elmer, would tape everything for two half-hour shows. One was a bluegrass show on Saturday, and there was an all-gospel show on Sunday.

In those days, you didn't get paid for playing on the radio. A show was just a way to get your name out. We had a couple of sponsors, the Foothills Telephone Company and Montgomery Ward, and they paid the station for the airtime. Keith wrote up a little jingle for Montgomery Ward that opened our program. We were broadcast for a hundred miles around. It was good exposure, but what really mattered was having our own band. It was our own little world. In the same way some boys had a clubhouse or a gang or a sports team they belonged to, we had the Lonesome Mountain Boys.

Sometimes Keith would go out and play with Dwight as the East Kentucky Mountain Boys; sometimes I'd play with the Skaggs Family band; sometimes I'd go off and play fiddle with Ray and Melvin, the Goins Brothers bluegrass band. But we always came back together as the Lonesome Mountain Boys.

I remember when Keith was spending the weekend at my house in Brushy Creek. We were out in the yard goofing off and we heard Lassie, our little squirrel dog, barking up a tree in the woods. My dad poked his head out the back door, and he hollered, "That dog's got something treed, and she ain't gonna leave it alone. Y'all go over there and see what's she got!"

Me and Keith let out a big war whoop and climbed the hill and followed the sound. We finally found the tree, and we saw a big ol' groundhog on a high branch, hanging on for dear life. There was Lassie at the bottom eyeing it, and she was going crazy. Now, our Lassie was a mix of shepherd and beagle, and she was a great little squirrel dog. She could see 'em from the longest ways away, and man, she'd take off and chase 'em down. In her mind, this groundhog was the biggest squirrel she'd ever treed.

Me and Keith got so excited we didn't even go back to the house to get a rifle. We grabbed handfuls of rocks and we knocked that groundhog out cold and it fell out of the tree stone dead. Lassie was proud as could be, even though it was twice her size and she couldn't carry it back.

When we brought the groundhog home to my dad, he laughed so hard. He couldn't believe we'd knocked it out chucking rocks. I know it seems cruel what we did. But it was a different time and place. We were just kids back in the mountains, and we didn't know any better.

I have a lot of good memories of those days. It was a carefree time, and we didn't think about tomorrow. To tell the truth, I'd have never predicted Keith would become a country star, and the same goes for me. I couldn't foresee what a brilliant career there was down the road for him, and I know he didn't see anything of the sort for me, either.

We were happy just playing music, and that was more than enough. We didn't think about money or what we could make out of music. We just wanted to sing and pick, and get better on our instruments.

It took someone else to see a potential in us, and the future that a couple of Kentucky boys could've never imagined in their wildest dreams.

Chapter 8

HISTORY OF THE FUTURE

One of the most intriguing events in bluegrass was the issue in the early seventies by two teenaged Kentucky musicians, Ricky Skaggs and Keith Whitley, of an album of early Stanley Brothers songs, imitated so perfectly as to be scarcely distinguishable from the originals. . . . This was attic bluegrass in the purest sense.

—*Bluegrass Breakdown*, by Robert Cantwell

RALPH STANLEY FOR PRESIDENT

—Popular bumpersticker at bluegrass festivals.

There have been a lot of stepping stones along my path. Without these to guide me, I'd have surely stumbled. One of the most important was Ralph Stanley. He gave me my first professional job. He taught me so much about music, business, and life, too. He didn't say hardly a word to me about any of it. Ralph's way is doing instead of saying.

In the spring of 1970, Keith and I got some big news. Ralph and his Clinch Mountain Boys were coming to a club not too far away

in West Virginia. I hadn't seen Ralph play since I was a kid. After Carter's death in 1966, Ralph went out on his own. We heard he had a new lead singer, a guy from eastern Kentucky named Roy Lee Centers who sounded just like Carter. We knew we had to go see him. Ralph was as big a hero to me as Bill Monroe, and he was for Keith, too.

Well, finally the day came. My dad drove me, Keith, and Dwight to the show. We made the thirty-minute drive about as excited as we could be.

The club was called Jim & Fay's. It was in Fort Gay, a town just across the state line. Lawrence County borders the Big Sandy River, and there's a huge bridge crossing over the two forks of the Big Sandy from Louisa, Kentucky, into Fort Gay. People from the Kentucky side used to drive to Fort Gay to buy beer. Lawrence was a dry county, and Fort Gay was in a wet county. You'd often hear people complain about how weak the beer was in West Virginia. They called it "stump water," but that didn't stop them from buying and drinking it. There were a lot of clubs in Fort Gay that sold beer and featured country music shows, and Jim & Fay's was one. It was just over the bridge, so close you coulda thrown a rock from the parking lot into the Big Sandy.

Keith and I were actually too young to get into the club. We couldn't even drive yet! But the man working the door knew my dad, and he let us in. We came early and waited for a while. As it got near show time, there were still no Clinch Mountain Boys.

The club owner walked on stage and said he'd just heard from Ralph Stanley, who'd called from a pay phone down the road. His bus had a flat tire, so he and the band were going to be late. Ralph said he'd make it somehow or another; he just wasn't sure when. Now, if you're running a beer joint, the last thing you want is a situation where you've got a packed house and you can't give the customers what they paid to see. They were restless, and some were getting a little rowdy.

The club owner was in a jam. Then he spotted us back in the

corner. He knew about me and Dad. He asked if we brought our instruments along with us, and if we could play for a while to calm down the crowd until Ralph made it.

Of course, we said yes. We never went anywhere without our instruments. We always kept 'em in the car in case someone asked us to play. I think American Express may have stolen Dad's motto: Never leave home without 'em!

Now, I'll tell you we had no idea we were going to play at a Ralph Stanley show that night. It was just like in Martha, all those years ago, when Mr. Monroe yanked me up on stage. I know some would say it was just a blown tire. But I believe some things are meant to be, and I believe everything that happened that night at Jim & Fay's was God's providence at work.

We grabbed our instruments out of the car, tuned up, and got on stage as fast as we could. The club owner tried to give us some build-up. "We've got some boys from over in Kentucky who sing pretty fine, and we'd like 'em to do a few numbers for you. Let's give 'em a hand!"

This was a tough crowd. They came to see Ralph Stanley and his Clinch Mountain Boys. They must have been thinking, "What are these teenage boys doing in our beer joint?" I guess having dad on stage gave us a little more credibility.

There was no booing or anything nasty. You could just tell the crowd didn't expect much. They were probably glad to see anybody get up on stage and give 'em some entertainment for a while until the real deal showed up. About all we knew were Stanley Brothers songs, so that's what we did. We opened with "Riding the Midnight Train." It seemed like the thing to do, to kick off with a barn burner. I was as nervous as a cat. But when Keith and I leaned in shoulder-to-shoulder at the mic and started singing, the crowd started paying attention.

About thirty minutes into our set, we got a big surprise. The club door swung open and guess who walked in? Ralph Stanley, carrying his banjo case. He didn't make a scene or cause any disruption. He

didn't say nothing, and nobody said a word to him. He didn't stay out there in the crowd, either. He just walked over to the bar in the back of the club and sat down with his banjo case on a bar stool next to him.

Normally, Ralph would have headed straight to the dressing room, especially since he was already running late. But he just sat there silent, taking in the show like any other customer. He didn't order a beer or call for the bartender. He just sat and watched the show.

I can tell you it was awfully strange for me and Keith on that stage, to have grown up listening to Ralph's music and to now have him listening to us play it back to him. It was one of those testing times, a stretching of the faith we had in our own abilities. Did we really have what it took to be on stage playing Stanley Brothers songs, with Ralph Stanley himself sitting in the audience?

We just did our best trying to stay focused on the music. Everybody had seen Ralph come into the club, but we didn't acknowledge him from the stage. We could tell he didn't want any attention. And the thing about it was, nobody in the audience was bothering him, either. I think the crowd wanted to let him soak up every bit of the moment, too.

Before, we'd been nervous. Now we were scared to death. All we could do was keep playing. Part of me was glad Ralph was in the club. I was singing every tenor line he ever sung, every little roll in his old style of harmony with Carter. Knowing Ralph like I do now, I think he'd probably forgotten some of those songs. I hoped he was thinking, "Lord, that sounds familiar." Maybe he took it as a nice tribute, which, of course, it was.

At the time, though, I couldn't tell whether he liked it or not. He was listening, but he wasn't applauding or even nodding in appreciation. Not a twitch. He was paying attention, but he had a stern look on his face. By now, the rest of the Clinch Mountain Boys had come in, too, and they stood behind Ralph at the bar. We just kept on, playing every Stanley Brothers song we could think of. We sang "Sweethearts in Heaven" and "Little Glass of Wine," one of the first

big sellers the Stanleys had. It was from 1947, when they were start-
ing out and not much older than me and Keith. We wrapped up our
set, and I looked back to see where Ralph was, but he'd already dis-
appeared.

We had left our instrument cases in the dressing room, and
we hurried back to move our stuff out of Ralph's way. Ralph and
the band were there getting ready to go on stage. The room was
cramped and hotter than blazes, but we were sweating more out of
nerves than anything. Ralph already had his banjo strapped on, and
he could hardly move it was so crowded. "We're so sorry to be in your
way," I said.

"That's all right, boys," said Ralph. "Thank you for holding the
crowd for us. You boys done a fine job. You sound like me and Carter
when we were young. You brought back a lot of old memories of
when we was first gettin' started."

We were thrilled. Ralph Stanley's thanking *us*? Band members
Roy Lee Centers and George Shuffler came over, and they bragged
on us, too, and soon Curly Ray Cline piped up, "You boys really do
sound just like Ralph and Carter!" We were just glad to get a chance
to help out.

Ralph Stanley is a man of few words, especially when it comes
to bragging on somebody. After getting to know him through the
years, I learned that even if Ralph liked something, a lot of times he
wouldn't ever tell you. He'd just smile his tight little smile and ac-
knowledge it, but he wouldn't verbalize it. So it was only years later
that I realized what a huge compliment he'd paid us that night.
Hearing us sing really touched him, and he wanted us to know it.

Looking back now, that night was one of those defining moments
you have in your life. When Ralph walked into that beer joint and
saw us for the first time, singing out of the Stanley Brothers song-
book chapter and verse, he saw the younger generation keeping his
music alive, and he saw the future. It was his history, all right, but it
was our future.

Then we got a table and watched Ralph and the Clinch Moun-

tain Boys, and my God, what a show. They were all about the music. They weren't wild or fancy. They got right down to business, as if they were compensating for making everybody wait.

It was just the four of 'em, not the full band, but it was solid. Roy Lee was playing and singing hungry; he was a real find. On some songs, you could close your eyes and swear he was Carter. And George Shuffler, he was known for his cross-picking guitar, but on this night he was playing bass, and he was unreal. Curly, being a West Virginia boy, was the crowd favorite. Ralph was Ralph, which is to say, about the best mountain singer ever. He was in his prime, and so was his band. They were tight as could be.

Near the end of the first set, Ralph gave us another surprise. "Those boys was awful good," he said. "How 'bout if we get 'em back up to do another show during our break?" and the crowd gave us a big applause. Oh, what a night to remember!

We hadn't planned to play anymore, but we were glad to give it another go. "Do some more of them old ones from way back," Ralph told us before we went on stage, and he even made some requests. It wasn't just a trip down memory lane he was interested in. I think he really enjoyed hearing the Stanley classics sung again, the way he and Carter used to do 'em.

Good thing I'd found the stash of records at that Columbus record store. Good thing Dad had that spare hundred bucks. We played every song he asked for. "Lonesome River" and "Angels Are Singing in Heaven Tonight," the songs from those 78-rpm records Keith and I had learned. Ralph later admitted he was trying to see if there were any old Stanley Brothers songs we didn't know. As far as he could figure, there weren't. I think we'd passed the first exam.

After the second set, we were back in the dressing room again, packing up for the night. Ralph bragged on us some more, saying when he first walked in the club he thought there was a jukebox playing Stanley Brothers records, until he realized it was a couple of kids.

Dad reminded Ralph of the shows in Prestonsburg and Blaine when Carter invited me to play my little mandolin with the band.

Dad couldn't help himself, and he laid it on a little thick: "After Ricky played, you know, Carter told him, 'Son, one of these days Bill Monroe will have to take a backseat to you!'" We laughed, and Ralph did, too, because we knew it was just Carter being Carter, as nice and gracious to a kid like me as he'd be to the president.

Ralph said he remembered that night, and he asked how old I was back then. When I told him nine years old, he said, "Well, you sure have growed up." He asked how old Keith and I were now, and we told him fifteen. He said he had another show the next month at the same club in Fort Gay. He invited us to come back and play again as his special guests. We'd be there.

On the ride home, me and Keith were going stir-crazy. We had trouble sitting still in the car seats. We wanted to jump for joy. We just couldn't hardly believe this was happening to us.

Keith and I had made a name locally with our family bands, and we'd won some talent contests and appeared on TV and radio shows. But this was different. This was me and him together. It wasn't just about me by myself or Keith by himself anymore. It was the two of us, and the possibility of careers in the music business. It wasn't just a crazy dream. It was real.

The only thing we knew for sure was that it was the greatest night of our lives. This was the first time somebody with any notoriety had recognized real potential in us. And not just anybody, but Ralph Stanley himself. He was more than just a bluegrass star; he was our hero. And he was more respected than anybody in bluegrass outside of Bill Monroe.

Nobody respected Ralph more than Dad did, and I knew how much this moment must have meant to him. I could see by the smile on his face the whole ride home how happy and proud he was to see his efforts with me validated. All those hours together practicing music—there was a sense of shared accomplishment that you can't put a price on.

When I think back on it, especially now that he's gone, I know I didn't tell my dad nearly enough how much I appreciated what

he did for me, all the while putting up with so much from me, the childish crap and whining I gave him when I was tired from practicing. I wish I could say to him, *Dad, thank you for working so hard with me all those years. Thank you for your love and patience and for the gift of music.*

Next month, we were at Jim & Fay's again as Ralph's special opening act. It went over even better than the first time. Afterward, Ralph had a proposition for us. There was a bluegrass show coming up in Reidsville, North Carolina. It was the Camp Springs Bluegrass Festival run by Carlton Haney, and one of the biggest festivals around. Haney was planning a salute to the Stanley Brothers. He had already done a Bill Monroe tribute, and this one was for Ralph and Carter. Ralph wanted to have us sing the old songs as part of the tribute, which was called "The Stanley Brothers Story" and would be narrated by Haney.

We didn't know a thing about Carlton Haney or his tributes; we didn't know he was the promoter who got the whole bluegrass festival thing started. All we knew is that we were ready to do whatever Ralph wanted us to do. To settle everything proper, he invited us to bring our parents and come down for a visit to his house near Coeburn in southwest Virginia.

Once school let out in June, we headed out to old Virginia, just like the long hunters going home through the Cumberland Gap after a long expedition. 'Course, we had a station wagon to carry us instead of horses. With it being summer, we made a family vacation out of the long drive. We camped out at Mount Mitchell State Park, and then we swung through Erwin, Tennessee, which was old long hunter country. It was like traveling back to the wilderness places my ancestors roamed centuries ago, only Henry Skaggs and his men didn't have all the truck stops along the way!

We finally made it to the old Stanley home place in Dickenson County, Virginia, where Ralph and Carter had grown up and started playing music together when they were boys. I'll never forget the first

time I saw Smith Ridge. It was so high up you could see clear back to Kentucky. This was real hill country. The mountains in southwestern Virginia were higher than what we had in Lawrence County.

Keith and his parents were there, too, and everybody got to meet Ralph's mother, Lucy, who was by then getting up in years. You could see Ralph took after his mother, not only in his looks but in his quiet ways. She was good country people. We also got to meet Ralph's wife, Jimmi, who was pregnant with their first daughter. We all fell in love with Jimmi and her sweet smile and her hospitality. She made you feel like family.

Ralph asked me and Keith to sing some of the old songs for his mama. Miss Lucy sat there listening and just teared up. I guess it made her think about the old days. We didn't mean to make her sad, of course, but we didn't realize at the time all that she had been through in her life, so much hardship and sorrow. At least she had Ralph and all her kinfolk close by.

We had a big supper, and even before Jimmi brought out the dessert, everything was settled about us going on the road with Ralph. There was no need for any powwows or family meetings. My folks were happy with the arrangement, and Mr. and Mrs. Whitley were of the same mind. Everybody agreed it was a great opportunity. The verdict was unanimous: "It'll be good for the boys."

It was still a few weeks before the big festival in Reidsville, but we just couldn't wait that long. We knew Ralph was playing in Columbus, Ohio, at a country music park called Frontier Ranch. It was a long drive, but we wanted to surprise him. There wasn't anything happening in eastern Kentucky that could compare to playing on stage with Ralph Stanley.

Dad drove as usual, with me and Keith singing and playing the whole way in the back seat. When we got to Frontier Ranch, it turned out exactly the way we wanted. We caught Ralph backstage; he was surprised, and he glad to see us, too. "What are you boys doing up here?" he said. "Why don't y'all sing a few with us?"

We hustled out to the parking lot, and I told Dad that Ralph

wanted us to join him on stage. He gave me the keys so I could unlock the trunk to get the instruments. I took my mandolin case off the top of the pile, and Keith got his guitar. Then my dad reached down and pulled out his guitar from the bottom of the trunk, as he'd done so many times. But I said to him, "Hey, Dad, Ralph just wants me and Keith to sing with him and the band."

Dad froze up and looked surprised, as if I'd splashed cold water on his face. Somehow, he got his composure back. He bent down and set his guitar gently back in the trunk. "Okay son," he said. "That's fine." I knew it wasn't fine, though. I could tell it hurt his feelings.

Dad still felt like he was part of the band we had with Keith's brother Dwight, and we didn't want that part to change. When we weren't playing with Ralph, we were still the Lonesome Mountain Boys, doing our local gigs and our radio show.

But Dad knew deep down what was happening. He knew that when it came to playing with Ralph, it had to be just me and Keith. He'd just grabbed his guitar out of habit. He knew we were our own musicians now and had been called to a new station in life.

Of course, I felt awful for him, and I really didn't know what to say. But after we went back inside, Dad was like Dad again, making new friends everywhere he turned. Right off, he found a kindred spirit in the crowd, Hazel Lambert, the widow of Pee Wee Lambert. Pee Wee had died way too young, a year before Carter passed. He was forty when he had a heart attack. Hazel lived in Columbus. She was still a fan of Ralph's music, and she'd come to the show with her daughter. Afterward, I got to meet her, and she was as nice and sweet as could be. "I loved Pee Wee," I said. "He was my favorite Clinch Mountain Boy." She said, "Oh, thank you, honey." I told Miss Hazel how much I loved Pee Wee's high tenor singing, the part I sang when we did the trios with Ralph. I told her how much his mandolin play-ing meant to me, too.

She was so glad to hear me say that, and she wanted me to know Pee Wee never lost his love for bluegrass. Even though he'd left the music business to work a day job in his later years, he played the blue-

grass bars of Columbus right up until the end. He could never quit music.

Finally, the big weekend came. That first trip to the Camp Springs Bluegrass Festival was how our careers started, really. It was the first time we traveled by ourselves, without our parents driving us. It was our first time on the bus with the Clinch Mountain Boys. It was also our first taste of the music business and life on the road as a musician. More than forty years later, I'm still on the road, riding the bus to the next show.

Dad dropped off Keith and me so we could meet up with everybody at Ralph's place. When the bus pulled out and started down the mountain, my stomach was turning in knots. We were taking it all in, looking out the windows at the coal chutes on trestles zigzagging above the winding road, neither of us quite believing we were actually on Ralph Stanley's bus headed for a show. My God in heaven, here we were!

Ralph had a 1950 Aerocoach bus converted for his five-man band. And now he had to squeeze in two more Clinch Mountain Boys to haul down the road. It was so cramped for space, just some tiny bunk beds thirty-something inches wide for these grown men to sleep in— and none for us new kids. Keith and me got these old ramrod, upright seats up front. You could lean them back a click or two, but that was it. So we sat up as straight as two hoot owls the whole ride down to Reidsville, North Carolina. To tell the truth, we were way too excited to sleep anyhow.

After about an hour, Ralph started firing off requests. Curly Ray was up front in the buddy seat, and Ralph was at the wheel. I thought that was so cool: Ralph Stanley driving his own bus! Eyes on the road, Ralph would ask me and Keith if we knew a certain song. "Yes, sir," we'd say. And he'd tell us to sing it for him. So we'd start singing, without a guitar or anything. We'd get done with that one, and he'd ask about another. Nearly every song he asked for, we knew. He was loving it.

I noticed that sometimes, while we'd be singing, Ralph and Curly would be talking to each other in low voices. We'd just about run out of songs when I overheard Curly ask him, "Reckon he's still up?" and Ralph said, "I bet he is." I was thinking, *What in the world are they talking about?* Soon Ralph swung the bus around, pulling off the main road and going down another, and then down another. This was some serious detour considering we had a festival we were supposed to be going to! I was thinking, *Well, this surely ain't the way to North Carolina.*

Finally we stopped. There wasn't a house or even a mailbox in sight. It was the middle of nowhere. Curly got off the bus and started walking down into the woods.

Now mind you, this was long before cell phones, before you could call somebody ahead of time and ask to stop by. Curly went barreling into the woods, and it was plenty dark, too. And Ralph was just a-sitting there at the wheel, like everything was absolutely fine. Finally, I asked Ralph, "Where did Curly go off to?" I thought maybe nature had called him. Ralph said sorta sharp, "He's going to talk to a feller about something." I thought to myself, *Okay, Skaggs, just shut up. This is their business, not yours!*

About twenty minutes later, here came Curly back on the bus. He was almost out of breath from walking in the woods, but he had a big ol' Curly Ray grin on his red face. He was carrying a jar, just like one of my mama's canning fruit jars. It was quart-size and full of clear liquid. Clear as spring water. But I knew he hadn't spend all that time down in the woods going after water. Ralph said, "That looks fine." It was the first time I'd ever seen moonshine.

I thought to myself, *If my mama knew what I was seeing, she'd beat us all to a pulp!* Well, I don't think I ever told her about that jar of 'shine. Never got up the nerve, I guess. I really didn't have to tell her a lot of things, though. She seemed to always know when something wasn't right with me. Mama and the Holy Ghost were a force to be reckoned with!

Many years later, when I was talking to Ralph about this, I told

him, "Honestly, if my mother had known that I was out there with y'all on the road, with a quart jar of moonshine on the bus . . ." Then Ralph said, "She'd a-probably whipped every one of us!" and we had a good laugh.

At the time, though, it wasn't very funny. I felt like I was in over my head, to tell the truth. I hadn't ever been around moonshine. Euless just drank whiskey or beer. Here it was, the real stuff, the good ol' mountain dew, what the old-timers used to talk about.

Curly took the jar to the back of the bus and that turned out to be the end of it. Keith and I didn't partake, and nobody asked us too. Ralph wouldn't have stood for it. This was strictly for the other Clinch Mountain Boys. Still, it was something I'll never forget, the whole dynamic. It was new, and a little scary.

It was still way before dawn when the bus finally pulled into Reidsville. We hadn't slept a wink, but it didn't matter. Carlton Haney's Camp Springs event wasn't just the first time Keith and me had played a bluegrass festival. It was our first festival, period.

Same for my Dad. He had driven down by himself and got there not long after we did. He knocked on the door of the bus and asked if he could come in and shave and wash up. 'Course, Ralph told him that'd be fine, and Dad got out the razor he'd brought and found the sink there in the back of the bus where Ralph had his bed. Over that sink there was a window with little curtains, not a mirror, so Dad started shaving without really being able to see what he was doing. He ended up cutting himself pretty bad with that ol' double-edge razor.

Talk about a close shave! He had some nasty cuts on his face where he'd stuck pieces of toilet paper to dry up the blood. He looked like a leper when he came up front to sit down to visit for a while, and he said to Ralph, "I never could shave without a mirror." And Ralph said, "Hobert, there's a mirror back there as long as you are!" Dad sorta grumbled, "Huh, why there ain't no mirror back there!" Ralph said, "Behind the door." So Dad marched right back there and opened a closet door next to the sink that he hadn't noticed, and lo and behold, there was a full-length mirror on the back of that door.

Now, here Dad had scraped meat off his face, and right there beside him was the mirror he coulda used to prevent all that blood-shed! He was looking at himself in the mirror and feeling sheep-ish. He couldn't hardly believe it; he was so gotten about that! Well, the whole bus just roared, and Dad had a good laugh about it, too. 'Course, Curly Ray had a field day and was crowing, "Hobert about tore half his face off without a-knowin' there's a dang mirror right there bigger'n he is!"

Poor Dad. It was quite an introduction to the world of outdoor bluegrass festivals, where you had to rough it best you could. It was a real eye-opener to see thousands of people camped out for three days in tents or sleeping in cars. This was a different crowd than the one you'd get at the Astro Inn or at Jim & Fay's. This was a mixed crowd, with Yankees and even city folk.

There were a lot of young people there, too. It was the first time I ever saw hippies. They had long hair, they were strangely dressed in colorful clothes, and they really loved this old mountain music. They had more fun than anybody. They danced to every song, even the gospel songs. I'd never really seen that before. I'd seen those people in the Holiness Church dance to gospel, but this was wild. It sure didn't look like the mountain clogging I'd seen back on Brushy Creek.

Ralph had Keith and me rehearsed and ready to go for the tribute. He needed us for the high-trio sound from the '40s and early '50s, the classic Pee Wee and Carter era. We were essential to telling the whole story, because Ralph wasn't doing those old songs with his new band. He had left them in the past and moved on.

Soon it was show time. Time for Carlton Haney to tell "The Stan-ley Brothers Story," or "stoh-ree," as he pronounced it in his western Carolina brogue. Ralph and the band played, and in between songs, Haney narrated the saga of two brothers who left their mountain home to roam far and wide, playing their music together for twenty years before Carter's tragic end. Waiting in the wings, Keith and I got a peek at the huge crowd, a sea of strangers far as the eyes could see. It made me shake a little bit. Ralph introduced us, and we went

out and sang "Lonesome River" and "White Dove." We did "Angels Are Singing in Heaven Tonight," and honestly, I believe they were. I believe that we had heaven's approval. This was meant to be!

A lot of the fans had never heard Ralph perform these songs on stage in the years since Carter had died. It was a wonderful surprise, and we got three encores. The clapping was as loud as thunder. Dad was there of, course, and he came by after the show to congratulate us. He was so proud. "That's the best I ever heard," he said. "That was the biggest hand anybody got all night, when you'uns went up there with Ralph!" Well, me and Keith were just glad we hadn't messed up and embarrassed Ralph. We didn't know we'd stepped into an important chapter of bluegrass history, when the music had matured to the point where it could look back on its past and honor its creators. Everybody was talking about the two young kids with Ralph Stanley, how it was part of a new youth movement. Bluegrass had always been an older people's music, and now there were a lot of young people in the crowd to see the Bluegrass Alliance, the Country Gentlemen, and other progressive acts. Bluegrass was bringing hippies and rednecks together. Even ol' Ralph Stanley, he was singing them lonesome ol' high mountain harmonies with a couple of teenagers!

The Atlantic Monthly had a story about the resurgence of bluegrass around that time, and it focused on the festivals that had grown into a nationwide grassroots phenomenon. The writer made special mention of me and Keith, and how we were carrying on Ralph's music to a new generation. "Two young Kentucky musicians created a sensation by playing and singing in an absolutely perfect imitation of the early Stanley Brothers," reported the article, called "Believing in Bluegrass." "To hear the whole group, then, is to hear not only Ralph and Carter Stanley, but also a kind of geological record of their career, collapsed into some of the most hair-raising and beautiful harmonies in any music."

The writer saw this as a watershed moment in the history of bluegrass: "An art may perhaps be said to have come of age when it can

refer to itself." Bluegrass was "all growed up" and out of the mountains and out in the world. And we were helping it along.

Nobody was more tickled than Ralph. He told us he was going to hire us out the rest of the summer at twenty-five dollars a day for show dates. Then, during the school year, we could work part-time traveling on weekends and holidays. After we graduated, he said, we could join the band full-time. It was a dream come true!

And that was how it happened. When classes started up in the fall, we'd do show dates with Ralph whenever we were able—and sometimes when we really shouldn't have. We were like two physics majors with the chance to go out on the road with Einstein. Getting paid for learning! How could being stuck in a classroom stack up next to picking a mandolin on stage with Ralph Stanley?

The only letter or number I cared about was "F-5"—as in the 1922 Lloyd Loar Gibson that Pee Wee Lambert had played and, especially, the 1923 F-5 Lloyd Loar Gibson Bill Monroe played. The legendary F-5 models, from a batch of only a few hundred made. Hand-cut from maple wood, hand-assembled, hand-varnished, tested, and signed by the master luthier Mr. Loar himself! When he started out, Bill had a decent instrument, an F-7 Gibson. But when he saw that F-5 Loar in the window of a Florida barbershop and bought it for $150, he found his musical partner for life. A great instrument inspires you, and after Bill got hold of that F-5, it was like he was struck by lightning. He wrote hundreds of songs and changed American music.

The story of Monroe's mandolin was holy writ for bluegrassers everywhere. At the time, though, an F-5 was something I could only daydream about, as unattainable as the Holy Grail. I had just bought a brand-new A-5 Florentine Gibson. It wasn't great, but it was all I could afford. Keith called it the Red Bomb.

I still did my best to make school a priority. I can remember there were times I'd get back home from the road at four o'clock on a Monday morning, take a bath—'cause we didn't have a shower in

those days—catch the bus, and ride the thirty miles to high school in Louisa, which was the county seat. I was the first to get on the bus in the morning and the last off in the evening. It was long ride back and forth, and I usually slept most of the way.

My teachers at the high school were lenient about letting me make up tests and homework. There was only one, my English teacher, who didn't see it that-a-way. She wanted me to get an education, and she came out strong against anything that interfered with classes. For her, school always came first, didn't matter if it was Ralph Stanley or whoever. So, if I missed an English test, her attitude was *sorry for your luck*. I know she was only doing what she thought was best.

The other teachers were more understanding. One of the best was Andy Wheeler. He was from Blaine, and he always helped me make up any work I missed. Mr. Wheeler and many of the other teachers knew I'd been playing music since I was five, and they knew how serious I was about it. They also understood I was working for a bluegrass star. It meant something to them; Ralph Stanley was a re-spected figure. They saw that I was working toward my future.

Later that year, we were finishing up school, and Ralph took us on full-time. Actually, I never did graduate with my class. I needed one credit to graduate from Louisa High School, and I promised my mom I'd take the correspondence course to do it, but I went right to work with Ralph as soon as classes ended. She forgave me for it, but I know how bad she wanted me to have a high school diploma, and I never did get one. Mom only made it to the fourth grade, and I know she wanted better for us kids.

But sure enough, Keith and I both left school behind and never looked back. Except for a job I had for a bit, playing music has been my profession and my calling ever since I was sixteen years old. Going full-time felt great, but we still didn't feel like real Clinch Mountain Boys just yet. See, the band members all had their own stage outfits. They were these real sharp-looking suit jackets, finely tailored and embroidered, almost like tuxedoes. There were four different styles that went with black dress pants. But there was a matching pair we

liked the best: One had a solid gold lamé coat-jacket with black trim and swirls sewn on; the other was the same design but reversed, black with gold trim and swirls. We thought they were the coolest, especially the solid gold coat, and we asked Ralph when we could get our own stage jackets. "Well," he said, "I reckon I plumb forgot about that, and I apologize. Next time we go through Cincinnati I'll suit you boys up."

Good as his word, after our next show date in Cincinnati, Ralph pulled the bus over to a store in the black section of town. Inside, there were suits and dress pants and costume gowns and shoes and wigs and everything else you could imagine, a world of crushed velvet bell-bottom slacks and suede dinner-club tuxes. This was the place for the coolest stage outfits in the music biz, where everyone from James Brown to Jim & Jesse did their shopping.

This was still the era of the flashy Nudie suit, and glitter was still a good thing. There was a dress code for entertainers, especially for country and R&B performers. Even if you weren't the best musician in the world, you could still look the best when you went on stage, and folks expected as much. Country music fans wanted their stars to have some sparkle.

This place had it all. Rack after rack, rows upon rows, floor to ceiling. We found our gold jackets, and we got fitted right then and there. Once we saw ourselves in the mirror, well, that was the moment when it finally seemed real. We were really in Ralph's band, and we'd made it as professional musicians. We felt like a million dollars, even if we had to borrow money from our parents to pay for our new threads.

It's strange how a coat jacket can make you feel like you done made it, but there you are. You can see for yourself how sharp they look, 'cause that's what we're wearing on the cover of *Cry from the Cross* and several other albums as well. I know the saying is that good taste is timeless, but now I wouldn't be caught dead in one of those!

* * *

Cry from the Cross was the first full-length record I ever cut with Ralph. It was baptism by fire. It was Ralph's second sacred album as a solo artist, and the first bluegrass recording to feature a cappella gospel singing. Me and Keith had somehow walked into another new chapter of bluegrass history, but you'd never have known it if you were in the studio at the time.

For one thing, the studio was in the engineer's remodeled basement outside Washington, D.C. I remember coming down the stairs, thinking, *Is this where Sinatra makes a record? Is this what a studio really looks like?* His name was Roy Homer, and he had nice equipment and vintage mics and all. Still, it was kinda makeshift, though I didn't have anything to compare it with except the Whitleys' garage. Roy had a tiny control room partitioned off behind glass, and he let us know when the tape machine was rolling. He had a mixing board where he could bring the volume on the banjo or mandolin up or down or whatever else was needed to get the levels right. I'll bet tape and all the session didn't cost a thousand dollars. Part of the reason was we finished the whole album in one day.

We cut the songs straight to two-track, with Roy mixing it live. There were no overdubs, no chance to fix any flubs like nowadays. If you messed up, you had to do it all over again. We didn't need many second takes, though. I got to play some twin fiddle with Curly Ray on the title song, and the mandolin and the other backup parts were straight-ahead, too, so the playing came easy.

The gospel singing was a different story. We had to go to church— Ralph's old country church from his boyhood, that is—and learn to sing the old-time Primitive Baptist way. So we practiced while we were on the road. When I say "on the road," I mean in the vehicle, going seventy miles per hour or faster, and at all hours of the day and night.

Anytime we were traveling, in the car or the camper or the bus, Ralph wanted something going on. Usually he wanted some music, but it didn't really matter what: He liked having people up and awake while he was driving. You could be talking, singing,

joking, or laughing. That was just part of the deal when you rode with Ralph. He didn't want a lot of dead air and watching the scenery going by. Back in the early days, he'd probably rode more than enough miles with him and Carter not speaking a word from Florida to Ohio.

Having a couple of gung-ho teenagers in the band pepped things up. Ralph had been on the road for twenty-five years, and that was an awful long stretch playing one-nighters. Me and Keith gave him a shot of energy. Ralph could see it through our fresh eyes, and I think he was able to enjoy the road more then than he had for years.

So we did a lot of rehearsing on the road. Ralph would throw us new songs, and we tried to catch 'em. Mostly, we worked out the vocal arrangements on the gospel songs Ralph had picked. It was a good thing the songs were a cappella, 'cause we didn't have a guitar inside the car. There wasn't room to play, anyway, with the whole band crammed into a Bonneville station wagon that Ralph had bought to replace the bus. We'd sing, and we'd sing some more, until Ralph was satisfied we'd got it. As usual, Ralph would be driving, and he'd lead us like an old-time preacher would his flock of parishioners, a little congregation headed up the highway. He'd say, "Awright, boys, I'm just gonna line out an old gospel song, so listen up," and that was all we needed to know. *"Sinner maaaannn-nnn, so discouraged, while traveling through this laaaaaaaaand."* He'd stretch those lines and ornament every syllable the way only Ralph could, and you knew there was no singer alive who could render a hymn with more power and conviction. And we'd follow every crook and turn of his voice. When he'd start lining out another song, we knew we had it right. And all the while the Bonneville barreled into the night.

Cry from the Cross earned Ralph his best reviews since Carter had died. It was hailed as a landmark in bluegrass, especially for the raw beauty of his a cappella gospel. "Sinner Man" and "Two Coats" gave Ralph a way to showcase his tenor as an incredible lead instrument, the voice that would thrill millions thirty years later. This was the

album where Ralph was finally ready and able to step out of Carter's shadow and shine in his own right.

I can still remember the photo shoot for the album cover. We were all lined up in our stage suits on a hill under a huge cross, and it was a cold and windy day. Curly was about to have a fit like he was gonna freeze to death, saying he felt like Hitler having to stand there ramrod straight and serious. It really is a photo for the record books. We've all got that classic bluegrass gospel look of reverence on our faces, where you're not looking at the camera, you're looking at the cross or up in the clouds! That probably started with Bill Monroe and the gospel albums he did for Decca in the 1950s, where the covers usually had a side profile of Bill looking off camera with an attitude of somber reflection. Ralph was one of the first solo artists in bluegrass to feature the whole group on the front cover, and I think it had a big influence on later bluegrass gospel albums.

Ralph was generous about letting the band members have something of their own to sell, too. He helped me and Keith record some albums under our name. We did our first, *Tribute to the Stanley Brothers*, in a few hours before a night show in Dayton. I always remembered that we cut it on January 8, 'cause there was an old fiddle tune called "Eighth of January" that the old-timers in eastern Kentucky used to play. It seemed like a good omen to make our first record that day.

Back then, I'd have done anything for Ralph. I was eager to please, sometimes too eager. One time we stayed at a motel after a show, and I offered to clean Ralph's banjo. 'Course, I had a banjo at home and knew how to take it apart and clean it and spiff it up nice and shiny. I thought shiny was good. So while Ralph was out getting something to eat, I gave his ol' Gibson Mastertone archtop the full job with cleanser and brush. I took it apart, scrubbed the corroded metal parts, put it back together, and had it looking brand-new.

When Ralph got back in the room, I handed it back to him, and his face got white. He said, "Well, thank you, Rick, you did a fine job there." But I knew something was wrong.

Ralph figured I was just gonna dust his banjo with a rag, and here I'd gone and wiped out all the precious ol' patina and crud that gave it the sound he liked. I had cleaned all of that funk off and down the drain forever! I had no idea what I was doing. He never reprimanded me, never said a word about it. It was only years later that I realized what I'd done.

Ralph was my boss and mentor, but my musical father was still Bill Monroe. Not just 'cause we both played mandolin. There was some kind of bond we'd established on that night in Martha, so long ago, and it just got stronger through the years, right until the day he passed on.

Traveling with Ralph's band, I would see Mr. Monroe at the festivals, and I could always count on him for a word of advice or encouragement. I still called him "Mr. Monroe," or "Mr. Bill." I would have never called Ralph "Mr. Stanley," and I'd never have dreamed of calling Mr. Monroe "Bill."

Mr. Monroe was big physically, and he had a presence about him. He didn't say much, and he didn't smile much, either. He commanded authority just by coming into a room. He was almost like Bigfoot. When he walked the festival grounds, sometimes you'd see the crowd scatter like scared deer.

There were stories you'd hear about Mr. Monroe, too. He didn't take guff from nobody. He was hard on his band, hard on himself, hard on everybody. When he was younger, he was a real brute, and he didn't mind proving it. He told me, "When me and Charlie would fight people, there weren't ten men that could take us." They'd put their backs together and bare-knuckle all comers. Later on, when a musician made a pass at his daughter Melissa, he told him, "Boy, if you touch her, I'll break you in two like a dead stick." And he wasn't fooling around.

A lot of people thought he was arrogant and kind of ornery, but the fact was Mr. Monroe was a very shy and insecure person. He had a lazy eye, and he got picked on by his brothers and everybody

else. By the time he was a teenager, he'd lost both his parents, so he'd grown up mostly on his own. He didn't have no family, really, outside of his Uncle Pen, and he was always looking for the love and respect he couldn't find at home. He learned how to survive by steeling himself, and becoming tough physically and mentally. He built a hard shell around himself. Course, I didn't know all this personal history at the time. I just loved and respected him, and he responded to that. And I was extra lucky because our meeting back in Martha got us started on the right foot, and it set the tone for how we got along. I was always very respectful, and he was as nice as he could be. I'd always try to visit with Mr. Monroe at the festivals when I was with Ralph.

I often asked Mr. Monroe how to be a better musician. One time, I just sorta blurted out, "Mr. Bill, what does it take to be a good mandolin player?" At first, he just looked at me. I don't think he'd ever been asked that question point-blank before by anyone. So I said it again, a little different this time. "I mean, what I was wanting to know was, how do you really get good on mandolin?"

I really believed in my heart there was something he could tell me. Something beyond the usual advice of "practice, practice, practice." I guess I was looking for that magic secret, and I figured if there was any person on earth who knew, it was Mr. Monroe. I asked the question with a sort of innocence that he must have appreciated, 'cause he didn't brush me off.

Instead, he got a faraway look in his eye. "Well, boy," he said. "You just got to whip it like a mule."

Now that may sound like strange advice, but I knew exactly what he meant. Play hard. Play like your life depended on it.

And I really took that advice to heart. Once in a while I'd borrow Jimmy Gaudreau's mandolin to play. He was with the Country Gentlemen then, and he was one of the best young mandolin players around. Jimmy also had a real nice mandolin, a lot better than my Red Bomb. Playing Jimmy's mandolin was like getting a chance to take a convertible out for a spin. I used it on stage a few times with

Ralph, and when I'd hand it back over there'd be two or three strings broken.

Jimmy was from up north in Rhode Island. He'd say to me in his New England accent, "You play too hard, pal!" I wasn't trying to hurt his mandolin, just playing the way Mr. Monroe told me. Guess I was doin' a little too much mule-whippin'!

Chapter 9

RULES OF THE ROAD

Homesick and lonesome and feeling kinda blue
I'm on my long journey home.

—"Long Journey Home," by the Stanley Brothers, 1963

Ralph looked out for us as best he could. It was still the road, though, and he couldn't shield us from everything. I was young to be traveling with a bunch of older men who were drinking and doing all the other sorts of foolishness that come with the territory. Sometimes I look back and I'm amazed Mom and Dad even let me get on the bus. But they trusted Ralph, and truth be told, Ralph and the band were good to me and watched over me and Keith both.

Even so, my folks knew how exposed I was, and they knew there were all kinds of trouble waiting out there around the bend. Especially my mama. She was a seer. Sure, now I was a Clinch Mountain Boy, and I was proud to wear the gold suit. But I was still Dorothy Skaggs's boy. She knew I was a teenager and there would be temptations, and she was right. Going on the road with Ralph was when I drank for the first time. But I came to realize that wasn't what I wanted to do. And that was because of my mother. She had a hold on me that nobody could ever break.

It was like she could read my mail. Not literally. I'm talking about my spiritual mail. I'd come back home from a weekend road trip,

and she'd tell me she had seen me in a dream doing something I shouldn't have been doing. So I knew that whatever I did, no matter when or where, the Lord was going to reveal it to my mom. Let me tell you, even when I was goin' down a crooked road, knowing that helped keep me on the straight and narrow.

Early on, I went out for a week with the band, the longest I'd ever been away from home. Ralph was coming through Kentucky on the way to a show in Ohio, so he stopped to pick us up. The bus was idling in the driveway, and my mom stopped me as I was headed out the door. She put her hands on me and prayed over me. She spoke a kind of blessing, only it wasn't the usual type of blessing.

"If you ever get out and start drinking whiskey," she said, "I pray that you'll get sick every time you drink that stuff!"

That might sound more like a curse than a blessing, but it wasn't. She spoke strong words because she knew our family history, and she'd seen what happened with Euless. She knew the power of the Devil's snares. She knew a lot more than I did. I wasn't worried about whiskey at all. All I knew was that her prayers had always kept me safe.

Dad wasn't one for big speeches. After my mom got through with me, he may have given his advice, but all I really remember him saying was this: "Son, you know how to act." He was a man of few words. In that way, he was a lot like Ralph.

Ralph was a quiet boss man off the stage and a quiet bandleader on the stage. He wasn't one to lecture or scold you. He wasn't one to compliment you, either. He didn't say much one way or the other. He figured criticizing would just tear a man down, and flattering would puff him up. He mostly taught by example.

I learned so much during my time with Ralph. He was easy to work for, and he was good about giving me direction when I needed it. Especially about music and what it means to be a musician. He taught me many lessons I still put into use today, leading a band of my own: Keep the music pure and simple and down-to-earth. Stay true to the song. It's more than a bunch of notes; it's a story you're

telling to the audience. Always play the melody before you try to get fancy. Don't be a big shot or something you're not: Play your instrument to put the song across, not to show off your picking. Make your instrument play what the singer is singing.

When you're a young musician, you're constantly trying to get better at your instrument, to grow and stretch your boundaries as you learn new things. That's fine, but you need limits, too, and Ralph was good at setting limits. On the festival circuit, I started hanging out with other mandolin players and trying to learn their licks. At a show one night, I played some of those new licks during our regular set. Ralph gave me some funny looks, like, *Don't believe that goes in there, Rick.* After we were done, he pulled me aside backstage and said, "You know, Rick, some styles work together and some don't. When you're taking a break, I want the audience to know what the song is without me singing it." He wasn't angry, just serious. He was real gentle making his point, but he wanted me to know how important it was.

What Ralph said made a lot of sense, and I've carried that with me ever since. I've passed it on to the guys in my band. It's something that good musicians have in common, and not just in bluegrass. Take Bob Wills, the King of Western Swing. He had his big swing band, the Texas Playboys, and they'd always establish the melody, then somebody would swing a solo—whether it was fiddle or steel guitar or piano—and then the band would all play the melody again. It's fine to stretch out on a solo, but you always have to come back to the melody.

I learned a lot from Ralph just by watching him do business. The way he handled the nitty-gritty stuff. He always had his trusty ol' money rock at the record table to hold down all the loose bills so he could make change and keep close tabs on the sales. Later on, I found out the rock Ralph had was the same kind the old-timers used when they bought illegal whiskey. They'd leave the money under a rock and come back later, and there'd be a quart waiting. That was the old mountain way of doin' business.

I also admired the way he treated the promoters at the clubs and festivals. He was a straight shooter, and he was polite and kind to them; he was thankful for the job and always made sure they *knew* he was thankful for the job. He shook their hands and looked 'em in the eye.

Now, Ralph also carried a pistol in his briefcase. But I think it was more out of habit, going back to the early days when he was on the road with Carter and they were playing the skull orchards, which is just an ol' mountain way of saying beer joint—one of those rough bars in the rough sections on the outskirts of town, like Marlow's in Pikeville, Kentucky. Ralph's pistol wasn't for show, it was for self-defense. Honestly, there were some bars that were so mean there was chicken wire around the stage. You'd just open the door, lock yourself in, start playing, and give 'em a little bit of music to gouge to!

Ralph was a solid businessman in his dealings with his band, too. He was as good as his word, at least he was with me and Keith. He was fair, he didn't fuss a lot, and he didn't play favorites, though he did think the world of Curly Ray.

And Ralph didn't ask anybody to do anything he wasn't willing to do himself. He did a lot of the driving, and he carried his own luggage and banjo case. He never put himself above any man in the band. I'll never forget when we had to get the grounds ready for the first festival Ralph had at the Stanley home place up on Smith Ridge in Dickenson County. The Carter Stanley Memorial Festival was what he called it then. Most festivals were at fairly accessible venues. Ralph's site was as remote as you could get. There was a two-lane gravel road that went up to where the mountain hits the sky.

Getting the site ready was a lot of real, hard labor. A hired man with a tractor mowed the hay, baled it, and hauled it off the property so people could have a place to park. That was about it for the paid help, though. Just about all the rest of the work was done by Ralph and the band and whoever he could get to come by. My dad and Keith's dad, Elmer, came with their tool bags and helped build

the stage down in the holler. We stayed in a little camper, just me and Dad.

The wood framing for the stage didn't look too stable. Ralph had had some neighborhood friends build a makeshift stage with what they had, and it was not a solid structure. It was as crooked as a dog's leg. Dad was trying to figure out how in the world we could straighten the thing out. He and Elmer shored up the floor and the walls, and that was about all they could do. With everybody pitching in, we had it ready for the Memorial Day weekend.

The festival setting on Smith Ridge was very primitive, and it was pretty as a picture, too. The stage was nestled in the holler below the family graveyard, and it made for a nice little natural amphitheater. But boy, if it rained, look out! Instant Mud Bowl. The first few years it rained like crazy, and it was a terrible mess. People would slide from the top of the hill all the way to the bottom, and there was nothing to grab hold of as you went down. If there was a big ol' rock, you had better make sure you didn't have your legs spread when you hit!

The bad weather didn't scare anybody away, though. The annual event drew some of the biggest crowds in the history of Dickenson County, and Ralph needed as many volunteers as he could get to help out. I worked all day playing music and worked the gate at night, taking money from the fans as they pulled through the entrance.

Three years ago, I played at the festival for the first time since the late 1980s. The old stage was still standing and so was Ralph. He's well into his ninth decade now, his seventh decade playing music, and he's still on the road. He's a national treasure and an American icon, and it's so inspiring to see him out there working show dates. He has steel in his spine and iron in his constitution. I did a few duets with him, "Riding the Midnight Train," and "White Dove," just like old times. It was hard to believe it'd been forty years since me and Keith had come to Smith Ridge with our parents to map out our futures. Here I was, right back on the mountaintop where it all started!

I was up there on stage, my shaggy gray hair long as Elijah's, and

Ralph looking frail behind the microphone but still singing solid as a rock of ages. It got me thinking about how many miles we'd ridden and how many rules of the road he'd taught me. Good rules to keep you going, so the road don't do you in. Maybe that's why we'd both made it through.

Ralph always said, "Eat before you get hungry, rest before you get sleepy, and take a shower before you get dirty." This was his way of saying be prepared and always try to stay a step ahead of what's coming, because you never know when you're going to get a good meal. At first, Keith and I would whine, "We ain't hungry," and he'd say, "Well, you'd better eat anyway, 'cause we don't know if we'll be able to get a meal till after show time." At restaurants and diners, Ralph always made us order before we went to the bathroom. That was a big rule for him: Once we pull into the truck stop, go sit down at the table, open up your menus, and place your order right away. "You don't have to have clean hands to open a menu," he said. "While they're cooking the food, everybody can go wash up."

There were a lot of unspoken rules when you traveled with Ralph. He wanted everybody to keep their minds on the job. He wasn't much for guys listening to music on the bus, unless it was by Ralph Stanley or the Stanley Brothers. Once in a while we'd buy a cassette at a truck stop or whatnot and give it a listen. I remember one time we had a tape by Porter Wagoner and Dolly Parton, and Ralph didn't have a problem with it. I guess he had a soft spot for those great duets Porter and Dolly used to sing together, and who doesn't?

Probably the strictest rule Ralph had was about being late. He hated to be late, and he hated for anybody else to be late. He laid down the law when it came to tardiness. Many a Clinch Mountain Boy has been left behind and had to find his own way to the show, or sometimes back home from a show.

Ralph left me once when I was late. My VW Beetle had engine trouble, and I had to get it fixed. I was at the mechanic's, so there was no way to call and let Ralph know I was gonna be about an hour late. When I got to Coeburn, where Ralph kept the motor home parked,

they'd already pulled out for Arkansas to play a festival the next day near the Ozarks. I knew it was Ralph teaching me a lesson, and I felt like I'd let him down. So I drove all the way back home, and I was really bummed out. When I told Dad what happened, he said that a neighbor, Charles Cordle, was heading to Arkansas that day to visit with his son, and that I could ride with him.

Well, Charles's son lived in Jacksonville, and the show date was about seventy miles away at the Petit Jean Mountain Bluegrass Festival near Morrilton. So we left Brushy Creek on Friday afternoon and made it to Jacksonville that night real late. On Saturday morning, we drove to Morrilton and pulled into the festival campgrounds just as Ralph and the boys were coming out of the motor home to head for the stage. Show time was minutes away. You can't believe the surprised looks on their faces, and nobody was more surprised than Ralph to see me there, ready to play.

I explained to him why I was late and told him I was sorry. He understood and said it was all right. I ran to the motor home, changed my clothes real quick, tuned up my mandolin and fiddle, and got to the stage right when the announcer said, "Ladies and gentlemen, please make welcome Ralph Stanley and the Clinch Mountain Boys." I thought to myself, *YES!!!!*

The road taught many kinds of lessons, especially lessons in what not to do. I saw things happen that I knew weren't good, at least not for me. I saw things happen that I didn't want to do, and things I knew I shouldn't do. Keith and I were surrounded by much older men, drinking and whatnot. Sometimes I had to learn the hard way what not to do. That's how it is when you're sixteen and still wet behind the ears.

Once we were playing a show in upstate New York. Friends of Ralph's who lived in the area put us up at their place for the night. Sometimes we stayed with people on the road. It was sociable for Ralph, and it was good for the band, too. We got a home-cooked meal and some hospitality. After the show that night, the family

fixed us a real nice dinner and stayed up talking with Ralph for a while after they cleared the table. He was the guest of honor, and he repaid the welcome by staying up as long as they wanted.

It was close to midnight, and me and the boys were all tired out. We all went back in the big guest bedroom they'd prepared for us, with cots laid out and fresh towels. We were used to riding all night, pulling into a truck stop to wash up, and then getting on down the highway. This was a whole lot nicer.

Roy Lee wasn't ready for bed, though. He was looking for a night-cap, and not the kind you put on your head, either. He went over and opened the closet door. Then he wheeled around with a big smile. Up on the top shelf were whiskey bottles, lined up in a row like you'd see in a bar. Roy Lee didn't waste a second. He reached up and grabbed a bottle, cracked the seal, and got right into it. He took a good long pull, wiped his lips, and said it was some of the best whiskey he'd ever had. Keith then said, "Give me a drink," and it went around till it got to me.

Well, I didn't know what to do. It looked like they were having fun, so I took a drink, too. I regretted it the second the liquor hit my tongue. This wasn't for me. But it was too late. The bottle came around again. Then I watched while Roy Lee killed the rest of the fifth of whiskey in a single swallow. I saw it, but I could hardly believe it. He turned the bottle up and downed the whole thing to the last drop before he ever took it from his mouth. He wasn't showing off. I think he'd done that before. Roy Lee was a big ol' boy, about 220 pounds, and built solid as a hog. That much would have laid out most anybody else.

Seeing Roy Lee kill the bottle really scared me. I'd never seen any-body do anything like that before. Not Euless, not anybody. I couldn't even comprehend it. I was amazed, and I was afraid. Then I felt the whiskey kick in.

As soon as I lay down on the cot, the room started spinning, and I knew I had to get to the bathroom quick. Here I was, sixteen years old and nothing on except for my underwear, and I was stumbling

down the hallway trying to find the bathroom. The family and other friends of Ralph were still out there in the living room gathered around the table. They were talking their grown-up talk, and I was too ashamed to even ask directions.

Somehow I made it into the bathroom in time. I didn't know what was going on. All I know is the first time I ever got drunk, I got sick as a dog. We'd just eaten a big dinner, and I hit everything except the commode. The host's wife was such a kind lady, and I felt so bad about the mess I'd made. She started cleaning it up while I stood there feeling terrible. She didn't get angry or scold me, she just felt sorry for me, and that almost made it worse. "Sweetie," she said. "You probably shouldn't drink that stuff."

The upshot was that Roy Lee was drunk the whole next day. We had a show that night, and boy was Ralph upset with him. By the time we went on stage, Roy Lee could sing and play all right, but any musician could have heard he wasn't up to his usual standards. And definitely not up to Ralph Stanley's. As far as me and Keith, Ralph didn't say a word to us about what happened with the whiskey. 'Course, Ralph knew it wouldn't have done much good to lecture me. He saw how bad I felt. I was so ashamed of myself. I kept thinking of the man's sweet wife having to wipe up my mess in the bathroom. The thing was, I was so young and dumb, I didn't learn my lesson. The second time was even worse.

I never did tell my mother about what happened when I drank whiskey. It was something I kept to myself. Twice drunk and twice dumb was enough for me. To this day, there's no way I can drink whiskey. Can't even stand the smell of it. Thanks, Mom! And, thanks God!

I learned a little about pride around this time, too. I know pride can cause you to make some bad decisions. I know my dad had some mountain pride, and it got him in some trouble, too, the first and last time I ever saw him drunk. This happened one New Year's Eve, before Keith and I joined Ralph's band. He invited us to join him

that night for a show at the Country Palace in Columbus, Ohio. This was a much bigger venue than the Astro Inn. You could get three hundred people in the Palace, and that night they had a full house.

On the drive up, we did our usual rehearsing in the backseat while Dad took the wheel; he was as gung-ho as we were. Jimmy Martin was headlining the show that night, and Dad was a longtime fan, especially after Jimmy left Monroe and went solo with his own band, the Sunny Mountain Boys. When we got there, it turned out that Jimmy needed a mandolin player who could sing tenor with him, and he'd heard about me. "Ralph," he said. "Do you mind if this boy sings with me on my show?" Then Jimmy shot a look at me; he had a reputation as a perfectionist who was tough on his band. "Son," he said. "Do you know some of my songs?"

So now I was on the spot. Truth was, I didn't know *any* Jimmy Martin songs, not well enough to play 'em on stage, anyhow. I liked Jimmy's music fine, but I just didn't know any of his songs. I sort of looked pleadingly at Ralph to rescue me, but he misunderstood my worried expression.

"If you want to sing with Jimmy tonight, that's all right," said Ralph. "I don't mind you helping him out." I could sense that Ralph wanted me to give it a try, because he really loved Jimmy. A lot of people didn't like Jimmy, since he was known to talk big, but Ralph saw through that. They had a bond, maybe because they were so different in temperament. I felt like I was helping Ralph by helping Jimmy, so I said I'd do my best.

Now I had to learn a bunch of Jimmy Martin songs in time for his evening show, and all this before I went on stage with Ralph for his first set. Jimmy started running over the material with me right there. He was a great rhythm guitar player, so he was able to show me the arrangements, and I got those down quick. It was learning the lyrics I was worried about.

I learned a few songs, the choruses at least. It was when I went on stage with Ralph that the trouble started. Not with the music, but in the audience. There was a guy there that night that Dad knew grow-

ing up in eastern Kentucky. His name was Whipple Ferguson. He was a distant cousin of my dad's mom. Well, this Whipple Ferguson, he lived in Columbus now. He was a short little smart aleck, and he'd seen me and Dad come into the club.

Near the tail end of the first set I played with Ralph, Whipple walked over to my dad's table and sat down, and they caught up on old times like anybody does. He pointed his finger at me, and then he got right in Dad's face. "I wish to God Ricky would learn how to stand on stage," he said. "Just look up there at him! He's just standing there like an old country stick!"

Whipple was a little ornery cuss with a big ol' chip on his shoulder. He'd been drinking, and it made him feel bold enough to mouth off to my dad, I guess. About the only thing that could make Dad upset was if someone tried to put down his family, especially one of his kids. It was too much to take. My dad's pride wouldn't let him sit back and stay quiet.

Whipple had pushed him too far, and Dad lost it. He stood right up and yelled, "Damn you, Whipple Ferguson! I'll tell you one thing! He'll be standing there when you're long gone!" Dad hadn't been drinking; he wasn't one to drink, after all. But it aggravated him so much that this sassy cousin he hadn't seen in years would go after his son.

There was a half-hour break in between shows, and I guess my dad wanted to calm himself down a little bit. He headed to the bar and got himself a Pabst Blue Ribbon or two.

I hadn't seen any of what happened with Whipple, but I knew something was up when I saw Dad standing right at the front of the stage, hollering through his cupped hands as if they were a bullhorn. "Jimmy, that's my boy up there! That boy singing with you!" I'd never seen him get rowdy in my whole life. I could tell he was tipsy, and I didn't know what to do. Dad then started shouting out requests from the Jimmy Martin songbook. "Hey, Jimmy! Why don't you sing that 'Tennessee, I Hear You Calling Me'!"

My dad was feeling no pain, and it was more comical than it was

threatening. Of course, Jimmy didn't know who my dad was. He must have figured he was just another customer who'd been over-served at the bar. He tried to calm him down as best he could. "Awwww right, sir, we'll get to that one a little later. Go back and sit down." For Dad to make such a scene in public was strange, but it was funny, too. He didn't talk about it after the show, and I didn't ask him.

Next day we were driving home to Kentucky, and that's when he started to tell me and Keith some of what happened. First off he wanted me to know how awful he felt for making a fool of himself in front of the crowd. He said he had some Blue Ribbon to steady his nerves and to keep from punching Whipple Ferguson in the nose. "I'm sorry, son. You know I'm not a drinker, but he made me so dang mad. I had to keep from hurting him somehow, so I walked straight to the bar. Well, I won't be doing that ever again. I'm sure sorry."

He said he felt sick, but not from the Pabst. He hadn't had enough for a hangover. What was gnawing at him was how bad he'd acted in front of me. He just felt rattled. The thing was, I didn't feel bad about what he'd done, and neither did Keith. When he finally gave us the whole story, we laughed about it so hard we just slid to the floor of the car.

We sure didn't feel like kids anymore our second summer with Ralph. By then we'd gotten a big raise and had cars of our own. Ralph hiked our pay to thirty dollars for Friday shows, and thirty-five dollars for Saturdays and Sundays, so we could make a hundred dollars for a three-day weekend of show dates. That was pretty good money for a couple of teenagers.

Now that I was making some more money, I bought myself my first car, a new Volkswagen Super Beetle. I remember going up to the auto dealership in Prestonsburg and picking it out. It was a nice bright yellow bug, like Herbie in the Disney movie *The Love Bug*. My dad cosigned for it. My first car, and boy, was it cool.

Not long after that, I wrecked it, and it was all my fault.

I was coming home from Virginia. I'd been on the road with

Ralph, and I was heading through Lawrence County back to Brushy Creek. It was one of those things that happens when you're young and impatient and not being careful. The closer I got to our house, the more I could smell my mom's fried chicken. So I was taking those curves between Louisa and Blaine a little faster than I should have.

About five miles from home, it started to rain. Not much, but enough to slick the asphalt road top. I had James Taylor's new album *Mud Slide Slim and the Blue Horizon* cranked up in the eight-track machine. I was coming down a hill, and I took the curve at the bottom too fast and started sliding. I tried to straighten it up, but ended up off the road and flipped over.

It was a pretty bad crash, and I had to climb out through the passenger door. Thank the Lord I wasn't hurt, but I was pretty shook up, and my new Bug was totaled. And you know what? The engine stopped running, but J.T. kept right on singing.

I think the accident weighed heavy on my mom. Not too long after, we were heading out to play at the bluegrass festival in Hugo, Oklahoma. I was getting ready to go, and Mom came in the kitchen and had me sit down there with her.

"Honey," she said. "I've had an awful dream. And I don't want you to go to Oklahoma with Ralph."

"Mama, I've got to go," I said. "I can't miss the show. Ralph's counting on me."

Then she started crying, begging me not to go.

"I had a dream that you all had a wreck on the highway and you were killed. If you go, you'll come back in a pine box. That's what I saw."

"Mama, it's just a bad dream. Don't you worry, I'll be careful."

Well, she wouldn't give it up. She was so sure of what she saw in the dream. She was crying and crying. I hadn't seen her so tore up before.

"Mama, do you really believe this?"

"Yes, I do," she said. "You know I don't get like this unless I really see something."

So I picked up the phone and called Ralph at his house. We were

supposed to meet at the bus in the afternoon. I had a two-and-a-half-hour drive to get to Coeburn.

"Ralph, I can't go to the show this weekend."

"You sick?"

"No, sir. My mom's had a really bad dream, and what she saw is that we had a wreck on the highway and I was killed. I think I'll be fine, but she's tore up over it. I'd better just stay here."

"Rick," he said. "When your mama has them dreams, you need to listen to them dreams and do what she says. That stuff's real."

Not too many boss men would have been so understanding. But Ralph was from the mountains, same as my mom, and he was validating her. He was raised up like she was, and he knew dreams like the dreams my mom had were a gift to see, and ain't nothing superstitious about it. The next weekend, Ralph and the band were back from Oklahoma, and we were headed to another date. We were going down the road, and I was talking to Roy Lee about the Oklahoma show. He said, "What's the reason you didn't come to Hugo with us?" Ralph hadn't said anything to the band about my mama and her dream.

"Well," I said. "My mom had a really bad dream about us going. Let me ask you a question—did you have any close calls on the road last weekend?"

"There was something happened, now that you mention it," Roy Lee said. "There was a big ol' box fell off a truck in the middle of the road, and man, we had to swerve like crazy to miss it."

In recent years, I was thinking about how Ralph handled that situation, how he respected my mom and her dream. And I got to thinking about a song he and Carter recorded in the '60s, one of the last records they made before Carter died. It was "Dream of a Miner's Child," in which a little girl has a bad dream and says, "Daddy, don't go to the mine." And he goes into the mine because he has to go to work to provide for his family, and he gets killed. The little girl had foreseen what would happen.

It takes a pure heart and a real humility and innocence to see that kind of stuff. My mom had it, and Ralph believed.

Chapter 10

NEW FRIENDS &
GOOD OL' BOYS

Hello, stranger, put your loving hand in mine.

You are a stranger, and you're a pal of mine.

—"Hello Stranger," by the Carter Family, 1937

Everybody talks about love at first sight. Well, there's also love at first sound. You don't hear about it as much, but it happens all the time. Especially with musicians.

Take A.P. Carter. He was a young fellow in the mountains of Virginia, out peddling fruit trees door to door. One day in 1914, A.P. stopped by a farmhouse and heard a beautiful voice ringing out. It was sixteen-year-old Sara Dougherty singing on the front porch. He fell in love with her singing, and later on, he fell in love with her. That was how the Carter Family got started.

Something like that happened to me, too. When I first met my girl, we were just about the same age as A.P and Sara. Only I was selling records instead of fruit trees, and she was from Texas instead of the next hollow over.

I was working with Ralph, and we were at a bluegrass festival in Kilgore, Texas. It was my first time in the Lone Star State. Part of my job as a Clinch Mountain Boy was selling records at the merchandise

table. It was the biggest responsibility me and Keith had on the road, and we went right to it after every show. Curly Ray set up his own record table nearby, because he didn't trust nobody else to sell his solo albums and souvenirs. Curly Ray was a born salesman, too, and he really loved hawking his stuff. Keith and I saw this job as a way to make a little extra money. We had to haul boxes of the old eight-track tapes and the LP albums with the heavy cardboard sleeves to the tables, and there were plenty to haul, 'cause Ralph was in the studio cutting records every chance we could get. Seemed like there was always a new Rebel release boxed up and ready to go whenever we hit the road. It kept the table busy.

At this festival, we had to park the bus way up in the woods, because there wasn't any place close to the stage. So after the show it was up and down the hill and back and forth to the table in the hot summer sun for me and Keith. I'd already taken off my stage clothes, hung 'em up in the bus, and put my jeans on. Let me tell you, it felt good to get out of those polyesters. There were some more record boxes to get to the table, but Keith still had to change his clothes and said he'd handle the last few loads.

I headed down to the record table ahead of him. I stopped for a minute, catching my breath and hoping for a breeze to cool me down. Through the woods, I could hear a band playing on the stage down the way. I recognized the song, one you didn't hear very often. It was "When the Golden Leaves Begin to Fall," a sad old Bill Monroe tune from the '50s.

I heard voices singing, sweet as angels, drifting through the stand of tall trees:

When the moon shines on the Blue Ridge Mountains,
And it seems I can hear my sweetheart call . . .

The sound gave me goose bumps. I set my boxes down and started following that sound, walking through the trees to get closer to the

stage. I started walking a little faster, and a little faster, until I was almost running.

I finally made it out of the woods to where I could get a good view. Up on the stage I saw this young girl about my age, playing guitar and singing. She was part of a family band, with her mom singing harmony, her sister on bass, and her dad on mandolin. I watched for a while. I wondered why I'd never seen this group before. It was the first time I'd ever heard girls singing and playing bluegrass music.

Then I realized I'd better get back and help Keith at the record table. I hustled back through the woods where I left my boxes, and by the time I made it, he was finishing setting up. All of sudden, two girls walked up to the table. I could see right away they were the same two girls I had just watched on stage. They were looking mighty fine in their stage dresses. The one with the lead voice came right up to me and said, "Hi, I'm Sharon White!" and the sister, the one on stand-up bass, went right up to Keith. "Hi, I'm Cheryl White," she said.

"We wanted to meet you guys," said Sharon. "Me and Cheryl saw y'all at the Bean Blossom Festival, and we said to each other, 'When they come to Texas, we're gonna go up and say hi.'"

"Well, I sure like your singing, too, Sharon," I said. "I heard you up on stage with your folks a while ago, and y'all really sounded great."

She had a great big smile. When she heard what I said, she blushed. I smiled right back, not knowing what else to say.

Sharon told us all about her family band, Buck White and the Down Home Folks. Buck, her dad, played mandolin and sang with her mom, Patty. She played guitar, and Cheryl played bass, and of course they all sang in simple, pure harmonies. They were from Texas but lived in Arkansas. She said they had just put their house up for sale in hopes of moving to Nashville. They really wanted to make a go of it in the music business.

Cheryl and Keith really hit it off. Keith was a better talker than me, and he was making her laugh. After just a few minutes, though, the girls looked at each other and said they had to get back to their

mom and dad. They promised they'd stop and see us at the next festival. And just like that they were gone.

Of course, back then, there was no way of keeping up with people you met on the road, no Facebook or Twitter or any of the stuff kids have today. So I took it upon myself to see that fair young lady again before we left the festival grounds.

I was looking for an excuse when I remembered the Monroe song that she and the family were singing when I first heard her voice. After the evening show, I walked over to their little campsite. I said my hellos to all the Whites, and then I asked Sharon if she could write down the lyrics to that song. I told her I needed the words so that me and Keith could learn it.

"Yeah, I can do that," she said, and there was that sweet smile again. She was just as innocent as could be. Years later, her mom and dad used to joke with me about it: "Ricky, you knew every word of that song, didn't you?" Honestly, I didn't know *all* of it . . . just the chorus.

It didn't matter much either way, 'cause my plan worked. Her mom fetched a piece of paper, and I watched Sharon write down the lyrics for "When the Golden Leaves Begin to Fall." She handed it to me, and I'd got what I came for. Now what? Sharon started telling me about living in Arkansas. Well, I didn't hardly know where Arkansas was. I just knew we drove through it on the way to Texas. I also knew it was a long way from eastern Kentucky. Thinking of the distance gave me a bad feeling. I didn't know when or where I'd ever see her again. Well, about four months later, we were back up in Bean Blossom, Indiana, for the fall festival in November. I didn't know it, but Sharon, Cheryl, and the Whites were there, too. When I saw Sharon, my heart sank.

She was with a fellow I knew, Jack Hicks. At that time, Jack was playing with Bill Monroe and the Blue Grass Boys. He was from Ashland, Kentucky, and he was a great banjo player. Come to find out Jack and Sharon were dating, and it was obvious they were serious about each other.

Jack and Sharon eventually did get married. Keith and Cheryl dated on and off for seven years, but they just couldn't decide how to make things work with both of their busy careers in music. So they finally broke it off.

I stayed in touch with the Whites. That day at the festival in Texas was the start of a long relationship with the family that has lasted more than forty years. The Whites have been the best friends I've ever had, and it's hard to know where to begin to try to tell you what they've meant to me personally and spiritually.

Traveling the road with Ralph was quite an adventure. When you're young and come from the sticks, everything seems exciting and new. Having us along made it seem more fresh for Ralph and all the guys in the band. They were well past forty, Ralph and Curly and bass player Jack Cooke were, and they'd already been on the road twenty-five years, so a lot of stuff was old hat to them. Not to me and Keith.

Just to pull into a festival was a thrill. Fans at the campgrounds would be waiting and watching for the bus with "Ralph Stanley and the Clinch Mountain Boys" painted in big letters on the side. They'd jump up from their lawn chairs, run over to greet us, and start waving and shouting as if they'd never seen anything like it before. It was a big deal to them, and for me and Keith, too.

For us, the festival circuit was new turf, and it was so fun seeing cities and towns we'd never been to or even heard of before. We got to meet people from all walks of life. The fans had such reverence for Ralph and the tradition he represented. Seeing the people from the northern part of the country respond so positively to the music of our mountains, well, it just made you feel part of something important. It could be a grind on the road, for sure, but we had a lot of good times, too. Most of the crazy stuff was on account of the jokesters we had on board—Keith and Curly Ray. They'd pull pranks to pass the time, which was part of the Stanley tradition from the early days with Carter. Back then, it was Carter and

George Shuffler doing the pranking. In our time, it was Keith pulling pranks on Curly.

By then, Ralph had bought another motor home that he converted into a camper. It had a couple of couches on each side, a couple of chairs with a little table where you could play cards, and a couple of captain's chairs up front. The camper was big enough that we all had just enough room to sit down and relax as we went down the road.

Keith was always seeing how much we could make Curly eat. Sad to say, but sometimes it was our main entertainment on the road. We had played some shows up in Ohio, and we were headed back home on Route 23. We weren't too far away, crossing from Kentucky into Virginia, where Ralph kept the camper in Coeburn. It was around lunchtime, and Curly started talking about how he'd sure like to have a good hot dog.

Ralph said, "Well, what kind you looking for, Ray?"

Curly said, "Maybe a foot-long."

"Well, how many of them foot-longs you think you could eat right now?"

"I'll bet you I could eat five foot-longs."

"Bet you couldn't," said Ralph.

Keith and I chimed in too. "I'll bet you twenty-five dollars you couldn't eat five foot-longs," I said. "Do you know that is five feet of hot dogs?"

Then Ralph, who started the whole thing, got behind Curly, and that sealed the deal. There was a hundred dollars riding on it.

We were passing through the mountains near Whitesburg, Kentucky, where there is a little place called the Four Way. At that time, it had a little drive-in stop with soft-serve ice cream and hamburgers and hot dogs. We parked the camper, went up to the window, and said we wanted to order five foot-long hot dogs. The man told us that they didn't sell foot-longs.

Keith said, "Then we want ten regular hot dogs, and we want chili and mustard and onions and relish—just blow it out!"

Curly said, "I can't eat ten hot dogs."

"Look," I explained to him. "A regular hot dog is six inches long, and a foot-long is just two regulars. You can do it."

Ralph egged him on, and Curly didn't want to disappoint Mr. Ralph Stanley, his boss man. Keith brings out two boxes of fully loaded hot dogs. We all sat around a picnic table to watch the show. Curly was already big by then. He got one down, then two, then three, four, and five. It was looking pretty good for him when he stopped to catch his breath.

Roy Lee started to put some pressure on. "All right, now, Curly, I ain't got all day to be sitting here. I gotta get home to see my kids."

"Yeah, Ray," said Ralph. "You need to go ahead and finish this on up."

Curly gets down number six, and with every bite slop is falling into the box. At this point we're not even worried about the money. This was better than going to the movies. Down goes number seven and number eight.

Curly was sweating pretty bad by now. "Ralph, I don't believe I can do ten of these things," he panted.

"Now, Ray, you don't want me to lose no money, do ya?" Ralph was right in the middle of it, just winding it up for all it was worth. He didn't care about that twenty-five dollars. He just wanted to see what would happen.

Roy Lee tightened the screws. "Ain't no way, Curly Ray, ain't no way!"

Jack chimed in; he and Curly were always at each other's throats when things got hot. "He's right, Curly, you can't do it."

"Shut up, Jack!" Curly barked. Seemed like Jack got Curly so mad it gave him the extra push he needed. Down went number nine, and by this point he was swallowing the thing whole without chewing. Curly inhaled number ten down in much the same way. That box of dogs was now just a bunch of crumbs, chili, and onions.

Keith then handed him a plastic fork and said, "Curly, you gotta finish this, too. Before we pay up, you're gonna eat this, too."

Curly said, "I can't."

"Well, the bet's off, then."

"Gimme that fork!"

And he just shoveled it in, cleaning out the box as best he could. But Keith was on him like a hawk. Finally, Keith took the box and emptied the rest all over Curly's face. Curly looked a mess, but he didn't care. He'd won the bet.

We got back in the camper and drove a while, and everybody was paying Curly. Ralph decided to stop at a liquor store. He said, "Ray, I think a couple big ol' tall boys will be a fine place for them dogs to lay in, don't you?"

Ray said, "Yeah, Ralph, it sure would!" Curly sucked down a can right quick, laughing and joking and counting out his money. He was celebrating big time. He'd won and done his boss man proud, too.

Meanwhile, we were driving through the mountains close by Pound, Virginia, coming down hard around those hairpin curves on Route 23. You can nearly see your taillights beside you it's so awful. Ralph was driving, taking the turns like they were nothing. Finally, near the bottom of the mountain, Ralph said we were low on gas and stopped at a station to fuel up. Now, at this point, for everybody but Curly Ray, the party was over. We were sore we'd lost the money, especially me and Keith. It was almost a whole day's work for us.

At the gas station, Curly was the first one out of the camper, and we didn't think about why he got off so quick. Ralph was fueling up, and back in those days, the gas attendant would come around to work the pump and wash the windshield. Ralph was in the driver's seat with the window open when the attendant poked his head in and said there was an emergency. "Ralph, it's one of your boys. You better come now and hurry! He's real sick! He's making an awful noise!"

We all jumped off the camper as fast as we could go and ran around the side of the gas station to the bathroom, where Curly was coming out. He was pale as a ghost, wiping his hangdog face, covered in sweat.

When we opened the bathroom door, it looked like a disaster zone. There were pieces of hot dog as long as your finger without a toothmark on 'em. It was a sight I've never seen before or since. You just can't make this stuff up!

Curly Ray didn't mind playing the fool, off stage or on. He liked to have his fun, but on the downside, he was misunderstood. A lot of people thought that Curly could only play Ralph's music, and that he had no real depth to him. But there was a lot more to Curly than that. He was a fantastic, talented musician, and he took his music seriously. Curly was deep, and he was versatile. He wasn't only an old-time, high-lonesome fiddler—that was just one of the roles he played with Ralph. He could play jazz and swing and a lot of different styles. He just didn't get the chance to show it all that often.

Curly's job was to fit into Ralph's sound. He played the way Ralph sang. He did the job he was hired for. He was willing to sacrifice himself for the greater glory of the band. Some musicians don't understand that.

Sometimes, though, he'd get the chance to shine on his own, like when they'd bring out all the fiddlers on stage for a big jam session to close down a festival. Head-to-head, there wasn't a fiddler around who could outdo him.

What I liked about Curly as a musician was the emotion he put into his playing. What I learned most from Curly wasn't so much technical. He was the type of musician who could only teach by example. If you asked him to show you something, he'd play it as many times as you wanted, but it would always be different than the time before. It was mountain-style fiddling, for sure, but it was hard to emulate, 'cause Curly played so much out of his heart and not his head. That was the lesson I took with me.

Being on the road with Curly Ray was an education in showmanship. Real showmanship is different than showing off; it's knowing your audience and loving your audience. It's a love that feeds on the connection between a performer and the people. Curly believed

music was about joy, and his job was to share that joy. He had a gift for knowing how to touch your heart and put a smile on your face, whether he was cutting up on stage or taking a fiddle break just as pretty as you please. I'd watch Curly work a crowd, and I'd say to myself, *I don't know how to do what he's doing, but I need to learn!*

I loved my time as a Clinch Mountain Boy. I loved working for Ralph. His knowledge of music and the feeling he put into it helped me grow as a musician, especially as a harmony singer. He helped me refine the tenor singing I'd grown up with. It was the best training I could have asked for.

But there's only one way to play Ralph's music, and that's Ralph's way. I wanted to try to branch out and do something more my own style. I got tired of playing the same mandolin break I had the night before. I wanted to try new things. So I started stretching out a little, and Ralph didn't mind as long as I stayed within the boundaries of his music. When you're as young as I was, you need limits to become a disciplined player. I wanted to push those limits. There were other factors, too. Ralph was paying what he could afford, but it wasn't much. Meals weren't cheap, and the thrill of riding the bus was getting old. I didn't have the stamina of the other seasoned players in the band. After a full week on the road, they'd be getting their second wind, and I'd be fried. I needed to rest and decide what my next move would be.

Two and a half years is a long time when you're still in your teens, and that's how long I'd been with the Clinch Mountain Boys. I called Ralph on the phone, sort of dreading how he'd react. I told him I needed a break. And he said, "Well, Rick, if you ever want to come back, you're welcome here any ol' time." I was so thankful that he understood. Ralph knew it wasn't personal. I felt like he gave me his blessing to try something new. And here's something interesting—it was years before Ralph hired another mandolin player.

I was looking for a paycheck and a more stable sort of life. I thought it was time to give that a shot, so I moved up to Manassas,

Virginia, in the suburbs of Washington, D.C., to be closer to my girl-friend and to work a regular job. We'd been thinking pretty strong about getting married, and everything sort of happened at once. It was a big change, and it felt right at the time.

So we set a date for the wedding. My new bride was a pretty mountain girl, Brenda Stanley. She was kin to Ralph. I met her at a campaign rally when Ralph was running for treasurer of Dickenson County. Ralph loved politics, and he'd decided to throw his hat in the ring. And why not? Roy Acuff had run for governor of Tennessee back in the '40s, and he almost won.

Brenda was out in the crowd when we were on stage singing for votes at one of Ralph's campaign stops, and she caught my eye. We talked afterward, and I liked her and she liked me. Ralph ended up losing the election, so I guess I did a lot better on the campaign trail than he did! Brenda and I started dating soon after, and for the next year, whenever I'd go down to Coeburn, I would stop in and see Brenda. We got serious pretty quick.

It happened as natural as could be. Brenda loved my folks, and they loved her. She came from a big family and was raised in the mountains around country people same as we were, so everybody got along great. Her dad, Oakley Stanley, was first or second cousin to Ralph and had been the sheriff in Dickenson County for a good while. Everybody knew and respected him.

I went and asked Oakley for his permission to marry Brenda. He said, "So you're the thief come here to steal away my baby girl!" 'Course, he was joshing, and he gave me his blessing and told me to take care of his daughter. He liked me, the whole family did, and I felt the same way about them. He wasn't a big music fan; he looked at my character and the kind of person I was, and I guess he was satis-fied with what he saw. I think he was glad that I wasn't some couch potato and that I'd been out working hard and making a living with my music for several years.

Our wedding was a small ceremony, just family and a few friends. We both thought we were ready. 'Course, you couldn't tell me I

wasn't ready. I was as headstrong as they come, and I was sure I was doing the right thing. My parents got married young, and they were still happy together. Why shouldn't it be the same for us? My dad, bless his heart, knew full well I wasn't ready for the responsibilities of marriage. He told me, "Son, you don't need to get married." And I said, "But Dad, I *want* to get married."

Not just get married, mind you, but work a regular job. Brenda had been staying with her sister in northern Virginia, and that's where we went to start our new life together. My new brother-in-law was working for Virginia Electric and Power Company, or VEPCO. He told me they were hiring. So I went down and put in an application. They called back in three days. I had the job.

When I told Dad the news, he was glad to hear it. He was proud of me for taking on new duties and obligations as a married man. He knew that working for VEPCO wasn't something I really liked or wanted to pursue as a profession, but it was necessary at that time. He respected that I was making a sacrifice. He never said anything negative like "Why are you quitting music?" I think he knew me well enough to realize it would just be a matter of time before I'd be back playing music again.

I heard Dad's words of caution about marriage, but I didn't really *listen*. I was probably too focused on trying to be a grown-up to take heed. Looking back now, I guess I pushed aside any doubts I may have had. I felt like I knew what I was doing, despite what Dad said about not rushing things. With eastern Kentucky in my rearview mirror, I really believed I'd prove him wrong.

I love you, Dad, I thought to myself, *but I know what's best for me.*

It wasn't the first time my Dad was right, and it wouldn't be the last.

Chapter 11

BLUEGRASS CAPITAL OF THE WORLD

In March 1974 a lengthy Washington Post *article was headlined "D.C. Is Also Nation's Bluegrass Capitol." . . . The entire region had long been a center for migrants from the eastern side of the southern Appalachians.
By the 1950s the children of Appalachian migrants were joining their parents in playing music once called old-time or hillbilly and now labeled by some as bluegrass.*

—Bluegrass: A History, by Neil V. Rosenberg

*About that time, the Country Gentlemen had Ricky Skaggs and Jerry Douglas in the band. There were all these young guys and you wondered,
"Where did they come from? How did they get so good?
How did they end up in D.C.?"*

—Folk musician Robin Williams

Some people go to Washington, D.C., to change the world. They go into politics and try to make their mark. I went up to Washington, D.C., 'cause I wanted to put some bread on the table. I ended up right

back doing what I loved, but it took a while to get back to music. At the time, I didn't even know if a career in music was an option. I'd put that dream on hold to punch a time clock at VEPCO. I worked in the basement boiler room of the power plant at Possum Point in Dumfries, Virginia, about a half hour south of D.C. Sometimes you have to start at the bottom. This job may not sound like much, but it was very important to me at the time. As a newly married man, steady employment gave me a sense of responsibility when I needed it.

The only problem was that I hated the job from day one, and it never did get any better. I had the worst rotating shifts, one week of 7 a.m. to 3 p.m., then a week of 3 p.m. to 11 p.m., and then the midnight shift, from 11 p.m. to 7 a.m. A week of this, a week of that, a week of the other—I could never get any regular sleep.

I wasn't getting to spend much time with Brenda, either. She was working a day job as a secretary for the Daughters of the American Revolution in D.C., so along with my crazy shifts, it seemed like we only got to see each other coming or going. It was a tough way to start a marriage.

The schedule did free me up for some music. Whenever I could get away from the power plant, I'd slip on up to D.C. and sit in with bands at bluegrass clubs like the Shamrock in Georgetown and the Red Fox in Bethesda. I could justify it to myself because I had my regular job at VEPCO.

After a while, there came a reckoning. Could I play music part-time to feed my soul and hold down a job to pay the bills? Some musicians in D.C. did just that. Well, I thought I could pull it off, too. I really gave it a try.

There was a catch, though. Most of the other part-timers enjoyed what they did for a living. And here I was a boiler-room operator, and not too good at it, either. I started to realize that in order to make that arrangement viable, you had to like your regular job and do it pretty darn well, too. Otherwise, you were gonna be miserable or eventually get fired. On the night shift, one of my main weekly duties was to clean the boiler out. Down in the basement was a huge turbine

boiler like something out of a science-fiction movie, with coils and pipes winding to the top. The water shot up in the boiler, and it'd get hotter and hotter as it went to the top, where the turbine moved so fast and so powerful you couldn't even see the steam. If there was ever a leak, you were supposed to hit the floor and crawl for your life, 'cause it'd just cut your head off like a laser.

The intense heat would cause some of the excess oil, called slag, to get all over the pipes and fall into the pool of water down at the bottom. Once a week, you had to flush all the nasty slag out. It was like mucking out a hog pen.

One night I had the pool drained and cleaned, and I turned the water jets on to fill it up again. It usually took about an hour, and after you were done you'd have to call upstairs so the system could be restarted. It should have been easy.

I had brought my banjo to work. There was a break room upstairs with lockers and a little lunch table. I was just sitting there practicing my Santford Kelly clawhammer to pass the time while the water filled back up in the boiler.

So there I was, relaxing in the break room, just playing and singing. You know how the labels warn you not to take certain medications while operating heavy machinery? Well, for me, music is a powerful medication, and I let the time get away from me.

It must have been an hour or so before a light bulb went on in my head and I realized what I'd forgot about. Talk about a shock. I hollered, "Oh, crap!" and jumped out of the chair like a scared rabbit. I threw my banjo into the locker and ran back down to the basement. It was too late.

There were fifty-gallon oil drums floating on a lake of water that covered the basement floor. Water had overflowed from the boiler bottom and was flooding the whole room. I had to hit the emergency switch, the last thing you want to do at a power plant. The supervisor rushed in and saw what a mess I'd made and was ready to kill me, 'cause all the equipment was getting wet. 'Course, I felt awful I'd let this happen.

My supervisor was the nicest boss you could have, too, and I had to see him standing knee-deep in water. I knew I'd let him down. He didn't fire me or raise a big stink. He knew as well as I did that the job wasn't for me, and that I was just biding my time.

Sometimes, it takes a big mess to push you to make a clean break. This was one of those times. After flooding the basement, I knew in my heart that God created me to be a musician, not a high-pressure boiler operator.

I was still pretty desperate, though, and that's when Bill Emerson came to the rescue. Out of the blue, Bill called me on the phone. He wanted to know if I could help out on fiddle for a big session the Country Gentlemen had in a few weeks. He said the Gents had just signed a contract with Vanguard Records, and they wanted to be a national act. They needed me for the first session with the label, scheduled in New York in a few weeks. I was ready. I told Bill I'd do anything they needed me to do. I had that weekend off, and I'd be ready to play for the studio date. I missed music so bad I was ready to join the Salvation Army Band. When I hung up the phone, I was fired up. Playing fiddle for the Country Gentlemen! Washington, D.C., was a hotbed for bluegrass in those days. It had a reputation as the "Bluegrass Capital of the World" because there were so many venues that catered to the bluegrass and country music crowd. It had been that way for years, after Southern migrants moved to D.C. and Baltimore for work during and after World War II.

To get ready for the studio sessions, I took my fiddle and sat in with the Gents at the Shamrock, where they had a regular gig. Right off, it felt great to be back doing what I loved. The Gents had never had a fiddler, so I was free to follow whatever style I wanted to play. I felt a new sense of purpose. The Gents would throw me a solo, and I'd just wing it. It worked! It was nothing fancy. I was playing a jumbled style based on my favorite fiddlers, Benny Martin, Santford Kelly, and Curly Ray Cline. I was mixing all those influences together to suit myself, and it fit the direction the Gents wanted to go in.

At the studio for the Vanguard session, I wasn't nervous, 'cause there wasn't any pressure. The Gents had also invited Mike Auldridge to play Dobro on the album, and he was as easy-going as they come and an awesome musician. I didn't have to worry about filling anybody's shoes, so I was able to add my own style to the mix. It was the first time I'd ever recorded with a band where it was so loose. The Gents told me, "Hey, man, just play what you feel. Just play what you hear. Don't worry about a thing!"

The Vanguard album was a landmark for the Gents, and it was good timing for me. After the session, they asked me to join the band. Brenda was happy for me when I told her about the offer. She knew I was gonna be a happier husband playing music again, and she loved bluegrass enough to know what an opportunity it was to be part of the Country Gentlemen. And I knew I wasn't cut out for anything else but music. The next day I gave my notice at VEPCO, and I never looked back. Ever since, I've made my living in the music business.

I didn't get to sing much with the Gents, though, and I missed it. They already had the vocal sound they wanted. So I was kinda stuck back there playing fiddle, but that was all right. I still had a lot of learning to do. Fiddle became my best friend again, and I realized how much I'd missed playing it.

This was another apprenticeship, but it was a different kind of education than I got with Ralph. Working for him was the best training ground to learn the fundamentals, a bachelor's degree from the Stanley School of mountain music. If the Clinch Mountain Boys were my college, then the time in Washington, D.C., with the Country Gentlemen was my graduate school. I was young and green, so it helped that the band was so encouraging. I heard later on that Charlie Waller wasn't too keen on hiring a fiddle player, and that Emerson and Doyle Lawson advocated on my behalf, and I appreciate what they did for me. Once I got on board, Charlie was a prince and a fine guy to work for. He was very complimentary about my ability, and he was nice to me right from the start.

Now, Charlie drank an awful lot, and everybody knew it. He never hid it, and it was just the way he was. I was always worried about him 'cause he put back so much vodka, his drink of choice. He drank pretty much throughout the day, but he always sang just fine. Sometimes, by the second show, he might have had a little more than he needed, but it didn't affect his job so far as I could tell.

And the drinking didn't affect his demeanor, at least not around me. Now, I've heard stories about Charlie being ornery. I think most people just didn't know him well enough. All I know is what I saw myself, and I'll tell you that I lived with Charlie Waller on the road and he was just as nice to me early in the morning at breakfast as he was after we finished the last set of the night.

It was a good time for me. I was able to pay my bills, and I was in a band playing at the top of its game. And the D.C. bluegrass scene was vibrant. Charlie even let me sit in with other bands when the opportunity struck.

N ot long after I joined the Country Gentlemen, the Shamrock gig dried up. The Gents had played that Georgetown bar regular for years. Too much of anything can get old. After a while, the sign above the stage, "Yes! We Have Cold Duck," don't seem funny anymore. It just seems lame.

So we were working more on the festival circuit, and a lot of the festivals were up north where the Gents had a big following, especially with the college crowd. We were at a gig at a club called the Lone Star Café in New York City when a local guy came up to me and said, "I've heard you with the guys, and I like your fiddle-playing a lot!" Well, this New York fella, Steven Price, he had a present for me. He later wrote a history of bluegrass called *Old as the Hills*, and he was one of those hardcore fans that made the bluegrass scene so exciting and fun in the '70s. "Here's some of the greatest music I've ever heard," he said. "And I think you're gonna love it, too."

He then handed me an album by Django Reinhardt. It was an RCA import compilation, a double-LP set with a heavy gatefold

sleeve featuring a caricature of Django, the great gypsy jazz guitarist. I took it home and wore out the grooves. When Django played, you could tell his heart was bigger than his guitar. Most of the songs on the record were with violinist Stéphane Grappelli, and together they were dynamite. These were their classic recordings from the '30s, "Ol' Man River," "Tiger Rag," and "I Got Rhythm," all these cool tunes were on there.

But it was more than just cool. It really *was* some of the greatest music I'd ever heard, and it blew my head off. I loved the rhythm, the tightness, and the interplay of a small combo. It was so dang lively. Here was this hot swing jazz from before my dad's time, and it was still fresh as the dew. It sounded a lot like bluegrass, and it amazed me that this was ten years before Bill Monroe had started the Blue Grass Boys! It had the same elements, the spontaneity and the improvisation, wide open and for the sheer fun of it. It was spur-of-the-moment stuff, and I was hooked.

Hearing Django and Grappelli was an oasis for me. Not that I was completely parched, but their music came into my life at a time when I was ready and primed for new and different sounds. That double album was like getting money from home without writing for it! A pure gift of a new musical world that I never even knew existed and yet totally connected with. If you keep your ears open, there's always something new to inspire you, even if it was recorded in a Paris nightclub in 1938. Thanks, Steven Price, for a gift that's never stopped giving!

It wasn't so much technique that I got from Django and Grappelli, it was the feeling of freedom I heard in their music. Like I told you, with the Gentlemen it wasn't so important that I play the melody. I could take off on my own and explore. But when you go off like that, you better know where you're going, or you're gonna get lost. Listening to Grappelli gave me new ideas more than new licks. He created a sound with his violin that captured my imagination. It was the classical touch with a jazz and blues feeling, and he made it swing. It gave me confidence to stretch out, and keep the melody in mind, too.

For the time being, I was still a picker and glad to get any odd jobs I could. In Washington, there was plenty of session work, and the Gents were happy to let me take the jobs when they came. Tony Rice came to town to cut a record called *California Autumn*, produced by John Starling. I sang harmony with Tony on that record and loved it. We sung like brothers, not the Stanley mountain-style thing, but just as magical.

Tony was progressive in his guitar picking, but he also loved the pre-war brother duets and the pre-bluegrass style of harmony. With Tony, we could cover new territory. We'd start out with Lester and Earl's "My Little Girl in Tennessee" and the duet songs of the Monroe Brothers, and then switch gears into Gordon Lightfoot or Hoagy Carmichael. With Tony's talent, it was all seamless, 'cause he made the transition seem natural and right. It was a ride that took in a lot of scenery, and I was right there with him. This was a new direction, just what I was looking for when I left Ralph.

The mountain music was part of me, but I didn't feel the need to flaunt it. I could pull it out whenever I wanted to use it. When it was called for, I was ready to oblige. Former Country Gentlemen cofounder John Duffey had a new group in Washington called the Seldom Scene. I sat in with them many memorable nights at the Red Fox Inn in Bethesda, Maryland, a suburb of D.C. John asked me to play fiddle for the *Old Train* album, the one with Linda Ronstadt on harmony vocals, and I was happy to help. They worked up a Monroe gospel song, "The Old Crossroads" from the mid-'40s and arranged it for full ensemble, with Linda adding just the right touch.

The old-time vibe was part of my DNA. I knew the vocabulary of the songs, especially the hymns. I knew how to pronounce the words the way you would back in the mountains, how to sing 'em, and how it all fit together. I was proud, and flattered, too, that the D.C. blue-grass crowd loved and respected the music tradition I was raised on. There was a real brotherhood of bluegrass in D.C., a real openness between the musicians, and I could thrive in that sort of sunshine.

We were all friends; there was enough work for everybody. I was a full-time employee for Charlie, and he didn't mind me playing gigs and sessions as long as it didn't interfere with my job with the Gentlemen. I never missed a show, and I was always there on time.

I n the spring of 1974, Roy Lee Centers was murdered by a jealous rival in Jackson, Kentucky, where his family came from and where he lived. He was twenty-nine, and he left behind a huge legacy in the Clinch Mountain Boys as one of the best pure bluegrass singers ever. Through the years, lots of folks have asked me about Roy Lee, wanting to know what kind of person he was. Not much to tell, really. Just a good ol' Kentucky boy. He was a fun guy to travel with, always cheerful and laughing. You know the type, happy-go-lucky and game for anything. Never had much, didn't expect much. Loved his kids and his wife and lived for music. Every show, he gave it the best he had. I liked Roy Lee a lot.

I went down to Jackson for the funeral, and I got to see Ralph and some of the Clinch Mountain Boys. Keith had moved back in with his folks in Sandy Hook but was itching to get back into music. We went to have lunch with Ralph, and he told us he needed a new lead singer to replace Roy Lee. He asked Keith to step in, and Keith went back with Ralph and stayed in the band the next four years. Well, that shot down any future Keith and I had together.

For years, Keith and I planned to put together our own band. It was something we had dreamed about when we were kids and talked about all through our years with Ralph, and it never did pan out. We came close one time, just after we'd both left Ralph and were trying to figure out what was next. We even rehearsed once at my dad's house, and it was magic. I was thinking it was a done deal and the only thing left to worry about was what to call the band.

Not long after, Keith up and decided to go with Jimmy Gaudreau and Jimmy Arnold and start the Country Store. I hadn't seen it coming, and it hurt. I had to face the fact that Keith had ideas about going his own direction, separate from me. There was no blow-up

or disagreement. I was just too blind to see that he wanted the same thing I did, which was to have his own band.

The thing was, Dad had foreseen the situation a long time before. He sized it up, but I was too stubborn to hear what he was saying. He said, "Now, Keith's gonna want his own band," and I said, "I don't think so, Daddy," and he said, "Yeah, he is. He's been thinking that away for a long time. He's a lead singer, and he's used to the spot-light."

Dad wasn't saying anything bad about Keith. He loved him. He was just telling me something I wasn't able to see for myself. Truth was, Keith really *had* been thinking and talking that way all along. I just wasn't listening.

To put it plain, I just wasn't as gung-ho to be a star as he was. Now, I was ambitious as all get-out, don't get me wrong. For me, though, it was somewhere further down the road and around the bend. It was something that could wait a while. But Keith wasn't willing to wait. After a while, we both knew our paths were better apart. Much as we'd been through since we first met in Ezel, we weren't Carter and Ralph. We knew we weren't blood brothers who stayed together, thick or thin. We decided we were gonna stay good friends and root for each other, but go our separate ways. We'd sing together when we saw each other and leave it at that. We weren't gonna be able to work together, but we were gonna love each other as brothers, same as always.

And that turned out to be all right, and we loved each other up till the day he died. And I still love him. I just couldn't help him. I don't think anybody could.

In the fall of 1974, I met an angel. A Fallen Angel, that is. It was one of those meetings that would change the course of my life.

In Washington, there were always all-night singings and guitar pulls going on somewhere. It was a tight-knit community, yet wel-coming to outsiders. These get-togethers were loads of fun, and you never knew who might drop by: bluegrass pickers and folk singers

and even rock and rollers playing hooky from their Marshall amps. A lot of people don't know that Jerry Garcia of the Grateful Dead started out playing banjo in a jug band and always liked to tell people his lifelong dream was to be a Blue Grass Boy!

One fall night Linda Ronstadt was in town playing the Cellar Door in Georgetown. John Starling of the Seldom Scene called and invited me over to his place in Arlington, across the Potomac from Washington. "Hey, Ricky," he said. "We're having a pickin' party. Bring your fiddle and mandolin and come on over to the house. It's gonna be a blast."

When I got there, I could tell right off this was a special night. There was Linda, who was gorgeous and already a big star. She was there with Lowell George, her boyfriend at the time. Lowell was singing for Little Feat then, and was digging into old Southern music. He was getting turned onto Monroe and Flatt & Scruggs and bluegrass. Linda was hungry for the old music, too, like a lot of the California rock and roll people.

Now there seemed to be a whole generation of city-bred kids learning about the country music I took for granted. They'd ask me to sing some old ones, and I'd dust off a few. I was starting to realize again just how precious and dear it was, the songbook I'd been taught.

Later that night, a friend of Linda's walked in. "Hey, Emmylou," everyone called out. I'd never met her. She was a long-haired, long-legged woman. She was so lanky, as skinny as a rail. She hunched over her guitar with her hair hanging down. She closed her eyes, and she was singing, *"One day a mother went to a prison."* I recognized the Louvin Brothers' "The Sweetest Gift," a song about a woman visiting her son in prison. Linda started singing on the chorus, and all of heaven started listening in. My God, it was one of those moments you never forget.

It was like everything stopped and time stood still. The room became deathly still, and Emmy's voice hung in the air. John Starling was playing guitar, and I was backing 'em up on mandolin, as quiet

as I could. I was thinking, *Man, I don't even want to play a solo. I don't want to touch this moment. It's just too sweet and too pure.* So I just tried to play behind these beautiful voices and stay out of the way.

I just remember how stunned I was at hearing this beautiful voice from someone I didn't know and had never even heard of. This beautiful stranger. This was my first introduction to Emmylou Harris. I found out she'd been a singer with Gram Parsons and his country-rock group the Fallen Angels. Gram had died of a drug overdose, and now she was starting a solo career. We became buddies. A few months later, Emmylou offered me a job playing fiddle with her Hot Band. It was a great offer, and I was tempted, but I had to turn her down. Emmy already had Rodney Crowell singing harmony with her, and I knew if I wasn't singing, I wouldn't be happy.

I'd made an inner vow that I wasn't gonna ever work again in a band where I couldn't sing. I didn't want to let my chops go to waste. I wanted to sing! The Gents were doing fine popularity-wise, and we were playing adventurous music. But the festival circuit was wearing me down again, and my role wasn't developing the way I wanted. I needed room to stretch out, and not just on the bus between shows.

So when J.D. Crowe called and said he had an opening in his group, the New South, for a mandolin player and harmony singer, I was already chomping at the bit. The New South was based in Lexington, Kentucky, and had earned a reputation as one of the most exciting bluegrass bands in the country. It was an offer I couldn't refuse. I was back to my first love, the mandolin, and I could sing my heart out, too. I was ready to go in another direction. It was that long hunter thing again, I guess. Back to ol' Kentucky, go out and explore with some young guns, try something new.

Chapter 12

NEW SOUTH

*In 1975 Rounder established itself as a label with outstanding contemporary
bluegrass when it released "J.D. Crowe and the New South," one of the most
influential bluegrass albums of the decade. . . . In Crowe's band Skaggs began
building his reputation as a spectacular singer and entertainer as well as an
instrumentalist.*

—*Bluegrass: A History,* by Neil V. Rosenberg

I knew when I came to Lexington to work for J.D. Crowe that I
was gonna have to get me a major-league mandolin. Every man in
that band had him a big gun. Tony Rice had the big ol' D-28 Martin
guitar that the late, great Clarence White once owned. J.D. had a
Gibson Mastertone RB-75 banjo that could knock down trees. I had
to have a good, loud mandolin that would measure up. It had to be,
as the young kids say, legit.

I had a great job. Now I needed a great instrument. I'd been
dreaming about a certain mandolin, one that I'd fallen in love with
a few years back. All I had to do now was find it. It wasn't gonna be
easy, but I was determined to track it down and hopefully make it
mine.

When I was on the road with Ralph, we played a lot in the Detroit
area around Port Huron. One day this local guy came to see us before
the show. He was an old friend of Ralph's from the early years with

Carter. He played a little bluegrass himself, just fooling around, and he brought in his old Gibson mandolin. He noticed I was eyeballing it, and he said, "Son, you want to play a *good* mandolin?" I told him I sure would, and he handed it over to me.

It was a 1924 F-5 Lloyd Loar. There was no finish on it, except on the headstock. The rest of the body was all sanded down or stripped off. And the neck had been cut down so much you could see the truss rod, so thin it was almost like a fiddle neck. You may be thinking, that's a beat-up old mandolin, ain't it? Well, for me it was love at first sight. I loved the way it felt, I loved the way it played. I loved the way it sounded. It was major-league. Legit!

The mandolin I had at the time was a little round-hole model, an A-5 Florentine mandolin. It didn't have any bark. Like I told you a while back, Keith gave it the nickname the Red Bomb as a joke, and it was a bomb all right. I didn't like it, but it was all I could afford at the time.

I wanted a mandolin as loud and ornery as the F-5s that Bill Monroe and Pee Wee Lambert had. Every time we'd go to Detroit, I'd get to spend a few precious hours with this guy's F-5 Loar on stage, and it always sounded killer. It fit me so well, too, 'cause I was playing twin fiddle then with Curly Ray Cline on some songs, and when I'd get back on mandolin, my fingering wasn't off, 'cause that Loar's neck was nearly as small around as a fiddle's. And that made it easy to switch back and forth on the instruments all night long.

After every show, the guy would take that mandolin back home with him. Ralph knew how bad I wanted it, and he tried to convince his ol' buddy to make a deal. Ralph even said he was willing to come up with the money to help me get it. It was always the same answer. "I don't want to sell it," he'd say. "I'm gonna just hang onto it."

There was no convincing him, but I wanted a way I could contact the guy if he ever changed his mind, so I finally got his business card, wrote "1924 Lloyd Loar" next to his name, and stuck the card in my wallet. Always hoping one day he'd change his mind.

Like I said, I used to dream about the mandolin, and I wasn't

kidding you. It may sound crazy, but I'd have dreams where I'd see myself playing this Loar. Recently, I saw an old black-and-white photo somebody posted on the Internet: It's Keith and Jack Cooke and me on stage with Ralph in Port Huron, and there I am, picking a tune on that guy's Loar and looking happy as a pig in mud.

After I got to Lexington to start with J.D., I knew the Red Bomb wasn't up to the job, so I borrowed a mandolin to have a decent instrument until I found my own. One day not long after Brenda and I had moved into our new place, I was going through some boxes and found my old wallet from the Ralph days. I rifled through it and *bingo*! I found this guy's card. It was wrinkled and worn out, and his name and phone number were barely legible next to my hand-scrawled note. Straightaway I got on the phone and called the number on the card. A gruff voice answered, and lo and behold, it was him. My heart was racing and I was rattled, but I tried to keep my voice steady and calm. "Hey, this is Ricky Skaggs," I said. "Do you remember me? I used to play with Ralph a few years ago."

"Yeah, I remember you."

"Well, I just moved to Kentucky, and I've taken a job with J.D. Crowe."

"I love ol' J.D!" the guy said. "How in the hell's he doing?"

J.D. was probably the only bluegrass musician more popular in the Detroit area than Ralph Stanley. He'd broken onto the scene with Jimmy Martin's band as a redheaded teenager with a hot banjo in the 1950s.

"J.D.'s doing real good," I said. "But the reason I'm calling is I need a mandolin real bad. I'm just wondering if you'd be willing to sell that ol' Loar. I sure would like to have it."

I knew he could probably hear how desperate I sounded over the phone, and that ain't exactly the best way to try to negotiate. But I didn't care. I *was* desperate, and he was the only man who could help me. I guess I caught him in a moment of weakness. Maybe he was hard up for cash, 'cause this time he seemed willing to make a deal.

"Well, I might," he said. "What can you offer me for it?"

That threw me off a little. I was expecting him to make an offer. "I don't even know what it's worth" I said. "All the finish is worn off, the neck's been cut down, and I'd have to pay extra just to get it up and going. But if you know a price—"

"I won't take nothing less than twenty-two hundred and fifty dollars for it."

"That's a lot of money for me," I said. "I'm making five hundred dollars a week. Let me see if I can get some cash together."

Well, this was the only Lloyd Loar mandolin I knew about that was up for sale. There just weren't a lot of old classic Loars floating around then that people were willing to part with. Monroe had made 'em the most prized mandolins in creation. And when people got ahold of one, they wanted to keep 'em forever, just like this guy. Up till now.

One thing was for sure. I could tell this guy wasn't going to budge on the price. Usually I'd have tried to haggle, which is how you make a deal when you're from eastern Kentucky. Not this time. Not with this guy. I wasn't sure why $2,250 was the magic number for him, and I didn't really care. My money supply was low, but my hopes were high. Seemed like the offer was serious, so I called John Paganoni, a friend in northern Virginia I knew from my time in the Washington bluegrass scene. He had one of those real top-secret, can't-tell-nobody kinds of jobs working for the federal government. But besides his day job, John was one of the finest luthiers around, and he specialized in mandolins. If anybody could help, it was John.

I explained all about this beautiful old Loar and the work it needed. It called for his touch. The idea was to spiff it up a little and highlight its fine pedigree, not give it a full makeover. A thin coat of finish was all I needed. He said he'd do it for $250, which was a bargain.

So now the total price was up to $2,500, and I didn't have a dime to spare. I went to my friend Hugh Sturgill, who was close with J.D. at the time, and I told him how bad I needed this Loar. I asked him if he could help me get a loan. Hugh said he'd do his best.

We went to the bank, and it didn't start out too good. I told the bank manager what I needed the money for, and he just about laughed in my face. "You're going to pay $2,500 for a mandolin? What's it made of—gold?"

"No, sir," I said. "It's wood and steel. And it feels great in my hands and it sounds great, too. I've got a new job in a great bluegrass band and I gotta have a great instrument and this old mandolin is what I need."

And I told him the story of Lloyd Loar and his legendary mandolins, and how Bill Monroe had changed the course of American music with his famous F-5 Loar. None of it meant a thing to him. He looked me up and down, shook his head, and sort of grumbled, "I don't know how we're gonna sell an old mandolin if you can't make payments on this loan and we have to repossess it." He talked as if I was just wasting his time.

Well, this banker's harsh words and bad manners were offensive to me. To his way of thinking, I was just another no-account musician. In his world, musicians didn't have a good reputation for repaying loans, and there were plenty of pawnshops full of hocked instruments to prove his point. Good thing I had Hugh along. At that point, when it seemed like all bets were off, he told the banker, "Look, I'm gonna co-sign for Ricky, and it'll all work out just fine." Now, Hugh built houses for a living, and he was well respected in the community. He had a friend who was high up at the bank and was a bluegrass fan, so he called the friend over and explained everything. And the bluegrass banker said to the non-believing banker, "Let's take a chance on this guy. I think he's good for it, and Hugh says he'll co-sign. Let's make the loan."

So that bank finally lent me the $2,500, and I needed every daggone penny. In 1974 that was a lot of money to borrow. Especially for a mandolin. I phoned the guy in Detroit and told him I had the check for him. We set up a meeting to make the deal, and I wanted to get up north fast before he had a chance to change his mind. I hopped on a Delta flight out of Lexington, and I flew to Detroit.

I had already booked a return flight within an hour straight back home to Kentucky. It was gonna be just get it and get out.

This was back in the days when you could meet somebody off the street right there at the gate—you didn't have to go through security like nowadays—and that's what happened. I came through the arrival gate, and there the guy was, waiting for me, right on time, and he had the mandolin case tucked under his arm. His grown-up daughter was there with him, too, but I didn't pay much attention to her. I was too fixated on what was in that case.

I didn't remember the case being so banged-up. It looked like a truck had run over it. The black covering was stripped away. It was just a raw wood case all scuffed up, with two little latches, one of which was busted. The handle was gone, and there was a piece of leather wrapped around the hinges so you could carry it.

I sat down and started playing. Oh, God, yes. This full, rich tone came pouring out. It sounded even better than I remembered.

I set the precious Loar down. I smiled friendly-like and said in the style of a satisfied customer, "I'll take it—here you go!" I tried to hand the guy the check, but he wouldn't accept it. "I don't know," he said, sort of scratching his head, wheels turning. "Buddy, I've about decided I don't want to sell it. Tell you what I'll do. I'll pay the expenses for your trip back if we can just forget the whole deal."

Thinking back on it now, I probably shouldn't have played the mandolin at all. I think the sound of the Loar made the guy start having second thoughts.

"No, sir," I said. "I've gone through a real hard time to get a loan so I could buy this mandolin. We had a deal. You said you'd sell it. To me."

Just then, his daughter piped up. She hadn't said a word the whole time, but she couldn't hold her tongue anymore. "Daddy, you know what you promised Mama!" she said. "You told her that when you sold that ol' mandolin, you'd buy her a brand-new washer and dryer."

He gave her a look. "Yeah, I remember." He knew he'd been out-voted. He knew he'd lost the Loar, and there was no turning back.

"You know," he told me. "This is the finest mandolin I ever played."

"Yeah, it's a good one," I said, all the while closing it up in the case, tightening that leather strap real good, putting it under my arm, and just hugging it. The mandolin was mine. My dreams had come true.

There was nothing else to say. He took the check, and they walked away. Sure was glad I had a short layover back to Lexington. Soon as we got finished, the gate agent called the passengers for our flight, and not a bit too soon for me. When I got on the plane and put my mandolin in the overhead and took my seat, I looked out the window, and there he was down by the gate, watching me leave with his Loar. I even felt sorry for the guy.

It took a good long while for this Loar deal to go down. For the first few months I was in Lexington, I was playing a mandolin I had borrowed from Larry Rice, who'd just left the band. J.D. and the New South had a big following in Lexington. For years they were the house band at the Holiday Inn North, which was a little ways up Newtown Pike at the intersection of I-64 and I-75. J.D. was one of the first to take his bluegrass uptown for the college crowd, and he made that Holiday Inn gig so popular they gave it the nickname the Crowe's Nest.

The hotel had a bar called the Red Slipper Lounge, and we played there five nights a week, four shows a night. Décor-wise, the Red Slipper was a fancy place for bluegrass, especially considering the era we're talking about. It had chandeliers and mirrors and thick shag carpet and real waiters, the works. But true to the music, it was rowdy and noisy as could be. It wasn't really a place to get food unless you consider booze and bluegrass to be food groups, and I reckon a lot of the regulars did. They loved to drink and holler and they loved their bluegrass and they let you know it.

The Red Slipper was loud and smoky, and when I say smoky, I mean every fiber of your clothes would be saturated with stale cigarette smoke, right down to your socks. I'd come home at night after four hours of playing and try to pull my shirt off, and I got to where

I'd flinch, I'd just about upchuck my dinner, by the time the shirt got around my nose. The crowd was a mix of locals from Lexington, townies and college kids both, and people who drove in from miles away. There were students from the University of Kentucky; some of the Wildcat basketball players were bluegrass fans, and they'd come by after practice and catch the late show. We were packing the place most every night. I was twenty-one years old playing music I loved for a living, and I was having a ball. A new band, a new crowd, a new town: Everything was new and fresh, 'cept for my clothes at the end of the night.

The thing I liked most about working for J.D. and the New South was not only their musicianship, but their approach. They were doing traditional and progressive bluegrass, and they were doing 'em both justice. They weren't afraid to try all kinds of music. Didn't matter what style, as long as it felt right. They were taking songs by Gordon Lightfoot and Fats Domino and Guy Clark and Bob Dylan and turning 'em into bluegrass. Nothing was watered down or compromised. Tony was good at finding folk-type material that could be adapted to our style. The New South was all about exploring new territory, and that was just my speed.

J.D. was the oldest member of the band by close to twenty years, and he was the leader and headman, but he gave his musicians a lot of leeway. It was a democratic setup, really, where every man counted equal. There was a lot of camaraderie and competitive fire. We had a real team spirit on stage, same as those UK Wildcats had on the basketball court. This band had chemistry. You can't force a musical bond like that; it just happens. From the first mandolin chop, I felt a surety and a rock-solid foundation I'd never experienced before. With these guys, you always knew where the "one" beat was, no matter what the tune. You could set your watch to it. Timing is so important. Anybody can play fast; what matters is playing together. The Red Slipper Lounge was where we started to make a name for ourselves. People were calling us J.D.'s hottest band yet. We were building a reputation beyond the local bluegrass

nuts to folks from all over the region who came to see what all the fuss was about.

It was the first real taste of fan adulation I'd ever had, and it felt good. The fans loved our music and wanted us to know it. One way people showed their appreciation was to buy you a drink. This happened so often that if I'd drunk every drink people wanted to buy me, I'd a-been drunk as a skunk every night and passed out on the floor.

Well, by now you know I just wasn't a big drinker. I mean, I might drink something every now and then, but I was not a heavy drinker at all. Never was and still ain't. Especially when music's involved. For me, drinking and playing music don't mix. Being a lightweight has saved me from a lot of trouble through the years. In this case, it saved me some money when I needed it.

If you turned down a free drink, it was an insult in a place like the Red Slipper—at least it was in that day and age. Like you were putting on airs. I didn't want to offend folks who were only trying to be neighborly, so I came up with an arrangement.

What I did was make a deal with the bar girl. I told her, "Look, if someone wants to buy me a drink, you go ahead and charge 'em for a drink. Then just bring me a glass of seltzer water and stick a cherry in it to make it look like a Tom Collins." And that was how we did it. She'd bring me a seltzer, I'd smile a thank-you to whoever was buying 'em, and then I'd sip on however many of came my way. Nobody was the wiser, and everybody was happy. At the end of the night, I'd settle up with her. She'd give me the seventy-five or eighty dollars people had spent buying me drinks, and I'd give her a nice big tip. Sounds like eastern Kentucky to me!

One thing I didn't like was that it was my first job trying to emcee a show. I say "trying" because I never really got a handle on it. I'd never really emceed before in my life. But I figured, what better way to learn than four sets a night? J.D. wasn't a front man, and Tony had tried it but didn't like it much, either. I had to learn the hard way that there ain't nothing easy about it. I mean, Carter Stanley and Lester

Flatt and Porter Wagoner, these were the great front men of country music. They were the role models I had in my mind. But they were incredible entertainers, and Lord knows they made it look easy. As soon as they hit the stage, they could take the measure of a crowd, and they could talk into a microphone so casual you'd swear they were catching up on old times with a roomful of their best buddies. It took years of work before I felt natural in that job. But I grew into it, and nowadays I love it. With the New South, I just tried to learn from my mistakes.

Working four shows a night is a great way to hone your skills. Singing with J.D. and Tony was another education for me. These weren't typical bluegrass vocal arrangements; there were lots of different harmony structures. I had to learn songs like Gram Parsons's "Sin City" that featured a high lead with J.D. and Tony singing their vocal parts below me. It was something I hadn't done before, and I really had to stretch and try new things.

As for my mandolin playing, well, those shows at the Red Slipper helped me get my chops back, and when I came back from Detroit with my Lloyd Loar, I felt like a ball player with a Louisville slugger, finally ready for the big leagues. Turned out it was just in time, because we were getting ready to cut an album for Rounder Records. Rounder had asked J.D. for some instrumentals to showcase the band's picking skills, and he told 'em we had a batch of fresh songs we'd been working up on stage, a wide range of material that hadn't been done by a bluegrass band. Rounder gave J.D. the green light.

We did a lot of rehearsing at J.D.'s house, and then we went to Washington, D.C., to make the record. I knew the young Dobro player Jerry Douglas from our time together in the Country Gentlemen. He still played with the group, so he was in town. I told J.D. about Jerry and suggested he might be a good addition for the album. I was telling him how Jerry was taking his Dobro playing to new levels, and J.D. said, "Well, maybe a song or two." He didn't want too much Dobro, 'cause he was worried it might take the music in a direction he didn't want to go.

I called Jerry and told him we wanted him to help out on the record. He was stoked and came by the studio. He played on a couple songs, and his Dobro sounded so fresh and fit so well with the group that J.D. asked him to play on another couple, and Jerry ended up playing on nine of the eleven songs we recorded.

My F-5 Loar was ready for action, and I got to step out with a solo on "Old Home Place." I know for sure the Red Bomb would have bombed out! The album was a big success. Bluegrass fans took to it, and so did a lot of young musicians. Rounder didn't give it a title, so people got to calling it the "Old Home Place" record, or just "0044," for its label number on the record jacket. I think back on it now and realize how fortunate I was to be there at the right time and get to be a part of the record. It's really become landmark of bluegrass.

There was a controversy about the photo on the album cover, which showed J.D. poking his finger in Bobby Slone's ear. J.D. was pranking, but quite a few people thought it looked like he was flipping the bird with his middle finger. Bluegrass purists could be a prickly bunch, and it didn't take much to get their hackles up. They raised heck about it, so Rounder had to issue a new version of the album with a different cover.

Not long after the record was released, Jerry Douglas left the Country Gentlemen and joined up with the New South. His Dobro added the right touch to our sound, like the missing piece to a puzzle. With our new lineup, we started a regular engagement at another venue in Lexington, a new Sheraton Inn. They had a dinner room and lounge, and it was much bigger than the Red Slipper. The album was bringing in a lot of curious people who'd never cared much for bluegrass. We were attracting fans who came to our music from folk and rock and roll, too. J.D. and the New South was *new*, especially when word got around that we had this hot Dobro player.

When we hit the festival circuit in the spring of 1975, we caused quite a stir. A lot of purists and old-timers didn't take kindly to our style of bluegrass. They didn't hear enough old in the new.

It wrinkled a lot of feathers, but we didn't care about the naysayers. There was one man whose opinion did matter to me, though, and that was Ralph Stanley. When he pulled into the campgrounds, I'd tell J.D. and the boys, "I'll see y'all in a while. I gotta go pay my respects." I did this because I wanted to honor him and let him know I hadn't left the fold, no matter what some people might be saying. I'd brag on Ralph, and I'd try to praise him from the stage, too. I didn't care if it made him feel a little embarrassed. I didn't want to let him think his music didn't mean anything to me anymore just because I was playing a different kind of bluegrass now.

Ralph was never a big booster of progressive bluegrass or newgrass or whatever name they called it, and he didn't pretend to love what we were doing in the New South. But he never put me down, never lectured me. He told me that he'd always stay behind me just like I stayed behind him. He blessed me when I left his band, and he blessed me now.

Sometimes we'd see Bill Monroe at the festivals, too. He never said much at all about what he thought of the new groups. I heard he hated the word newgrass and didn't much like the musical sound of it, either. He tolerated us youngsters more than anything. By then, though, he was already moving into his role as the elder statesman of bluegrass. In those days, we all had shaggy long hair that hung down to our shoulders. Even J.D. had let his red hair grow. Mr. Monroe used to love pointing us out to folks and poking fun at us. "How about J.D. Crowe and his outfit," he'd say. "They look just like a herd of Shetland ponies, don't they?" You have to understand that Mr. Monroe still worked his farm with plow horses instead of tractors. Coming from him, that was a real compliment!

In August we went to Japan for a ten-day, eight-show tour, starting in Tokyo and traveling to some smaller towns. It was the first time I had been out of the country, ever. It was a real eye-opener, and an ear-opener. We played big concert halls, and they were packed everywhere we went. The crowds were louder than anything we'd ever heard, even louder than the drunks at the Red Slipper. In those days,

the Japanese were probably the most devoted bluegrass fans in the world. They were on fire for bluegrass. To them, it was more than music—it was almost like a religion. What impressed me was how many had taken up the music, and they played well, too. After one show, I had a kid come up to me, maybe eighteen years old, hair as long as mine. He didn't want an autograph. He wanted to pick. He had a little red, round-hole mandolin like my Red Bomb. This kid got right in my face and proceeded to play the whole daggone solo from "Katy Daly." He played every lick exactly like I had when I recorded it with Ralph. He had it down perfect. When he finished, he smiled real big. I acknowledged that he did a good job and smiled right back. It wasn't much use for me to try to speak Japanese, being a boy from eastern Kentucky who demolishes the English language to start with! Bluegrass broke through the language barrier. They understood my mandolin playing just fine, and that's all we needed to connect. It was another step in my journey discovering how music is a universal language.

During the tour, we got the news that Tony was turning in his notice. He was leaving the band to take a job with David Grisman, who was based in Marin County north of San Francisco. I was glad for Tony, because I knew David's music would stretch him in a fruitful direction, but I was sure gonna miss him. I'd enjoyed the past year and a half singing with Tony. His singing was different from Keith's, but we had a chemistry that was rare. He sang hard, and our voices blended so well together.

In my heart, musically, I would like to have stayed with J.D. a few more years. It was such a fertile creative environment, and I liked all the guys in the band. With Tony gone, though, J.D. had to find another lead singer and guitar player, and there was no guarantee it was gonna be somebody I'd enjoy working and singing with. It was something I didn't want to go through. It was J.D.'s band, not mine. I couldn't make those kind of decisions. That was up to him.

So I asked Jerry, "What are you thinking?" and he said, "Well, what are *you* thinking?" And I told him, "Well, you've known for a

while now that I want to put a band together. It feels like the right time to do it. Wanna give it a try with me?" He said yes. I was so glad, because Jerry and I had been in two bands together, and we'd become great friends, and I didn't want to lose that bond.

When we got back home from Japan, we told J.D. that we'd be leaving the band, too. J.D. wasn't sore at all, and he wished us the best. He knew when he hired me about my intentions of putting a band together. I didn't want it to be hard for J.D. to rebuild the New South, and it wasn't long till he found the guitar player and lead singer Glen Lawson, who did a great job. He also hired the talented mandolin player and tenor singer Jimmy Gaudreau, who'd been with the Country Gentlemen during my days with Ralph Stanley. J.D. decided not to find a new Dobro player at that time and just stay with a four-piece band.

I got busy making calls to put together a band and also started calling some promoters who just might book our new band. With Keith back in Ralph's band after the death of Roy Lee Centers, I knew he wouldn't be eager to start up a new group, so I called a guy named Wes Golding. Wes sang lead, played guitar, and was a good songwriter. I also called a friend I knew who played really good fiddle, Terry Baucom from Monroe, North Carolina. I had another friend, Marc Pruett, who was gonna play banjo, but at the last minute he decided to start a music store around Asheville, North Carolina.

Tough luck for us. I'd already started calling promoters for my band that didn't exist. Then Terry saved the day, saying he could play banjo good enough to get us started and until we could find someone permanent. We never looked for another banjo player. Terry just kept getting better and better, and he was our banjo man for our whole run.

We originally wanted an upright bass player, but the guy we tried to bring on board decided to stay with the band he was already in. It was hard asking people to move from another state and go to work with a band that had no track record. Some were coming in, some were backing out. Things got serious when Wes and Terry moved to

Lexington, where Jerry and I were living with our wives. We started rehearsing together, writing new songs, and working up old gospel quartets and fiery new instrumentals. We still didn't have a bass player, but now we had a name. We called our band Boone Creek after a little tributary that runs through the area near Lexington.

The phone started ringing from some of those promoters I'd called a few months before. They wanted to book us. We heard of a bass man named Fred Wooten working at a club in town. He played electric guitar and steel guitar. We thought that might come in handy in the future, but right now we needed a bass player, so we hired him. He'd never played bluegrass before, but we didn't care. He took to it pretty quick.

It was the right moment for a band like Boone Creek. Lexington had a diverse music scene well beyond bluegrass. It was a place and a time, a college town in the mid-'70s, where you could pursue any style that you wanted. Boone Creek started off with a bang. There was a youthful energy and a chemistry to what we were doing that just felt right. We landed a steady gig at the Sheraton Inn on I-75 south of town, Tuesday through Saturday. That was our bread and butter, pulling in about $2,500 a week. We were making a living. Of course, you had to slice it four ways, and then pay a bass player, too. It didn't go far, but we sure were having fun.

We booked show dates outside of town and tried to expand our fan base. We'd travel to Louisville and work for a week at bars like the Storefront and, our favorite, the Great Midwestern Music Hall. It was new territory, and we wanted to prove ourselves. Things were busy with the band, so busy that I almost missed the birth of Mandy, our first baby.

Brenda was due, so I had rescheduled a two-week tour of Canada that we had coming up, but the baby was late and the due date passed. The tour dates were set now, so me and the boys drove on up north of the border. We'd played two shows before I got the phone call saying Brenda was on the way to the hospital. I caught a flight back home to try to make it in time for the delivery, but our baby girl

wouldn't wait any longer. Amanda Jewell was born on November 5, 1977. I was back in Canada three days later to help the band finish the tour. It was really hard to leave her and Brenda. A musician's life sure ain't for everybody!

Having Mandy made me want to come home more, but with me doing most of the booking and business for the band, it was hard to find any free time when I wasn't playing a gig or practicing or planning for a gig. My being away so much was really starting to cause a rift between me and Brenda. I think I may have given too much time and attention to Boone Creek and not enough to my family, but I just wanted to do my best to make the band work, figuring that once that was going well, everything else would go well, too.

Thing was, those early days in the band were exciting. At first, we got some resistance for being different. We had electric bass, and we played a lot of new songs we'd written. We also had new arrangements for some of the old songs we played. The electric bass was a no-no for a lot of the purists, but it gave us a more progressive, cutting-edge sound. We'd get heckled on stage sometime, but the baiting gave us attitude. I'm not proud of some of the wisecracking I did back then about the bluegrass establishment, but I was just spreading my wings, I guess. It was part of growing up in the music with these towering figures. Sometimes they cast a shadow that smothered you and could stunt your growth.

We had good reason to be trying something new. We didn't want to sound like Ralph and Bill and Lester and Earl, 'cause they'd already done it, and done it the best it could be done. We wanted the freedom to paint whatever picture we wanted, and we just went for broke. Most of the crowd was with us, especially the younger kids who really dug it. We even had a young Vince Gill in the band for a while. He was the youngster of the group, barely eighteen years old, but he could already do it all! Hiring Vince worked out great, and not just because of his talent. He had a van, too, so he hauled the sound system and his instruments: electric guitar, pedal steel, electric bass, and fiddle. He could play just about anything with strings, and he sang like a bird.

* * *

Boone Creek was the perfect outlet for musical experimentation. I was young, so I can't say I had a clear vision of what we were supposed to be. I didn't have a specific sound in mind. It was a musical mesh of stuff that everybody in the band liked. It was swing and country and bluegrass and blazing instrumentals that featured Jerry's Dobro and Terry's banjo. But we always had a traditional side, as with our gospel quartets. It was a tradition we wanted to carry on, and our respect for it seemed to keep us in the good graces of the hardcore bluegrass purists.

Boone Creek's debut album was my first chance to produce a record, and that too was a learning experience. When we cut the old Stanley Brothers song "The Memory of Your Smile," we put piano and drums on the track. We felt like we needed to do it our way. We recorded at a studio in Lexington called Lemco. It was a big enough facility for bluegrass bands, but for the drums and piano parts, we decided to go to Nashville. We recorded some tracks at the old Starday studio on Dickerson Road, and it was a great place to experiment with different sounds.

That's what Boone Creek was, a valuable experience, but it didn't last very long. I needed to learn what it was like to have a partnership in a band where everybody was equal. Musically, there were lots of ideas and lots of different directions, and a lot of it was my own doing. Plus, we were working hard and not making much to show for it. I'd got to a place where I was running the roads and not even making what I was working the clubs in Lexington. I wanted more than that. I loved those guys dearly, and I still love 'em, but I felt like a change was coming.

Looking back now, I realize that my heart was changing, and I was slow to catch up. I knew I wasn't living right, not the way I should have been. I knew in my heart I needed to live right, to tell the truth. I got a big dose of truth when I went to see my Grandpa Thompson. He was ailing with terminal cancer, and I drove up to Columbus, Ohio, to check in and see how he was doing.

When I got there, it was plain to see he was dying, and he didn't try to hide it. We talked for a while about the old times we had to-

gether fishing and hunting and seeing the horses at the Darby Dan farm where he used to work as night watchman. Then he got real serious, and he said he wanted to say something to me before I headed back to Lexington.

"Pap's gonna die, and I won't be seeing you no more on this side," he said. "Now, I want you to promise me that you'll see me on the other side, and that you'll be there with me in heaven."

I couldn't say nothing. I just started crying.

"Now, son, don't worry. You know how to get there. You know that all you have to do is give your life to Jesus and trust in Him, 'cause He's the only way to heaven."

"I promise, Papaw," I said, trying to be brave as I could. "I promise you I'll see you in heaven."

"Now, son, this is serious. I'm not just jokin' or teasin'. Pap's serious about this."

"I know, Papaw, and I promise you, I'll be in heaven with you."

"Well, I'll be looking for you."

Then I hugged him, and he kissed me, and boy, it like to have killed me to have to leave him that day. I was sitting in the car and just bawling, and I turned on the engine and started backing out of the driveway. But before I hit the road, I put it in drive and went straight back. I ran in the house and hugged him one more time.

Driving back to Kentucky, I knew there was some heavy truth in what Pap had said to me. I'd been saved at thirteen, but I wasn't really growing as a Christian, and I think he knew that. He knew I needed to make a deeper commitment, and he was giving me a nudge. Papaw was right.

Later on I came to realize that Boone Creek had inspired a young generation of pickers and singers. Exciting bluegrass groups like Alison Krauss and Union Station, the Lonesome River Band, Blue Highway, and IIIrd Tyme Out. You just never know where your music will drop a seed.

Alison Krauss said she learned to sing harmony listening to our records. Now, Alison, she's a freak of nature, she really is. She woulda

been an awesome singer whether she heard Boone Creek or not. But it was nice of her to tell me.

Boone Creek was together for two years, and we made two albums that didn't sell all that well. But we had an underground influence, and it was something we could be proud of. Once again, I was moving on to new territory.

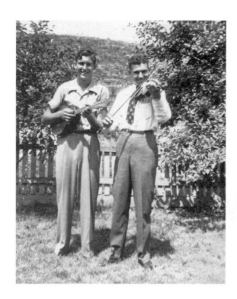

My great uncle Homer Skaggs playing the fiddle (right), and my uncle Okel Skaggs (left) playing the mandolin just a few months before he left for the war in 1941.

That's me having lunch, 1954.

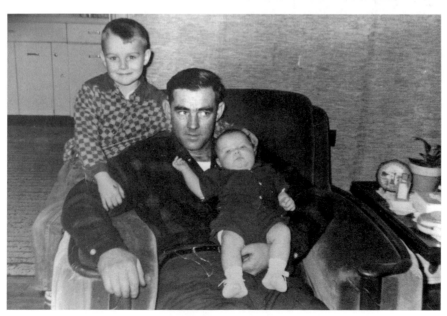

My dad and I are holding my baby brother Gary, 1959.

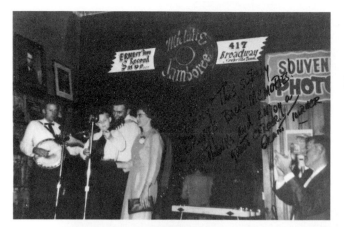

My very first appearance at the Ernest Tubb Record Shop in Nashville, Tennessee. I'm playing alongside my mom, dad, and Elmer Burchett, June 1961.

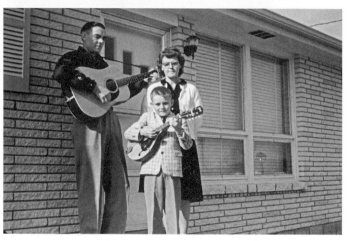

Playing my first Gibson mandolin with mom and dad on the front steps of our new home in Goodlettsville, Tennessee, Fall 1961.

My dad and I sang for our friends and neighbors at the Blaine High School in 1960. I was six years old. That same year I got to meet and play with my musical hero Bill Monroe.

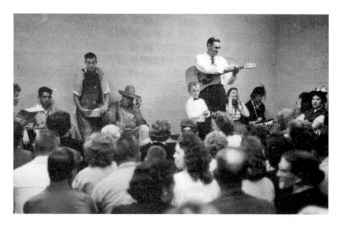

That's me holding my toy Kentucky flintlock rifle on the steps of Abraham Lincoln's birthplace in Hodgenville, Kentucky, 1961.

My high school picture from freshman year. I was thirteen years old, and it was the year I got saved, 1967.

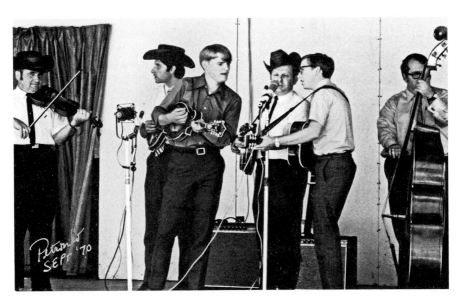

My first bluegrass festival with the legendary Ralph Stanley at Camp Springs, North Carolina, in 1970. My best friend Keith Whitley and I had both just turned sixteen.

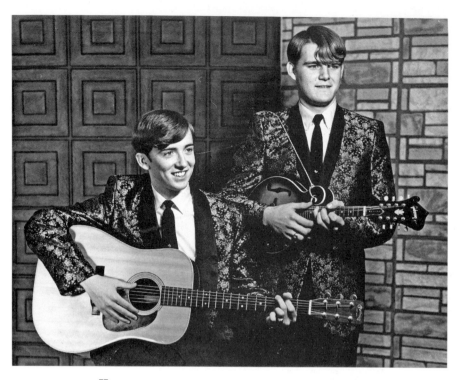

Keith and I sitting for our first publicity shot, 1970.

In the summer of 1971 Keith and I took our first
trip to Texas with the Clinch Mountain Boys. This
photo was taken on the day we met Sharon
and Cheryl White.

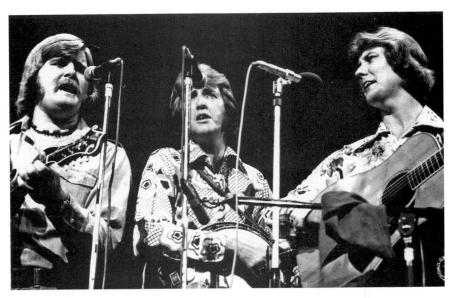

I joined the band The New South and played alongside J. D. Crowe and Tony Rice, 1975.

A year later I left The New South with bandmate Jerry Douglas to form Boone Creek. Clockwise, from top left: Tommy Hough, Jerry Douglas, me, Terry Baucom, and Wes Golding, 1976.

Holding my firstborn, my precious little baby girl Mandy, 1977.

My first solo
publicity shot,
1980.

Mom and dad were always such pillars of strength for me. They looked so
healthy and happy here at their home in 1981.

My first guest appearance at the Grand Ole Opry as a solo artist. My friends
Sharon and Cheryl White joined me for vocals and moral support, 1980.

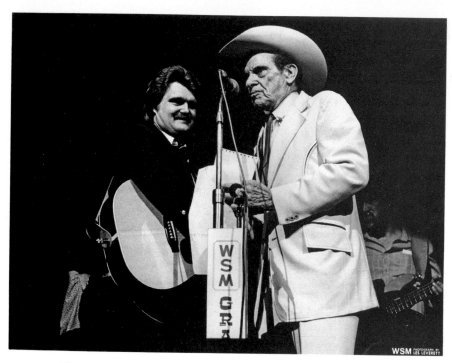

My old friend Ernest Tubb inducted me into the Grand Ole Opry
on May 15, 1982.

Here I am receiving my
award for CMA's Entertainer
of the Year, 1985. It was an
emotional night.

My brother Gary (left) and my brother Garold (right) and dad, always behind his three sons.

My friend Keith Whitley and me backstage in Knoxville, Tennessee, 1987. This was taken a few years before Keith tragically passed away on May 9, 1989. I still miss him!

Me and my beautiful wife, Sharon White Skaggs, in 1989. What a blessing she has been to me.

Sharon and my hero, the father of bluegrass music Bill Monroe, 1987.

Bill Monroe's music has inspired me all of my life. Here is a picture I took of him in 1970 at Frontier Ranch in Columbus, Ohio.

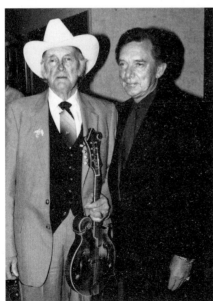

Bill with country music legend Ray Price, 1983.

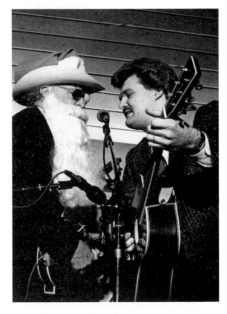

Bill, dressed as Santa, singing "Christmas Time's A Comin'" with me, 1988.

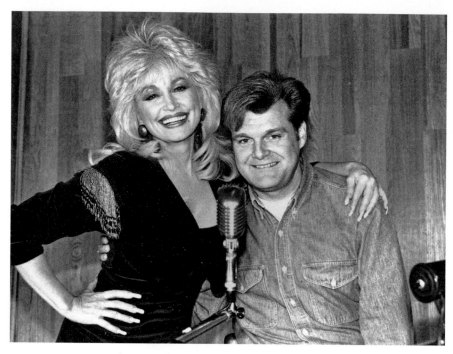

I had the pleasure of coproducing with Dolly Parton on her
album *White Limozeen*, 1988.

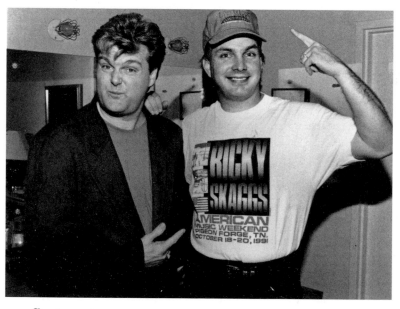

Garth Brooks helped Sharon and me with a benefit called "Teens
in Trouble" at Dollywood in Pigeon Forge, Tennessee, 1991.

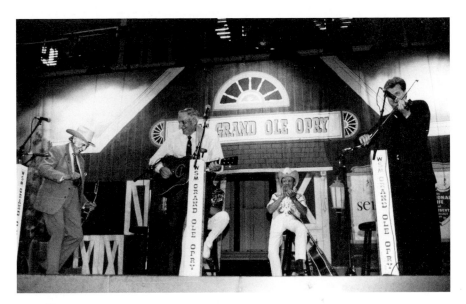

Before the Grand Ole Opry's Ryman Auditorium was renovated I got the chance to bring my dad up on stage with me. Left to right: Bill Monroe, Dad, announcer Keith Bilbrey, Little Jimmy Dickens, and me, 1993.

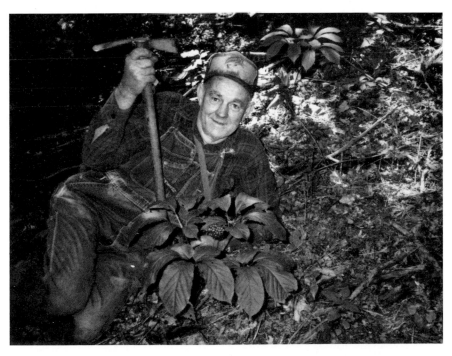

My dad hunted wild ginseng in the Kentucky woods his entire life, 1975.

I grew up in music with the help of my heroes. These men influenced my career in so many ways. Here I am with jazz violinist Stéphane Grappelli and mandolin great David Grisman in California, 1979.

Here I am with Gibson CEO Henry Juszkiewicz and my good friend banjo legend Earl Scruggs, 1987.

Me with banjo great Louis Marshall Jones, better known as Grandpa Jones, 1992.

Me and Marty Robbins goofing off backstage, 1982.

Billy Graham is a Christian above reproach. He's literally preached "The Good News" to millions around the world. Here we are at one of the many crusades where I had the honor to be a musical guest, 1995.

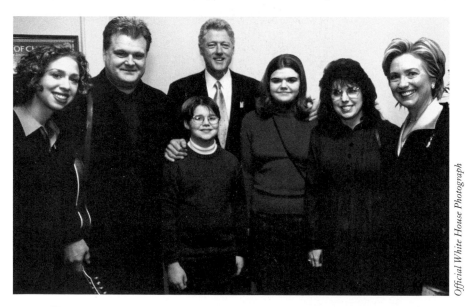

My family and I had the honor of meeting President Bill Clinton at the Library of Congress, where I did a solo concert on New Year's Eve, 1999. Left to right: Chelsea Clinton, me, Bill Clinton, Luke Skaggs, Molly Skaggs, Sharon White Skaggs, and Hillary Clinton.

Chapter 13

HOT BAND

I know dark clouds will gather 'round me,
I know my way is rough and steep,
Yet beauteous fields lie just before me,
where God's redeemed, their vigils keep.

—"Wayfaring Stranger," by Emmylou Harris, 1980

I learned an incredible amount from having
Ricky Skaggs in the band. We did a different kind of
harmony singing, and there were a lot more specific parts.

—Emmylou Harris, from *Will the Circle Be Unbroken: Country Music in America,*
edited by Paul Kingsbury and Alanna Nash

Right on cue, I got a phone call. It was Emmylou, and it sure was nice to hear her sweet voice. She told me Rodney Crowell was leaving her band, and I was number one on the call list for the job. She said I could sing Rodney's vocal parts and play mandolin and fiddle and guitar, and anything else I wanted. She was offering a full-time spot in the Hot Band. I told her I'd call her back in couple of days and give her an answer.

I needed some time to think about my position in Boone Creek. We were a unique band playing cool bluegrass our own way. These guys were creative musicians and some of my closest friends. I was doing most of the managerial duties, bookkeeping and making calls for show dates. The band depended on me.

With Emmylou, I knew I'd have a steady paycheck, which I didn't have in Boone Creek and wouldn't have in the foreseeable future. The Hot Band would offer me a chance to learn more about other types of music, and even more important, I'd have some financial security for my family. As hard as it was to leave Boone Creek, I felt I needed it to do it. So I called Emmy and took the job.

Next thing I knew, I was on a jet plane, going from Lexington to Los Angeles. I'd stay there a week or a few weeks at a time, and then I'd fly back home to see Brenda and Mandy. I never did move out to the West Coast. California's a fine place to live, but I sure was glad Emmy didn't require me to move out there. It was hard being away from the family. On July 25, 1979, not too long after I joined the Hot Band, our son Andrew was born. Now there were two cute little faces tugging at my heartstrings. We felt so blessed, and I also felt better prepared to provide for our children now that I had a steady job with a regular paycheck. They had a nice place in Lexington and a good mama there at home with them. I saw myself as the provider, and everything else came after that.

Mandy and Andrew were so young and cute and all, and I know they missed their daddy, same as I missed my dad when he was gone on his welding jobs. I wish I could have been around more, but I had a great opportunity and knew I'd made the right decision. Brenda tried to understand as best she could, and I know it wasn't easy for her. When you're a musician, you have to go where the gigs are. Probably neither of us reckoned I'd be gone for so long and stay so busy. It sure didn't help our marriage any.

I really was lucky to have Emmy for a boss. She was more like the coolest sister you could ever have. She remembered what I'd told her a few years before, when I said I wanted to be more than just a picker

in somebody's band. She helped me to spread my wings even further, and she hired me as much for my singing as for my picking. With Rodney gone, there was a hole in the band's harmony structure, and Emmy filled that hole with my mountain voice. My mandolin, fiddle, and guitar diversified the band's sound even more.

Singing wasn't gonna be a problem, but the picking had me worried. This was my first time working in an electric band. It was an area I hadn't really traipsed around in that much. I was grounded in acoustic music my whole life, so plugging in was a big leap. Emmy's guys were seasoned pros, the best around. They weren't called the Hot Band for nothing. To tell you the truth, I was a little fearful of jumping in the pool. I knew I had to swim well enough to keep my head above the waterline. Instead of worrying myself, though, I decided to let the circumstances guide me. It was time to plug in and learn something new.

A band is a team, and I wanted to be a good team player. There wasn't much time to get up to speed, either, 'cause Emmy was starting to cut tracks for the album *Blue Kentucky Girl*, her venture into a more rootsy, traditional country sound. Then we were doing some rehearsing and heading overseas for a European tour. Things were happening fast, and I had to jump in with both feet.

The late '70s was the disco era, and Los Angeles was ground zero for dance clubs and the partying nightlife. It was the fast lane for that crowd, but none of that stuff interested me at all. Still, there was a lot to like about Los Angeles. Everything you could ever want was at your fingertips. There were restaurants serving food from all over the world and at all hours of the night. I wasn't too adventurous, but I did love the Mexican restaurant that served enchiladas you could never have dreamed of in Kentucky. It was right around the corner from the hotel where I stayed whenever I was in L.A.

My commute was a breeze, and for Los Angeles, that's saying a lot. Every day I took a ten-minute drive from the Sportsmen's Lodge in Laurel Canyon to Emmylou's ranch house on Lania Lane, tucked in the woods of Coldwater Canyon. Emmy and Brian Ahern, her hus-

band and producer, had turned their rented home into a recording studio, and they worked on music every day. Their life was music, just like mine.

The recording console and control booth were in a mobile unit, which was actually a forty-foot-long semi parked in the driveway. It was called the Enactron Truck, and it was Brian's favorite place. He ran audio cables through the yard into the house, and he ran the sessions from the truck, headphones clamped on his big mop of curls, listening in to what we were playing and calling out to us from the soundboard like P.T. Barnum.

The truck was Brian's brainchild, and the control booth was his catbird's seat; his ears were all he needed to monitor the action in the studio. We'd do a lot of overdubs and background singing and vocal fixes in the truck, in a room at the far end he called the Comfort Zone. That's where I ended up spending a lot of time, trying to learn as much as I could about the producer's craft. I wanted to know how to make the best-sounding records, and I had the perfect teacher.

When it came to vintage audio equipment, Lania Lane was a heaven on earth. Brian had a microphone collection to die for: tube mics from the '40s and '50s made by Telefunken, Neumann, Schoeps, and PML. I was learning about compression and EQ, and which mic to use for vocals and which mic for what instrument. Neve, Lang, Langevin, Teletronix. He knew how to use all of it to the fullest. He didn't rely on studio gimmicks and shortcuts, and he took his time, a slow-food chef in a fast-food music industry. He cared about quality.

What I admired most was Brian's determination and dedication. It wasn't trendy to be making cutting-edge country records in L.A. He was a maverick outside the Nashville system. Even later, when he did move to Nashville, he brought his Enactron Truck with him. He never was embraced by the establishment as a "Nashville" producer, because he took more time making a record than most producers in this town. He couldn't change his stripes. Brian was more of an artist than an assembly-line guy. It was during those incredible nights on Lania Lane that I became a studio hound. Producing is

all about mixing the proper elements, and you have to experiment. Brian loved to create effects so he could capture on record a sound he had in his head: You can hear how adventurous he could get on "Beneath Still Waters," a number-one hit from *Blue Kentucky Girl* on which he made James Burton's electric guitar sound as if it were being strummed underwater. I was lucky to have Brian. When he was mixing, I'd stick my head in the control room and listen, pestering him with all kinds of questions about the technical stuff. It was astounding to see him work on a track from scratch, bringing out richer and deeper mixes. His rough mixes sounded better than some producers' final ones.

After a week or so of rehearsals and finishing the sessions for *Blue Kentucky Girl*, the Hot Band headed out for the European tour. The first leg was in Ireland, and we started in Dublin. It's a very friendly city, and some local musicians invited us to bring our instruments and join 'em at a ceili. That's Gaelic for a musical gathering. Sort of a Celtic jam session. I'd never heard of a ceili, which is pronounced "kay-lee," so I had no idea what to expect. When I walked into that place, I thought I'd died and gone to eastern Kentucky.

The ceili was held at a grand old house in downtown Dublin. It was organized by the Folk Music Society of Ireland; the name of the place was in Gaelic. It had a good-sized living room with the old plaster walls you'd see in Boston or New York. The room had a huge brick fireplace with a big roaring log fire, and it was crowded. It was wintertime, but inside this place it was as hot as the music they were playing.

The center of the action was an old man sitting in a big ol' armchair. He ran everything from his seat, calling for this or that song. He wore a suit and looked like he'd just come from church. He reminded me of my dad in the way he commanded respect—he was clearly the patriarch of the community, helping to preserve a traditional music that went back centuries. At this ceili, he introduced the evening's entertainment in his wonderful Irish accent.

He knew all the musicians and dancers and kept the music flowing, seguing from a fiddle tune to an accordion song or to something solemn with the bagpipes. Then he'd call out for a dance number, and a bunch of girls and boys would come leaping out of the crowd into the middle of the floor, and they'd dance up a storm. This was all new to me, and I just loved it.

What a feeling of belonging. I felt a kinship with these folks. Though I didn't know it at the time, many of my ancestors were indeed from Ireland.

I was amazed how familiar the songs were. I knew some by different titles, but the melodies were the same. Lord, I thought to myself, how Santford Kelly would have loved sitting in with these old Dublin fiddlers.

Before this night, I didn't know much about Irish music. But what I heard at the ceili was a revelation. Inside I felt the higher purpose of the trip. I was having a musical homecoming.

If nothing else happens on this whole tour, I said to myself, almost like a prayer, *it was worth it all to have been here at this ceili tonight.*

Everything about the ceili reminded me of my upbringing. There was a big spread of food and drinks. Women were busy in the other room cutting sandwiches and making tea and coffee, same as my mom did when we had picking parties on the weekends back in Kentucky. 'Course, mama didn't allow any alcohol in the house, but it was the same feeling of hospitality. I felt like I was at home on Brushy again.

A ceili is about much more than music. It's a way to preserve tradition and promote fellowship and keep the old ways alive. What stays with me the most from that night was when the old man sang an old ballad in Gaelic from his armchair. He didn't play any instruments that I know of, but Lord, he could sing. 'Course, I couldn't understand the lyrics, but his voice was so beautiful. It was so mournful and heartfelt, and I could hear the way it connected with the singers from our mountains, like Roscoe Holcomb and Ralph Stanley.

* * *

Traveling with Emmylou, I saw how the guys in the band made friends with technology. I was getting to watch Albert Lee play shows night after night, and I was amazed at the way he mastered any amplifier and any stage setup. His tone was in his hands. Didn't matter what he was playing through—it could be a small Princeton amp or a big ol' Fender Dual Showman Reverb, and his guitar would have the same gorgeous tone. The real magic wasn't in the gear; it was there in his right hand. Albert's got great-sounding hands. So do so many great musicians, including the legendary James Burton, who was lead guitarist in the Hot Band before Albert and still played on Emmy's records as session man. One time I asked Mr. Monroe why his mandolin sounded so good. He just stuck out his leathery farmer's hands with knotty calloused fingers and said, "These hands."

For me, the sheer volume of an electric show was definitely an issue, and a lot of it had to do with the size of the places we were playing. When playing larger venues, the instruments had to be plugged in to give them the volume they needed to be heard by the audience. This was all new to me, and to tell you the truth, I've never totally liked the sound of a banjo or a fiddle played through a pickup. Even thirty years later, technology hasn't made banjos and fiddles sound much better. I still use microphones; that's the best for a natural sound.

Something happened on the European tour that scared me half to death and also taught me a lesson. I had a routine with the road crew to handle the instrument changes I had to make. After I played a few songs on mandolin, a member of the crew would be there to take it from me and hand me a guitar, plugged in and ready to go. One night near the end of the tour, we had made the exchange and I happened to see, out of the corner of my eye, one roadie pitching my Loar F-5 mandolin to another. Luckily, he caught it and put it safely in the case, but I was less than happy.

When I saw that 1924 Loar flying through the air, all I could think was: *If that thing hits the ground, that's the end of it.* At that time, the mandolin was probably worth $7,500, but to me it was priceless.

I decided right then that there was no way I was going to carry this precious mandolin on the road anymore and take a chance on it getting broken or stolen. So I retired my Loar from touring.

I still have that mandolin, and I still play it from time to time. It's worth a lot more than $7,500 these days, but I'd never sell it. It'll always have a special place in my heart, like an old friend you've been through so much with and will never forget.

Emmy leaned on me for the traditional stuff, and I was happy to give her support. I was her go-to guy for the bluegrass and old-timey mountain music. Emmy wasn't just dabbling. She was serious, and I truly respected her devotion. She had an intuition for what suited her vocal style, and she knew a good song when she heard it. It's just that she didn't always know where to get the good old songs. After rehearsal and sound check, whenever we had time to kill, I'd sing country and bluegrass tunes I knew from childhood, ones that Emmylou had never heard, not even when she was singing with Gram. One she loved was "I'll Go Stepping Too" by Lester and Earl. Her bass player, Emory Gordy, was a huge bluegrass fan, and he'd usually jump in and help out. We always had a bluegrass warm-up to get ready for the show. It was a real growth period, and it led to a fruitful collaboration, the pair of traditional albums *Roses in the Snow* and *Light of the Stable*.

Emmylou and Brian had been itching to make a bonafide bluegrass record for a while. *Blue Kentucky Girl* was a critical and commercial success, earning Emmy two hit singles and a Grammy. It proved she could move closer to traditional country without sacrificing radio play and record sales. She and Brian had earned the right to do as they pleased. They wanted to wander further away from the mainstream with an acoustic record, with the material that fit that sound, and that meant bluegrass. With me in the band for a while and comfortable in my role, they figured now was the time. Emmy and Brian wanted me to help choose and arrange the songs. The idea was to highlight the stark beauty of bluegrass, the inter-

play of voices and instruments, and let Brian add his touches to give it a modern feel. Without the electric bass and drums, the rhythm section was anchored by Brian's giant Gibson Super 400 archtop guitar, and he focused on that aspect while I worked on the acoustic string-band arrangements, and got the right musicians for the job. First off, I brought in Tony Rice to handle lead-guitar chores on his Martin D-28 herringbone. I also wanted to bring in Jerry Douglas to play Dobro, which would replace the steel guitar sound that had been prominent on Emmylou's records. The White girls, Sharon and Cheryl, were already seasoned singers who'd worked with Emmy on *Blue Kentucky Girl*, so she asked them to add their skills on harmony.

Brian then invited a musician named Bryan Bowers to bring in his autoharp, giving us a touch of the Carter Family sound.

We'd rehearse three or four days to get the arrangements down, and then we'd go in and record. Next we'd listen to the track and make a laundry list of things we were gonna add or take out—the exact spot in the track we wanted to put a fiddle or a Dobro. Every detail was a big deal to us. We all knew this was going to be a very special record.

It was during these sessions that I got a nickname that's followed me around ever since. I was doing some overdubbing but wasn't satisfied with my performance. Emmy said, "Picky Ricky's at it again." It just sorta flew out of her mouth. Sharon and Cheryl were standing there, and they got to giggling. "Emmy, we've been thinking that for a long time!" So Emmy sort of coined the nickname that I'd unknowingly had for years. My dad probably wanted to call me that many a time out of frustration, but he never did.

During the sessions, Emmylou was pregnant with her daughter Meghann. As we recorded, she just kept getting bigger. Sometimes she'd stand up while she sang, and sometimes she'd have to sit and try to lay down vocal tracks that way. She never complained, and it can't have been easy. I really don't know how she got enough air to sing at full strength, but somehow she managed it. I've always said that I think *Roses in the Snow*, as well as *Light of the Stable*, features

some of the very best singing I've ever heard her do, and she's had some beautiful performances through the years. To this day, she's still a truly amazing singer.

There was one song I brought to Emmy that she really fell in love with. It was a Stanley Brothers gospel song, "The Darkest Hour Is Just Before Dawn," and she always asked me to sing it for her. It's one of Ralph's best sacred numbers, and we wanted to get some bluegrass hymns onto *Roses*. We were working up the song in the living room on Lania Lane, getting the vocal arrangement together, and Emmy asked, "Why don't you sing a verse?" That was the first time she featured my lead vocals on one of her songs, and my first lead vocal on a country record.

Working with Emmy got my name out beyond the bluegrass world, and for that, I'll always be grateful. It was amazing hearing my voice come through the speakers all alone. You have to remember, I'd been singing harmony all my life, even in Boone Creek. I was not a lead singer and didn't think of myself that way. Emmylou was introducing my voice to a new audience, and it was such a nice thing to do. When she was starting out, Gram Parsons invited her to sing solo on his records, "Return of the Grievous Angel" and "Love Hurts" to name a couple. He helped her step out, and she was giving me the same chance. It wasn't only me. Emmy was willing to let all of her musicians step out on a solo and try new things. Some bandleaders aren't as generous. She gave of herself when she didn't have to. The great bandleaders, from Duke Ellington to Bill Monroe, love to see their musicians shine and take a solo and inspire the rest of the band. They didn't want to hog the spotlight. They wanted to share it, and Emmylou did, too. Whenever we were introduced on stage, it was always "Emmylou Harris and the Hot Band."

Now, Emmy's record label wasn't as excited about the bluegrass records we were making as we were. When Emmylou took the tapes for *Roses* to the execs at Warner Bros., they turned up their noses and pressured her not to release it. She stuck to her guns and told 'em that she was passionate about this music and really felt it was the direction

she wanted to go. She was willing to put her career on the line. Luckily the label came around. *Roses in the Snow* went gold faster than any album of Emmylou's career.

Another nice thing about Emmy as a boss: She had no problem letting us pursue solo projects, as long as it didn't interfere with the Hot Band. So when I had some time off, I drove down to Nashville from Lexington and cut an album for an independent bluegrass label called Sugar Hill. Barry Poss was headman, and he rented out a basement studio called the Pond and hired Nashville pros like Buddy Emmons and Bobby Hicks, and I called on my buddies like Jerry Douglas and Albert Lee and Tony Rice and Marc Pruett, and we made *Sweet Temptation*. We cut the whole album in two days on a budget of ten thousand dollars, which for a small indie like Sugar Hill was a lot of money. But Barry had faith in me, and here was a chance to see what I could do on my own.

It was a freedom I'd never known in the studio, with no agenda other than to try to make a great record. Barry helped round up the musicians and let me go at it. I was only twenty-four, but I was ready to give it a fair shot. Brian Ahern showed me you could mix a bluegrass instrument like a mandolin as loud as an electric guitar if it was recorded properly. And I'd always felt that a lot of Flatt & Scruggs and Stanley Brothers songs were basically acoustic country. So I wanted to try to blend classic bluegrass and country, with the fiddle and mandolin working right alongside the drums and steel guitars, and some good ol' mountain harmony. I wanted to do my own versions of favorites by the Carter Family and the Stanleys. And Merle Travis. Buck White's piano added just the right touch of western swing for the Travis songs. I didn't know if it'd work or not, but I was gonna have fun trying.

What a baptism it was! I was finally getting the chance to cut Carter Stanley's "I'll Take the Blame" the way I'd heard it in my head, with Buddy's pedal steel guitar kicking the song off and leading the way. Radical for bluegrass purists' ears, maybe. But to me, the sound of Buddy's steel was exactly what you oughta hear when

you think "country." Emmylou was kind enough to sing harmony on another Stanley Brothers song, "Could You Love Me One More Time," and two other tracks. I couldn't believe that my boss even pitched in on my moonlighting project. But that was the camaraderie we all felt for each other. If only every album I've done since could have been as fun!

And the fun was only beginning. Sugar Hill released "I'll Take the Blame" as a single, and suddenly it was getting airplay. I'd made the record almost as an experiment, and come to find out, folks liked it. It was number one for six weeks in Houston, and then it became a local hit in Detroit and down in Orlando, Florida, too.

I had a few days of down time from Emmy's band, and I spent it at Brian's Enactron Truck studio recording tracks for my second Sugar Hill album. Right around then, Dolly Parton came through town, working on a project with Emmy and Linda Ronstadt. I met her at those sessions, and after a few minutes we felt more like family than some musicians I'd known for years.

Dolly and I shared the same kind of mountain upbringing and church background and Mom and Dad and brothers and sisters, and we loved the same kind of good ol' country cooking and, of course, the same kind of music. She said she loved to hear me sing 'cause it reminded her of her home back in the Smoky Mountains of east Tennessee.

I told her how much I loved her singing, too, and how when I was a kid me and my folks couldn't wait to see *The Porter Wagoner Show* on TV every week just to hear her sweet voice! I told her that I was working on my second record for Sugar Hill, and that it was gonna be real country with some ol' mountain bluegrass thrown in for good measure.

Then I got up my nerve, took a deep breath, and asked her if she'd sing harmony on a couple of songs I was working on. She immediately said she'd love to, and just to let her know when I was ready for her. I thought, *Lord Jesus, did she just say YES?* I couldn't hardly believe it. I thought, *Oh my God, Dolly Parton is gonna sing on my record!*

Then the thought came to me that maybe she had said yes just to save face, and that she really wouldn't do it. When it comes time to record, I was thinking, she'll say she's too busy. That's how the Devil works; he's always trying to steal your joy and make you believe things about people that just ain't true. But I really didn't know Dolly. She's a woman of integrity. If she tells you something, she means it. That's just how she is. A straight shooter. I've never known her to be any other way.

I wanted her to sing on a few Stanley Brothers songs. It turned out that she'd seen Carter and Ralph play a show at a little schoolhouse in Sevierville, Tennessee, when she was a girl, around the same time I had. It was so easy for her. She fell right into that ol' mountain stream of music she'd swum in many years ago, and she was lovin' it. This was the kind of music that was close to her heart, and Dolly is all about heart.

I'll never forget when we cut Carter's "A Vision of Mother," one of his most beautiful, almost mystical, songs. Dolly sang Pee Wee's high-trio part, and it came so natural she nailed it in no time. I remember she hit a note that she didn't mean to sing and wanted to fix it, but I loved it. It wasn't a wrong note; it was just something that came out that she wasn't planning to sing. I didn't want her to re-sing it or try to do it over. It came out of a deep place in her spirit, and I felt it, and I wanted the listener to feel it, too.

There I was, making a record with Dolly Parton and having the time of my life. I thought, *How stinking cool is this?* To be here and get to experience this. I felt extremely blessed. And you know, Dolly's spirit of generosity may have blessed the project in a whole other way I wasn't even aware of, 'cause things were about to get bigger than I'd ever imagined.

Some call it fate, or destiny, or a God thing. Some things really do seem like they were just Meant to Be. You think back and you wonder how different your life could have been if things had gone another way, if you'd walked down one street and not the other,

opened one door and not the other, taken one flight and not the other.

Well, I'm sure thankful for the day I took a flight from Los Angeles to Nashville. I got bumped up to first-class, and I settled into a seat with my Walkman. I had four or five songs on tape that I'd done for my second record for Sugar Hill. They were just unfinished masters, rough mixes that I wanted to keep fooling with. One was the Stanley Brothers' "Don't Cheat in Our Hometown," and another was a remake of the Webb Pierce song "Honey (Open That Door)."

Somehow I got to talking with the guy in the next seat. He turned out to be Jim Mazza, vice president of Capitol/EMI/United Artists in Los Angeles. He didn't know me from Adam, and I'd never heard of him, either, but we hit it off. I told him I played with Emmylou but was working on my own music and had some demos on my Walkman. He was a record man down to his bones, so he was open to new sounds. "Mind if I take a listen to some of your stuff?"

I gave him the headphones and cued up "Don't Cheat in Our Hometown." I think he liked it okay, but when he got to "Honey (Open That Door)" he was bopping in his seat, a big smile on his face. Here was one of the top dogs in the music business, and he looked like a groovin' teenager. He took off the headphones and went from silly to serious in a split second. He wanted to know who produced it.

"Well, I did."

"Son," he said. "This could get you a record deal."

I couldn't believe what I was hearing, but I kept listening, wondering, *Do I tell him I've already got a record deal with Sugar Hill?*

He asked if I was staying in Nashville. I was supposed to get back home to Lexington, but I told him I sure could be. So we scheduled a meeting for the next day on Music Row. That's the place in Nashville where all the major record labels and song publishing companies have their headquarters.

When I got to Capitol Records the next day, the top brass were in the office and ready to hear my songs. Jim introduced me to Lynn Schults, the head of Capitol in Nashville. He was as friendly as could be and knew a lot about country music. "Don't Cheat in Our Home-

town" was the first song played. I saw Lynn's eyes light up. Next was "Honey (Open that Door)." They all started bopping to the beat.

By the time a song called "Head over Heels in Love with You" started playing, everybody in the room was up dancing. This was too easy! Or so it seemed. They asked me if they could make a copy of the music and send it to the head of EMI. Their boss, Don Grierson, had to sign off on any new artist considered for Capitol or United Artist. I knew the music they were listening to belonged to Sugar Hill, but I kept on.

I said they could make a copy, and they sent it overnight to Mr. Grierson in Los Angeles. The fellows in Nashville told me to come back tomorrow. I was back in the Capitol office late in the afternoon the next day. Lynn was the only one there, and I thought, *This ain't a good sign.* "Ricky," he said. "I'm as frustrated as I can be. Grierson passed on your music. Said it's 'too country.' I think he's wrong. I can't do anything to sign you. But I've got an idea." He picked up the phone and said, "Hey, Rick, gotta few minutes to listen to a new artist? It's good, you'll like it. Okay, I'll send him down." Lynn told me where the CBS Records building was.

You know, I've often thought back on that day and how odd it was for the head of Capitol Records in Nashville to pick up the phone and call the head of CBS Records in Nashville. He basically gave away an artist to a rival. That sort of goodwill gesture would never happen today. It blows my mind. It was definitely a God thing. He closed one door and was about to open another. Lynn Schults played a huge part in my career, and I'll never forget what he did for me that afternoon. I was a total stranger, just a kid with a cassette.

Music Row is a small world. And it was a real small world thirty years ago. Everybody knew everybody, and every office was a stone's throw from the next. I went down the street, and fifteen minutes later I walked into Rick Blackburn's office. He was waiting for me.

Right from the start, I knew me and Rick were gonna get along fine. He was easy to talk to. We spoke the same language, and we loved the same things, especially when it came to music. He grew

up on a farm. Early in his career, he played in a rock-and-roll group called The Sounds that was signed to King Records, the legendary label out of Cincinnati where the Stanley Brothers and James Brown made so many classic recordings.

Now, Rick loved old country, but he had studied trends, too, the way tastes change with every generation. To his thinking, the *Urban Cowboy* craze had worn out its welcome. He figured things were just about to cycle back to the classic country he and I grew up with. He put on the tape, and we listened to "Don't Cheat in Our Hometown." He remembered the original by the Stanleys and liked what I'd done with it: polished off an old chestnut. He could tell I wasn't just a throwback or a revivalist. I was a carrier of an old tradition.

"That's a hit!" he said. "This can work. "

Then "Honey (Open That Door)" came on. This one really caught his attention.

"Oh, wow, that's a smash! It worked for Webb, and I think it could work for you, too. Who in the heck produced this stuff?"

"I did," I said. "And by the way, if we get serious about a deal, I want to produce my music."

Rick sorta winced, and I knew I'd hit a sore spot. He said that Larry Gatlin was the only artist at the label who produced his own records. "That's a tall order on your first album," he said. "I've got to think about that."

I didn't want it to be a deal-breaker. I just wanted him to know up front that it was important to me. "I know a lot more about Ricky Skaggs than anyone else here in town," I said. "If you like what you hear, I can do it again. I know my limitations and what I do best. I know what I can sing and what I can't sing. I don't want to sound like Nashville. I want to sound like me."

I told him I'd make a deal with him: If we didn't have any success with my first album, I'd be willing to take on a coproducer. "That's fair, ain't it?"

"Who owns this stuff?" he said.

"Sugar Hill does."

He'd never heard of Sugar Hill Records. I explained that it was an independent label out of North Carolina, that I had already recorded one album for them, and that what he was listening to was for the second release.

"Well, it's great stuff, and I want to sign you," he said. "You hungry?"

I wasn't sure if he meant hungry for a record deal or for lunch, and to tell the truth I was hungry for both.

"Sure, I'm always ready to eat!"

So we drove over to Ireland's, a restaurant nearby that had steak and biscuits. It was a popular meeting place on Music Row. Before I knew it, Rick was scribbling a record deal on a table napkin. He was already mapping out my future, and we'd hadn't even had anything to eat yet.

I stayed firm on what I'd said about producing my own records. I didn't have the clout to be so stubborn, but I was young and naïve, and I really believed my main selling point was that I had my own sound. I told Rick about how the Sugar Hill single had gotten airplay in several cities with hardly any promotion. About how the deejays said callers were flooding the stations with requests to hear it, and how folks were dancing to it in Texas. Rick was listening.

Rick liked that I was willing to take a risk. There's a little bit of gambler in everybody, and he wanted to roll the dice on me. So we hammered out my first record deal right there at a table in Ireland's. That's how fast I signed up with Epic, a subsidiary of CBS. I guess it was my destiny, 'cause it sure wasn't on account of very much haggling!

To be honest, I wasn't the one taking a chance; I didn't have anything to lose. Rick did, and he went out on a limb for me. People in the promotions department thought he was out of his mind. Here I was, an unheard-of and unproven artist, and Rick was giving me free rein and a key to the studio. I felt like I couldn't let him down. I knew I had to make good records, and come in under budget and on time, too.

Meanwhile, I got word from Emmy. She was just about to deliver her second daughter. She told me she was going to take a year off and focus on being a full-time mama. She said the band was on hiatus. When I told her about my record deal, she was happy to hear the good news.

My career finally seemed to be taking off. The only problem was my personal life was falling apart.

Chapter 14

EASTBOUND AND DOWN

Now the seven wonders of the world I've seen
It's many other different places I have been.

—"Ramblin' Blues," by Charlie Poole, 1929

It takes a worried man to sing a worried song.
I'm worried now but I won't be worried long.

—"Worried Man Blues," by the Carter Family, 1929

I was laid off. On the horizon I had the chance for a whole new career, but in the meantime I was just trying to pay the bills. This was a very strange period of my life. I was so busy I didn't know where I was a lot of the time, but it was usually a studio somewhere. I was a picker for hire, doing all the session work I could. No job was too big or too small. I ain't never been shy of working.

I was burning it at both ends, going from the West Coast to the East Coast and back again, flying the friendly skies. Some jobs were in Los Angeles, back on Lania Lane with Brian. I helped out on albums by Rosanne Cash, Rodney Crowell, Guy Clark, and Tony Rice. I was always happy to get a paying gig, and I always did my best to lend a hand however I could.

There was a lot of work in Nashville, too. I've never been able to make my living as a songwriter, but I always found plenty of work picking and singing. Chet Atkins helped open some doors for me. There weren't many producers with more clout than Chet, and he hired me for a bunch of sessions.

I remember when Chet produced an album for Janie Fricke that I played fiddle and sang on. I had a ball watching the old master at work. He'd come out in between songs and grab his guitar and we'd play some old fiddle tunes. Chet also played fiddle. I asked him to play for me, he played "Arkansas Traveler." I learned a lot from him about the Nashville way of recording, which was a little different from the way Brian recorded in LA. Nashville used the number system for their charts. For example, G, C, and D would be written 1, 4, and 5. If you started with 1 being G, you would count up to 4 and have C, and then count one more and have D. It's just a simple way to know where you are in any key instead of having to read sheet music as they do in LA.

What made a good session man back then was to play what was called for and not a note more. You needed to check your ego at the door and look at every job as being part of a team. It's a little different nowadays, especially in bluegrass. I want guys to play what they can when I have them in the studio. It shows off their talents, and it lets folks know that I like sharing the spotlight. I'd rather have a player with a good heart and a teachable spirit than one with all the talent in the world, yearning to be the star of the show.

Most of all, a session player has to be adaptable and go with the flow. Every job is different, and some are a whole lot different. One week I played fiddle on a superstar session for Bobby Bare, with a major label. The next week I was in a different studio, hired to help produce and arrange a "comeback" album by Jimmy Murphy, who hadn't cut a record for years. Murphy was totally unique, sort of a rockabilly Rip Van Winkle. A session like that, you do it for the love of the music, not for the money.

Jimmy Murphy was a character. Back in the '50s and early '60s,

he'd cut dynamite records like "Sixteen Tons Rock and Roll" and "Baboon Boogie" in Nashville, and then he'd quit music and worked as a bricklayer. It was like he'd stepped out of a time machine, the way he looked and the way he played. He had this Hank Snow kind of hairpiece, for one thing, to make up for his middle-aged baldness, and he had this intense, religious demeanor like some guy you'd see in a snake-handling church. It was that explosive fusion of the spiritual and the worldly, that Pentecostal fervor you find in a lot of Southern musicians, like Jerry Lee Lewis, the gospel-bluesman Reverend Gary Davis, and Brother Claude Ely, the Holiness singing preacher from Kentucky.

It seemed to me Jimmy had this battle going on between the Pentecostal music and the hard-core rockabilly, like two sides of the same coin, Saturday night and Sunday morning. Holiness music and rockabilly are kin, really; it's the same groove and rhythm and raucousness. About the only thing different is the lyrics. Jimmy played both kinds, and you could tell he loved 'em both but couldn't quite reconcile those different worlds.

It was the first time I'd landed in a studio with somebody who was cut from that kind of cloth, with those two sides to it. It was also the first time I'd heard somebody play with an open-string tuning on guitar. There was a lot of blues in his guitar licks and a lot of church in his singing, which reminded me of those house-rockin' Holiness services I heard as a boy back in Brushy. I remember one song in particular, "Holy Ghost Millionaire," that pretty much sums up Jimmy's music.

The album, called *Electricity*, was released in 1979 and earned rave reviews, but it didn't make Jimmy any richer, and me neither. I ain't complaining, though. I had loads of fun. If you can't have a good time on sessions with Bobby Bare and Jimmy Murphy, then something ain't right. You're probably taking yourself way too seriously!

But no matter how much fun I had, and no matter how much I worked, I sure wasn't earning much. Most sessions paid $150 to $200 back then. You had to work a whole lot of sessions and show dates

to make it all add up. With Emmylou, I was on salary and had been getting a healthy paycheck every week. That was on hold. I had a house payment and a mailbox full of bills and a young family to support. To tell you the truth, I was happier at work than I was at home at that time. My marriage with Brenda was just about over. We had filed for divorce, but it wasn't final yet. Technically, I was still living in Lexington, but I was away more often than not. Whenever I was there, it was to see the kids and try to get some rest. "Try" being the key word there, because it was definitely not harmonious at home. There was a lot of fussin' and fumin' and hollerin', times when our language got a little too loud and the children could hear, so I'd try to stay gone to keep the peace. Seemed like the only time my marriage was on good terms was when I was away from home. That's another reason I stayed so busy. I felt sorry for Brenda and bad about the situation we were in. I was doing my best to keep the bills paid, and she was doing her best with the kids and keeping the house up. It was a tough situation for us both.

Mom and Dad knew we were having trouble, and they knew there wasn't much they could do to help. I remember my mom would just say, "Y'all need to be in church!" And she was right. We were "Eastergoers"—you know, we'd go to church on Easter Sunday and that was about it. We just never could find the time.

Looking back now, I know I should have stayed home more instead of working another session whenever I could. I was so driven to get my career going. Brenda had a lot of responsibilities with Mandy and Andrew, and I couldn't really help. I was trying to be the breadwinner and needed to work, and Brenda and the kids needed me at home. It was an impossible situation.

I was in limbo in my professional life, too, with the record deal and all the pressure to live up to the expectations being placed on me. This was my big chance. Was I going to blow it? All these heavy thoughts kept creeping into my mind. I was trying to be a good dad, a decent husband, a great session player, and a worthy investment for my record company. My emotions were spinning like a top. My

mind was fried. My nerves were shot. Help arrived by way of a phone call from an old friend, Joe Wilson. He's spent his life promoting the music he loves: salt-of-the-earth, honest-to-God country music like the hillbilly string bands he heard when he was a boy in the 1940s in the mountains of east Tennessee. For years he ran the National Council for the Traditional Arts in Washington, D.C. Joe's the real deal. He has always stood up for the music whenever folks tried to put it down. Joe and his wife, Kathy James, promote artists they believe in. Joe's got a bloodhound's nose for talent and a good sense for bringing it to the marketplace.

"How'd you like to play a tour of the Far East?" Joe asked.

"Love to," I said. "Where are we headed and for how long?" I was eager for a change of scenery.

Nothing too strenuous, was how he pitched it. It would cover 48,000 miles in about six weeks.

Well, that sure sounded like a long way to me. I knew a trip around the world was 24,000 miles, so I asked why we had to go twice that. Joe didn't miss a beat.

"Well, Ricky, we've got seven countries to play, from Southeast Asia all the way to Athens," he said. "And there's a lot of doubling back and gyrations involved. All I can guarantee is you'll see things you've never dreamed of."

This sounded like a paid vacation. Exhausting, maybe, but exotic, too. What really sold me, though, was the lineup that Joe and Kathy had put together. This was a cultural exchange program sponsored by the U.S. International Communications Agency to spread goodwill through the arts. The idea was to share American music with our friends abroad. They'd assembled a package tour called Southern Music USA. There was a great bluesman and songster from Virginia, John Jackson; and a seasoned Cajun group, D.L. Menard and the Louisiana Aces; and best of all, my favorite family band, the Whites.

The plan was I'd help Jerry Douglas back up the Whites on my fiddle or whatever they needed. And then the Whites and Jerry would back me up when I played a few songs on my own. That way

there was no need to hire a pickup band. It'd make the whole thing more affordable for everybody. Plus, Jerry was an old friend, and it'd be good traveling with a guy my age.

I told Joe to count me in, but said I had a few shows to get through first. Turned out, these shows nearly did me in. What happened was a physical breakdown. It hit when I was playing a bluegrass festival with the Whites in Grass Valley, California. I was doing the gig for extra cash so I could send some to Brenda and the kids and pay my rent.

Well, I flew out to Grass Valley for the gig and came up sick. Now, I'd played dog-sick with Ralph and J.D. and all the rest—every blue-grasser has to grin and bear it when they're under the weather. But this was different. I felt real bad, worse than I'd ever felt.

The fever started on the flight and then spiked. During the ride to the festival site, it got worse. My shoulders and back were aching something terrible. Somehow, I made it through the first show, but as soon as we finished I went looking for help. At the festival grounds there was a nurse practitioner who checked me out and gave me a deep-tissue massage. The massage broke my fever, but the nurse feared I had an infection.

She called 911 and sent for an ambulance to take me to the hospital. The Whites had to go on without me. The doctor gave me a worried look and said I was dehydrated and probably had walking pneumonia. He gave me a round of antibiotics and a few shots and told me I'd have to stay at the hospital until they could pump enough fluids into me. Well, this wasn't gonna work, 'cause I needed to be in Nashville the next day to get my passport for the Far East tour. I promised the doc that I'd check into a hospital once I got my passport. He wasn't too happy about letting me go, but he gave me the okay. We caught a plane that night in San Francisco, and I was throwing up the whole flight.

Back in Nashville, I was a wreck. I dragged my sorry self in to have my picture made for the passport, and I could hardly stand up for the camera. I still have the photo on my old passport somewhere, and I look as rough as a cob.

Somehow, I got the proper documents together, and I went straight to the doctor. My temperature was 104 by then. I heard the nurses say it was double pneumonia. You've heard about the "boogie-woogie flu." Well, I reckon that's what I had. Too much music, too much work; not enough rest, not enough peace.

My life was a mess, and my body was paying the price. I was in that hospital for five days. I needed bed rest and lots of medication, as well as fluids to fight the dehydration. I realized this was a wake-up call. Friends came by, and they all said the same thing, *You look terrible, Ricky. You gotta slow down.*

The double pneumonia was a warning. This ailment was more than physical, it was spiritual, too. My ambition was in control of my life. I felt like the Lord was telling me that I could keep doing things my way, or let Him help me find the right path. I needed to get humble, and slow down. Lying in the hospital bed made me think about a lot of things. It had been a long time since I'd prayed and asked God to help me. I wondered if He really would.

A few weeks later we were in San Francisco, rehearsing for the tour. We were staying at Point Bonita in the Marin Headlands overlooking the Golden Gate Bridge. It was a foggy night, and you could barely see the lighthouse in the hazy darkness. Somebody had decided we should do a song or two together for a big finale to close the show, so we were there to practice, sort of eyeing each other, wondering what to try. "Hey, D.L.," said Kathy, "how about a Hank Williams song?"

It was a great suggestion, and it broke the ice. D.L. hit a chunky rhythm chord on his old guitar and kicked into Hank's gospel song "I Saw the Light." His voice hung in the fog like a spell, and then Buck and Sharon and Cheryl all joined on the chorus. I got chill bumps and went hunting for my fiddle. Hearing Hank's message of hope and salvation, I thought, *Maybe this song is meant for me and what I'm goin' through and what I need.* I sure needed some light to shine in my life.

Singing that ol' Hank song pulled us together and gave us the right direction. By the end of that rehearsal, we felt like family and knew this tour was gonna be special, and it sure was. We passed through seven nations in Asia and the Near East, doing our best to make friends for our country with our music and fellowship.

As the trip went on, I found myself spending more and more time with Sharon. We'd talk about what we were gonna do when we got back home, about trying to make it in the music business. Just a couple of young kids dreaming about the future.

Whenever we had the night off, I'd want to go and find some live music. Everybody was usually too tired to come along. Except for Sharon. She was about the only one who wanted to hang with me. "Shoot, yeah!" she'd say. "I'll go!" She was game. She was always up for some music she'd never heard before. I had decided to use all my free time and my portable tape recorder to search out local musicians so I could document what I found. I sure was the son of Hobert Skaggs!

One night we went into a little bar in Bangkok, and we could hardly believe what we found. There were college-age kids on stage picking and singing bluegrass. Thai-style, but it was bluegrass all right, banjo and all. It made me proud that I knew Mr. Monroe. I don't think I've ever been to a country where they didn't know bluegrass, and love it, too.

In Pakistan, I went to a workshop program with a legendary sitar player. He was tall and skinny with long spidery fingers, a real master. His expression was calm and peaceful, but man, could he wear it out. I played my mandolin a little, too, but I got the sense it was more his show than mine, so I switched to my Sony recorder to get him on tape.

He made it look like so much fun that I got the urge to try it for myself, so I made a special request through the translator. Well, swapping instruments wasn't on the program, and the lady from the State Department wasn't too happy 'cause it broke protocol. The sitar man didn't seem to mind, though, and he offered up his instrument

with a smile, like, *Help yourself, young man*. You could tell he wasn't expecting much, and neither was I.

A sitar is bulky, so I held it as if it were a big ol' banjo. It felt good in my hands. I started playing a basic melody, I think it was "Cripple Creek" or "Cumberland Gap," and I got a decent banjo tune going. It surprised everybody, especially the sitar man. He just stared wide-eyed at my hands, 'cause he'd never heard Western melodies coming from a sitar, which was tuned for ragas, not old-time breakdowns. The gal from the State Department just about fainted. I wish my dad coulda been there—he'd a-loved it!

Another highlight was when we got to see a concert of Burmese classical music, part of a tradition that goes back two thousand years. It was performed by a circle-drum player who sat in the center of the orchestra, and the instruments blended as natural as porch chimes in the breeze. It humbles you to hear songs that go back to the days when Christ walked the earth. That's your old-time music. We met the circle-drum player after the show and told him how much we enjoyed his playing. I acted like an interviewer and put a mic up toward his face, asking him what he thought of country music. He said something back to me that sounded so funny, though I have no idea what he said. He may have said, "Get that mic out of my face." Who knows!

That Eastern tour was more like a pilgrimage, and I felt lucky to be a musician helping to spread good cheer and fellowship in a language that goes beyond borders. I saw how music can reach the nations of the world and bring people together. It's a sacred language, really, the breath of the Creator. And it was a privilege to travel with our little troupe, especially with wise elders like John Jackson, and get to watch them share their gifts. It was a great lesson in what music can do.

Getting away from my life and seeing the world did me a world of good. The trip was full of show dates and catching planes and carrying luggage and running around, but it was a good kind of

busy. Seeing places and meeting people who were so different from me opened my eyes and freed my mind. In those days, there was no Internet or e-mail. We didn't live in a "global" society the way we do now. I was being exposed to cultures that were entirely new to me, and it changed my life. It was also, in many ways, a total break from the reality of my life back home.

Much fun as I had, there was a sense of dread, too. I knew there was a lot of stuff I had to face down once I got back. There was no escaping the reality that my marriage was over.

Near the end of the tour, I got the divorce papers. They came special-delivery airmail to my hotel in New Delhi, and the bad feeling came with them. The life Brenda and I had together had come to an end, but it was still hard to face. Getting the divorce seemed like I'd failed. I was raised to believe a marriage was supposed to last forever. Mom and Dad had been married for decades. They'd had some tough times, but they stayed together. They were still standing. I felt like I'd let them down. Not to mention the guilt I felt over what my divorce would do to my children.

Dad never said, "I told you so," the way some dads might do in that situation. He said, "I love you, son." Dad and Mom pledged their love to me more deeply than ever. As far as things with Brenda and I went, the divorce was more a truce than anything. We both wanted peace and civility. There was no call for finger-pointing. Getting married at eighteen years old, we probably jumped into something we weren't ready for. We really didn't know what marriage meant, or what it *could* mean. Marriage is a union ordained by God. We just got lost on our path together. It happens a lot, I guess, and it hurts a lot, too.

Chapter 15

MUSIC CITY

The late seventies and early eighties had seen country go pop. . . . But Skaggs re-introduced the backwoods sound, and with an impeccably tight band and clear, snappy bluegrass-influenced productions, his records and live shows came like a breath of fresh air through a stagnant Nashville smog.

—*Who's Who in New Country Music,* by Andrew Vaughan

His hits testified not only to the new life which Skaggs's singing, arrange- ments, and production infused into them but also to the fact that these relatively simple songs were as well crafted as those of the more sophisticated Nashville songwriters.

—*Bluegrass: A History,* by Neil V. Rosenberg

When I got back to Nashville, I hit the ground running. I took meetings with my manager, my music attorney, and Rick at CBS, the company that owned Epic. I needed to get in the studio and start recording my first major-label album, *Waitin' for the Sun to Shine.* How appropriate the title was, given all I was dealing with. My heart was very heavy but hopeful, and I was looking for the

best songs I could find. I was working hard in pre-production at my apartment, and thinking about my future.

After a few months,. Sharon and I started going out and doing things together. We weren't calling it dating, we were just, as the young kids today call it, "hanging out." We'd go to church together, go have dinner somewhere, and always end up back at Buck and Pat's place. It was kinda like dating, but it was pretty supervised, to be honest. Almost like a courtship you hear about in an old parlor song. Obviously we were both grown-ups and had both been married before, but we wanted the blessing of Buck and Patty, same as with my mom and dad.

We were lucky that we'd had a long friendship with each other, and we were even luckier to have the families we did. 'Cause it was our families that helped take our new relationship to the next level; they gave us the emotional support you need when you're ready to take that leap into the unknown.

Now, my mom and dad both loved Brenda, but they loved Sharon, too. They treated Brenda the same after the divorce. As far as they were concerned, she was still their daughter-in-law. Even after Brenda got remarried, they were always Mamaw and Papaw to Andrew and Mandy. Always.

I ain't saying things were perfect, and in no ways would I defend divorce. It's never a good thing. In every divorce, a family is broken and everybody suffers. Time can't heal the wounds, but God can. I didn't know it at the time but I know it now. My kids Mandy and Andrew have gone through a lot, but they're great people and I love them so much.

After a while, I knew that Sharon and I were becoming more than just friends. We understood each other 'cause we were friends before we got serious romantically. There were no illusions, nothing to hide. We had the same goals, we were focused on music, and we felt safe around each other. Sharon had gone through a divorce, too. She was hurting, and so was was I.

When it started becoming romantic, it scared us. We decided that

if dating each other was going to ruin our friendship, then we'd just stay good friends and hang out together. Well, we tried that route, and we ended up spending even more time together than before! The next thing we knew, we were crazy about each other.

Epic and Rick Blackburn were in a big hurry to get my debut major-label album out on the market. The only problem was that we had to record it first.

The demos I'd played for Capitol and Epic, the songs that had gotten me the deal, belonged to Sugar Hill. Now, I didn't have an exclusive recording contract with Sugar Hill, so signing with Epic wasn't a problem, but I still needed to finish the album I'd started for Barry Poss and Sugar Hill. I also had to get in the studio and start a brand-new project for Epic. Rick wanted it sooner rather than later. So I focused on the Epic project.

Barry was a friend and a good businessman, too. He was smarter than the average bear, and he was willing to wait for a while. I think he saw the possibility that the Sugar Hill project, even though it was uncompleted, could become a lot more valuable in a year or two if he was patient enough and if I became successful. Well, he was sitting on a gold mine, and a gold record.

In the meantime, I had to deliver a whole album of fresh material, but I couldn't do it by myself. I needed to put together a band, and I hit the lottery. There was a British guitarist, Ray Flacke, who I'd met when I was on tour with Emmylou in England. He'd just moved to Nashville, he was a friend of Albert Lee, and man, could he play a Telecaster. There was a pedal steel guitarist, Bruce Bouton, who I'd heard about, and he was young but plenty road-tested. And there was Joe Osborn, a session legend who'd played bass on hits by Ricky Nelson and Simon & Garfunkel and so many others. He had a bass tone like no one else. On drums I hired Jerry Kroon, who came highly recommended.

That was a lot of talent on such short notice. Along with these new guys, I called up some old friends. Bobby Hicks was ready to help out

again on fiddle. Bobby could play country as well as bluegrass. I had my buddy Jerry Douglas on Dobro, Mr. Buck White on piano, and Sharon and Cheryl on harmony vocals.

I had my blue-ribbon band, and now I had to make the music that was in my head. To tell the truth, I didn't know the exact sound I wanted. I was just going on gut instinct and what inspired me. I knew I wanted to cut some real country music, not just the kind that was popular. One thing was for sure—I knew my music would sound different than what I was hearing on the radio. I didn't know if it'd be different in a way that people would like or not. I just hoped it would be!

Country music had changed so much from what I'd grown up with. There were a few singers in the young guard who I loved, like Johnny Rodriguez and John Anderson. 'Course, I still had my boy-hood heroes, Merle Haggard and Buck Owens and George Jones, but they were pretty much the older guard standing watch over country music. When I came to Nashville, it was the right time for some-thing new to break through. The stage was set, though I didn't know what role I was gonna have. I was just a young man who in his heart wanted to see old music become cool again.

The framework I used was old-fashioned country done simple and straight-up, but with modern recording techniques. That meant bluegrass instruments raised to the same volume level as country's steel guitar, electric guitar, electric bass, piano, and drums. Let the harmonies be bluegrass-style and mix the mandolin, Dobro, banjo, and fiddle as loud as the electric stuff. Like one of my mom's reci-pes, it was all about blending the right ingredients for the best flavor. My goal was to see the best of both worlds, country and bluegrass, coming together, and to create a new sound.

There was a song I'd been wanting to record called "Crying My Heart Out over You." Lester Flatt and Earl Scruggs had cut it first, back in 1960, and made it into a top-twenty hit. I'd loved the record ever since I was a kid. It's as good a bluegrass song as you'll ever want to hear. But I wanted to juice it up and put some drums and piano and steel guitars and triple fiddles on it and make it a country song.

The ears I was aiming for didn't know the Flatt & Scruggs version. I figured the country audience would appreciate the drums and piano and steel in a way that the hard-core bluegrass crowd never would. I wanted my new version to be danceable in Texas, just like "I'll Take the Blame" had been.

Buck White is well known for his holy-ghost honky-tonk piano style and his fine mandolin playing, but he's also a heckuva dancer. I wanted Buck to help us set the tempo for the song as if he were at a Wichita Falls dance hall on a Saturday night in the 1940s. We'd run through the song for him, and I'd stop the band and ask, "Mr. Buck, could you and Miss Patty dance to that tempo?"

"That's a little fast!" he'd holler.

"All right, boys, let's take it down a notch," I'd say, and we'd nudge the tempo until it felt right to Buck.

Being my own producer gave me a lot of freedom. I didn't have to worry about someone being bothered by Mr. Buck and Miss Patty dancing 'round in the studio. That's how we got that nice two-step shuffle on a Flatt & Scruggs song.

Now we had our sound, we had our tempo, and all we needed to do was get a great take and put it out. We released "Crying My Heart Out over You" in December 1981, and it became my first number-one country hit.

I had another Flatt & Scruggs favorite, "Don't Get Above Your Raisin'." The girl in this song had gotten a little too big for her britches. I loved the record, but I thought it could use a little different groove. I made some chord changes, goosed it with a rockabilly beat, and swapped the banjo part for a Dobro so Jerry could take a solo and, boy, did he ever! Nobody in Nashville had heard that kind of Dobro playing before. Our version still had a bluegrass tinge, but with a heavy beat.

Now, Lester Flatt passed on the year before I was working on this record, and I don't how he'd have felt about the changes I made to songs he wrote. But I know Earl loved it, 'cause he told me so. After he broke from Lester and started a band with his sons, Earl was a big advocate for experimentation. He encouraged me to take risks and

find a new audience. That way the music we all loved wouldn't die. "If a song's got a chance to reach another market," he told me, "don't hold it back. Let 'er go!"

Earl's blessing meant the world to me, just as Ralph Stanley's had all those years ago. Ralph never once lectured me or told me to quit playing country and come back to bluegrass. Around this time, I saw Ralph at a festival, and I got a chance to play him those demos of Stanley Brothers songs I'd made. I was so excited for Ralph to hear his music rendered in a country style. I had my Walkman cassette player, and I cued up "She's More to Be Pitied" and put the head-phones on his ears and held my breath.

Ralph sat there stone-faced. And then . . . buddy, let me tell you, big tears came running down his cheeks. In all the years I'd worked for him, I had never seen Ralph get emotional. You know, he's a deep well, and he keeps his feelings under the surface. It shocked me to see him like that, and I tapped him on the shoulder and said, "Ralph, are you okay?" He took off the headphones, and he said, "I'm all right, Rick. You done a fine job. That's as good as I've ever heard that song done. I'm proud of you, and I know Carter woulda been proud of you, too."

There was nothing he could've said to me that would have ever made me feel better. That was all I needed to hear. I knew I was on the right path. I had the blessings of those fathers like Ralph Stanley and Earl Scruggs. I had all the confidence I needed to keep going.

My goal was to bring traditional bluegrass and commercial coun-try together, the way things were when one hand fed the other in the late '40s and the '50s. Back then, there wasn't any segregation in country music. Whether it was hillbilly or honk-tonk or Ap-palachian or bluegrass or western swing, we just called it country. Every star had his own signature sound that you knew from the first note. You'd hear Ray Price, George Jones, Webb Pierce, Buck Owens, and Kitty Wells on the same radio station as the Stanley Brothers, Flatt & Scruggs, and Bill Monroe. By the '60s, country went uptown with the polished, pop-oriented Nashville Sound, and by the late '70s, the *Urban Cowboy* dance craze took country music as far from its roots as it had ever been. Meanwhile, bluegrass

was pushed off the radio and the record charts, surviving on the festival circuit, where Ralph and Bill and the others still kept the faith. There was a huge chasm between bluegrass and country, and I wanted to bridge the gap.

When I was a kid listening to bluegrass in the late '50s and early '60s, I didn't know much about how the music was supposed to sound. I heard a lot of banjo and fiddle and mandolin, but to my ears, there were some missing elements, especially the bass fiddle and the acoustic guitar. I didn't hear enough of the drive. The records didn't have the full, driving sound that a live bluegrass band did.

When I'd hear rock and roll on the radio, though, I could tell the mix was different. The kick drum was helping the bass to sound louder. The acoustic guitars of the Everly Brothers were so distinct on their records, as was their vocal style. The Beatles sure picked up on that, and lots of early rock records had a punch and drive to 'em that I really loved.

Now, I wanted all those cool sounds to be used. The bass and acoustic guitar were so important to the drive of the song, and they provided the groove for the singer. Of course, the secret ingredient to any great bluegrass or country record is the singing, and I was so lucky to have the Whites to help me. Family harmonies are the bedrock of country singing, all the way back to the Carter Family. That type of close harmony singing was as rare as hen's teeth in Nashville, so I was beyond grateful to have Sharon and Cheryl in the studio with me.

Sometimes I'd change the structure of the songs to fit the style of singing I'd learned from my folks at home and during my earliest churchgoing experiences. I'd even stack the harmonies the way we'd sing in the congregation back on Brushy. It was so much fun to try new things in the studio. This was my first major-label record, and I really wanted it to be the best it could be, and something different, too! I was having a ball!

Right before my first album for Epic was released, there was an important event in Nashville called the Country Radio Semi-

nar. This is the industry's largest annual trade show, where all the deejays and media types meet in Music City to schmooze. The CRS gives the record labels a chance to promote their most popular artists. That year, Epic and a few of the other major labels had a performers' showcase, and George Jones was the headliner.

George was hotter than ever. His first million-seller, "He Stopped Loving Her Today," was riding the charts and fueling an incredible comeback. But behind the scenes, the great singer they called "the Possum" had hit a rough patch in his life. He'd gone through a painful divorce with Tammy Wynette, and he was missing his show dates. Folks were starting to call him "No Show" Jones.

If he was No Show, I was "No Name." I was too new on the Epic roster to get an invitation to perform, but I went to the event anyway to show my support for my label. I also wanted to introduce myself around and do some howdy-and-shake with the press and the deejays. Plus, I wanted to hear George sing. I was a huge fan, and I could hardly wait to tell Mama I'd seen the Possum in person.

Well, it turned out that when the time came, the star attraction was nowhere to be found. Bonnie Garner, who was working for Epic at the time, came running over with her clipboard in her hands, and she was desperate. No Show Jones had struck again!

"It looks like George ain't gonna make it tonight. Can you fill in and sing a few songs?"

"Oh, Lord," I said. "Are you serious?"

"Yes, I'm *very* serious."

Well, I knew the house band didn't know any of my songs any better than the audience did. The album hadn't been released yet. If I got up on that stage, I'd have to do it solo, just me and my guitar. In those days, I wasn't too keen on performing without a band. I'm glad I listened to my dad's advice: "Son, don't leave home without your guitar. You might just need it sometime." Well, sometime had just come.

I stood there almost frozen, with Bonnie waiting for my answer. I was nervous and a little bit fearful, but everything in me was saying

yes. So I took a deep breath, put on a brave smile, and told Bonnie I'd give it my best shot. I ran outside to the car, grabbed my guitar, and headed for the stage. Rick Blackburn introduced me and told the audience I was brand-new to the label. There was some polite applause, and I went out there and did my thing. I sang my tried and true Flatt & Scruggs covers and a pretty ballad from the new album called "Waitin' for the Sun to Shine." I ended the set with "So Round, So Firm, So Fully Packed," the old Merle Travis hit. Lo and behold, the audience loved it and gave me a standing ovation. I think their reaction was sheer surprise, plain and simple. Rick was thrilled! This level of exposure was going to be really helpful, and was coming about a year ahead of what he'd planned. It was fuel for the fire that Rick was starting to build for me at Epic. His bosses in New York saw what happened same as he did, and so did every country disc jockey worth his salt from Maine to California. I couldn't have had a better audience to generate buzz for my first album release. After that night, Rick was ready to go for broke.

Two days later, I got this note from Rick that I'll always treasure:

Dear Ricky,

Wednesday, October 14th, I saw one of the most incredible but difficult performances on our CBS Show. The manner in which you were able to captivate 4,000 people, hold their attention and receive standing ovations with only a guitar is a blatent display of your natural talent.

I am proud that you are in our CBS Family and look forward to your superstardum in the coming months. Ricky, you are a tremendous performer.

Best regards,

In the meantime, my singles on Sugar Hill were still getting some heavy airplay and positive word-of-mouth. Chuck Morgan, the nighttime disc jockey at WSM, was playing the snot out of "I'll Take the Blame," and he phoned to say he was in my corner. WSM was the flagship station of the Grand Ole Opry, and its 50,000-watt broadcast signal reached all over the country. Chuck's word carried weight, and it wasn't long after that Hal Durham, who was in charge of the Opry, invited me to be a guest on the Saturday night broadcast. Oh, man, was I ever excited. You couldn't have kept me away with a team of horses.

I'll never forget that night. Emmylou was in town and came by the Opry House to help as only she could. I sang "I'll Take the Blame" first, with Sharon and Cheryl singing backup. Then Emmy strolled on stage and we sang a duet on "Could You Love Me One More Time." 'Course, it was Emmy who first introduced me to the country music world, and here she was making it official.

It was a big boost to my career at a time when nobody knew who Ricky Skaggs was. I'll always be grateful to Emmy. And to have the Whites share the moment, too; it was ice cream on the cake. The Opry crowd made a lot of noise stamping and clapping for the old Stanley Brothers songs done hard-core country-style, and they made me feel welcome. To get to be a guest on the Grand Ole Opry was the coolest thing ever!

Mom and Dad were back home on Brushy Creek, listening to the Opry on the radio the same way they had since they were newlyweds, when they would tune in to hear Monroe and all the rest of their favorites. Now their little Ricky was on the Opry, too, singing on the radio. Quite a special moment for Hobert and Dorothy Skaggs and, especially for Dad, a dream come true. Had it been only twenty years since the Opry security guard Mr. Bell had taken pity on a mountain man and his mandolin-playing son and let them sneak backstage?

By now, Sharon and I decided it was time to start a new chapter in our lives. We both had dreams to make it in the music business,

and we were gonna help each other as best we could. Sharon's career with the Whites was already up and going, and mine was starting to take off. We decided to take the ride together.

Our wedding was at the Two Rivers Mansion, an antebellum plantation house outside Nashville, on a bluff overlooking the Cumberland and Stones rivers. We tried to keep the guest list small, just family and a few friends. I'd only been in town a little while, but Sharon had been here since 1971. She and the Whites knew everybody in Nashville, from Hazel Smith to Grandpa Jones. With so many musicians coming to celebrate, we decided to make our wedding day into a pickin' party. On the invitations, we made a special request:

NO GIFTS, PLEASE. BRING A COVERED DISH AND YOUR INSTRUMENT TO HELP US CELEBRATE.

The night before the wedding, we got a head start on the festivities with a musical get-together at my apartment, and we had us a big ol' time. My folks were staying with me, and they'd brought family friends, Bud and Ophelia Huntley. Bud used to book the Clinch Mountain Boys at a little schoolhouse in Franklin, North Carolina. After one show, we went to the Huntleys' house for dinner out in the country. Ophelia had fried up a chicken and made some biscuits and gravy, and we had an unbelievable meal, with Keith, Curly Ray, Roy, Jack, and Ralph crowded around the supper table.

During my time with Ralph, Bud and my dad had become great friends. Dad would drive down to Bud's and go out in the woods diggin' for ginseng in the Carolina mountains. Then Bud would come over to our place in eastern Kentucky and go coon hunting with us. Bud was a stonemason by trade, and he even built the fireplace and chimney for Dad and Mom's new house on Brushy Creek.

That pre-wedding party turned into quite a bash. People kept dropping by, and my place could hardly hold everybody. It was like being back on Brushy Creek, when neighbors gathered at our place to sing and play. I remember Maria Muldaur came by to wish us well,

and she joined in on the musicmaking. When she heard my mom sing, she started to cry. She'd never heard an ol' mountain woman's voice like my mom's, and it touched her heart.

That night, we roared till past two or three in the morning. As usual, my Dad was the boss and kept asking for "one more." Back on Brushy in the old days, you remember, he knew how to clear the place out when it got too late. Well, now it was my turn, and I put my foot down. "Dad," I said. "We gotta let everybody go and get some sleep. Didja forget that I gotta get married tomorrow?"

Well, Dad did what he was told. But don't you know, on the big day, bless his heart, he almost missed the ceremony. We were running late, and there he sat with the reel-to-reel machine out, listening to the tapes he'd made of Santford Kelly. When we finally made it out the door, Dad was following me in his car with Bud and Ophelia and Mom. What shoulda been a twenty-minute drive took us three times that. Poor Dad couldn't keep up, much as I tried to guide him. Seemed like he was bound and determined to get lost.

Over at the mansion, everybody was waiting on us. Sharon was busy telling folks we'd be there any minute. I thought she'd be worried sick, but she later told me her heart was as light as a feather that day. We had asked the McLain Family Band to entertain the guests as they arrived. The McLains were a wonderful traditional country group from Kentucky and good friends of ours. They were supposed to play for about fifteen minutes and, after the vows, maybe serenade the newlyweds with a few tunes. They ended up putting on a whole darn show, and they kept going for almost an hour while the groom and half the wedding party was AWOL.

Then a big cloud of dust came churning up the driveway, with gravel flying everywhere. From a distance you'd have sworn it was Richard Petty on the backstretch, but it was me. It was quite an entrance. I got out of the car, and everyone started applauding. I didn't know if it was for my driving skills or just for the fact that I'd finally got there.

Within a few minutes, I was at the altar. I got married in jeans and a long tuxedo coat and cowboy boots. Sharon was wearing a pretty flowered wedding dress. She had Cheryl stand up with her, and I had my manager, Chip Peay, as my best man. Sharon's sisters Rosie and Melissa were bridesmaids, and my groomsmen were Jerry Douglas and my bass player and road manager Jesse Chambers.

The ceremony was on the front porch of the mansion. It was about as laid-back as you could get, but we took our vows as serious as any oath on God's earth. We've been husband and wife thirty-two years now, and we're shooting for thirty-two more. You know how at some weddings the bride lights a candle and then the groom lights a candle and then they take the two candles and they light one candle together? Well, at our ceremony, I sang a song to Sharon, she sang a song to me, and then we sang a song together. It was a beautiful moment, signifying our love and new life together. Our wedding day was August 4, 1981, and we couldn't have picked a hotter day. It was so daggone hot that the cake melted. The lady who made it was from our church, and she worked so hard in the kitchen baking that triple-decker. The reception was outside, where it was a hundred degrees in the shade, and the cake made it to the table in pieces. The baker was devastated, but the cake served a purpose. It was the only thing Sharon and I got to eat. By the time we got done picking and singing, all the food was gone!

My old bluegrass buddies came to help us celebrate, Jerry, Sam Bush, Béla Fleck, and my whole band. The party went for three hours straight. . I had made a special request for Bill Monroe to join us for our special day—and to remember to bring his mandolin. So he did, and he showed up dressed to the nines in his white linen suit and his famous white Stetson.

The best part came when he set his mandolin down and got up and buck-danced with our dear friend Beverly Cotton. Apart from the ceremony, I'd have to say that was the highlight of our wedding, to see him dancing and having so much fun.

Epic released the album *Waitin' for the Sun to Shine* in June 1981. Now they were waiting on me to go on the road to promote it. I needed to put together a band and start touring.

A record company ain't no charity organization. The labels sign you up to a contract on their faith in your potential, but they need some early returns on their investment before they loan you any money. We were on the road when the album's first single, "Don't Get Above Your Raisin'," climbed into the top twenty on *Billboard*'s country chart, taking us all by surprise. We knew we were offering something new, but the rest was up to the marketplace. Then Epic released another single, "You May See Me Walkin'." It broke into the top ten. I couldn't believe it.

The public reception of the album's title track, "Waitin' for the Sun to Shine," was another nice surprise. The crowd sang along to every word, and you'd see couples holding hands and swaying in their seats. Sonny Throckmorton had written a sad and pretty tune, and it really spoke to people. I don't play that song much anymore, just once in a while when I play with a full orchestra. It still strikes a chord with audiences.

Early on, "Waitin' for the Sun to Shine" was a signature song for me. And the funny thing was, it never got released as a single, as much as I wanted it to be. I remember calling Joe Casey, my contact at Epic who chose which songs to release as singles. I told him the song ought to be a sure-fire hit considering the audience reaction when we played it. He thought it was a little soft, and that "Crying My Heart Out over You" ought to be the next single. I wasn't so sure. "Trust me on this," he said. "It's a smash." And boy was he right.

It went straight to the top. I called Joe to say thanks and told him to keep on picking those singles he wanted, 'cause he sure knew what he was doing. Well, now I had my first number-one country record, and it was a dream come true. Wow, what a feeling! 'Course, my life would never be the same again.

Once we started seeing that radio and record sales were picking

up, Epic really got behind us. We got more confidence as a band, more comfortable with each other, and we were getting encores at our shows. We started opening up for major stars like the Statler Brothers, Barbara Mandrell, and Marty Robbins. We were playing at big venues for a whole new audience. After my second number-one record, a remake of Webb Pierce's "I Don't Care," I started headlining my own shows.

Everything happened so fast I could barely take it all in. It felt like getting shot out of a cannon and landing in the spotlight. I tried not to blink and counted my blessings. I was just happy that radio was playing traditional country music again, and was glad some of it was mine.

'Course, my new career in mainstream country didn't make everybody happy. It angered a lot of bluegrassers, and some of 'em probably never forgave me. But I knew I had to follow this path. I've tried not to let the naysayers bother me. Never really had time to dwell on that, and besides, the people I really cared about were still behind me.

When I had my first number-one record, I remember calling my folks on the phone. Dad didn't pretend to know much about the country charts, but he sure was tickled that my version of an old Flatt & Scruggs song was all over the radio, and he liked the fact that I was still showing my bluegrass roots. But what got him most excited was when I told him I'd gotten to meet one of his favorite country stars, Merle Travis, the finger-picking guru guitar master from Muhlenberg County, Kentucky, who could make a Martin D-28 sound as big as a coal truck. Dad's favorite Merle song was "Dark as a Dungeon," and he loved to sing and pick "Nine Pound Hammer" on his Martin guitar. Dad was as giddy as a Justin Bieber fan, and he asked, "Well, Son, what'd he say to you?"

I told him how friendly and down-home Merle was to talk with, how he knew I was from the coal-mining area of eastern Kentucky, and how he'd thanked me for recording his songs "Sweet Temptation" and "So Round, So Firm, So Fully Packed." That thrilled Dad to pieces, 'cause he idolized Merle and had such respect for his sing-

ing, songwriting, and musicianship. Having a hit single was nice and all, but meeting Merle Travis, well, that was about as good as it got in Dad's book.

When Mom got on the phone, she started crying and praising the Lord. "Son, you know who got you here, don't you?"

"Yes, Mama. Jesus did."

"Don't you ever forget Him. Always put Him first in your life. He'll always bless you and take care of you."

I knew she was right. And I knew I wanted to honor God in everything I did. My mother was such a powerful prayer warrior. She knew how to pray, and she knew how to believe in what she prayed for. That's as important as praying: If you don't believe, you won't receive. She'd prayed for me all my life. She prayed that God would make my gift of music a blessing to others and that Jesus would get the Glory for it, not me. I don't think the rest of us could hardly believe the boy from Brushy Creek had finally started to make it in Music City, but Mama sure did!

What a long strange trip it had been from the top of a soda-pop cooler in Butler's Grocery store, and the journey was just getting started.

Chapter 16

OPRYLAND

Dread not the things that are ahead,

the burdens great, the sinking sands,

The thorns that over the path are spread,

God holds the future in His hands.

—"God Holds the Future in His Hands," by the Monroe Brothers, 1936

Things got crazy pretty dang quick, and it happened on a large scale. I was getting a crash course in the music business, and I made sure to pay attention. We'd come to a city somewhere that I'd never been before, and we'd have a sell-out show. It was hard to believe all those people in the seats were there to see me. I'd look out from the stage at all those faces and think, *How'd y'all even know I was coming?*

This experience opened my eyes to the incredible reach of radio and to what a powerful medium it was, at least at the time. With radio and promotion, the market was primed and ready for us ahead of every gig. People knew the songs and sang along with me. It was like you were friends with thousands of strangers, all because of the music. You never forget that sense of community. They all wanted to help this ol' country boy.

Waitin' for the Sun to Shine cost fifty thousand dollars to make, a piddly sum compared to standard production budgets in Nash-

ville. All I'd wanted to do was make a record with good songs that I wanted to sing and, hopefully, people would want to hear. Boy, did they ever. Rick Blackburn guessed it'd sell maybe fifty thousand copies at the most, but it sold more than five hundred thousand. And the music critics came to my side and cheered me on, too, 'cause I was sort of a young renegade waging battle to bring back the hard-core, traditional country sound.

The success of the record was a nice surprise for the executives at Epic, and it was a shock to the industry. It was new territory for me, and I felt like a pioneer. I got pitchforked to the top of the heap, and I came out of the pile fighting for my music and my beliefs both. It's been a whirlwind ever since. Success is a tricky business, and it can fool you at every turn. I was lucky I had Sharon to keep me grounded while my career took off. Honestly, I don't know if I'd have survived without her. See, it wasn't till after we married that I started *really* trying to live my Christian faith every day—the best I could, anyhow—and it couldn't have come at a better time. When the Lord opened those doors for me in Nashville, I needed to be focused on Jesus, not myself, and to walk as best I could through the miry clay of Music Row.

I'd been attending services with the Whites at Holiday Heights Baptist Church, their little church in Hendersonville, Tennessee. One night the preacher was talking about this one simple truth: Christ alive in us is the hope of Glory. His words hit like a ray of heavenly light in a Bible picture card, breaking through the confusion I had about my faith. Imagine, Christ living His life in me and through me!? The preacher made me think about my situation, and the spiritual journey I'd been on since I was a boy.

I'd grown up in the old Free Will Baptist faith, where they believed that you could lose your salvation if you didn't live right, and that you could keep it if you did all the right things. I thought, "Where is the free will in that?" I didn't like the way that tasted. It felt like it wasn't the whole Gospel, 'cause it didn't square up with all the Scripture, in which Jesus said He'd never leave us or forsake us.

I had long doubted the salvation I experienced at the revival when I was thirteen. For years, I thought God was mad at me. I didn't talk to God for a long time.

The preaching I heard at Holiday Heights helped me finally understand. My salvation was a done deal. I'd made my commitment to Christ and He had not forgotten it. I realized He wasn't mad at me. I had to understand that salvation is not about what we do or don't do. It's about His grace and sacrifice on the Cross, and about the fact that no matter what, Jesus loves me and lives in me. I rededicated my life to the Lord at Holiday Heights. I was baptized and, along with Sharon, finally started my walk of faith. It's easier for two to walk together than one alone. One can help the other. And we did.

Part of that walk of faith meant taking stands on morality and worldly things. I was a public figure, and I knew that kind of publicity and media exposure made you into a role model whether you were ready or not, especially when it came to younger people. I didn't want to be a hypocrite.

I remember the first time *Country Music* magazine ran a cover story on me. It had a huge national readership—it's like *Rolling Stone* for country music fans. I was leafing through the pages when I got to the classifieds in the back. I couldn't believe how crude some of the ads were! There were people you could call on phone-sex hotlines, lewd photos you could order, and all kind of filth for sale. It bothered me.

I phoned the head editor of the magazine in New York and asked him what all this stuff had to do with country music, family values, and the Grand Ole Opry. He was nice and polite and said I had a good point. I think for a while he made a concerted effort to cut back on some of the more suggestive ads.

Maybe I was a little starchy or square, but I didn't care. Nowadays, of course, kids see much worse things on TV and the Internet.

I knew that if I felt that way, others did, too—only they didn't have a say in it. I decided I was gonna speak up for those folks and myself. I felt the same way about the music I was making. I tried to

find songs that could reflect my beliefs about what was proper and morally right. Otherwise, I'd be selling a lie. I believe traditional music and traditional values go hand in hand. To me, traditional country music has a wholesomeness and decency that's part of our common heritage and represents everything we're about as a people.

In the tradition I came out of, there were cheating and drinking songs, but there was a price to pay for sinning. When Kitty Wells sang about those things, she sang about it in a way that let you know she thought it was wrong. Kitty always had strong morals in her material. So did so many of the greats, from Roy Acuff right down the line. I wasn't trying to be self-righteous, but I just felt like there was an audience for clean country music, and a place on the radio for good songs if they were done right. I figured I could sing about some other things that would interest people, things like faith and love and honor and a relationship with God.

Taking a stand made me a target once in a while, but I didn't mind the scrutiny. That comes with the territory. Add to this the fact that I was suddenly in the public eye for the first time. I had a strong tailwind behind me, not just the chart singles, but an Academy of Country Music award for Best New Male Vocalist. Things were heating up for me in Nashville, in more ways than one.

There was some strong opposition from some groups to tobacco products, with bans against smoking in public and what not. Marlboro wanted to get in the good graces of country music. They launched a package tour with Hank Williams Jr., Ronnie Milsap, Barbara Mandrell, and other country stars, and I joined up. There was a public outcry against a bunch of singers on a big-money, barnstorming national tour that was sponsored by a cigarette company. People wanted to know what I, a nonsmoker, was doing out there promoting unhealthy habits that could hurt people, especially young people.

Well, it wasn't easy defending myself. I tried to explain that I wasn't encouraging anybody to light up or take a chew or dip snuff. Marlboro never told me or even asked me to promote their products

from the stage or anywhere else. To my mind, the company was giving me an opportunity to take my music and a positive message to the mainstream.

Maybe I was naïve, but I didn't know any better. Promoters were booking us into arenas and stadiums with twenty thousand people, a huge crowd for a new artist. These weren't the crowds of bikers, blue-grassers, hippies, and outlaw types I'd seen at shows with Emmylou. They were Middle Americans with families: older people from my parent's generation, young couples my age, and those couples' kids, who were just discovering country music for the first time. Being on this tour allowed me to play my kind of music for far bigger crowds than I would have otherwise.

You see, I was young, too. I was fresh-faced and long-haired, full of the joy of my faith and wanting to share it with everybody. Yeah, I was probably a little full of it, too. I thought I could use the stage as a soapbox to speak my mind and heart. Not that I tried to make speeches or sermons. I just had things I wanted to say, especially with my songs. I was following my heart and my Christian conscience.

There were a lot of venues where I wasn't inspired to talk about the Gospel. But whenever I felt moved, I did. If a little story came to mind, I told it. Looking back, I'm sure I said things from the stage I shouldn't have said. Learning to speak out in public is a hard thing. It takes lots of tries and lots of mistakes.

But sometimes it felt like I was forcing it on people—I thought it'd please God if I did—and for that I'm sorry. The spirit of God is nowhere close when you have to force Him on someone. I was young and immature, and I realize that now.

There was every sort of response, from people thanking me to drunks yelling for me to shut up. I even had finger-wagging church ladies tell me I needed to offer a plan of salvation if I was going to save people at my shows. These well-meaning Christians thought I oughta be singing at churches instead of on stage. So I had to contend with both sides: believers with good intentions, and nonbelievers who didn't want to hear a gospel message at a show they'd paid to see.

When I look back on this period, I feel like I did my best to follow my conscience. Tell you what, though, it could be a lonely place sometimes. Back then, there wasn't anybody in country music, or even in bluegrass, willing to talk about Christ from the stage. Except for the Whites. When they sang "Help Me" and "Follow the Leader," they told the audience what these gospel songs meant to them, and how they believed in what the songs said. They had the courage of their convictions, and they still do.

You have to remember the way things were in the old days. Bill Monroe and the Stanley Brothers and every bluegrass band worth its salt, they all sang gospel music. But they didn't talk about the faith— most of 'em weren't living it, and they didn't pretend to. For them, "Hymn Time" was great music but just part of the show.

When I started evangelizing at my country shows, I knew it wasn't a cool thing to do. I could see I was losing some of the audience. I might talk about Jesus, or sing a gospel song without saying a word, and it was offensive to some people. They were drinking and partying and here I was bringing the church, the name of Jesus, into their party. It went against their notion of a good time.

Most of 'em were good loyal fans. They appreciated the kind of old-school music I was trying to bring back, but they weren't too pleased with the old-fashioned values I was trying to promote along with it. Anyhow, I had my stadium-sized soapbox, and I had my say—and there was a price to pay. Back in the '80s, it was scandalous to some audiences for an entertainer to be a Christian and to be vocal about it. Speaking about your faith, especially in the record business at that time, was an invitation for people to mock your beliefs. There's nothing new about this. You know, the apostles Peter and John, they were rejoicing in prison, happy for the chance to suffer for the sake of Christ. Believe me, I don't try to pick a fight with the Devil every day, or try to pick a fight with the world. I just have the desire to live my faith as Peter and John did. Now, you won't win a popularity contest by doing that. But God called us to be faithful, not famous.

These days, I'm glad to say, you have proud, strong Christians in

public life—whether in entertainment, sports, or politics—who are encouraged to be up front about their faith.

I've learned to go on faith, not feelings, and I'm still learning. Trying to put the Gospel salt into a show or a stage presentation is no easy thing. There's an artful way to get your message across. For example, I'd never tell an audience they need to go to church. What I might say is, "We're gonna do one more song for you tonight, 'cause we need to get out of here so we can get back home and get to church in the morning. Haven't been to church in a month!" I am just dropping that subtle hint that I think there's value in going to church. My hope is that maybe this is enough to reach someone in the audience who has strayed from the fold.

But when I was twenty-six, having country hits and talking about Jesus in front of twenty thousand people, I hadn't learned the lessons that actions speak louder than words. I was too sure of myself in my own conviction. There was a big risk in what I was doing, career-wise. I know for sure that it was unpopular with radio programmers and industry people. I sure heard plenty from my label when I came off the road.

The top guys at Epic weren't happy with it, and they told me so. They'd say, "Ricky, we heard you were preaching from the stage again, and that wasn't part of the deal we made." I was called into the office more than once to have a meeting to discuss my actions.

As much as I understood what they were up against, I wanted them to understand my side, too. My faith wasn't like a suit of clothes that you hang in the closet the whole week long and then put on for church Sunday morning. It was how I tried to live my life, and I couldn't separate myself from the core of who I was. I wasn't a Christian artist, but an artist who's a Christian, same as I am today. My faith is more than just a religion to me. It's my relationship with Christ.

In those early years, at least, the record execs tried to get me to stop talking about my faith. But something happened that made them cool down a little bit, and it wasn't a conversion in the front office. In

1982, less than a year after my debut, my second album, *Highways & Heartaches*, was released. It went straight to number one and was certified gold. Rick Blackburn's long-shot sure was turning out a winner at the bettor's window. Not just a flash in the pan, but a tried and true Kentucky racehorse who was in it for the long haul.

Of course, it was a two-way street. My record sales put me on a longer leash as far as speaking out was concerned, but Epic was still calling the shots as far as what kind of music I was contracted to play. I wasn't so free I could just hand over a bluegrass gospel album like Emmy's *Light of the Stable*, or satisfy a craving to cut a solo acoustic record, the way I can now. It took some hard knocks down the road to get me that freedom, and man, I am so glad I made it out alive and can make the music I want to and sell it on my own.

In 1982, I won the Country Music Association's Horizon Award and Male Vocalist of the Year. Every single we released made the charts. The awards and the hit records were awesome, but nothing could compare with the thrill of joining the Grand Ole Opry. It was a dream of mine ever since I was a little boy on my Papaw's lap, listening to the Opry on the radio in his 1952 Ford pickup truck.

One day out of the blue, Opry manager Hal Durham phoned and invited me out to lunch. We'd barely sat down when he said, "Son, you're setting the woods on fire! What would it mean to you to become a member of the Opry?" Well, I about swallowed my fork. I told him what an honor it would be, and how much it would mean to me, and my family, if I were a member. And it still does mean a lot, thirty years later. You know, trophies tarnish and gather dust, and hit songs dry up. But that honor you carry as a member of the Opry is for life, if you want it to be.

On May 15, 1982, I became one the youngest country performers to be inducted into the Grand Ole Opry. I was twenty-seven years old. They made it official during the weekly broadcast from the Opry House, where so many of my heroes had stood. It was about the only stage in the world that could give me butterflies, and that night I sure

was nervous—as my dad used to say, as nervous as a cat in a roomful of rocking chairs! I was on the Ernest Tubb segment of the show, thank God, and ol' E.T. helped calm me down for the big moment. Ernest read some telegrams, and one came from Bill Monroe, who sent his congratulations. Bill wanted me to know how happy he was that I was a part of the Opry family. It was such an honor, something I'll never forget. It's still one of the highlights of my career.

I thought of Mom and Dad. I knew it meant more to them to hear me on the Opry broadcast on the radio back home on Brushy than it would for them to be there in person. In later years, they came down to Nashville from time to time for visits, and sometimes I'd be on the Opry while they were there, and they enjoyed going. But I think it was always more special for them to stay home and hear it on the radio, thinking of all the days and nights we'd worked together, all that they'd poured into me, and all the prayers they saw answered. It was sweet for them to share that together. I still listen to the Opry on weekends when I'm on the road touring, and now I can listen on my iPhone no matter where in the world I'm at.

After the show, Roy Acuff congratulated me backstage. Mr. Acuff was top dog of the Opry's cast of stars, and he could be as gruff as they come. He said, "Well, son, we made you a member, but I know it won't be long 'fore you'll be gone. Just like all the rest of these kids we bring in here. You'll be out doing shows and making so much money on the road that I reckon you'll forget the Opry, same as the rest of 'em."

Well, it really got under my feathers to hear him say that. I looked at him dead serious and said, "Mr. Acuff, you don't know me. You don't know my heart for this music and for the Opry. You just wait and see. I'm not made that way. I'm true to my word. I didn't join the Opry just for the name." In my mind, I wanted to tell him off—I wanted to say, "Old man, you're gonna eat those words!"—but I didn't because I respected him too much. Instead of mouthing off, I was gonna show him what this Kentucky mountain boy was made of. Every weekend when I wasn't on the road, I wanted to play at

the Opry. I'd make sure I went to his dressing room to tell him that
I was there. I'd poke my head in the door and say, "Hey, Mr. Acuff,
just wanted you to know I'm here again this weekend." And he'd say,
"Okay, son, I'm glad you're here." It almost got to be where I was pes-
tering him; I wanted him to eat a little crow. I finally wore him out.
One night, he said, "You win. I don't want to hear it anymore." It's
been twenty years since Mr. Acuff passed away, and I'm still showing
up pretty regular. I hope I never get to where I don't want to play the
Opry.

I loved Mr. Acuff and the Opry elders, Hank Snow, Minnie Pearl,
Little Jimmy Dickens, Grandpa Jones, Jimmy C. Newman, and all
the rest. They welcomed me with open arms. I've tried to show that
same hospitality to every new member. Monroe was right when he
said the Opry is a family. I'm grateful to have gotten to know all of
them, not just as entertainers, but as husbands and wives and fathers
and mothers.

Everybody was scared to death of Mr. Acuff, which was under-
standable, 'cause he could be a little intimidating. Nobody except Bill
Monroe and Minnie Pearl called him Roy. He was the senior states-
man, and he didn't take any guff. As serious and business-oriented
as Acuff was, though, he always made time for music. You'd always
find folks in his dressing room, strumming on banjos and playing
fiddles. He never forgot that the Opry was about enjoying the music
and having fun. There was a plaque on his door that said, "Ain't
nothin' gonna come up today that me and the Lord can't handle."

Mr. Acuff and Minnie Pearl were the heart and soul of the Opry
ever since they joined the roster before World War II. Nobody was
nicer to me than Minnie, country's first lady of comedy. She could
light up a stage with her smile and her straw hat with the $1.98 price
tag. You could hear her wild "Howdee!" for a country mile. She
loved the Minnie Pearl character as much as the crowd, but Minnie
was just a character to her. She kept her comedienne role separate
from her personal life.

Off the stage, she was Sarah Cannon, a kindhearted and digni-

fied lady. She was married for nearly fifty years to Henry Cannon, a pilot who was also her manager, and they were a wonderful example of a strong, joyful marriage. The Whites and I worked several Opry package tours with her, and we loved both Sarah and Henry dearly. Sarah didn't tell a lot of jokes, 'cause she didn't feel the need. She saved the laughs for Minnie and the show.

Minnie knew I appreciated the Opry's history, and she told me stories about the early years, like the night Hank Williams made his debut appearance on the Grand Ole Opry. It was June 11, 1949, and he was twenty-five years old. He sang "Lovesick Blues" and got six encores. The crowd at the Ryman Auditorium wouldn't let him leave the stage. Opry management had to tell the crowd to stop so the other scheduled artists could go on. How amazing is that? Minnie said there was a mysterious blue light that hung over Hank's head that night. She told me she never saw anything like it in her life.

Speaking of one-of-a-kind, Grandpa Jones was quite a character, too. Only thing was, though, Grandpa wasn't play-acting. He was an all-around funny guy all the time, and he was even funnier off stage. He told jokes and stories and kept everybody in stitches when he was around. You never knew what he was gonna say or to do. He was unpredictable, sometimes as nutty as a Payday bar, and he had a stormy side, too. You just didn't know which Grandpa you were gonna get.

There was once a comedy roast for Grandpa, and the place was packed with some real comic pistols, from George Lindsey to Roger Miller to Tennessee Ernie Ford. The party afterward was unbelievable, I'm telling you what. Everywhere you turned, somebody was cracking a joke or cracking up after they'd heard one, so I walked around, listened in here and there, and laughed till my sides about split. The biggest noise came from where Grandpa held court. He had the sharpest comebacks, and when he threw out a zinger, anybody in earshot would double over. He about had 'em on the floor!

Let me give you a taste of classic Grandpa humor. One time he called up Jumpin' Bill Carlisle, his friend and an Opry member for years. He was a neighbor of Grandpa's in Ridgetop, north of Nash-

ville, where they both had farms. Grandpa asked if he'd seen his cow, and Carlisle said, "No, I ain't seen your cow."

"Well, if he shows up over at your place, call me, and I'll come and get him."

A week went by, Grandpa called again, and he said, "Bill, I found my cow."

"You did? Where was it at?"

"In my deep freezer!" Grandpa had killed his cow and had it butchered and stored the meat in his freezer and then forgot all about it. Talk about your senior moment!

Grandpa often forgot things. Sometimes he'd forget the punch lines to old jokes he knew by heart. Mostly he'd forget the names of people, even folks he'd known for years. One night, he was introducing the Osborne Brothers, Bobby and Sonny. He couldn't remember their names, and they'd been members of the Opry for fifteen years. They were backstage waiting on Grandpa, and the audience was waiting, too. He finally hollered, "Ladies and gentlemen, here's a couple ol' boys from up in Kentucky, and they got a fine sound . . . Here's him, and him!" The boys laughed so hard at Grandpa's flub they could hardly sing.

Another time Grandpa and his wife of fifty years, Ramona, hosted the cast and crew of *Hee Haw* up at his farm for a Sunday afternoon dinner. They'd been working hard all week filming the show, so Grandpa invited the whole gang over for a big cookout. Everyone was out in the backyard, gathered along these picnic tables. Well, Ramona wanted Grandpa to give the blessing. There must have been fifty or more people there.

Grandpa bowed his head to say grace over the food, and everybody bowed their heads. Then he just froze up for a while, not saying a word. It was dead silence, 'cause everybody knew he was having a Grandpa moment. Only this time he was having trouble with the name of the Man Upstairs. He was red-faced and mad as a hornet trying to remember. "I know His name as good as I know my own," he snarled, and everybody cracked up, 'cause it was classic Grandpa.

He ended up thinking it was funny, too. He loved to make fun of himself more than anything.

Grandpa could be moody, too, and some things just set him off. Some of you may remember the knee-high work boots Grandpa always wore for his act. They were old leather mountain boots, and I'm talking *old*. He wore 'em for fifty years, and when he first got 'em during the Depression, they were already fifty years old. He had those boots resoled many a time, and he loved 'em to death. They were a big part of his stage persona, and he kept wearing 'em years after he got rid of his fake mustache. Years ago, Grandpa was working an outdoor show on the road somewhere. I heard that a drunk broke into his dressing room and stole his boots and took off before anybody could nab him. Grandpa was devastated. Folks said they never saw him as angry as they did that day. Somehow, he chased down the thief, who'd passed out in the woods wearing those boots. He was caught red-footed. From what they say, Grandpa had to yank 'em off the old drunk to get 'em back.

You hear about Grandpa going off the handle or forgetting this or that. But you know, there are just as many stories about what a good friend and neighbor he was. I know for a fact he was real good to the Whites when they first moved to Nashville. He hired 'em to work on show dates opening for him in their hungry years. He just wasn't the type to sugarcoat much, so he could come off as a grouch. Like Mr. Buck said many a time, Grandpa was a salty old gentleman. He loved the Lord, but he didn't tolerate much foolishness.

Like Grandpa Jones, Roger Miller was the same off stage as on. He always had off-the-wall jokes to tell, or something outrageous to say. He really knew how to live in the moment. He'd just hang out and be funny, as only Roger could be. He'd tell me about songs he was working on, sometimes just a phrase that popped into his head and that he'd try to get down on paper. One time he said, "Ricky, I've got the title and the hook line for a new song, tell me what you think: 'If You Won't Be My Number One, Then Number Two on You.'" All I could think to do was say, "Wow," and then laugh my head off.

Another time Roger came to Jimmy Dickens backstage at the Opry, and he held his hand down around his belly between his chest and his belt buckle, and he said, "I've had it up to *here* with Little Jimmy Dickens!" You may have heard about when Roger visited the Grand Canyon, looked out on the sunset over the west rim, and said, "Just think what God could have done if He'd had money!" It was never a dull moment with Roger.

I almost forgot to tell you a little story about Jumpin' Bill Carlisle. He was another fun-loving hillbilly from Kentucky, one of country music's great showmen, same as his brother Cliff. In his younger years, Bill was famous for jumping a good four feet high straight up right behind the mic, all the while carrying a tune—I believe he was a Pentecostal, so you can see how he could pull that off. He was still going strong in his seventies as an Opry mainstay.

One night backstage, I was carrying my daughter Molly on my shoulders. She was maybe three years old at most. We saw Carlisle coming down the hallway, and he went up to Molly and he said, "How are you, little girl?" and he pulled a funny face to try to make her laugh. Molly looked down at him, a little scared. Then she blurted out, "Daddy! He's *ugly!*"

Oh, God, did I ever wince when I heard those words come out of her mouth! I was so embarrassed. I wanted to just crawl under a log somewhere and play dead. I was trying to find a way to apologize for Molly while telling her that what she had said wasn't very nice.

Bill just grinned and said, "Ricky, the look on your face was worth a thousand dollars."

It was bittersweet to be around legendary performers in their declining years. Herman Crook of the Crook Brothers Band was in the original cast of the Opry and he made his debut on July 24, 1926. He was still a regular when I joined up, a quiet and courtly ol' fella in a suit and bowtie, never in a hurry. The Opry members knew him but hardly anyone else did. Yet he played his harmonica with such pride, and he enjoyed a good long Indian summer into his late eighties. For

a young newcomer like me, Herman was living history, the last of the old-timers.

I remember seeing Porter Wagoner in his last few months, going on stage with such dignity and honor for the Opry, for the music, and for the fans who came to the Opry. He was weak and sickly and in a lot of pain, but he never let the audience know he was suffering. It was all about the show. He was a master among the old-school country entertainers.

Some just kept on playing till the very end. On May 26, 1984, the legendary harmonica player and *Hee Haw* star Onie Wheeler, who'd worked with Acuff and George Jones and so many greats, collapsed and died of a heart attack on stage at the Opry. He died doing what he loved best, playing music.

The worst thing is to watch the Opry stars grow so feeble that they can't perform anymore. I remember Minnie's last show. I knew her bones were aching her, but she didn't complain. We went to visit Minnie in her final months after a series of strokes put her in a nursing home. Me and Sharon and the kids would go by for a visit and sing to keep her company. She gave Molly one of her Minnie Pearl straw hats, and Molly still has it. Such a kind person, Minnie was.

These precious elders taught me and my family so much about music, life, and how to soldier on. They taught me how they brought traditional music into the Opry and then expanded on it. Sure, they loved tradition, but they also embraced new artists and new sounds, and that's how they grew the tradition into the future. That's how the Opry stays evergreen and everlasting, and that's why it will always be around. So many of the elders have passed on in the last several years: Jumpin' Bill, Porter, Hank Snow. And more recently, we lost George Jones, Jack Green, Charlie Louvin, Ferlin Husky, Johnnie Wright, Wilma Lee Cooper, and Kitty Wells. Sometimes in a quiet moment, I'll catch myself reminiscing, and I'll feel like crying, I miss 'em so bad. Sometimes I can hear their voices over my shoulder, singing or talking or just encouraging me. It's that great cloud of witnesses the Apostle

Paul talks about. Minnie used to say, "Just go out and love 'em, and they'll love you back."

Sometimes you wonder, *Who's gonna fill their shoes?* as the George Jones song says. All we can do is try our best—go out on stage and sing a few songs and try to make the people happy for a while. You don't play the Opry for the money. There ain't no big money in the deal, really. You do it out of love and gratitude for the history and to carry on the tradition that's been handed down.

And you know what? There are plenty of Opry legends still with us, singing their hearts out every Saturday night when they're able, from Jean Shepard and Jan Howard to Little Jimmy Dickens and Jimmy C. Newman, and we need to appreciate them while we can. They sure don't make 'em like that anymore. Family, and the generations, that's what the Opry is all about.

Chapter 17

COUNTRY BOY

*Skaggs is blessed with the clearest and most expressive tenor voice that
has been heard in country music since Ira Louvin, and his instrumental
virtuosity is breathtaking. . . . He is not purely a traditionalist, even though
he does traditional material beautifully. His music is informed by the wide
range of music that he and other young people have heard
and played in today's world.*

—*Country Music, U.S.A.,* by Bill C. Malone

There is a famous quote from Chet Atkins in which he says I singlehandedly saved country music in the early '80s. Well, I loved my friend Chet, but I didn't quite do it all by myself. It's true I had my thumbprint in a lot of places, and I had a big role in the process, but no bigger than Reba McEntire and George Strait.

Back in '82, George and I had appeared together at the Country Radio Seminar that really set my career in motion. We started at around the same time in Nashville. Reba had been at it for a while when I got there, and she was an up-and-comer, on her way to becoming the top female country singer of the decade.

Of the three of us, I was lucky to have the first number-one hit, but they were soon nipping at my heels on country radio and on the *Billboard* charts every week. We were winning awards from Country Music Association, Academy of Country Music, and *Music City*

News, and there were plenty to go around. Things were going our way, and we were rooting for each other.

We three didn't set out to wave a banner; we were just singing from the heart, and the best part was that the music we were making was real country. In the 1980s, there was a revival going on of the old sounds we'd heard growing up. Some writers were giving it a name, the "New Traditionalist movement." In England, the journalists took to calling me a neo-traditionalist. I had to look up that term in the dictionary. There were lots of changes in the music business. We were all young kids, but we were selling lots of records and lots of tickets to our shows, and the radio was playing country songs with fiddles and steel guitars again. The fans were certainly happy about that, and so were we. It almost seemed too good to be true.

Back in those days, there were lots of different country sounds and looks. Thing was, I never fit in too good with the herd, whether it was neo this or hat-act that. I didn't sound much like anybody else, and I didn't look or dress the part. I never wore a cowboy hat, except on a few show dates in Texas, where hats are just about required. Speaking of looks, I had a few crazy hairdos that were popular in the '80s. Yeah, I plead guilty. I had some doozies. I thought at the time they were cool. My kids look at those album covers now and have a good chuckle! And I just chuckle right along with them. I don't try to defend my haircuts. I just tell my kids that back then, I thought that was stylin'.

You can check out the back-cover photo of *Don't Cheat in Our Hometown* and get a side profile look at one of the finest hairdos that money could buy in 1983, courtesy of stylist Earl Cox at Trumps Hair Salon in Nashville. Earl still cuts my hair to this day. Well, when I get a haircut, that is, which ain't all that often, now that I've got more of a shaggy sort of "Elijah thing" going on.

I like to think my music has stood the test of time a whole lot better than my fashion sense. For that, I give a lot of credit to my band. If anything set my sound apart and made it unique, it was the Ricky Skaggs Band. The reason was simple. We were a real band, a

band of brothers in a town where musicians could feel like factory workers.

Being a picker as well as a singer, I always felt part of the band. I knew they depended on me to pull my weight and take a good, hot solo on guitar or mandolin. There was a role for me leading the band besides just singing. I've never considered myself to be just a front man. I put on a show, but as a musician and a singer.

Look at a great singer like Conway Twitty. He was not the entertainer type, either, though he entertained. I toured with him and saw him perform many a time. He walked on stage and just stood there and sang hit after hit for almost an hour, and the crowd went ballistic. All he needed was his band and his voice. That's why he had forty number-one records. What an artist like Conway proves is that the music itself is enough to satisfy people, whether in a little club or a huge arena.

I'm not talking about volume; I'm talking about charisma and pure God-given talent. Ain't nobody sounded like Conway. He had his own sound that was as distinct and recognizable as Elvis Presley or George Jones. There haven't been many singers who could hold a candle to him.

In that regard, I wanted to be like Conway and make music worthy enough to stand on its own. My situation was different, though, because I had to play and sing. In the Ricky Skaggs Band, it wasn't a case of me and the band. It was us, together, making our own sound. This group philosophy went back to my training with Ralph and with J.D. Crowe. In bluegrass, the band is the most important thing, not the soloist or the singer. Monroe started that group chemistry, where the focus was on the whole ensemble. That approach is the foundation of a bluegrass band.

For all my major albums and hits, I used a full band—a country band with a bluegrass attitude. It was different than the usual Nashville way. A lot of artists used the same session players, and it gave their records uniformity. Having my own band made us sound different, 'cause we worked different. We were working in the blue-

grass tradition, where you get in the studio and record an album with the band you tour with. In fact, it was the same with the old country guys, Ray Price, Ernest Tubb, Hank Williams, Little Jimmy Dickens—they all used their touring bands in the studio.

That was especially the case with *Highways & Heartaches*, my second LP for Epic. The band was road-tested, and you could sure tell by listening. Every musician added their own flavor to the mix, and it all gelled. Producing is a tricky balance of preparedness and spontaneity. I wanted the record to sound like we cut it live. I think we got close on Rodney Crowell's "One Way Rider," where we tried to catch the drive that a band gets on stage when things really start cooking, and where the solos kept shifting into higher gears, and the music took you on a joyride that ended just a little too soon.

We were making a stand for bluegrass and the integrity it represented. By that second album, we started to make converts of people who'd always turned up their noses at bluegrass music. Maybe for some, the bluegrass sound is too nasally or too fast. All I wanted was a chance to open up their ears. Thanks to country radio, they heard my records, and they liked what they heard. And I had plenty more to give 'em where that came from!

Though I wanted my music to be popular, I also wanted to keep it clean, and sometimes that meant a compromise. Like when I had to tweak two songs from *Highways & Heartaches*. I guess the audience didn't mind, 'cause both singles went to number one. The first was a catchy tune, "Heartbroke," written by Guy Clark. I had played fiddle and sung backup for Guy on his 1981 album *The South Coast of Texas*, and the song had grabbed me. I knew I wanted to record it myself, but there was a line in the second verse that started out, "Pride is a bitch and a bore when you're lonely."

Well, I knew I couldn't sing a curse word, no matter how great the song was. I wanted to keep the lyrics clean and decent. I wasn't trying to be a prig or a Goody Two-shoes, but I just couldn't record a song with salty words that I wouldn't be comfortable singing for my mom and dad. Now, I know life ain't always clean and decent, but I could try and do songs that talked about a better kind of life.

That one word was all that was holding me back. I loved Guy's song. I just couldn't sing the line the way he wrote it, so I changed it to "Pride when you're rich is a bore if you're lonely." Not much different, but enough so that folks like my parents could enjoy the song and not be offended.

Now, you hate to take the liberty of messing with a songwriter's lyrics, especially when they're from a true wordsmith like Guy Clark. It's their song and it's a work of art and it's almost sacred. But I felt I had to do it. It was the same thing with another killer song I loved, "Highway 40 Blues."

The songwriter was Larry Cordle, and his family was neighbors of ours back home in Lawrence County, where his mother Christine delivered the mail on Brushy Creek. I had a feeling that "Highway 40 Blues" could be a huge hit, and I was ready to cut it, bringing in my buddy Béla Fleck on banjo to give it a bluegrass touch. But there was a reference I didn't care for: "My eyes are filled with bitter tears; sure could use a good cold beer."

Now, that may not seem so bad, especially in this day and age and the anything-goes-and-whatever-feels-good world that we're living in. But this wasn't about the culture now or back in the '80s, either; it was about how I was raised as the son of Hobert and Dorothy Skaggs. I didn't think it was something I'd want them to hear me singing. So I went ahead and changed the last part to "Lord, I ain't been home in years." It didn't damage the song's integrity, and it didn't alter the meaning too much. I didn't like to do it, but I felt I needed to so that I could feel right singing it and be true to myself.

Hits are great, and you need hits to have success in the music business. But it was more important to have songs that I could live with— and that the kids and the parents could sing along with, too—and not be embarrassed. Lots of country music fans agreed, and both songs went to Number One.

Funny thing was, the label had wanted me to edit "Highway 40"—not the line that I tweaked, but 'cause of the fact that it had four instrumental solos in a row. They didn't think the public could handle all that hot picking on a country record, especially on a single

targeted for heavy radio airplay. I said sure they could, if the solos were exciting enough, and sure enough, people loved it.

In that sense, "Highway 40 Blues" was a real breakthrough for '80s country radio, 'cause it brought the banjo and mandolin right up there with electric and pedal steel guitars. I know that Larry was fine with how it all turned out. He kidded me about how I'd fooled the public into digging bluegrass by adding the piano and drums and steel guitar.

After *Highways & Heartaches* did so well, with four number-one singles, Epic wanted to release another album as soon as possible to keep the momentum going. That meant it was finally time for those rough demos I'd made for Sugar Hill to get finished as masters for my third major-label release. Epic worked out a deal with Sugar Hill to purchase the tracks, and Barry Poss had been wise to wait, because Epic paid dearly.

There was one glitch. RCA, who had Dolly Parton under contract, found out that she'd sung on two songs, and there was no paperwork granting permission or approval or anything. RCA was a rival label, and Dolly was by then a huge crossover success on the pop charts. Rick told me I'd have to take off Dolly's vocals. I was so naïve about the record business, I couldn't believe it. I thought he was kidding.

"No, I'm not," he said. "RCA's throwing a fit, and they're not playing around."

So I went back in the studio and overdubbed Dolly's vocal parts, which is like trying to repaint the *Mona Lisa*. It about killed me to sing tenor that high. Pee Wee could have done it with no problem. The overdub sounded all right, it was just bittersweet that no one was gonna get to hear Dolly's angelic singing on these songs. So we were ready to go ahead and include the Dolly-less songs for release on the album.

Around that time, I saw Dolly and told her what had happened. She went through the roof, she was so upset. She said, "Let me take care of this!" Somehow she stood up to RCA and got it all worked out where in exchange for her singing on my record, I'd sing on one of her pop records later on, which I did.

This all happened just in the nick of time. We were able to restore Dolly's vocals to the master just before it went to the pressing plant. Thanks, Dolly—I still owe you one. Even before this situation finally got cleared up, though, there still wasn't enough material for a full album. We had to get in the studio and knock out a few more songs.

We'd been featuring a few bluegrass tunes on the road, "Uncle Pen" and "Keep a Memory," and I knew we could cut those without much fuss. We got in the studio and soon we had our third album, *Don't Cheat in Our Hometown.*

The title track was the Stanley Brothers song that Keith and I sang together on our first album. This time, I sang solo and overdubbed my own harmonies, and it went to number one. Sharon and Cheryl sang harmony on my next single, "Honey (Open That Door)," a cover of the Webb Pierce record that Hank DeVito had put on a mix tape for me years ago when we were in the Hot Band together. It also went to number one! One of my heroes, Albert Lee, played the guitar solo for me, and Buck White laid down a red-hot piano solo, too. I couldn't believe my good fortune.

There was some discussion at Epic as to what to release as the third single. I remember one day I was listening to Bob Kingsley's *American Country Countdown* show on the radio. He was talking about the hits from the album that had already been released. He said, "I think there's another hit on this record. It's Ricky's version of the old Bill Monroe classic 'Uncle Pen.'" Then he played it on his show! It gave me chill bumps. I thought, *Could it really be? Could this be a number-one country hit? Bob Kingsley thinks so!*

That gave me the courage to go talk to Joe Casey, the head of radio for Epic. He was the guy you wanted in your corner fighting for your singles. Joe was skeptical. "I don't think so. It's way too bluegrass." I knew he was right to a certain extent, but what was different now was my track record: eight number-one singles, some champions at radio stations, and a great listener fan base out there. "Let's try it," I said. I knew it'd be risky having a bluegrass-sounding release that was different from my other singles. I told him I'd take full responsi-

bility if it tanked. Joe said he'd hold me to that. Lucky for me, it went to the top of the charts. "Uncle Pen" was my third number-one single from my third Epic album. It was also my fourth number one that had originally been recorded as a bluegrass song.

In those days, I'd see Mr. Monroe around, either at the Opry or at some event somewhere, and he was always supportive and complimentary. He'd encourage me and say in his customary few words, "You're doing a fine job. You're keeping bluegrass in your music." It thrilled me to hear him say that. He was appreciative, and he recognized what I'd preserved, not what I'd thrown out. I'd be thinking, *Mr. Monroe's happy with what I'm doing! I'm still in the bluegrass family!*

When "Uncle Pen" came out as a single, I didn't see Mr. Monroe for a while, and I wondered how he'd react to drums and piano and a steel guitar solo on one of his signature tunes. Well, one night at the Opry, I got my answer. He walked over and said, "Ricky, you can record all my songs if you want to. I got a powerful check on that 'Uncle Pen' you did." It was sort of tongue-in-cheek, you know, his way of saying he was fine with it. I knew he didn't care for drums and electric instruments in his band, but I don't think he minded 'em in my band, and he sure didn't mind getting the royalties!

'Course, there was a big difference between my countrified cover versions and the real thing. There were bluegrass overtones in my music, especially the singing, but it wasn't bluegrass. It was an homage. People would say, "I love your bluegrass," and I'd tell 'em, "Thank you, but if you really want to hear some real bluegrass, you should listen to Bill Monroe and the Stanley Brothers."

During shows, I tried to build up bluegrass and educate the audience as much as I could. I'd ask, "How many folks out there ever heard of the Stanley Brothers? How 'bout Bill Monroe, the Father of Bluegrass?" I'd talk about the history of the high, lonesome sound and play a song to help illustrate. Whenever we were on the same show, I'd invite Mr. Monroe to sit in on our set for a few songs. I wanted my audience to know who he was, and I wanted to share the

spotlight with my hero. He was a hoot, and he loved the attention. I got to see what a consummate showman he was, and how funny he could be. He was past seventy and slowing down, but we'd gotten close enough to where he felt free to loosen up around me.

One time in Florida, I introduced him and he walked across the stage wearing these crazy-looking glasses fitted with penlights beaming on the side. It was a total surprise. He looked like something from another planet, but he still had his Bill Monroe hat on. The audience was roaring, and he was a perfect straight man playing right along with the joke with a classic *What's all the fuss about?* look. Sometimes we'd be singing together and he'd take off his hat and put it on my big ol' hairy head.

That playfulness was another side of Monroe that wasn't too well known. He had comedy in him if you could bring it out. He was a good dancer, too. If Monroe was feeling his oats, he'd show off his Kentucky back-step and bring the house down. It looked like hillbilly break dancing, feet facing forward but body goin' backward. Back in the '30s, he and Charlie used to dance on the WLS *National Barn Dance* broadcast in Chicago.

During my country heyday, I was mostly playing rhythm guitar. I'd gotten away from mandolin, 'cept for a couple tunes in the show. One time I walked into Mr. Bill's dressing room at the Opry, and he was resting on a couch with his mandolin next to him in its open case. I couldn't resist. I asked if I could play the legendary Loar, and he said go right ahead! I hadn't played it since I was six years old. Lord. When I picked up the mandolin—which, you have to remember, was almost as old as he was—it was like holding a living, breathing thing. In all their years together, he'd endowed that wood and steel with an aura that I could feel. It was his partner in life.

It felt and sounded so good. I went up and down the neck playing these little licks. I kept at it for a good while and finally laid it back in the case. He looked at me and said, "Did you find anywhere on that mandolin where it didn't sound good?" He was bragging on his precious ol' mandolin, and let me tell you, he had a right to. "No, sir,"

I told him. "It sounded great on every inch of it." I got Mr. Monroe in the studio for my next album, *Country Boy*, 'cause I wanted him to play mandolin on our rendition of his classic "Wheel Hoss." We had to overdub his part on the track we'd already cut, something he wasn't used to doing. To make him comfortable, I took out the piano and lowered the drums and cranked up the acoustic guitar in the mix he heard on his headphones, and he nailed it in the first few takes.

That record got me a Grammy Award for Best Country Instrumental. I gave my Grammy to Mr. Monroe, because he hadn't yet won a Grammy, and I thought he deserved one. He was thrilled to death, but the thrill was mine to get to bless him that way. I loved him more than any award. Here was a man who started a whole new genre of music and had never been properly honored for it. I wanted my fans to know he was cool. It didn't matter what I was doing; I wanted to include him. Even in a music video.

I remember planning the video shoot for the "Country Boy" single. In the video, I played a hayseed-turned-yuppie lawyer in New York City. The director, Martin Kahan, said he wanted to get an old guy to play the part of my grandpa. That gave me an idea, and I said, "Hey, how 'bout let's get Bill Monroe to play my Uncle Pen!" I explained about the song's bluegrass origins and how Monroe would be perfect as a cranky old cuss in the big city, chewing me out 'cause he thinks I've gotten above my raisin'. Martin asked, "Can he act?" and I said, "Sure. He'll do anything you tell him." I fibbed a little on that.

Honestly, I wasn't sure how he'd do in front of a camera, or if he'd even want to get involved in a video, and I was a little nervous about it. Martin came to Nashville and met Mr. Monroe, and afterward he told me not to worry, 'cause we had our Uncle Pen, all right! We went to Manhattan for the shoot, and we rented out a swanky lawyer's office for the morning, a downtown street for the afternoon, and a subway car in Times Square from midnight to 5 a.m. It was going to be quite a day.

The day of the shoot, we took a limousine to the hotel to get Mr. Bill, and he was there in his work pants, just as the director had

asked him to be. "I don't know why I'm dressed like I'm ready to go out and work on the farm," he said. "This is for television, ain't it? You've gotta dress up for that."

He was used to sporting a suit and tie to perform. I explained that he was acting a part, and that we'd be starring in a little skit built around the song, for broadcast on a special channel on TV. Music video was a new format in the 1980s, and ol' Bill had been around since the days of vaudeville. Once he got the concept, though, he went right with it.

You might even say he stole the show. I mean, I had fun hamming it up, but the real star was Mr. Monroe as Uncle Pen. He laid down his Kentucky back-step like a pro, and it really impressed those break dancers. They said, "Man, that is a cold-blooded step!" Same with the female dancers on the set. They were classically trained, but Mr. Bill really showed 'em a thing or two! In between the filming, he was throwing 'em over his shoulder and dancing up a storm with these gals. They loved him!

This video turned out to be a winner all the way around. There was even a cameo from the city's mayor, Ed Koch. He played a New York cab driver chomping on a bagel and lip-synching, *"I'm just a country boy, country boy at heart."* He was perfect. The "Country Boy" video was the first time a lot of people in my generation had ever seen or heard of Bill Monroe. It gave him a chance to get his feet wet in the pop-culture mainstream, and he made a real splash. It was the second video that VH1 broadcast when it first went on the air, and it's now sort of a classic. CMT still airs it once in a while.

My favorite moment during the shoot was when we took a lunch break and went to Chinatown. Jerry Rivers, the fiddle player for Hank Williams, was helping out as Bill's wrangler on the trip, and he found us a Chinese restaurant. He ordered Bill some chicken and vegetables, and Bill told the waitress to make sure and fry the chicken until it was real done to get all the juice out of it. He'd had food poisoning too many times from uncooked chicken he'd eaten in diners on the road.

She brought him a plate and set it down and was walking away when Bill hollered at her, "Ma'am, ma'am, you got any bread?" She came back to the table and smiled as polite as could be and said, "No have bread, only rice." Well, Bill couldn't believe he couldn't get a biscuit or dinner roll or even a slice of Wonder bread. He got as mad and grumpy as Uncle Pen does in the video. "That's the stupidest thing I ever heard of," he said. "A restaurant that ain't got no bread! That ain't no part of nothing right there."

That would have been a great scene to get in the video.

From shooting videos to making records to playing shows, I was busy. As my dad used to say, busy as a one-eyed cat watching two rat holes. But it was a different kind of busy from my days as a sideman. Now it was me calling the shots and dealing with the repercussions, and the stress was double. I was realizing what Ralph and Emmy and other bandleaders had to deal with—lots of new responsibilities, and lots of new things to worry about.

Thing was, I had only myself to blame. The reason I had so much on my plate was that I'd put it there, especially when I demanded to be my own producer. Now, it was worth any headaches for the artistic freedom to control what I put my name on, but it also meant a lot more responsibility. There was no way around that. If a record didn't succeed, the only one to take the heat was me. I also had a lot of extra chores. I had to find the right songs, have enough quality material for a full album, plan all the recording sessions beforehand, and then go in to the studio to cut the tracks and do the overdubs. And always on a deadline . . .

On top of all of that, I had to be out on the road as much as possible. I couldn't afford to miss shows, no matter how much I'd rather camp out in the studio. Ticket sales are how most artists make money to cover their expenses, everything from the bus payments and the salaries of the band and office staff to the mortgage and groceries.

Whenever I was off the road, there was always a project to work on—a video, a record, or a guest host slot on a TV show like *Nash-*

ville Now, where I invited Ralph Stanley on as a featured performer. There was always something to finish up on or something new to start.

Because of these commitments, I only got up to Kentucky to see my folks a couple times a year. Mom and Dad didn't wanna uproot themselves and move to the big city where I was, and I'd never have asked them to do that. Brushy was where their kin and neighbors and church was. But I sure missed 'em, and I wished they coulda seen their grandkids more.

I knew my folks were proud of me, and that's what mattered most. Same with my brothers and sister. For a while, my younger brother Gary worked on my road crew. It was a tough job, with lots of late nights and early mornings and lots of heavy lifting, but he was thankful to have the work, and I was glad to have him. Gary was always happy for my success and always rooting for his brother, same as all my siblings.

Whenever our tour hit the West Coast, my big sister Linda would come to our show and drop by backstage and say hello, and we'd get to catch up for a while. She had moved to the San Jose area because she had multiple sclerosis and the California weather was much better for her health. It was always good to get to visit with her. She passed away last year, and we miss her dearly.

My older brother Garold has always been as proud of me as he could be. He knew that having some hit records hadn't changed me. I was the same kid brother he'd grown up running the woods and jumping creeks and skinning his knees with. He's a hunter and an outdoorsman, and he always will be. You know, Garold recently got remarried, and I drove up to Kentucky for the wedding. Turns out that his bride, Janie Fyffe, was Linda's best friend from their school years, and it was great to get to see the happy couple. Gary was there, too; he also lives in Kentucky with his wife, Regina. It was a nice family reunion.

At the time, staying focused on my career seemed worth the sacrifices. I was making hay while the sun was shining, as the saying goes.

There was no telling how long that sun would last. Being a full-time performer, I was a part-time dad, but I made the most of whatever time the kids and I had together. I got to take Mandy and Andrew on the road with me in the summer when they were out of school. They got to see firsthand what their dad did for a living. Plus, they got to see a lot of the world.

It was really great when Mandy and Andrew got old enough to travel with me on the road. After the divorce, I still tried to be the best dad I could, and spend some quality time with the kids. I'd take them on tour with me during their summer vacations, and so we got to see Disneyland and some of the cool theme parks whenever our shows were nearby.

It was like a big caravan back in those days. We'd pull the buses into a park somewhere by a river or creek and set up camp for the night. We'd have a big cookout and we'd fish and we'd have fun just goofing around. The guys in the band would string up a volleyball net, and we'd pick teams and play games.

Me and the kids would stay up late and eat popcorn and watch movies on the VCR. They just loved sleeping on the bus; that was a big deal for them. They had a really good time, and I think they got a good education out there on the road. It really enlarged their view of the world. Mandy got to see Scotland with me on my UK tour in '86. They learned to appreciate other places and other people.

They enjoyed the shows, too, all the excitement and energy that comes from performing for big crowds. Sometimes Andrew would bring my fiddle or mandolin on stage when it was time for me to switch instruments. He was my little roadie, helping out as best he could. Now, Mandy, she was still so shy she wouldn't dare to walk out on that stage in front of all those people, bless her heart!

It was a lot of fun, and it was the best I could do under the circumstances. I was working 250 show dates a year, with a new record to promote every tour. I probably spent way too much time on the road and in the studio, trying to keep all the plates spinning. Sharon and I always tried to make the best of our life together. We had to schedule

times to get away, alone. Sometimes, if one of us wasn't working, she or I would join the other one on the road just so we could be together. At the same time my career was taking off, the Whites were starting to enjoy a lot of success. Once in a while they'd tour with me as my opening act, and that was wonderful, because we were together all the time. We were "making it," and I guess we bought into the idea that the busier we were, the more successful we were.

O n March 5, 1984, our daughter Molly was born. It was such a watershed moment for Sharon, and it was doubly exciting for me, not just to be a father again but to see how excited Sharon was to have her first child. It really changed our perspective and helped us slow down and take stock of our lives.

Sharon's view of success started to change when she had Molly. She had seen how Cheryl's life had changed when she had her daughter Rachel. I believe in the back of Sharon's mind, she was thinking maybe it was time for her to be a mother, too. We didn't do anything to stop it but just prayed for God's perfect timing.

Sharon didn't want us to have to raise Molly on the road, where things can be unscheduled and inconsistent. She wanted Molly to sleep in her own bed every night. Sharon started touring less. I went home whenever I could. And we hired a wonderful Christian couple named Earl and Sheila Green to be with Molly when we couldn't be.

The Greens were sort of like another set of grandparents for our children. But they did so much more than care for the kids. Earl took care of our yard and the house repairs like our home was a fancy estate. And Sheila did the laundry and housekeeping chores. Earl had served time in Folsom Prison, but he'd been rehabilitated and we saw a gentleness in his heart. He was a humble and hardworking person, and he was good to our children.

Sheila and Earl were truly part of our family. Later, after our son Luke was born in '89, the Greens took the kids to church on Sunday if we were on the road playing weekend shows. And they worked for us for years, even when Sharon was home-schooling the kids

for a while, as she did until Molly and Luke were in high school. It took the worry and pressure off Sharon and me to know the kids were with such great folks who loved them as if they were their own. When Mr. Earl passed away, the kids cried their hearts out, they loved him so much. It was like losing a grandparent for them. We were blessed to have the Greens in our lives, and in our family.

Sharon's a great mother, and she's a great musician, too. She has a great voice and great ears as well. I've always admired her ability to hear a good song and recognize how it could work for her and the Whites. She knows a good musician when she hears one, too! There have been some great ones that came through the Whites' band: Jerry Douglas and Tommy White, to name just two. I've got so much respect for her musical judgment.

Sharon has been such a positive force in my life. She believed in me at times when I didn't have much faith in myself. Like in 1985, when I was up for the CMA's biggest prize, the Entertainer of the Year award. I figured the competition was too much, going up against top-selling groups like Alabama that were popular not only with fans but with the Music Row establishment.

In the weeks before the awards show, Sharon kept telling me I was gonna win, saying it was my year. I didn't think so, and I didn't want her to get her hopes up only to be disappointed. But nothing I said would change her mind. When the presenter called my name as the winner, I was as surprised as anybody. Not Sharon, though. She just said, "When are you gonna start listening to me?" We both had a big laugh!

Let me tell you, I was definitely starting to learn. The year before, Sharon had seen something in me that I couldn't see in myself. That time, I paid attention.

We had a two-week tour of Canada coming up, and I found myself without an electric guitar player. I couldn't find a replacement, hard as I tried to. All the guys I knew from Emmylou's Hot Band were busy or unavailable. Albert Lee was working for Eric Clapton, and I couldn't afford James Burton, one of the all-time gods of the Fender

Telecaster, idolized by everybody from Keith Richards to Clapton, who said it was James that first inspired him to play guitar. Then I thought about Vince Gill from my Boone Creek days, but he was trying to get a record deal for himself, so he wasn't available, either.

With only a week to go before the tour started, I was in a serious bind. Sharon saw me worried sick about it, and she said, "Ricky, you can play electric guitar. I've heard you play, and I know you can do anything if you set your mind to it." She'd actually seen me play a little electric Telecaster-style mandolin (I called it a "Mandocaster") that Joe Glaser had made for me. 'Course, that was an electric mandolin, a whole different animal.

Now, it's true I'd played some acoustic lead guitar, but I'd never seriously considered taking over those duties entirely. I told Sharon there was no way I could get comfortable enough on electric guitar in a week to avoid embarrassing myself on stage. But Sharon really persisted, and eventually I started to believe her when she said, "You can do this!"

That night we went to bed, and I couldn't sleep. I kept thinking, *Maybe she's right.* About four in the morning, I went downstairs and plugged a guitar into an amp and turned the volume down low and started playing. I knew all the licks in my head; I just had to figure out where they were on the guitar. The hard part was trying to learn the backup fills the lead guitar needed to play while I was singing. It was a tall order, the toughest challenge I'd ever had as a musician.

So I decided to learn the intros and the turnarounds and the solos on about a dozen songs that absolutely had to have that electric guitar sound. Then I just set down with my records and practiced those backup fills like I used to do with those old Stanley Brothers LPs.

In less than a week I had the lead guitar down good enough to head out on the tour. Well, I was *hoping* it was good enough. The first night I was really scared. Not just for myself, but for the whole band. I didn't want to let them down or embarrass them in front of the fans. Backstage, the guys were as nervous as I was. Everybody was on edge, 'cause we didn't know how it was gonna turn out.

Finally the moment of truth came: I was holding a custom-made purple Joe Glaser Fender Telecaster plugged into an amp. I was armed for battle, and I thought I was ready. Then I looked out at 15,000 people in the seats, and I thought, *What are you doin', Skaggs, are you crazy? They're all gonna know you're green as a gourd.* It was too late to turn back now. We kicked into "Honey (Open That Door)," and it sounded pretty daggone good. The guys gave me a thumbs-up by the first solo, and I could tell by the smiles on their faces it was working. I passed the "Heartbroke" test, and I survived all the breaks on "Highway 40 Blues," and by then, I knew I could play. To be honest, I'd hate to have to listen to the tape of my performance that night, but it was good enough to get us through the concert.

After the show, I called Sharon and shouted over the phone, "Thank you so much for telling me I could do this! I love playing this guitar, and I love you, too." For the next four years, along with my other duties, I played the electric guitar in my band, and I enjoyed every minute. You can hear how much fun we were having on the *Live in London* album, recorded in 1985, and yes, that's the purple Glaser Tele that I'm holding in the cover photo. I still have the Tele, and my son Luke's played it and thinks it rocks. Which it does. Purple used to be my favorite color; now it's plaid!

At that time, I had a pretty good-sized organization, with lots of moving parts—a manager, a band, an office staff, and a road crew, as well as two buses and a tractor-trailer to haul our gear to the show dates.

I always tried to be good to the fans on stage and off. It's easy to be polite and smiley-faced when it happens to be convenient, but it's a lot harder when you're dining out or shopping. Country music fans are as devoted as any you'll ever find, and most just want that moment to connect in person. Sometimes it was an autograph or a handshake or a hug. Sometimes it was a picture. Those just-off-the-bus, hadn't-had-a-shower, looked-like-a-dog-and-smelled-like-it-too shots were hard to do, I admit. But most of the time I said yes, because I knew that without those fans, none of the mouths would ever get fed. I had

my fans to thank, right after God, for my success, and am so grateful to them.

To this day, I still remember the wise words of Ernest Tubb, "Be good to your fans, 'cause they're the ones who got you here," and that's the truth.

Around this time, when I was wrestling with success and learning how to handle it, I was lucky to have Johnny Cash as a friend and a role model. I first met him in 1979 when I worked on the sessions for his *Silver* album, which Brian Ahern produced. I played fiddle and banjo and 12-string guitar on a few songs, one of the rare times Cash ever used a fiddle on a record. Talk about nervous: Try laying down a fiddle solo with the Man in Black a few feet away staring you down. Then I had a chance to be a part of his 1983 Christmas TV special, which was broadcast from the Carter Family Fold in Hiltons, Virginia. I sang Monroe's "Christmas Time's A-Comin'" with my country band. It was such a joy spending time there with John, his wife June, and the Carter Family, especially knowing that all the Carter girls had grown up in Maces Springs, just a ten-minute walk from Hiltons. 'Course, A.P. himself had walked these hills. It's hallowed ground for country music.

Well, now John and June were our neighbors in Hendersonville, and we got to know them pretty well. They were wonderful to Sharon and me. The local police used to lock up John every year for a charity fundraiser, and it was always a kick to pick up the phone and hear his voice: "Uh, Ricky, this is John. They've got me in jail again, do you think you could help bail me out?" I'd say sure, and he'd play it to the hilt: "Well, whatever you can give will help the Hendersonville Police Department, and help get me outta this here cell, too!"

John was a superstar, but you'd still see him down at the Kroger's or the post office or wherever; he didn't want to hide from people and be a celebrity recluse. I appreciated that about John and June both. As much as they could, they didn't let fame run their lives. Sharon and I took their example and decided we were not gonna let our popularity as country performers keep us from going to the store, to church, or

to our kids' activities. We're gonna be part of the community just like everybody else.

John and June loved to entertain and have people over to their house for dinners and social events. We lived close by and were invited a lot, and it was always a treat. Sometimes they had a preacher come over; he'd bring the Word, and we'd have a sort of Bible study after dinnertime was over. It was always great to hear John read the Bible or pray. He was a big inspiration.

We looked forward to our visits to John and June's, and we became good friends. They were like everybody's grandparents, really, especially in the way they doted on their guests. They followed the old-time tradition of folks in the country, giving something to their guests when they left at the end of an evening. June would want Sharon to pick out a dress or an outfit she liked from her wardrobe, and she wouldn't take no for an answer. "Aw, Sharon, honey, I've got so much stuff. I'll never be able to wear it all."

One time John took me back to his closet room, where he had his pocketknives and watches and keepsakes he'd collected over the years. John knew that I loved antique pocket watches, and during one of our visits he wanted to give me a rare vintage railroad watch from France, the kind that conductors carried in their pockets. I held it in my hands. It was forged from coin silver, and you could feel the craftsmanship that went into it. Solid and built to last. I told him, "No, John, that's way too nice to give away," and he said, "No, you take that home and enjoy it. I've got more of these watches than I'll ever be able to wind up."

And that's the way John was, as humble and generous as anybody I've ever met. I knew the watch was a token of friendship and affection, and it came from the heart of a man who'd been through a lot of suffering and pain and grace and redemption. I've kept it to this day, and I will always cherish it. It still works when I wind 'er up. I wouldn't take anything for that ol' railroad watch. Thanks, John.

Chapter 18

HIGHWAYS & HEARTACHES

Talk about suffering here below, and let's keep following Jesus.

—"Talk About Suffering," by Doc Watson, 1964

In 1986, I was at the top of my game. About every song we'd released as a single had gone to the top of the country charts. I'd had eleven number-one hits in five years. It was almost more than I could believe.

That summer, I had a few days off from the road. It was nice to rest up and spend time with the family at home, doing not much at all. We were living in Hendersonville, a few miles north of Nashville, and we loved the peace and quiet.

On August 17, 1986, Sharon and I were coming home from evening church service. As I pulled into the garage, the phone rang in the house, and I ran to get it while Sharon got Molly out of her car seat.

It was Brenda. That weekend, she and Andrew had gone to northern Virginia for a family reunion while Mandy had stayed with my folks in Kentucky. Brenda was raising the kids as a single mom in Lexington. We tried our best to be civil, and we were on pretty good terms with each other, as good as we could be. It's never a good divorce, no matter what you try to do. Anyhow, we stayed in touch, so I figured Brenda was just letting me know they'd made it back home safe. I was wrong.

"Andrew's been shot," she said. "We're at the hospital in Roanoke, Virginia. Get here as quick as you can!"

"Oh, no. Where'd he get shot?"

"In the face."

That was all she could tell me right then. She was so distraught she could hardly talk, and I could tell she was in shock. I'd never heard her sound like that. I told her I'd get there as soon as I possibly could.

I called my manager Chip Peay in a panic, and he arranged for a plane to take us to Virginia immediately. Then I called a close friend, Milton Carroll, who knew how to pray, and I asked him to come along with us. We left around midnight.

On the flight, my mind was spinning. I was wondering how in the world Andrew had been shot. He was seven years old, and he knew better than to fool with guns. The only thing I could imagine was a freak accident at the reunion. Maybe his older cousins were out banging around in the woods with a .22 rifle, and Andrew tagged along. Maybe someone had accidentally shot him.

We got to Roanoke Memorial Hospital at two in the morning, and I went straight to Andrew's room in the pediatric intensive care unit. His face was swollen, and he had a hole above his mouth. He was breathing with the help of a machine. He was in real bad shape, worse than I'd imagined. It was awful to see him like that. I just wanted to hold his hand for a while.

Brenda then explained what had happened. On Sunday night, she and Andrew were southbound on Interstate 81, heading home to Kentucky after the family reunion in Virginia. She was driving, and Andrew was up front with her. A few miles north of Roanoke, she got behind an eighteen-wheeler that was weaving in and out of the lanes, and it nearly ran her off the road a couple times. She tried to pass, but there was a construction zone, so she was stuck behind the driver for some time. This trucker was driving like a maniac, and it was making Brenda nervous. She had a long drive ahead of her, and it was already getting dark.

When the highway went back to four lanes, she tried to get past him again. By now, he was swerving his truck all over the road. She flashed her headlights and laid on the horn to warn him. She was trying to steer away from a bad situation before it got worse. All she knew was she wanted to get clear of this crazy driver.

What Brenda didn't know was that the trucker was high on drugs and out of his mind. He'd just driven a coast-to-coast run, and he'd been awake for days. He was so high he didn't even know he was headed south on I-81. He was supposed to be hauling his rig north back to Maryland. When he saw Brenda's car trying to pass, he became totally enraged.

As she drove by in the left lane, Andrew was in the passenger seat. He was looking up at the trucker and making the ol' arm-pump motion to get the guy to blow his horn, the way kids do when they see a big rig rolling down the highway. 'Course, the only one laying on the horn just then was Brenda. At that moment, the trucker shot into the car with a pistol.

Now, if Andrew had been looking straight ahead, that bullet would have likely hit him in the temple and killed him instantly. But because his head was turned, and he was looking up at the cab of the truck, the trajectory was such that the bullet hit him above the upper lip and went through his mouth and lodged in the backside of his neck. A single shot through the passenger-side window. Andrew fell over, bleeding all over the seat. Brenda was screaming as she pulled off I-81 at a truckers' weigh station to get help.

Hours later at the hospital, Brenda was still shaken up. While I was trying to make sense of what had happened, Andrew was fighting for his life. The bullet had ripped a hole above his mouth and damaged his palate, five or six teeth, his tongue, and one of his tonsils. There were shards of broken glass from the window embedded in his face and right eye.

That morning, surgeons from the trauma team were able to remove the bullet, and they tried to clean out as many of the glass fragments as they could. The operation went as well as they'd hoped

it would, and it looked like he was out of danger. We thanked God that He had spared Andrew's life, but it was an incredibly close call.

Turned out the bullet was a .38-caliber. Now, how did that bullet go through his teeth and bones—right past the jugular vein and his carotid artery—and get lodged in the backside of his neck without touching any major blood vessels or doing deadly harm? I don't believe that part of it was an accident. I know who guided the bullet and saved Andrew from a certain death. The Lord, strong and mighty, in whom there is no weakness!

Most of all, I was just grateful Andrew was alive. But there was a real sense of anger, too, at first. It was such a senseless, random act of violence that had happened to my son. I was emotionally blown away. I was thinking, *Why him, Lord?* That question ate at me: The Lord had promised me when my kids were born that He'd take care of them, and I believed Him. I now had a lot of unanswered questions.

This was a situation where I knew I couldn't trust my feelings. I had to go to a deeper place and put my faith in God.

It was hard to get a grip on the rage I felt for the man who almost killed my son. We found out later that he'd been listening to his CB radio and heard about a little boy who'd been shot by a trucker on I-81. He realized what he'd done and stopped at a weigh station and turned himself in. Authorities searched the cab of his truck and found drugs and pills. And there was the pistol, loaded with bullets. One had been fired. It was a case of road rage that turned violent.

Andrew happened to be in the wrong place at the wrong time. Well, fine, but I was still angry inside. How could I feel anything else toward the person who caused Andrew so much pain and suffering? And poor Brenda, I'm sure she went through that whole scene a hundred times in her mind. How could a parent not have bitterness in his or her heart? But it was Andrew who showed me a way out. We were in his hospital room after the operation, and he was able to talk a little with us. He was having a hard time understanding

why it happened. I told him that the police had caught the man who shot him. I tried to explain that the man wasn't in his right mind. It was just a terrible accident. Andrew looked at me real sad and said, "Daddy, we need to pray for that man, and we need to forgive him, too, 'cause he doesn't have Jesus in his heart."

When he said those words, I felt like I'd been grabbed and shaken. Here I was feeling hate, and Andrew was talking about forgiveness. I knew right then I was the one who needed to forgive. How could I hold bitterness in my heart against the man when Andrew had already forgiven him? God was teaching me through my son. He'd been raised up right by his mother, and his grandparents, too, and he'd been taught Christian values, so his natural reaction was to forgive.

I told Andrew how happy I was to hear him say that he forgave the man. Then I told myself I needed to forgive him, too. I knew it would take some time for me to get to that place, but I would. The only way to reach complete and lasting forgiveness is through the Lord Jesus and His example on the Cross, when He said, "Father, forgive them, for they know not what they do." How can we hold unforgiveness when God has forgiven us so much?

Right then, though, I had other things to deal with. The doctors had run more tests, and there was a problem. After studying the X-rays, they found a slight bruise in Andrew's carotid artery. It was caused by the vibrations of the bullet as it went through his neck. Those vibrations were strong enough to damage the lining of the artery and almost puncture it. That "almost" is what saved Andrew's life, and here again, we were reminded of God's grace.

He'd been spared, but now there was the matter of the damaged artery to reckon with. Tiny as the bruise was, it could become dangerous if it went untreated. There was a young doctor and an older doctor. They told us there had to be a decision made. The younger one thought Andrew would be all right without risking another operation. But the old doc was leaning the other way, and he advised us to take care of it now. "This is your call," he said, "but I feel like we

need to go in and repair the artery just in case. If he were my grand-son, I'd do it."

He told us that Andrew might be fine without the operation. But someday he could be playing football or engaged in a strenuous activity where he worked up a big sweat and got his blood pumping, and that was when this artery could go out on him. So we had to decide whether to take the risk of operating or just hope for the best down the road. We decided to let the doctors do their work.

The operation took an hour and a half, the longest ninety minutes of my life. The surgeons found a bucket-handle-shaped tear in the inner layer of the artery, just what they were looking for, and they stitched it up. When they told us the operation was a success, we prayed and thanked the Lord again for His faithfulness.

Get-well cards and best wishes came pouring in, mostly from strangers letting us know they cared. We heard from old friends, too. We got a phone call from Johnny Cash, which was so encouraging for Andrew. John told him, "Not everybody is tough enough and brave enough to go through what you've been through. God must have a real special plan for your life, son, if He spared you like this." How cool was that? That lifted Andrew's spirits, and who wouldn't feel better after being told by Johnny Cash how brave they were? It was quite an act of kindness, and an example of how great a man he was.

Andrew was getting cards, flowers, balloons, and presents from all over. There were so many flooding in that the nurses had to store 'em in another room. FAO Schwartz, the toy store in New York City, sent a huge box of stuffed animals and toys. Andrew was embarrassed by all the attention. He said, "Dad, I can't take all these presents for myself." So he gave a lot away to the other kids at the hospital.

The biggest get-well card came from Knoxville. It was a poster-sized card signed by truck drivers from across the country who wanted us to know how sorry they were. They wanted to make sure Andrew understood that most truckers were hardworking family men who loved to blow their horns for kids, and that they were on the road to help people, not to hurt 'em.

After Andrew came home from the hospital, things were still really tough. It was a long, slow recovery. It was months before he could eat solid food, and even longer before he could go back to school and play with his friends. It was hard on everybody, but especially for Mandy, with her brother needing so much attention. She was a wonderful big sister, though, and she helped her mama a lot.

I know that for me, Andrew has been a big part of my faith journey, and what happened on that highway in Virginia was only the beginning of it. He would bring me to my knees a few more times.

The truck driver got forty years in prison. Somebody asked me if I thought forty years was long enough. This person didn't think it was, not for such a heinous crime. I said it was enough punishment. I was satisfied, knowing justice was done. By then, there was no anger. There was nothing I could do to call back what had happened.

I had to let it go, taking a lesson from Andrew, and from the Lord Jesus. I had to forgive the man and release that anger from my heart. Unless you can picture yourself in the person you want to forgive, it doesn't work. You have to take that person to the Cross with you, at least in your own heart and mind. Having anger toward someone is like taking poison and hoping the other person dies. It will kill *you* instead.

I never met the man. I stayed out of it as far as the trial and the sentencing was concerned, 'cause I didn't want my stature as a public figure to sway the jury in any way. I didn't need to shake his hand or tell him I'd forgiven him. It was between me and God.

By this time, my career was driving me, and I was just hanging on for the ride. Later that year, a duet with Sharon, "Love Can't Ever Get Better Than This," reached the top ten, earning us the CMA's Vocal Duo of the Year award in 1987. To share that honor with my wife was the best thing in the world. I was so proud to see Sharon get recognized for her singing talent.

After this song, Sharon and I wanted to do a whole album of duets. The timing seemed right, and we thought there was an audi-

ence for a record by a young couple in love and happy to sing about it. Well, Epic shot down our idea before it even got off the ground. They were worried that promoting my happy marriage with Sharon would hurt my record sales among young single women, who were a big majority of record buyers. I thought that was ridiculous, and I told them so. They didn't know about the Christian marketplace that would have been there to support us, a great opportunity not taken.

Soon came more disappointment, and more bad blood between me and Epic. I wanted to do a gospel album, and that idea was also nixed by the front office. They thought a religious record would turn too much of my fan base against me and damage my sales. Looking back, I think they were trying to protect me as much as themselves, as misguided as I thought they were at the time.

I decided I'd do a gospel album if I wanted to, so I set up a recording session. Right around then, a friend of mine, Bob Jones, called, and I told him what I was planning. Instead of giving me a pat on the back like I expected, he said, "Ricky, you don't need to do a gospel album to let people know you're saved."

Bob told me what I needed to hear, not what I wanted to hear. I knew I'd been caught letting my pride get the best of me. I canceled the session. I had to come to a painful realization. God was not going to honor my rebelliousness or self-righteousness. I'd convinced myself I was defending my faith, but in fact, I was doing it all for the wrong reasons. It was a good lesson to learn, and I didn't get bitter. All I could do was focus on the good stuff. I got a chance to record with James Taylor on "New Star Shining." That was a real thrill for me. I've always loved his singing and guitar playing, and here I was getting to sing a duet with him. I'd come a long way since I was that Kentucky kid in a VW Super Beetle cranking JT's *Mud Slide Slim* on the eight-track machine.

When I met him, I told JT the story about crashing my brand-new car while listening to his singing. He said, "So the music was so bad it caused you to wreck?" I told him it was some of the best music ever, and that the album was still a favorite of mine.

The Whites were by now having quite a bit of success on country radio. They were very excited to become members of the Grand Ole Opry in 1984. They were traveling quite a bit because of their radio success. Touring was just a part of life, same as making records. One fed the other.

One night I was out somewhere in the Midwest pulling an all-nighter on the highway to the next show date, and my driver pulled into a truck stop to fuel up. Unbeknownst to me, the Whites' bus was in the next lane over, also fueling up on the way to a gig. One bus was pointing one way, one bus the other. After both buses fueled up, the drivers went in and had a cup of coffee together.

It was three in the morning. Sharon was asleep on her bus, and I was probably fifteen feet away asleep in my bunk. After a while, the two buses pulled back onto the highway, Sharon going one way and me going another. Neither of us even knew about it till the drivers told us the next day. It was the weirdest feeling, and it made us think about just how crazy things had gotten. We weren't like two ships passing in the night, but we were often apart. We took it for what it was, though, the reality of life as a performer.

I have to admit that I wanted to fire my bus driver for not waking me up. I didn't, though.

In 1988, my record sales had dipped, and my advocate Rick Black-burn had decided to leave for another record company. One day not long before he left for his new job, I was in Rick's office and his boss, Walter Yetnikoff, the head of Sony in New York, called. Rick and he talked a while, and then Rick looked at me and said, "Well, he just walked in my office. Why don't you tell him?"

I thought maybe I was gonna get a talking-to from the Big Boss Man. By then Epic was owned by Sony, so there were a lot of changes going on. The first thing they do when they change things is look at your record sales. Don't know if I had that hunted look or not, but it sure felt like it.

I said, "Hey, Mr. Yetnikoff, how are you, sir?" He said, "Ricky, my

boy, we gotta get you selling records in the pop market. That's where the real sales are."

Walter was a very flamboyant character, as loud and persuasive as anybody in the music business, and he meant it as encouragement.

Well, I wasn't buying into it, 'cause I knew myself, and this country boy with his high tenor voice wouldn't have a clue how to make a pop record. But I was polite to Walter, and I told him, "That will be great. Hope we can do that."

His call didn't make any difference, to be honest. I'd already flirted with a new style and approach on my previous album, *Love's Gonna Get Ya!*, and it hadn't really connected with country radio, or with any other radio market. It was my fault as much as anybody's, 'cause I was the producer. It was a case of trying too hard to reach new ears, I guess. I was trying to venture out and try something different. The pop group Orleans had sent me a demo I liked, "Artificial Heart," and I'd invited them to sing backup.

At the time, I'd let my manager go, and I was getting some advice from a New York producer, a guy who'd worked on hit records with Gloria Estefan and Miami Sound Machine. He had an idea to sort of get me crossed over to a broader market, and I was listening. He was in the studio when I was recording and mixing the album, and he was nudging me to not be so traditional. It was kinda of an experiment for me, like, How far can I go and still be country? Well, it turned out I went too far, and my fans didn't like my new direction. The single for "Artificial Heart" tanked, and so did the album.

Along about then, Dad said to me, "Son, you really oughta do you a good bluegrass record."

Now, Dad, he was one of my biggest fans, probably the biggest of all. And here he was speaking as a fan, and he was seeing that I really needed to reel it back and be true to my musical calling. Because of contractual obligations, I couldn't cut a bona fide bluegrass record, but I sure could get back down to basics, and that's what I did.

So I decided that even if my record sales were down, I wasn't gonna compromise. I wasn't a crossover artist and never had been. I

made up my mind I was just going to make the best records I could.

With nothing to lose, I cut an album with the prophetic title of *Comin' Home to Stay*, and I meant it. I invited J.D. Crowe to guest on an old Jimmy Martin favorite, "Hold Whatcha Got," and a batch of other solid songs. I tried to go back to the old-school chemistry I'd had on *Waitin' for the Sun to Shine* and *Highways & Heartaches*, but popular taste had shifted again.

Folks were ready for new sounds and new faces. By then, me and Reba and George Strait and the rest of the Class of '81, we'd had a great run for six or seven years. Now there was a new wave of rising stars like Randy Travis, Ricky Van Shelton, and Clint Black, young and hungry as we had been.

The sales for my records just weren't there, and Sony suggested it was time to make room for somebody else in the control booth. Well, I had told Rick at the beginning that if I wasn't selling records and having hits on radio, then I'd take on a coproducer. So I gave into the label's demand, and it turned out to be a good thing, but not without some struggle.

My next album, *Kentucky Thunder*, was coproduced with Steve Buckingham. It was a little rough going at first, working with someone else, but Steve and I eventually found our groove. Buckingham was a supportive producer, and he had a nose for hits. We had a number-one single with "Lovin' Only Me," and a top-five single called "Let It Be You," a beautiful love song that was popular with young couples. It became a wedding favorite.

Earlier, Steve, or "Buck," as I took to calling him, had asked me and some guest singers to help out on an important project he was working on for Tammy Wynette called *Higher Ground*. She was going through a dry spell, and he wanted to steer Tammy back to basics and let her shine. There was one track, "Your Love," on which I recorded several harmony parts, including a vocal so high Buck said, "That's as high as a dog whistle!"

I wish I could get my voice up there now!

Tammy was so appreciative and gracious. *Higher Ground* was a

critical success and a commercial comeback as well. "Your Love" hit the top twenty, and I was so happy for her, 'cause she'd been suffering a lot in her personal life. But she was able to turn that pain into something she could express through her art. She came out of a country tradition where singers lived what they sang and sang what they lived. She truly was the First Lady of Country Music, and that's why she still has so many devoted fans fifteen years after she's been gone.

I enjoyed working on side projects, especially when it was with living legends like Tammy, but I was starting to overextend myself again. I thought I had my career, but my career had me. I didn't know when to quit. It was too hard to say no, and let me give you an example.

In 1988, I was in Los Angeles doing a guest spot on Dolly Parton's TV show. Afterward, I was packing up to leave and asked her when she was gonna do another country record, a *real* country record. It had been a few years since crossover success had made her a pop star. And she said right back to me, "I'm gonna do one next, and I want *you* to produce it." It was that quick and spontaneous, 'cause that's how Dolly is. I wouldn't have dreamed of turning her down, 'cause she's one of my all-time favorite singers and songwriters. And I was so grateful she'd lent her gorgeous mountain voice to my early Epic records, too.

Next thing I knew, Dolly was calling me to get started, and we went right to work. She'd written a beautiful ballad, "Yellow Roses," and a bunch of other songs, and I had some tunes picked out specially for her. Talk about talent. Dolly can sing the phone book and make it sound good. She's also an incredible perfectionist, and she sets the highest standards for herself.

That project was her return to country music, *White Limozeen*, and it was such a thrill to collaborate with her in the studio. More recently, she's gone even further back to her east Tennessee roots with some fine bluegrass albums like *Little Sparrow*.

Thing was, it was one of a handful of projects I was juggling at once. I was finishing Dolly's record, producing a gospel album for the

Whites, and then starting another album of my own. Meanwhile, I was on the road for more than two hundred shows dates a year with a full band and road crew, and trying to stay alive on the charts. I knew I needed to cut back on my schedule. I was praying that God would open up something where that could happen.

For a while there, I was a good-sized fish in a small stream. Then came the flood of new artists and young acts, and I found myself in a big rushing river with a whole lot more fish trying to swim. The current was stronger, the dangers were more present. It was starting to feel like I was in survival mode.

Just when I was trying to slow down career-wise, Keith Whitley's star was on the rise in Nashville, and it was a long time coming. He had finally found the right producer and the right songs to fit his one-of-a-kind style of singing. He was finding success in his work and happiness in his marriage to Lorrie Morgan, and I was glad that things were finally going his way.

We did some shows together when we could, and we saw each other from time to time. I remember me and Sharon going over to Keith and Lorrie's place in Goodlettsville after their son, Jesse, was born. We wanted to see the baby and bless and love on him. I was so happy for my old friend.

We spent almost the whole day there goofing off like old times, back when we were kids with peach fuzz on our chins and riding with Ralph. Who'd a-known that road would lead us here together, living out our dreams in Nashville, making records and raising families.

We talked about the night when Whipple Ferguson got in my dad's face at the bar in Ohio, and we laughed so hard that Lorrie thought we were out of our minds. She'd never heard that story. She loved hearing about Keith and me when we were teenagers. It was great to see Keith so happy with his new family, 'cause I had heard the stories around Nashville about his battles with the bottle. You know, back in the days when we were with Ralph, I saw Keith take a few drinks of whiskey, but in my whole life I never saw Keith drunk.

When his album *Don't Close Your Eyes* went gold, things started happening fast for Keith, same as they had for me in '81. We both were so busy, too busy for each other. He'd call and say, "Hey, we're getting ready to play softball tonight, wanna come over?" And I'd have to say, "Got something going on, so we can't make it, but give me a call next time." A few months later, I'd be calling him, "Hey, we're gonna have a cookout at the house, why don't y'all come?" And he'd have to take a rain check: "Gotta leave at eight tonight to go back on the road." It had gone on like that for years.

We still loved each other like brothers, though, and when we did get together, it was like a homecoming. We'd hug each other and hang out as long as we could. But that didn't happen often enough. There just never was enough time. I look forward to heaven, because I know I'll get to visit with old friends and family as long as I want.

In the spring of 1989, Keith was riding high with another hit, "I'm No Stranger to the Rain," and his voice was all over the radio. One Friday night, I was working the Opry, Lorrie was, too, and Keith was out with her for the performance. We were backstage in the green room talking and goofing like we always did. Keith was a star now, he'd finally made it to the top, and yet, he was still the same ol' rascal.

Sharon and the Whites were on the Opry that night, too. Keith knew Sharon was pregnant and the baby was coming soon, so he asked, "Y'all got a name picked out?"

I said, "If it's a boy, I think we're gonna call him Luke, short for Lucas Buck," after his granddad, Buck White, and 'cause Sharon and I loved the sound of Luke. So did Keith. "Man, I really like that name, Luke Skaggs," he said. "Sounds like a shortstop!"

About that time, Lorrie walked by and said she was next on stage. Keith got up grinning his big wide Whitley grin and said, "Well, I'd better get out there and see the wife sing." He gave me a bear hug and said we should get together soon. I said we would. As he walked toward the stage entrance, he turned back and looked at me with his big blue eyes and his big smile, and that's the last time I saw him.

A few weeks later, on May 9, I had to take a trip back to eastern Kentucky to speak at a memorial service. There's a cousin of mine, Gloria, who ran the grocery store in Martha, Kentucky, Gar Ferguson's store. She's married to Gar's son Ralph. Well, their teenaged son had died in an accident—he was cleaning his gun and he shot himself. Gloria called and asked if I could come and give a talk to his classmates and friends and maybe sing a song.

Ain't no way I could have said no to that. Little Luke had been born five days before, on May 4, but Sharon said she'd be all right, and I decided to make a day trip and get back before dark.

So I drove to Sandy Hook, where they were holding the service at Elliott County High School, the same school Keith had gone to. On the way, I passed by the Whitleys' house, where Keith's mother, Faye, still lived, just down the road from the school.

At the memorial service, I told the kids how important it was to stay close to their parents and to cherish their moms and dads and brothers and sisters, and to try to live a life that's pleasing to family and pleasing to the Lord. I encouraged them to always try to make things right with each other and to cultivate friends and to not have enemies. I spoke to them from the heart, like any father would.

Heading back home, I drove past the Whitley house again and noticed three or four cars parked in the driveway. I was thinking how much I'd love to stop by and give Miss Faye a hug and say hello. It had been so long, I was thinking. But it looked like she already had company over. Maybe it wasn't a good time to just show up on the doorstep. Besides, I really needed to get back home to be with Sharon and the baby.

Somewhere around Winchester, Kentucky, I got a phone call from Sharon. She asked if I was driving, and I told her I was. She said to pull off the road, 'cause she had some bad news. I was afraid maybe something was wrong with Luke, but she said he was fine. I stopped the car on the shoulder of Interstate 64, wondering if something had happened to Mom or Dad.

Then Sharon told me it was Keith. They'd found him dead earlier

that day in his home outside Nashville. He'd died of alcohol poisoning. I said that I'd just driven past Miss Faye's and that something had told me to stop by, but there were cars parked outside. Now I knew why. Must have been neighbors rushing over after they heard the news. I knew I had to turn around and go see about Faye. Sharon said that was the right thing to do, and not to worry about her and the kids.

So I headed back to Sandy Hook, and I went to Faye's house and stayed for a while. We tried our best to comfort her, but there wasn't much anybody could do right then 'cept to just be there for her. She was completely distraught. In the previous few years, she'd lost an older son, Randy, in a motorcycle accident; then her husband, Elmer; and now her youngest, Keith.

I ended up spending that night with my mom and dad on Brushy Creek. They'd already heard the news about Keith on the radio. Lorrie called me and asked if I could help officiate at Keith's funeral in Nashville. "You know what kind of sermon and which kind of songs he would have liked," she said. "Nobody knew Keith better than you did." I told her I'd do my very best for her and the family. To lose Keith was such an awful thing for Lorrie. She would now have to bring up Jesse, as well her daughter, Morgan, from a previous marriage, on her own.

Even today, when I think back on his death, I can't say I ever saw it coming. Keith seemed to be doing so well, at least on the surface. Every time I saw him, he seemed sober and in good spirits. Everybody knew that he wrestled with alcoholism, that he'd be fine for a while and then go on binges. The danger was that Keith wasn't social when he drank; he'd get by himself somewhere, and that was the scary thing.

Keith never called me to ask for help with his drinking, or his career or fame or anything like that. I'll always regret that I wasn't a better friend, that I didn't spend more time with him, and that I wasn't close enough to him to see what was going on. But I honestly don't know if I could have helped. Lorrie tried, and so did others,

like Joe Galante, the head of the Nashville division of RCA, Keith's record label. Joe believed in Keith so much as a singer, and as a person. He went out on a limb for him and sent Keith to clinics and counselors. Joe was beside himself trying everything he could think of. The saddest part is that I think Keith tried his best, too.

Alcoholism is a disease, but it's a spiritual sickness as well. The Scriptures warn in Proverbs 20:1 about how strong drink can become a deceiver. Its power and reach are as strong and widespread today as ever, and it can be as destructive as any drug. Alcoholism is a plague, really. I've seen it prey on my cousin Euless and so many others, and it took Keith away, too.

Music Row was draped in black ribbons, and the country music world was in mourning. The service for Keith was north of Nashville at St. Joseph's Catholic Church, where Lorrie was a member. There were five hundred people at the funeral, and we sang some of our favorite old hymns and Stanley Brothers favorites: "White Dove," "The Fields Have Turned Brown," and "Drifting Too Far from the Shore." I remember singing one in particular, "Talk About Suffering," with its message about how faith can help get us through anything: "Talk about suffering here below, and let's keep following Jesus."

I gave the eulogy, and I kept thinking about that night in 1971—when Keith and I were driving back from a road trip with Ralph's band, and I got drunk and sick as a dog in a motel room in Jackson, Kentucky. Keith took care of me and laid me out on my bed. He helped me to the commode when I got sick and held cold washcloths on my head.

So I talked a little about that night and told some other stories. Then I said that if anybody was in a desperate situation or as dark of a place as Keith had been, or knew somebody who was, they should get help, and keep trying to get help. I thought he'd want me to tell people that no matter how bad things were, they weren't alone. I've had people on Music Row come up and tell me that Keith's funeral was a turning point in their lives. After the service, they went to

rehab and got clean. Keith's death had a real impact, which I suppose is the silver lining to a terrible tragedy.

Once in a while, I'll hear one of Keith's records, or I'll play a Stanley Brothers song at a show, a sad ol' tune that we used to sing together like "A Lonesome Night," and my mind wanders back to those innocent days at the Whitleys' place in Sandy Hook, where we recorded our radio shows in Keith's garage. I'll always remember the special bond we had.

There was something about Keith. You could just never know him, I mean *really* know him. Not that he lived a double life or anything like that. There was something inside him that he felt he had to protect from the world. Some secret place behind a locked door where no one else could go. He only let himself in there. I never felt that I really knew him. All I know for sure is that I loved him like a brother and I still miss him all these years later.

Chapter 19

HONORING THE FATHERS

Let us now praise famous men, and our fathers that begat us.
Their seed shall remain forever, and their glory shall not be blotted out.

—Ecclesiasticus (Book of Sirach), Chapter 44

Remember how I was telling you about my ancestor Henry Skaggs and the long hunters? About how they'd head into the woods for a year or two, and they'd hunt game and trap fur and push further into the wilderness, and somehow they'd eventually make it back home? You know, it's kinda funny, you never hear about Henry and his guys getting lost when they were out trailblazing. But you know they must have, at least a time or two.

Well, I'd gone out exploring in the world of country music. It's a tough path to follow. Many of my friends got lost out there. Some, like Keith, didn't survive. God's word helped me to stay on the narrow way. Psalms 119:105 says, "Your word is a lamp unto my feet and a light unto my path." Musically, I tried to keep my bearings by following the old pathways of my heroes, Bill Monroe, the Stanley Brothers, Flatt & Scruggs, Webb Pierce, and others.

And for a time everything clicked, with radio, the record label, and the marketplace rallying around my old-fashioned style of country music. But after a while, people's tastes started to change again. So I was asking the Lord which way to go. I was at a crossroads,

which is not a bad place to be. I knew I had to take everything to the Cross and leave it there. If God wanted to kill my worldly success and music career, He could. If He wanted to resurrect it and give life to it, He could do that, too.

It wasn't until after I lost the two pillars in my life, my dad and Bill Monroe, that I was able to know which way I should go. Both of those great men knew how much I loved bluegrass and the old ancient sounds of the mountains. So I decided to go back to the music of my youth. Not to take Bill Monroe's place, no one could ever do that, but take my place around the table of this great music that God had set before me.

I don't have any regrets about my career in country. The success I had and the lessons I learned have helped me to do what I'm doing today as an independent musician with my own label. I had a good long run, and a good string of hits that I can sing as long as I want, and the fans still love to hear those country hits even in a bluegrass style.

In the early '90s, Nashville made a swing back to a blend of pop and country, kinda like what it had been when I'd come to town ten years before. Things had come full circle again, the way Rick Blackburn used to say it always does. Country had gone uptown before. Now it was going suburban!

The video networks were really embracing country. Garth Brooks went on the road with a bigger stage show than Nashville had never seen before, and he was selling out arenas like a rock star. Garth is the most successful country artist of all time. He's sold more than 123 million records worldwide, and he's taken country music to more people than anyone. I'm very proud of him, and he's always been very respectful of me.

Now I was in a bind. My heart was crying out to do rootsy, traditional stuff, but I couldn't under my contract with Epic. I switched labels and tried to find new inspiration. Well, my situation changed a little, but the country scene didn't.

Around this time, the Ryman Auditorium was closed down to the public. Another sign of the times, sad but true. There was talk of

condemning the old brick building and even tearing it down. Marty Stuart, Vince Gill, and I took a stand. We said publicly, "Over our dead bodies you'll tear this building down." It was still the Mother Church of Country Music, and it was hallowed ground for millions of people.

Even in these dark days, sometimes the Ryman hosted special events. One year, there was a special show during something called Fan Fair week. In 1993, I was headlining with Bill Monroe and Little Jimmy Dickens.

As luck would have it, my dad was in town. He and my mom had driven down from Brushy for our Skaggs fan-club picnic. We used to have it every year at the Belle Meade Mansion, which had a restored horse barn where we could put on a free show for a few thousand people. It was a kid-friendly, come-as-you-are party, really, like a big family reunion.

The event at the Ryman was scheduled for the day before the picnic. It was a solo gig without the band, so I asked Dad to be my surprise guest and bring his guitar so I could play fiddle and we could do our little old-timey duo like we used to. We were there backstage getting ready for the show, and Bill asked us to join him for a few songs. Talk about a dream come true!

Here was Dad on stage at the Ryman with Bill Monroe singing "Little Cabin Home on the Hill," a song he'd seen Lester Flatt perform with Bill in '47. It was truly a highlight of his life. Even better, Dad and Mr. Monroe hit it off great. After the show, they sat around and swapped stories about fox hunting and farming and gardening. Dad talked about taters and sweet corn and those huge tomatoes he raised. Bill just loved that kind of farm talk.

You'd a-thought they'd been buddies for years. One time, when he was working on his *Southern Flavor* album, Bill told us there was an instrumental he was getting ready to cut in the studio in a few days and that he needed a title for it.

He asked my Dad, "Hobert, is there a creek that runs close by your house up in Kentucky?"

"Yeah," said Dad. "There's a little branch."

"What's the name of it?"

"Well, it's called Stone Coal."

Bill smiled, and he said, "That's what I'm gonna name this tune right here!"

He did. That album won him his only Grammy.

Mr. Monroe and I ran into each other a lot in those days. One night at the Opry I asked him to help us out on "Wheel Hoss" so he could show the crowd what an eighty-year-old icon could do. This was my full country band, with drums and steel guitar and electric guitar, but he didn't flinch one bit. Something clicked, everybody got in the right groove. It wasn't too fast, and it wasn't too slow. It was just right for Bill to get in there and tear it up with his mandolin.

"Wheel Hoss" was the last song of our set, and as we walked off the stage he was still fired up. He looked at me and said, "That song ain't never been played no better than that right there!" I was thinking of all the great bands he's had over the years, and I knew what a compliment that was. Notice he didn't say it was *the best*. Just that it ain't been done no better!

I remember another night at the Opry when I found myself standing alone in a dark corner. The pressure of trying to balance career, family, and business was a little overwhelming sometimes. I guess Bill sensed that I was carrying a heavy load. He sort of took me aside backstage, where it was just the two of us, and said, "Ricky, I'm really proud of you, boy. You're a good daddy and you're a good husband, and you're a fine musician, too. You love bluegrass, and you love Kentucky. And the way you love God, you're just a fine man to know!"

Lordy! He'd never said anything like that to me before, and hearing his words during such a rough period meant a lot. Of course, my dad affirmed me many, many times, and he was as proud as could be. But this came from my musical father, and at a moment when God knew I needed to hear it. It was so heartfelt, and he didn't expect anything in return. I'd never seen that side of him before, but I could tell he meant every word he said.

* * *

After that night, I knew there was so much more to Mr. Monroe than just music. There was a deep well of wisdom in him that I wanted to tap into. I wanted to learn from him as much as he wanted to teach. Music-wise, of course, there was nobody I respected more. He was a genius, up there with the great innovators like Django Reinhardt, Charlie Parker, and Duke Ellington. But there was something more than his musical knowledge and wisdom I was longing for. I wanted to experience that awesome mantle of creativity.

It wasn't easy getting close to him, though. I had to push my way into his life. Lots of people were scared of him, but he was really a shy and lonely person with a fear of betrayal and being abandoned that went back to childhood. He was an artist, of course, and he turned a lot of that pain into great music, but that goes only so far.

Some of us younger musicians, especially Marty Stuart, Vince Gill, and Alison Krauss, we showed him our love and respect, and it helped to break down the walls he'd put up around himself for protection. In his last ten years or so, he started accepting things for what they were and opening up a lot. I was glad for that.

He also had open-heart surgery, and that sure got his attention. He knew he'd hurt people over the years, and that he'd made enemies, and what hurt most was that so many were former Blue Grass Boys.

Everybody who knows their bluegrass history knows about the feuds Bill Monroe was involved in. It started with Flatt & Scruggs leaving Bill to form their own band, the Foggy Mountain Boys, in 1948. Bill didn't speak with them for a long time. Lester and Earl were only the first in a long line to feel the wrath of Monroe. The Stanleys used to listen to Bill on the Saturday night Opry broadcasts and learn his songs, writing down the lyrics as best they could; then they'd perform those songs on Monday at noon on their *Farm and Fun Time* radio show on WCYB in Bristol, Virginia. The Stanleys worshipped Bill and his music, and they were playing his songs out of respect more than anything. Well, Bill sure didn't see it that way, and he called Carter and Ralph "cutthroats." There was bad blood for years.

And then Flatt & Scruggs came to Bristol to play on WCYB, and

Carter sure didn't like that. So Lester and Carter got into a shouting match about Carter singing songs that Lester had sung with Bill. Jealousy was at the root of it all, but that shouting match caused Carter to start writing his own material, and he became one of bluegrass music's finest songwriters.

With Lester gone and Carter gone, I think Bill realized he was running out of time to make up with the people who were still around. So he starting making calls to say he was sorry, and he did his best to mend those broken fences, with Earl Scruggs, Kenny Baker, and others.

So I got close to Monroe at a special time in his life when he was given the chance to grow as a person. We became real good friends, me and Mr. Bill. I'd go to his place, the farm he had a few miles away in Goodlettsville, and we'd play music the whole afternoon. At night, we'd set out by the fire and turn his dogs loose and let 'em run. We'd listen to the hounds in the woods, and we'd talk about life and music and whatever came to mind. Now, he couldn't explain much about his music, and I'm the same way. Sometimes I'd go over to his house early in the afternoon before I had to pick up the kids at school. We'd sit there and swap tunes back and forth and maybe fifteen words would pass between us, and when I'd get up to leave, he'd say, "Believe we done good today." It was his way of talking, all through his music.

He had his own way of expressing things, too. If he was talking about how Kenny Baker was one of his best fiddle players, he might say, "Kenny sure could drive a nail." Talking about another Blue Grass Boy, he wouldn't mention the guy's musical ability at all, he'd just say, "He was a powerful bus driver."

Mostly, we just spent enough time together that stories started to come out of him. Things from his childhood, memories he treasured, and things he wanted to share. He told me about a time when he was growing up in western Kentucky. After his folks died, he was a teen-aged loner living with his uncle Pendleton Vandiver, the fiddler he later immortalized in "Uncle Pen." Bill said he used to go out in the

woods by himself and cut big timber down and saw the limbs off the trunks and roll 'em down the hill and pile 'em up and then load these huge logs on a wagon. All by himself. The only help he had was a team of workhorses pulling the wagon.

"Ricky," he said. "I'd ride that wagon out of the woods, and when I got close to Rosine, I'd stand up in the driver's seat, and I'd let everybody see the man that cut them trees and loaded that wagon. Them people would start clapping their hands when they seen me comin'. It was something powerful, man!"

He was as strong as a brute, but he had a soft heart. Sometimes I'd take him out to lunch, and I used to watch him hand out quarters to little kids. It was a kindness in him that went back to his lonesome upbringing. Folks in the restaurant would say, "What you all doin' today?" I'd say, "Just the student following the teacher around."

Sharon and I used to invite Mr. Monroe to prayer meetings at our house, and he always brought his mandolin. He wasn't playing as much then, but he still never left home without his instrument. Once we were praying for each other and all of us husbands and wives paired off. Well, Bill was odd man out, 'cause he didn't have a spouse, so he asked, "Would you all pray for me?" and we all huddled around him and prayed. He was so appreciative.

I remember one night getting on my knees at his feet, and asking him, "Would you bless me like a father blessing a son; would you pray that I'll be a caretaker of this old music?" And he said, "Why, yes, I will." He bowed his head and said these words I'll never forget: "Lord, would you just give Ricky the love for the old music, like you've given me through the years, and help him carry it on? Bless him and his family." With hands laid on me, he gave me his blessing.

I needed it, too, 'cause those were some real trying times for me. All I could do was focus on my music, but it was hard. I felt like the times had passed me by. There was a real change on country radio, and my records weren't going to the top anymore. I was waiting for what would come next. I toured, I played my songs, and I dabbled

with the old bluegrass music, but I was far from certain about what lay ahead.

With Mr. Monroe ailing, I'd talk about him from the stage and give the audience an update on his health condition. Once he was supposed to headline a show with me at Wolf Trap in northern Virginia, but he got sick and had to cancel. We had him call in from the hospital, and we plugged him into the sound system so he could say hi to everyone. The crowd started singing "Blue Moon of Kentucky," and he could hardly believe it.

My band started going out and doing bluegrass shows. We'd go without a drummer or a piano player. The steel player would take over on Dobro. But we were still doing quite a few country shows as well. I was happy getting to switch it up. The promoters didn't really care what configuration we showed up with. The fans loved getting to hear the old bluegrass songs and seeing me have such a good time.

Doc Watson invited me to MerleFest and asked if I'd bring a bluegrass band. So I did, and the crowd response gave our confidence a big boost. Then we did a tour in New Zealand, where we sort of opened the shows for ourselves as a bluegrass band. After that, we'd do some shows where we'd open as a country band, talk about the music's roots, and then finish the night with a good dose of bluegrass. We were having a blast as a band, mixing it up. Whenever I played bluegrass, folks in the audience started telling me there was a look of joy on my face they hadn't seen for a long time.

In the spring of '96, Bill suffered a stroke. He was losing his strength and his will to go on, that much was clear. I'd go visit with him at the nursing home outside Nashville where he resided then. He'd fret about his horses back at the farm, but after a while I came to see it was the future of bluegrass that had him worried. He'd given his whole life to this music, and now he was worried it was going to die along with him.

I told him that all of us in the bluegrass community, myself included, would work hard to keep his music alive. There were times he seemed so depressed, and I would reassure him that the music

was bigger than any one person, even him, and it would never die as long as people kept it going. I told him he just needed to rest and not worry, to trust the one who entrusted the music to him, and that was the Lord.

Before he lost his ability to talk, I wanted to know if Mr. Monroe had really given his heart to Jesus. I was really concerned about him and where he was going to spend eternity. At first, he said he was looking forward to seeing his father and his mother and his brothers and sisters in heaven. Then I asked him if he was looking forward to seeing Jesus, too, and he said, "Oh, yes! He's the one I sung so many gospel songs about!"

And we talked about the little community church in Rosine, Kentucky, he visited as a boy the night he got saved, and I asked him if he remembered the sermon the preacher preached. He said, "No, but I remember the song they sung." He was out in the churchyard, as youngsters often were during service, and he heard the hymn "What Would You Give in Exchange for Your Soul" coming from inside the building. The power of those words drove him into the church house to commit himself to Christ. That was the first record that he and Charlie cut back in the '30s, the bestselling gospel song that launched the Monroe Brothers' career and set Bill on his path. It was through music that Mr. Monroe found the Lord and his calling.

Many of the old-time preachers in Kentucky would frame their sermon with a hymn that echoed the verses from Scripture they were preaching on. I'd heard them do it that-a-way many times as a child. It's very possible that the preacher Bill heard that night was preaching out of Matthew 16:26: "What would it profit a man to gain the whole world and lose his own soul, or what shall a man give in exchange for his soul?"

After he told me about that precious moment so long ago but still so fresh in his mind, I knew in my heart that Mr. Monroe was all right. He'd made Jesus his Lord, and I knew I'd see him in heaven. Even with all his health problems, he stayed creative right till the end. At the nursing home, he had scraps of paper all over the room

with ideas and song titles jotted down. His body was failing him, but his mind was still creating.

It wasn't too long before he couldn't talk much anymore, so whenever I visited I'd play music to pass the time and get him to join me. Sometimes he'd want to get up and walk around, but he really wasn't able to. Then the caretakers would have to restrain him, and it'd break my heart. He'd look at me so sad, and then he'd look at those leather straps on his arms. I'd say, "I'll take 'em off if you'll stay in your bed and not try to get up." He just wanted to stretch his arms and legs.

I'd get my mandolin out and play for a while to try to lift his spirits, maybe a hot instrumental from his glory years, like "Roanoke" or "Raw Hide." Hearing the mandolin would usually get him feeling better. After a few songs, he'd grab the mandolin from me and play a few chords of a familiar tune, just to let me know he still remembered and still could.

It was his way of telling me he was hanging in there and wasn't whipped yet. On the outside he might have been a frail old man, but on the inside he was still the same ol' Bill, and there was still a fire in his soul. He'd survived car wrecks, a broken back, open-heart surgery, even cancer. I really hoped he'd get better and get to go home to his farm, but I knew in my heart that it wasn't gonna happen.

The last time I saw him alive, Bill was alone in his wheelchair. He didn't have many visitors anymore. He had on his Blue Grass Boys hat, that old white Stetson, but he couldn't talk and could barely move. He looked so depressed and so lifeless, you could tell he didn't want to be in the nursing home anymore. When I walked into the room, he looked at me kinda strange and then he looked away.

It just about killed me to see him like that, but I tried to stay cheerful. I got his mandolin from the night table, and I played "Raw Hide," his signature instrumental tune. He'd written it in the backseat of a limousine before he was forty, when he was strong enough to carry all the Blue Grass Boys on his shoulders. I thought for sure "Raw Hide" would pep him up. I held the mandolin out to him and

said, "All right, Bill, I want you to play one for me now." But he didn't even reach for it.

I asked the nurse how he'd been feeling. "Not good," she said. "You know, a while before he stopped talking, he kept saying how he was wanting to be going home." I said, "He ain't wanting to go to Goodlettsville, is he?" She shook her head, and she pointed up to heaven. I said, "Well, if he don't want to play music anymore, he's ready for the Lord to take him home."

So I hugged and kissed him and told him I loved him, and I said a prayer. Then I blessed him, same as he'd blessed me at my house, and I said I'd play his music as long as I lived. I promised I'd take bluegrass everywhere I played, and I'd tell the story of how he started it. He didn't say a word, but I know he heard me.

When I left his room that day, I knew I wouldn't see him again on this side of heaven. But I thanked the Lord for all He'd done through Mr. Monroe's life and music. Then I had a good long cry driving home.

That was on a Friday morning, and I had to go on the road that weekend. Bill died on Monday. His memorial service was at the Ryman Auditorium, and it was one of those occasions that only could happen at the Mother Church. There were lots of artists and Opry stars there to pay tribute: Ralph Stanley, Marty Stuart, Emmylou Harris, Alison Krauss, Vince Gill, Patty Loveless, and many others who loved him. Emmylou sang "Wayfaring Stranger," which Bill had requested, and we joined in for an a cappella rendition of "Angel Band."

While the preacher spoke his eulogy, we were gathered backstage. I looked at a digital clock on the table, and it glowed "11:11." Eleventh chapter, eleventh verse. The numbers were illuminated, and it was speaking to my heart like it was a sign. I told Marty it was a Scripture that I had to look up when I got home. The memorial service was almost over, and we'd sung all these mournful songs, and somehow it didn't seem right to end on such a sad note. So when we went back on stage, Marty made an announcement over the microphone.

"We're gonna send Mr. Monroe home with a fiery tune to celebrate his life. Let's do 'Raw Hide,'" and I said, "Yeah, let's do it!"

First, though, I warned anybody in the crowd who might be offended. "If you have a problem with this, well, just get over it. It won't last long." Then we went for broke and played "Raw Hide" fast and furious and flat-out hog wild, and the audience packing the Ryman felt an electric shock. We all did. It was a holy-ghost experience.

They escorted Mr. Monroe's casket out of the Mother Church of Country Music with a bagpipe ensemble. It was like a king or a chieftain being honored. The highlands pipers played "Amazing Grace," and I thought of the grace God had shown him all through the years—from the Ryman Auditorium, where on the Grand Ole Opry the world heard bluegrass for the very first time, to Rosine, where Bill played his very first notes on the mandolin.

When I got home, I took out my Bible and looked at some Scriptures. Then my eyes fell on Isaiah 11:11: "And it shall come to pass in that day that the Lord shall reach out his hand again the second time." The second time. That's what caught my attention. It was the Lord's way of saying that Mr. Monroe's music was the seed and that there was going to be more fruit to come from it in the future than there was in the past.

I felt like it was the Lord saying, *I'm going to bless this music again that I birthed through Bill Monroe, but it won't be for Bill Monroe's or any man's glory. It will be for My glory.* I felt like I'd been called to help spread the music, and to do my part in that evangelization. Today I look back and see how bluegrass music has exploded in popularity since 1996, the year Mr. Monroe passed away. There are now more people playing it and hearing it and loving it than ever before!

Not too long after Mr. Monroe's passing, I was with Ralph one night, and he asked me, "Did you get Bill's mandolin?" It was a good question, 'cause Bill knew how much that mandolin meant to me. It was like King Arthur's sword, Excalibur, to me. Well, there was no doubt it was headed to the Country Music Hall of Fame, not to

a person, whether it was me or anybody else. "No," I told him. "But I got his blessing, and that's better than the mandolin." And Ralph said, "Yeah, I guess you're right, Rick." He understood what I was talking about, but I have to tell you, I'd a-sure loved to have that legendary Loar! That was the same mandolin I played in Martha, Kentucky, when I was six years old!

In his last years, my dad was laid back and happy as could be. He was a homebody, and he was very content with family life back on the creek. He puttered around and worked on the house and played his music and hunted a little ginseng. With the exception of his back giving him pain, he was healthy as a horse into his late sixties, when he was diagnosed with a disease called myelofibrosis. It's a type of leukemia, a blood cancer that affects your bone marrow stem cells. It's a progressive disorder, and very debilitating. Even after he got sick, though, he did his best to keep to his routine. He'd take shots to boost his white-cell count, and he'd feel good for a while. But the disease gradually wore him down.

Sharon and I would often take the kids and go up to Brushy and spend time with him. He still had his passion for music, only now he'd get to where he was too tired to play. He'd sit there and play his guitar till he dropped his pick. Then he'd sit and listen to us for a while. It lifted his spirits, for sure, but it just wasn't the same as the old days, when he was the ringleader and the last man standing.

One time I went by myself for a visit. I got alone with him, 'cause there was a question I really needed to ask. I wanted to make sure there weren't any bad feelings or grudges between us. Maybe there was something I'd said or done that had hurt him. A wound that was festering, that he hadn't been able to let go of.

He and Mom had gone through a lot of pain watching every one of their children struggle with divorce and broken families. He was supportive, but I know it hurt him deep down. You suffer seeing your kids suffer, and you want to help, but you really can't do much as a parent. He and Mom were such an example of love and trust and

friendship, but that wasn't enough, 'cause my siblings and I all fell short. It took more than what Mom and Dad had mirrored.

And then there was that time at Frontier Ranch when Dad reached for his guitar from the trunk of the car and I had to put my hand on his arm and tell him that Ralph Stanley just wanted me and Keith to play. I could see the hurt in his heart then, and I felt it, too. It was the first separation that had to come between us. It was hard on us both when I started to pull away into a life of fame. He'd been with me the first time I picked up a mandolin.

These painful memories had been weighing on my mind. I wanted a chance to apologize and ask him to forgive me for anything that I had done to hurt him.

When it was just the two of us in the room, I took a deep breath and asked him, "Dad, is there anything bad or strained between us that we need to get cleared up?" He gave me a funny look and said, "Why, no, son! Everything's good!" I told him, "I just wanted to make sure there was nothing that could come between us on this side of heaven." He smiled, paused for a second or two, and said, "There ain't nothin' between us. It must have been hard for you to ask me that, son!"

Well, it was kinda hard to press him on such a thing, I guess, but probably not as hard as it must have been for him to forgive and let go after all the pain that we kids had put him and Mom through. Somewhere in his life, he'd dealt with all that hurt, but all was forgiven. Now there was only love. That lifted a heavy burden off my shoulders. It was another gift from my dad, and I was so grateful to have received it.

I've told you how important music was to Dad. Even in his last hours, when he couldn't speak a word, it was foremost on his mind. I remember when the family was gathered around his sickbed. He was having a hard time breathing. It was so quiet that all you could hear was him struggling for breath. He grabbed my mother's hand and squeezed it real tight and started pounding out a rhythm, like he wanted us to sing something.

So we started singing an old hymn, and his eyes filled with joy. He just perked right up at the cheerful sound of our voices. Even in his last few moments, he wanted music around him. To this very day, I haven't met anyone who loved music more than my dad. I was so glad he was able to bless us that-a-way before he went on home.

Then something happened, and I'm not sure exactly what. It's a mystery. We'd finished the hymn, and it got real quiet. We noticed Dad was staring at the wall across the room. Just a bare wall, no window or pictures or nothing. Well, *he* saw something, and he got a surprised look on his face, a look of awe and wonder. He was looking right past us, and he stretched out his arms like something or someone was coming for him.

Now, I was there in the room, and I still don't know how to explain it to you. All I can tell you is it was real, as real as can be! I don't know if it was an angel or the Lord Jesus Himself, but Dad saw someone from the other side, and he was reaching out like he was ready to follow. He passed on shortly after, and he had a look of total peace and assurance on his sweet old face. His eyes had seen heaven, and he wouldn't have stayed here with us even if he could have.

We had the funeral for Dad in Louisa, and there were folks there from all over eastern Kentucky, Ohio, Tennessee, and North Carolina. He had touched so many lives, whether it was helping out with a repair or hosting a picking party at the house or giving away vegetables from his garden. He was as good a friend and neighbor as he was a father. People were coming up to me at the service, and they were crying and saying how sorry they were. Some said they went to grade school with dad. Many told me, "Your dad was my best friend."

They were just trying to express their sympathy. I appreciated the condolences, but I wanted them to know his passing wasn't all about gloom and sadness. His death wasn't the end, and I was so happy and so hopeful. Scripture tells us to be joyous at a funeral, especially when we know where our loved ones are going. "Dad's not hurting," I told them. "He's up in heaven, and that's something to rejoice about."

This assurance is what Christ died for us to have. Freedom! Free-

dom from guilt, shame, bitterness, envy, strife, and all of the weight that the Devil wants to heap upon us. But we don't have to carry it. Jesus said in Matthew 11:29–30, "Take my yoke upon you and learn from me, for I am gentle and humble in my heart, and you will find rest for your souls, for my yoke is easy and my burden is light."

Dad's passing was light and easy because he was free. He had no one to forgive. He had no bitterness, no guilt. He'd laid all of that down at the Cross.

I just want to encourage you to make every effort that you can to go to your dad, mom, brother, sister, neighbor, or whoever it might be whom you haven't forgiven or who hasn't been able to forgive you— and forgive them or accept their forgiveness and try to make things right with them. Maybe it's not possible for you, but with the Holy Spirit there is no distance. Wherever you are, you can ask God to forgive them, and you can also ask God to forgive you for what you've done to somebody.

I promise you, when you do that, you'll set them free, and you'll also set your own self free. Dad was prayed up and ready to go, but I've had to sing at funerals where I really didn't know if the person had made their peace with God or not, and that's a tough thing.

Mom didn't doubt Dad was in heaven, but it didn't help much in her sorrow. She lived in a time and a place where you're expected to grieve for weeks and months and even years. Some folks call that respecting the dead, but if they are with Jesus, they ain't dead, they're rejoicing. And that's what we should do.

Ecclesiastes tells us there's a time to mourn and a time to laugh. Grieving is important for healing, but not if it gets to the point where it rules your life—where you can't find joy in waking up mornings, where there's so much grief that you don't go anywhere and enjoy things, where you're almost afraid to laugh 'cause people might think, *Well, gosh, her husband's only been gone for six months, and look at her!*

Some of that was pressing down on my mom. I tried to explain to her about the verse from Hebrews 12:1 that talks about how we're surrounded by a great cloud of witnesses, our loved ones and all the

saints who've gone home to glory, and that they're all watching down from heaven, cheering us on, praying us on, and encouraging us on. I think it helped her some, but Dad's passing was a loss she never fully recovered from.

You know, I really understood how my mom felt. I missed my dad, too, and I'm still missing him. But he ain't missing me where he's at! The Lord has been so good to me that I've even seen him in my dreams. One night I dreamed he came to me and said, "Son, I have such a good time up here. They're treatin' me so nice." Then he said, "Wanna play Bible trivia?" And we did, and he knew all the answers and beat me so bad!

Another dream came one time when I was really missing my dad. I just needed to hold him, and feel him hug me. That night I dreamed he came right to me and leaned over and started to hug me. I reached up, put my hand on one side of his face, and pulled him down where I could kiss his cheek. His sweet face had a three- or four-day-old beard on it, just like it sometimes did back when I was a kid. When I kissed him, his ol' prickly beard stuck my lips, and I felt him just as real as if he was here. The Precious Lord knew I needed that.

Dad died in 1996. Losing Bill and my dad in the same year was hard to take. But sometimes it's the hardest things that push us in the right direction. The next year I decided to go back to bluegrass for good, and to make good on the promise I'd made to Mr. Monroe. I've kept my promise, and I'm still on the road playing bluegrass, the music he created, and I'm doing my part to keep the tradition going.

It's only been recently that I've come to understand more about that summer night in Martha, Kentucky, more than a half century ago. What it meant when Bill Monroe took his mandolin and put it on me. I'm fifty-eight now, only a few years older than Mr. Monroe was on stage in that schoolhouse, and my hair hangs down shaggy and gray just like his did in his last years. Maybe it took some gray hairs to get me to the point where I could ponder on this.

There are a lot of stories about elders seeing something special in

the next generation. I don't know what Bill saw in me that night in 1960, but I know what I saw in him. I saw a man who was driven by a passion for his music, and a performer who commanded respect. There was so much fire in him then. He was one of the biggest stars of the Opry, and he was such a professional. He looked and dressed and acted the part.

He was there to do his show, yet he was able to step back from the applause to let a little six-year-old local boy get up and sing a song. And not just sing, but play his old 1923 F-5 Gibson mandolin, his most treasured possession. Thank God I didn't drop it, or I might not have lived to write this book!

That night I found a champion, a hero, and a musical genius to follow. I found a style of music I chose to be the foundation stones of everything that I play. He didn't have to invite me on stage, but I'm very thankful that he did, and I'm better off for it.

Now, I don't want to give the wrong impression. I know that whatever talent and gift I have for music comes from what God gave me, not Bill Monroe. What I'm talking about is a musical father whom I learned so much from, and not just music. Was he perfect? No, he wasn't, and neither am I. There's only one who's ever lived a perfect life, and that's the Lord Jesus Christ.

I am fortunate to have felt the strong hand of two generous men in my life. My father and Mr. Monroe were different, that's for sure, but they shared the same foundation. They shared a love of God, and of music, that they passed down to me. My life is what it is because of them. I couldn't ask for anything more. And though I still miss them both every day, I thank God for the gift that He gave me in these two men.

When you honor someone, you can never go wrong, and you honor God, too. After Mr. Monroe passed away, I felt like it was time to go back to the music that set my little six-year-old soul on fire! The time had come for me to take my place at the table.

Chapter 20

HEROES

My studio is like my second home. Called Skaggs Place Recording Studio, it's tucked in a little unmarked low-slung building that you'd never notice from the road, and that's how I like it. We bought it from the Oak Ridge Boys a few years back. We made quite a few changes and now have one of the best-sounding studios around. Just ask Merle Haggard, Dolly Parton, John Fogerty, the Dixie Chicks, or Barry Gibb, to a name a few who've cut records here. Also, a lot of bluegrass groups love it because it's a great live room.

From the outside, it's pretty plain, but inside it's a paradise for a studio hound like me. It's not far from where I live in Hendersonville, a few miles north of Nashville but a long way from Music Row, and that's good in a lot of ways. I believe producing records is a craft where it doesn't pay to be stingy. We've invested a lot in outboard gear and vintage equipment to make our instruments and vocals sound the best they can.

When CBS closed down the famed Quonset Hut Studio, I bought a bunch of microphones from the '50s and '60s, including the Neumann U 47 house mic that George Jones and Tammy Wynette sang

into for their classic duets. I bought it not just for the history, which I do love, but for the sound you get from vintage gear when you're cutting a record. I have an old RCA 44 ribbon mic that I use when I'm recording with my old Gibson mandolin.

I've been collecting old gear for a long time, hoping to have my own studio someday, and finally I do. I'm always on the lookout to add to my collection; there's always cool stuff to be had from somebody's garage or attic. There's a photo of me when I was seven singing into an RCA ribbon microphone at a radio station in Ashland, Kentucky. The mic is mounted on this awesome boom stand you can't find anywhere anymore. I wish to God I had that boom stand in my studio. I'd sure put it to use!

Our crown jewel is the 9098i Amek console we got from a defunct studio in Los Angeles. It is one of engineer Rupert Neve's magical contraptions, an older model from the '90s. He also signed it, making it that much more special, and that's fitting, 'cause it's hand-wired and hand-soldered, like most of the equipment he designed. As far as analog recording gear goes, he's revered by gearheads like me for his equalizers, microphone pre-amplifiers, compressors, and large mixing consoles like the Amek. He's a pioneer, and he's very critical of digital sound, and so am I.

And, like me, Rupert has a love for Jesus and is proud to talk about his faith in the marketplace. He's a living legend in the recording industry, and he's on my bucket list of people I'd like to meet and say thank you.

Now, I love using newer technology, too, as long as it sounds good to my ears. The recording quality is incredibly high nowadays, and we use what we can, the best of the old and the new. We can make an acoustic guitar sound as big as a truck. We have an acoustic room we call the "guitar parlor" with a wooden floor and guitar tops and backs strung from the ceiling. We do most of the music out in the studio in a big space where the band can play together in the same area. There's an original pew from the ol' Ryman Auditorium, which has a vibe all its own, and a Yamaha grand piano that every pianist

just loves. It's a warm, low-lit studio with an art-gallery kinda feel.

The studio is a laboratory, a sanctuary, and a workshop. More than anything, though, it's a clubhouse for a brotherhood of musicians. It's where we find inspiration and try to create songs that bring joy and hopefully will stand the test of time. Far as that goes, we've got plenty of help from some wise elders whom I call my Preachers, Prophets, and Pickers.

There's a gallery of pictures on the walls of my studio that pay tribute to my heroes. Some are famous and some aren't, some are musicians and some aren't, some have passed on and some are still with us. But they're all heroes to me. Not only for what they've done, but for the way they've lived. They all have strong wills. Nothing could stop 'em.

Sometimes when I'm recording, I'll look up on the wall and see a picture of Mr. Monroe, or an old poster of Minnie Pearl, and think how grateful I am to have known these precious old souls. They were great musicians, great entertainers, and plain great people. It gives me a lot of inspiration and encouragement to know that they loved me and they're cheering me on from heaven. Now, I'd like to share with you a little bit about my heroes. Some you'll know, some you might be surprised by. But I hope that now that you know me a little better, you'll understand why I want to give thanks to each and every one of them.

It seems right to start with Ray Charles. I met Ray on a recording project in 1983, and it was an incredible introduction. He grabbed my right hand to shake it, and then he took his left hand and rubbed up and down my arm. He had a way of seeing with his touch, and the way he got to know me was by touching my arm. You could feel his energy, as if he were connecting with my spirit.

The first thing Ray told me was how much he loved bluegrass music. He said he could hear that "old-timey, way-back-in-the-hills" sound in my singing. He appreciated that I was staying true to my roots. He said he had been a diehard bluegrass fan ever since he was a kid in Georgia listening to Bill Monroe on the Opry.

Ray was special. We were together only a few times over the years, but I loved each meeting. I loved to be in the same room as him and soak up his energy. He had a presence about him, a life force that charged you up and kept you going for a while. I've never met anyone so fully immersed in music as Ray. If you'd have cut him, he would have bled musical notes. He was a total musician, totally into what he was singing at that moment. He had complete focus and concentration, and the song was all that mattered.

The picture of Ray in the studio is a poster promoting his 1984 album of duets, *Friendship*. The caption says "Every mother's son in town," 'cause all the top singers in Nashville wanted to be a part of this project. Lucky for me, I made the cut. Thank you, God!

Our duet was the title song, and back then my tenor was higher, so I was able to sing harmony above Ray. During the overdubs, he was in the booth coaching me on the talk-back mic. People who call me Picky Ricky should have met Ray Charles. He ironed out every wrinkle. He wanted the best I had, and after a few takes, he got what he wanted and shouted his hallelujahs. Ray wouldn't settle for anything less. When he heard what he was after, he was in heaven. You know, you get a Ray Charles once in a lifetime, if you're lucky, and I was very blessed to have known him and recorded a song with him.

On the wall near Ray is a portrait of Roscoe Holcomb. It was painted and given to me by Bruce Hornsby's wife, Kathy. Roscoe was from Daisy, Kentucky, in Perry County, a couple hours south of where I grew up. As a young man, Roscoe was a coal miner, but the mines dried up. He hoed corn and taters on the side of a mountain, but the land in that region was poorer than he was.

All the while, Roscoe worked on his music. He picked old-time banjo, and he played guitar tuned like a banjo. He sang ballads like "Omie Wise," "Little Birdie," and "Man of Constant Sorrow," and he sang hymns, like "A Village Churchyard," in the a cappella style of the Old Regular Baptists. He took pieces from blues and folk songs and put 'em together like an old patchwork quilt. No matter what the song, it always came out 100 percent Roscoe.

He was skinny as a pencil, and his singing cut to the bone. He had the kind of voice you only hear in the mountains, high and lonesome and loud enough to take down a hawk half a mile high. My mom sang like that, too. He didn't entertain for the public back then, just for neighbors and in church. He played his music to suit himself when he felt happy or worried, or just to ease his suffering.

Roscoe was a Christian man, and he prayed and asked the Lord to help him provide for his family. Right about then, folklorist John Cohen was mining these nuggets of musical treasure out of the Appalachians, documenting local musicians who played the old-time way. In 1959, Cohen showed up with his tape recorder and film camera, and it changed Roscoe's life. The folk revival was just around the corner, and Roscoe was in the right place at the right time.

Roscoe made some recordings and won over crowds on the festival circuit. He traveled to Europe with the Stanley Brothers, and he played colleges and folk concerts. He was the same ol' Roscoe at a Boston coffee house as he was on his back porch in Daisy. Now, he didn't get rich and famous. He always struggled with poverty, bad health, and hard times. But I'd say his prayers got answered, many times over. God blessed Roscoe with the gift of his talent and opened doors so he could get work as a musician and scratch out a living. For the next fifteen years, Roscoe was able to play his music and touch the hearts of people who'd never been near an eastern Kentucky coal mine.

Without Cohen showing up (thank God he did), we might not have heard Roscoe Holcomb. Same thing back in the 1920s—if Ralph Peer hadn't made his field-recording trip to Bristol, Virginia, we'd maybe never have heard the Carter Family and so many others who lived back in the mountains. We're so lucky these old-time singers and pickers got to put their sound on records and add their thumbprint to our musical heritage. They teach a lesson, you know, with the passion and feeling they brought to a song instead of technique and precision. Roscoe became a cult hero for all kinds of musicians, from Bob Dylan and Eric Clapton—who says Roscoe is his favorite

country singer—to some others you might not expect, like Bruce Hornsby. The painting of Roscoe above the control-booth window is a reminder of my Kentucky roots. I see him as a humble man who wasn't too proud to ask God for help. There was such pain and suffering in his life, and Roscoe offered it all up to the Lord through his music. He's an example of what real faith is all about.

Having heroes also means being a fan. In the hallway of the studio hangs a souvenir any diehard bluegrass fan can appreciate. It's a piece of yellowed old WSM stationery paper set in a frame, and to me it's priceless. It has the autographs of the "Fab Five," the classic lineup of the Blue Grass Boys that my dad saw back in '47.

These are the young men who planted the seed of bluegrass in the fertile ground of country music, and it's still bearing fruit all these years later. They blazed the trail and laid the foundation everyone has built on. They created a revolutionary sound that had the essence of old-time string-band music, but with a raw energy and fire. It was a whole new vocabulary of original songs, musical licks, jazzy hot solos, bluesy rhythms, backup fills, and vocal arrangements. It was truly a sound never heard before. These guys were coloring outside the lines! All these years later, I'm still learning from their music, studying outtakes and alternate versions and hearing new surprises: the way Lester Flatt puts a twist on a word, or Chubby Wise's touch on a fiddle break. That's honey to me.

You already know how important Bill was to me, but the members of his band are my heroes, too. They all had a hand in designing the blueprint, and I've been blessed to have known these architects. I had a personal relationship with each of the Fab Five, except for the bass player, Howard Watts, whom I sadly never got the chance to meet. They've been mentors and musical fathers, not only to me but to generations of bluegrass musicians.

Chubby Wise had a background in old-time and country-style fiddling, and he put his stamp on everything he played. Chubby seldom used his little finger on his left hand, and as a result he made a lot of long slides during his solos, giving the music a bluesy feel that

was perfect for Bill's style. I've wished a thousand times I could have talked to Chubby more about the old days.

Hard to believe, but it was more than fifty years ago that I met Lester and Earl as a wide-eyed seven-year-old. I saw Lester quite a few times on the festival circuit while I was with Ralph in the early '70s. He was the same ol' Lester off the stage as he was on stage, and his down-home personality made him the best emcee that bluegrass ever had. We talked about the time I did a guest appearance on the Flatt & Scruggs TV show, and I was amazed he remembered me. I know for sure that bluegrass fans will always remember the man who wrote so many classic songs, like "Cabin in the Hills" and "God Loves His Children," and who gave the world the "Lester Flatt G-run," which every bluegrass guitarist can play in his sleep! You've probably heard it, that run on the guitar that fills the space before a solo or a vocal. Charlie Monroe kinda started it, really, back in the '40s, but Lester was the one who popularized it, and it's become the signature Martin guitar lick for bluegrass.

There's a story about Lester's bedside conversion that shows how it's never too late when it comes to salvation. A friend told me that when Lester was close to death, he asked to be taken to his hometown of Sparta, Tennessee, to get baptized. When Lester came out of the water, he started to cry and said, "Why did I wait so long?" and he kept crying and saying those words over and over.

Lester was right. If you've never been born again, don't put it off until it's too late. There is no promise of tomorrow (Acts 4:12 and 2 Corinthians 6:2). It's the most important decision you'll ever make, because it is for all eternity.

Next to Bill, the Blue Grass Boy I was closest with was Earl. He was my mentor and friend both. When I first moved to Nashville in 1980, I got to know Earl and his wife, Louise, as well as their boys, Gary, Randy, and Steve. I admired how Earl raised up his sons, getting involved in their music and pouring it into them like my Dad did with me.

Earl and I worked on several recordings and TV shows together,

but the project I was most proud to be a part of was *The Three Pickers*, with him and Doc Watson. It would have been great if Mr. Monroe had been the "third picker" instead of me, but he had already passed away. It was quite an honor to record that album with two of my heroes.

Earl was one of the most humble musicians I ever met. He had such a quiet dignity and was so laid-back you'd never know he was one of a handful of musicians who ever truly changed the way an instrument was played. His impact on American music is immeasurable, and there's hardly a banjo player alive whose style of playing can't be traced back to Earl. When he recorded "Foggy Mountain Breakdown" back in 1949, it sounded superhuman. It's absolutely flawless.

God made just one Earl Scruggs, and I'm grateful we had him and his playing for so many years. He passed away at eighty-eight years old loving the music and playing his banjo. He was always listening, not to himself but to the next generation, and that kept him forever young while he was with us. That was the Fab Five I knew and loved—Bill, Chubby, Lester, Earl, and Howard. These five men were only together a little more than two years, but they exploded onto country music like a supernova or an earthquake, whatever they call an "act of God," which it truly was!

Of course, no discussion of my heroes would be complete without mentioning the Stanley Brothers, who built on the foundation the Blue Grass Boys laid all those years ago. I've got a blown-up photo of Carter and Ralph from their Columbia years, 1949 to 1951, when they forged that classic Stanley Brothers sound. The songs they sang are the heart and soul of bluegrass. The music they left behind gives us a taste of the sounds of heaven, and hardly a day goes by that I'm not singing or hearing one of their songs. Carter died on December 1, 1966. He was only forty-one, way too young. I wish he could have lived to see how the bluegrass community loves and honors him today.

'Course, Ralph is as big a hero to me as Carter or even Bill. It took the Coen Brothers' film *O Brother, Where Art Thou?* to bring Ralph

a whole new audience that discovered what the bluegrass community had known for years—that he is a national treasure. Ralph's popularity is an affirmation of mountain music and culture, and it proved to the uptown bunch that we're pretty smart after all. We'd been behind Ralph for years; we had a vested interest in one of our own, an elder we held in high esteem. And now Ralph gets the respect he deserves, wherever and whenever he plays.

Not long ago, I got to visit with Ralph during the Memorial Festival at his old home place in Smith Ridge. He's slowed down some, but says he's gonna keep singing for the people as long as he's able. That day, we went up to the cemetery where Carter is buried. It was getting dark, it had been raining, and well, it was a little spooky.

Thank God I took my camera with me, though. I took some amazing pictures of Ralph there, with the light dying behind the mountains. He showed me the big ol' mausoleum with his name and his wife Jimmi's name on it, and he said he was ready whenever the Lord called him. Well, Ralph, guess the Lord has more work for you to do! I'm sure glad you're still around to inspire a new millennium of bluegrass pickers and singers, and that you took a chance on me when I was nothing but a kid.

I think of so many musicians whom I hold near and dear, bluegrass royalty like the Osborne Brothers and Jimmy Martin and so many others who earned a place in the pantheon. There's just not enough space on the walls in my studio to do justice to the men and women who've kept bluegrass music going. I especially want to mention the sidemen, who never got the accolades that the stars did. They're the unsung heroes who could raise the hair on the back of your neck with an incredible mandolin solo or fiddle run or high, lonesome vocal lick.

Some you've heard me talk about, like Pee Wee Lambert, George Shuffler, Curly Ray Cline, Benny Martin, Ralph Mayo, Curly Lambert, and Curly Seckler. But there are so many others: Paul Warren, Chubby Anthony, Red Taylor, Art Stamper, Lester Woodie, Tex Logan, Charlie Cline, Rudy Lyle, Cousin Jake Tullock, Benny Sims, Art Wooten, Jim Shumate, and hundreds more. These were

the men traveling six deep in a station wagon with no AC just to get to hundred-dollar gigs, eating sardines or Vienna sausages from a can and washing up at gas-station restrooms. There was hunger in the music these men played, 'cause there sure wasn't much money to be made in those early days. Music was a calling to these men. We could never repay those early fathers who paid such a huge price for birthing this music and raising it up. They have given so much to my generation, which has it so easy compared to what they had to go through.

There are heroines on the studio wall, too. Minnie Pearl, in an old Hatch Show Print poster from 1944 in which she's young and radiant and beaming her famous Minnie smile. And there's a poster of my favorite female trio: Barbara Fairchild, Connie Smith, and my wife, Sharon White. These talented ladies are very special to me. They all three have gorgeous voices that are as unique as their personalities. They did an album that I produced, *Love Never Fails*. It was so cool to hear each of them taking turns singing solo on the verses, and then singing harmony together on the choruses.

There's another picture that's really precious to me. It's a photograph of Johnny Cash on stage paying tribute to John Lennon after he was killed in 1980. Cash is dressed in white, wearing dark sunglasses, and holding a bouquet of flowers. Marty Stuart was on the road with Cash at the time, and he took the picture. He gave me a print of that moment for my gallery. When you think about it, Cash was a preacher, a prophet, and a picker, all three—and so much more, too. He was one of country music's great defenders of the faith, like a modern-day troubadour.

You know, every generation has its heroes. These are some of mine. I hope they are some of yours, too.

Now I want to talk to you about a preacher, one of my all-time heroes and a true spiritual father, the Reverend Billy Graham. In a very special place I have a rare photograph that I treasure. It was taken in 1949, during a Youth for Christ crusade in Los Angeles,

where Dr. Graham was preaching to huge crowds in a circus tent. Thousands came to know Christ as savior in those eight weeks.

In this photo you can feel Dr. Graham just wearing it out. He's tall and lanky and full of Holy Ghost fire. He's preaching the Gospel with his arm outstretched, like he's pointing to where we need to go. A visionary, a champion, and a man of God.

The work Billy Graham has done is phenomenal. Nobody in our lifetime has evangelized more lost souls, from the man on the street to the high and the mighty. He has stood before kings and queens, he has counseled ten presidents, starting with Harry Truman. I see Dr. Graham in this Scripture: "A man's gift makes room for him, and brings him before great men" (Proverbs 18:16). He's a household name, synonymous with what an evangelist should be: steadfast and forthright, with integrity to spare. No scandals have touched him. When Billy Graham speaks, you know he's going to tell you the truth.

Through the years, Dr. Graham's message has never wavered. It's always been about preaching the message of the Cross in a way so that people want to fall in love with Christ, hearing something in the message that points them not to Billy Graham, but to Jesus. His sermons celebrate the goodness of God, and for good reason, because Scripture says in Romans 2:4 that it's the goodness of God that leads men to repentance.

But Dr. Graham knows it's not easy in this life to do the right thing, so he's taught us a battle strategy. If you don't wake up and make a plan to stop Satan from having control, he'll do everything he can to have his way in your life. Paul says, "We wrestle not against flesh and blood but against powers and principalities" (Ephesians 6:12). Of course, evil and sin are buffers put between us and God. They are learning tools. If it hadn't been for the law given in the Old Testament, we'd never have known what was sinful. If there's no struggle and wrestling with sin, we'd never know forgiveness and mercy and grace. We'd never know the real love of God if there wasn't the suffering and the strife.

I first met Dr. Graham back in the '80s. I was a musical guest for

a Billy Graham crusade in Columbus, Ohio, but I was just a hired hand, really, and he was such a towering figure to me. It wasn't till about a dozen years ago that I started getting to know his heart and not just his public persona. He was getting up in years, and he'd cut back on his schedule. I was at the RCA Dome in Indianapolis, and I walked into his dressing room. He was sitting alone, and he looked up and said hello. Well, all I could do was start weeping. I felt so broken there in front of him. He just smiled and said, "Bless your heart."

It's hard to explain, but I was overwhelmed by his spirit of humility. He wasn't sad or lonely or in bad health or any of that. He was joyful, actually, but he'd emptied himself of his self, and you could feel the love of Jesus all over him. Here was the greatest preacher of our time, and he was as humble and gentle as a lamb. He'd gotten to a place in his walk with Christ where there was this total dependency on Him, and that was manifest.

Over the years, I've become a lot closer to the Graham family, mostly through my missionary work under Franklin, Billy's son. Sharon and I traveled to Bosnia and Croatia for Operation Christmas Child, taking gifts and providing aid for orphans there. I've learned about Billy Graham just following Franklin around. He's a good son and a great friend. Sometimes we even hunt and fish together.

Not long ago, Franklin invited me to his father's house in the mountains outside Montreat, North Carolina. In recent years, Dr. Graham hasn't been able to travel on his crusades. He's had a few health scares, especially after he lost his wife Ruth in 2007, and he doesn't see many visitors anymore. This was an incredible honor. He was sitting alone in a yellow sweater, looking a little frail. I casually asked him how he was feeling. "I've come to find out one thing for certain in my life," he told me, "and that is Jesus Christ is the only one that I totally trust. He's the greatest friend I've ever had."

Then he sort of paused, and he said, "I'm asking God for one thing." I said, "What's that, Dr. Graham?" I thought maybe he was asking God to heal him and give him more years. Or maybe he was asking God for peace in Jerusalem.

Instead, he said, "I'm asking God to let me preach one more time." I told him I was so happy to hear that, and said I'd be there to sing for him when the time came. I then asked him, "What would you preach on?" but before I could get all the words out, he said, "I would tell people about the Cross and what Jesus did on that Cross, that there is no other way of salvation but by the Cross, and that they must come to Jesus by faith and accept what He did, and that there is no other way to the Father but by Him."

He had such a determined look on his old face, and he said, "If just one more person would come to Christ, it would all be worth it. Just one more!" I'll tell you, that day at Dr. Graham's house really made me look closer at what I do for a living. We came into this world with nothing, and the only thing we can leave with is the souls that we've won for Christ. That's a sobering reality!

It was like an old apostle speaking. Here was one of God's great warriors in the winter of his life, and he was still fighting the good fight. I then thought to myself that I want to finish well and hear the Lord say, "Well done, good and faithful servant" (Matthew 25:21).

It does me good to visit with Dr. Graham and see his love for Jesus. I know that's all he wants the Lord to say, too. All that really matters in the next life is to hear those words from the Savior. Can you imagine what it would be like to hear the Lord say, "Depart from Me, I never knew you" (Matthew 7:21-23)? We won't have to hear those words if we're faithful to Him.

I always want to be willing to let the Lord work in me. I read Scripture and pray and keep my heart open. I don't try to set any long-term spiritual goals. I know that deep down inside I'm the same ol' country boy from Kentucky I always was. I'm just a sinner, saved by His loving grace. I try to take it one day a time, and I say, "Lord, what would you have me do today?" and let Him guide me.

One of the ways I've honored the Lord in my studio has been to hang, in a place of prominence a big color banner that says "JESUS" in big bold letters. Quotes from the Scriptures and beautiful religious artworks are all well and good, but the name of Jesus is really enough

for me. His name is above every name (Philippians 2:9–11). He's the ultimate inspiration for everything I do and everything I believe. To boil it all down to what really matters, He is all you need.

God is love (1 John 4:8), and love is all you need. John Lennon sang it right!

Chapter 21

THE PRODIGAL RETURNS

'Twill be a wonderful, happy day up there on the golden strand
When I can hear Jesus my Savior say, "Shake hands with Mother again."

—"Shake Hands With Mother Again," by Jimmy Martin

Now, it's one thing to play bluegrass music, and it's a whole other thing to make a living at playing bluegrass music. It was a walk of faith to leave the country world and all the financial security that went with it. The insiders on Music Row and in the media thought I was crazy to walk away from a successful career. Well, people are gonna talk no matter what you do in this life. I didn't let the mud-slinging bother me. Saying goodbye to the big machine of the Music Row industry was a relief in a way. It was saying hello again to blue-grass that had me kinda nervous. You see, I really didn't know what sort of welcome I'd get. You have to understand that I was highly judged and roundly condemned in some circles for leaving bluegrass at all. I'm talking about some of the more devout bluegrass fans with long memories, the hardcore purists who're still as mad as wet hens that the Osborne Brothers used drums all those years ago. There were a lot of sore heads who took me for a turncoat and traitor, and they weren't gonna let me forget I'd spent all those years playing the country star. Some will probably always hold it against me.

Well, I was surprised in the best possible way. Most people not

only forgave me, they embraced me as a prodigal son who'd finally returned to the fold. Instead of hoots, I got hugs. Also, I had support where it mattered most, from my old boss, Ralph Stanley. He made it known loud and clear he was behind me all the way. He said that the name I'd made for myself in commercial country would help raise the profile for bluegrass and bring more folks out to the shows.

I sure hoped Ralph was right, for all our sakes. All I knew for sure was that playing bluegrass again was a blessing for me, like giving water to a thirsty man. I was forty-two years old when I devoted myself to bluegrass again, almost ancient for the Nashville crowd. But I felt as young and excited as a kid let loose to run the woods again. Being around so many talented musicians at the festivals really stoked my creative juices, too. It was the perfect environment to get my chops back on mandolin, and to reexperience bluegrass as a living, breathing thing.

My years away gave me new eyes and ears to appreciate things about bluegrass that I'd taken for granted. I realized how pure and uncorrupted and timeless it was. With country music, image was such a big part of the business, especially once CMT, GAC, and the other cable TV networks came along. But bluegrass was still about the beauty of the music, not what the musicians looked like or dressed like. It was music that still had a heart and a soul and an integrity at its core. It was staying alive by staying true to its roots and its heritage. Even many of the newcomers were still paying respect to the music's fathers while carving out a niche for themselves.

After a while, though, there came a day of reckoning. You can play the festivals and talk about how wonderful bluegrass is till the cows come home, but I knew I had to put up or shut up. I knew I had to make a straight-up bluegrass record, put it out on the market, and see if the public was interested. And to tell you the truth, we needed a record to sell on the road.

The contract I had with Atlantic Records gave me the freedom to pursue my own projects. But they also had first right of refusal, and they weren't interested in a bluegrass album. Well, that gave

me the freedom to cut a record as raw and traditional-sounding as I wanted to. Nothing watered down, and nobody to please 'cept myself. My days of worrying about country radio were over, 'cause I knew they weren't gonna play bluegrass anyway. If I had anything to prove, it was to those bluegrass purists, the doubters and the naysayers. I wanted to show 'em that I wasn't dabbling. I was dead serious.

Making this record was pure joy. I felt like a man coming out of jail and getting his first home-cooked meal in years. It was a favorite dish I could put together just the way I liked. So I paid for studio time, the band, and the artwork—every bit of it—myself. When it was paid for and done, it was all mine. I called it *Bluegrass Rules!*, and it was the first album I'd ever owned in my life. I started a label, Skaggs Family Records, and found a distributor that wanted to work the album.

It wasn't that I just wanted to run my label as an independent; I wanted to conduct my business from a Christian perspective as well. This wasn't easy. There was a lot of conflict in my heart, and there were a lot of sacrifices to be made.

We went from having twenty employees, two buses, and a tractor-trailer to less than a dozen people and one bus. We didn't need a stage full of amplifiers, drums, pianos, and electronic equipment to put on a bluegrass show. I had to cut my band and road crew from fifteen to eight and simplify my whole organization. It was painful, but it was necessary.

At first, the enemy was busy setting traps and whispering in my ear: *What sort of Christian are you to let people go from their jobs? What's gonna happen if this doesn't work out like you wanted? You won't be able to make a real living doing bluegrass.* I felt bad having to lay off people for sure, but it was necessary in order to do what I wanted to do.

The Devil tried to sow doubt and unbelief in my heart, but God kept saying, "Trust me," so I did.

Then something really wild happened. In the first month, *Bluegrass Rules!* sold well enough to recoup all our expenses. It ended up

selling more than 200,000 copies, a whole lot more than my previous two country records combined. Mind you, if a bluegrass album sells 25,000 in any year, it's a huge hit, so this was a shock. The sales figures told me there was an audience out there for bluegrass music, and all I had to do was deliver the goods.

I believe the Lord was blessing the leap of faith we took. 'Course, we weren't selling as many records as in the old days at CBS/Epic, but now I was getting to keep the profits, and keep my masters, too. And now we could pour that money into developing new artists and giving them a fair deal on our label.

The vision I had for Skaggs Family Records was for it to be more than just a home for my recordings. We wanted our label to be a haven for traditional roots music—for young groups like Blue Highway, Cadillac Sky, Cherryholmes, and Mountain Heart, and for seasoned acts like the Whites and the Del McCoury Band. Our label provided a rare chance for young or unsung artists to grow their talent and grow their audience. I'll always be grateful to my cofounder Stan Strickland for helping a dream become a reality by helping to get Skaggs Family Records down the runway.

It was important to show people the bluegrass style we were resurrecting wasn't a museum piece we dusted off and set on a pedestal. We wanted to tap into the power and dynamics of classic bluegrass, like jump-starting an ol' '47 Ford and taking it for a spin on the interstate. I kept thinking we had a big question to answer: Are we gonna settle to be copies, or are we gonna try to take the music to new places?

Our style of bluegrass was a little different from the start. I included three acoustic guitars, one to play solos, one to play rhythm on the two and four of the beat, and the other to play rhythm in a capoed position. At the same time, I wanted to pay tribute to the high, lonesome vocal sounds of the mountains. Paul Brewster was willing and able to blow out some high tenor singing, and he's been with me ever since.

Musically, I felt like myself again, because this was the deepest part

of who I was as a musician. There was such a feeling of honesty and happiness singing bluegrass. And the best thing was coming home to the mandolin. It was my first love, and I had missed it.

Not long after Mr. Monroe's funeral, I got a call from somebody wanting to know if I was interested in a 1923 Gibson Lloyd Loar F-5. It had been locked away in a gun cabinet for 43 years. This mandolin was signed by Lloyd Loar himself on July 9, the very same date as the signature on Bill's famous 1923 Gibson. There were only four serial numbers between the two mandolins. I played it, and it had the beautiful, resonant tone you find with aged wood, and I had to have it. So I bought it and named it "Mon," and I took it with me everywhere. I just couldn't play it enough. Having a new instrument sparks new ideas, and it wasn't long before I was coming up with new tunes.

I remember sitting on the bus and heading to a show date, just picking chords and strumming as the miles rolled by, when a tune came to me out of nowhere. It reminded me of an old Monroe tune. I played it for Bobby Hicks, and next thing I knew, I had a song. I named it "Amanda Jewell," after my daughter Mandy, and I gave it to her as a graduation present.

Creativity is the key to keeping the music fresh. Bluegrass has changed in some ways for the better. The musicianship has risen to a very high level. The generation coming up now has some of the finest players I've ever heard. You listen to what a brilliant player like Chris Thile can do with a mandolin these days, and you can imagine how thrilling it was for folks back in the '40s when Monroe raised his mandolin up to the microphone. I've heard tapes of live Opry broadcasts from that time, and the applause for Bill and the Boys is ear-shattering, the same sort of excitement there was when the Beatles were on *The Ed Sullivan Show*. It wasn't teenagers at the Opry, but the excitement was there just the same.

Chris is part of a new generation. He's establishing his own style, and he's influencing young players all over the world. Sam Bush is another great mandolin player who influenced a whole generation of young musicians. But even with all the great mandolin players out

there, and there's a bunch, Mr. Monroe started it all, and his style, or echoes of his style, can be heard in nearly everyone.

I've always had the impulse to go both directions at once, to connect to the tradition and nudge it forward, too. That's why I recorded *Honoring the Fathers of Bluegrass*, my tribute to the Monroe band of '46 and '47. I felt it was important to remind the iPod generation about the masters who birthed this sound when it was cutting edge, and to inspire them to go back to the originals and glean from those records, too. Honoring our fathers and our elders is always worthwhile. It keeps us humble and grateful to the ones who came before us.

I'm a bridge to the past and to the future both. I try to be a father of encouragement to young musicians. I'm lucky to have a great band of young guns, Kentucky Thunder. They're the Blue Angels of bluegrass. They keep me young, and they push me to stay creative. It's a real blessing to have talented guys in your band whom you can pour into, and they pour into me as well. There's an exchange between us every night on stage, and we feed off each other's energy.

I know that Kentucky Thunder is a big reason why people come to see our shows, 'cause the guys in the band represent the highest level of musicianship in the business. They're my employees, but they're also my musical partners and bandmates. I know the rhythm will be there where it needs to be, and I know everybody's competing to play the best solo they can, night after night. Every night on stage, these guys exceed my standards, and I'll tell you what, the bar is set awful high in bluegrass.

To work in Kentucky Thunder, you need to have the chops, for sure, but you also need to have a head and heart for bluegrass. And that means knowing the history of the music. You have to be able to pull out licks from the '40s and '50s, and love doin' it. That passion is what makes the difference. I can usually tell what's in a player's heart.

Recording for my own label gave me the freedom to make music that was in my heart and pursue whatever pet project I wanted to.

In my later country days, I'd sometimes be second-guessing myself in the studio, wondering if I had a hit or not. I don't need to worry anymore if radio is going to play a record. Bluegrass radio does not dictate what's cool or what's not in the way that commercial country radio does.

Now, I'd long been wanting to do a gospel album, but my contracts just hadn't allowed for that kind of artistic experimentation. I knew that some fans had come to expect a certain thing from a Ricky Skaggs album, and it wasn't gospel. But every once in a while, Dad would say, "Son, you need to do ya a good gospel album, a *bluegrass* gospel album," and I'd tell him, "I know, Dad, and I promise I will one of these days."

So now I was free to follow my heart. I didn't have to sit around a conference table with people from the record-label telling me why bluegrass wouldn't sell to a certain demographic or why a gospel album expressing my Christian faith was bad for my career. I owned the record label, and now I could make good on that promise to my Dad. I aimed high when I made *Soldier of the Cross*. I knew it had to be a keeper. I thought of those classics on the shelf: Bill Monroe's first gospel LP, *I Saw the Light*; the Stanleys' *Sacred Songs from the Hills*; Jimmy Martin's Decca masterwork, *This World Is Not My Home*; the Louvin Brothers' *Satan Is Real* album, and Flatt & Scruggs's *Foggy Mountain Gospel*. These were all very important albums, to me and to many others.

But mostly, though, I kept one goal in my mind: I wanted to cut a gospel record that Hobert Skaggs woulda loved to hear on a Sunday morning!

There are plenty of gospel evergreens, but I wanted to showcase lesser-known songs, like the title song by Lorin Rowan. I'd seen the Rowan Brothers sing at a festival years before, and the words of that song really spoke to me. A soldier of the Cross lifts up Christ and defends the faith. No matter where he goes. I'm a Christian, and I want to walk the faith. It doesn't matter if I'm playing music in a casino or shopping for groceries in a Kroger's. The Christian life is always a

presence. It's not something that you keep in the closet and put on for Sunday.

I sung a cappella on a hymn, "Lead Me to the Rock," a song that my preaching uncles Roby and Addie Ferguson used to sing, and boy, did they sing it loud! I love singing that hymn, 'cause it gives me a lot of comfort. When the Sauls of this world are chasing me, I know I can always hide in the shadows of my Father's wings, where I'm safe and loved.

What a joy to sing that hymn. In fact, what a joy it was to make that whole album. I'm a "musicianary"—one who brings hope and truth to the lost and hurting through music. I wanted to show that Jesus was alive in my life, and the music was an expression of that truth. James 4:8 says, "Draw nigh unto me and I'll draw nigh unto you." We're all as close to Christ as we want to be.

One song on the album is very special to me. It's called "Seven Hillsides," and it was based on a true story about a pastor from eastern Kentucky who had to preach seven fallen soldiers' funerals in one day. He struggles with what to say to the loved ones about their loss, and how to show them the Lord's way. I've gotten a lot of letters from pastors thanking me for the song. They struggled and wrestled with the same issues, and it gave them strength.

With *Soldier of the Cross* we won our third bluegrass Grammy in a row. It wasn't the award itself that thrilled me—it was knowing that making this record had been the will of God.

It was a blessing that my mom had a chance to see my return to bluegrass. It set her mind at ease to have me playing the music she and Dad had introduced me to. And she even told me how tickled Dad woulda been that my gospel record got a Grammy!

In those days, Mom was living alone in same house on Brushy Creek, and she'd get lonely there, especially 'cause she didn't drive. She battled depression, same as a lot of folks who've lost their spouse, the partner they've spent their whole lives with.

I'd visit with her when I could, and we'd sing together like we

used to. Sometimes Sharon and I brought the kids, and they loved to hear their mamaw sing old songs like "Heaven Will Surely Be Worth It All." It really wasn't the same on Brushy Creek without Dad, though, 'cause he was the life of the party and the master of ceremonies. But life has to go on, and you have to try to fill that emptiness the best you can. One morning in 2001, Mom woke up early for a doctor's appointment. There was a lady staying at her place as a caretaker who was gonna drive her into town to the doctor's office. Mama told her she was gonna lie back down and rest while the caretaker finished getting ready, but Mama woke up in heaven!

She had a stroke. It was a merciful way to go. She didn't suffer or have to linger in a hospital. Thank you, Jesus!

My mom was the first person I ever sang with. She poured her sweet mountain voice into me, and she gave me the gift of harmony singing, which I learned at her feet when I could still barely walk. But the most precious gift she gave me was the gift of faith, pointing me to the Cross. Our love for Jesus always drew Mom and me close together, the same way that music did for me and Dad.

All my life, Mom was there when I needed her. Not having her anymore hurt so bad, but it made me feel glad to know that she had gone home. The next year, Sharon's mom had a heart attack and died on Father's Day. Patty White was a powerful Christian woman and another great example of the love of Jesus.

Now both the family matriarchs were gone. These women were so important as mothers and wives and sisters. Mothers are the soul of a family, and they model the faith in a way that nobody else can. I had wonderful grandmothers, I had a great mother and mother-in-law, and I'm married to a great mom. I'm convinced that there is no way that two men can do the work of one woman!

Too often, people like Patty White and Dorothy Skaggs don't get the recognition they really deserve in this life. But God knows their names, and they are both big in heaven. You know, it's better to be known in heaven than to have the praises of men here on the earth. And their prayers for us are felt every day.

In our family, we're blessed to have Sharon carrying on that matriarchal role. It's a big job, and I thank God every day for her. She is a true Proverbs 31 woman: "strength and dignity are her clothing." She's raised our children to fear the Lord, and to love and honor Him.

Putting God first has made the difference for us. That's what's kept us in love and in tune with the Lord. We've had rocky times, like any couple, but our marriage has never been in jeopardy. I believe God allows us to go through the testing times to help us purify our hearts and make our commitment to each other stronger. We take care of our relationship as husband and wife, and we're happier now after thirty-two years than when we first got married.

We're lucky, too, both of us being musicians and having a shared love and passion. But our faith in Jesus is what helps us stay close when we catch ourselves drifting apart, and that is the intimacy that seals and protects our sacred bond. To us, God is in music, it's part of His nature. Music was created by Him and for Him (Colossians 1:16).

That goes for the whole family, too. There are always instruments around our house, and there's always some music coming from somewhere. It's a little quieter than it used to be, with Molly and Luke out on their own with bands and ministries they're involved with. But we get together whenever we can and just sit around and have fun making music as a family. Andrew and Mandy both love music, too. Andrew plays guitar and sings bluegrass up in Kentucky, where he lives, and Mandy is always checking out new bands coming through Nashville.

In recent years we've had an annual tradition that started from the living-room sing-alongs we've always had at Thanksgiving and Christmas. Every holiday season, we go out on the road with Kentucky Thunder to perform concerts of carols and hymns and traditional favorites, a show we call Skaggs Family Christmas. There's Sharon and Molly and Luke, Cheryl White and her daughter Rachel, and, of course, ol' Mr. Buck, who performs "The Christmas Guest," a recitation made famous by Grandpa Jones.

Like a lot of the best things in life, this wasn't planned, it just sort of happened. I was on a tour with Kentucky Thunder doing shows with the Chieftains. Sharon and the kids joined me in Baltimore for the show there. We had a few days off before the next date, in Atlanta, so we made it into a road-trip family vacation. My band was driving down from Nashville, but the bus caught fire, and they didn't know if they were gonna make the show.

I had an hour to fill on stage as the opening act, and I went into full-panic mode. Sharon said she could sing with me on a few songs, and then Molly piped up, "Daddy, I can help out, too! I can play some clawhammer banjo and sing harmony like we do at home." That made three, and there was a musician named Jeff Taylor there helping us on accordion and penny whistle, and soon enough we had us a cool little homemade band. Sharon and I sang a few duets to warm up the audience. Then I called Molly on stage, and she did an old folk tune by Jean Ritchie that really wowed the crowd. Our spontaneous show turned into something really special. My booking agent Bobby Cudd was in the audience that night, and he got the idea for us to work up some Christmas songs and play as a family. The rest is history. We added a pianist and a percussionist, and now it has evolved into a festive traveling show that we look forward to every Christmas season. For the past ten years, the Lord has led us to share our tradition in little community churches and big symphony halls, even at the National Christmas Tree lighting ceremony in Washington, D.C., with President George W. Bush and Laura. We had a ball. Texas was well represented that night!

The Christmas tour of 2011 was very bittersweet. Our percussionist Tom Roady had been diagnosed with stomach cancer, and he didn't know if he'd be able to go on the road with us. He prayed about it and decided to take a holistic approach and do what he loved, playing music, instead of surgery or chemo treatments. He was in great spirits rehearsing with us, and he told me, "Ricky, I want to be on the road with my musical family, knowing that you all will love me and pray for me every day we're out here. That's all I need."

On the night before our first show in South Carolina, Tom passed away on the tour bus. It was quite a shock, but we all agreed that the best way to honor Tom's life was to play the show just like he was there with us. So we set up his drum kit on stage as a tribute, and we somehow got through the performance. And you know, we could feel his presence, the same way Sharon can hear her mom Patty's voice singing with her on "White Christmas." We loved Tom like family, and celebrating that love in song was the whole purpose of the show that night.

Luke and Molly both have worked so hard at their singing and playing, and their confidence has gotten stronger every year. Same with my niece Rachel, who's a wonderful singer, too. To see her and Molly and Luke take the stage as a trio and win over a crowd with their harmony singing makes me a real proud papa and uncle. To know what fine young men and women they've become makes it even more special.

Now I know the joy and pride my dad and mom must have felt as we traveled eastern Kentucky in the early years, presenting our little family music show at churches and radio stations. Being able to share music with my family is worth everything. The greatest success I've had in my life is spiritual success, just knowing my family is intact and my kids love God just as I do.

In the past dozen years, me and my band Kentucky Thunder have played in nearly every state and in some foreign countries, too, and we're only just getting started! We take our show just about anywhere they'll have us. My mom used to scold me for working the venues where there's drinking and carrying on, but it's part of the calling. I feel like I've been called on to do more than just put on a show. I go on stage and pay tribute to the forefathers of bluegrass, Bill Monroe and Ralph Stanley. I talk about my faith and how lucky I feel that God has let me do the thing I love most, and for so long. I get to play the songs I grew up with and keep them alive for a new generation. *So what if folks are having a few beers?* I think. *Maybe the music will touch them.*

We play at churches and high schools and community arts centers, and we also go to county fairs, nightclubs, and even casinos. Some Christians wouldn't be caught dead in a casino or a bar, but people there need to hear about the love of God just as much as people in a church.

But first, you have to get your foot in the door, and bluegrass music is a great door-opener.

In 2000, the Dixie Chicks invited us to open for a few shows on their first headlining tour. They were the hottest thing in country music, and they hired us to give their fans a dose of our bluegrass music. They gave us a stage in these huge stadiums to influence and educate the young kids about the music Natalie and Emily and Martie grew up playing. The girls really thought this would work for their crowd, and it sure did.

Their young audience loved the traditional sound of pure raw bluegrass. Part of the reason we connected with that crowd was that we played so loud. The fans responded to the sheer volume and the musicianship. They'd never heard anything like "Pig in a Pen" blasting through a PA system as big as a truck. It was thrash-metal bluegrass, and it was awesome.

I'll never forget one show on that tour. It was at the University of Tennessee basketball arena in Knoxville. The crowd was stoked. Knoxville is the top market in the world for bluegrass, as far as record sales and radio airplay. So a lot of these folks were already bluegrass fans. They were hollering out for "Rocky Top," the Osborne Brothers hit and the Tennessee state song. As a rule, we don't ever play it, 'cause somewhere some bluegrass band probably already just did!

But somehow this time it was the right thing to do. Not only for forty thousand people to request it, but for us to play it. Well, we did, and before we even hit the first chorus, that stadium shook with the most deafening roar I've ever heard in my life. I mean, so loud it was almost scary!

I think we got a lot of new fans that day. Now, don't get me wrong, bluegrass didn't need saving. It was doin' fine without us. I just hope we've brought some new fans to this great music!

Chapter 22

SOMEBODY'S PRAYIN'

There's many miles ahead 'til I get home,
still I'm safely kept before your throne,
'Cause Lord I believe, Lord I believe
Your angels are watchin' over me.

—"Somebody's Prayin'," by John G. Elliott

If I were stranded on a desert island and could bring only one in-strument to keep me company, I'd take a guitar. It's versatile, and it gives you such a huge repertoire to draw from. I'd be able to play so many more types of songs than I could with a mandolin or a fiddle or a banjo. A guitar is handy to sing along with, too, and I'd have a lot of singing to do to keep from getting too lonesome. Praising God fights depression and loneliness like nothing else can. When you're praising Him, you're not thinking about yourself.

I'd sure miss having other instruments along. Especially ol' Pee Wee. He's a special mandolin of mine, and I love him so much. He's more than ninety years old, and he sounds better every day. Now, the only problem with a guitar is deciding which one to bring. It's like the joke goes, "How many guitars do you need?" "Just one more." I've got way more than I can probably count, I guess, and I must have a dozen favorites that I'd never get tired of. I've always been partial to big, robust-sounding guitars, like Chunky Boy, my old L-5 Gibson

archtop. He was built in 1931, and he's quite a piece of work. I use Chunky Boy for rhythm tracks, because he's so forceful and moves so much air. I've played him on every album I've done for more than twenty years, and he's never let me down. I'd feel lost without him in the studio.

Another favorite of mine is a Bourgeois Brazilian D model, a real beauty. Sharon nicknamed it Liberace, 'cause it's dressed out with a fancy slope-shoulder and a solid-pearl inlay fretboard. It looks great and sounds broken in. That's the main guitar I've had on stage for the past ten years, about half of every show, so that's a lot of breakin'-in time.

Recently, I've sorta been goin' steady with a PRS Tonare Grand, custom made by Paul Reed Smith. It's what I call a "friendly" guitar. Usually, you find an acoustic guitar that sounds great, but the neck is hard to play and it just doesn't feel good in your hands. This one feels and sounds great. At my age, I don't want to have to be working to play an instrument; I want *it* to play *me*. The PRS acoustic fits the bill.

Lately, I've been discovering the magic of small-body guitars, especially older models, and when I say older, I'm talking pre–Civil War era. I recently traded for a Martin guitar from 1855, and it was one of the best swaps I ever made. It proves that bigger isn't always better, especially when it comes to tone. There's a romance in the old aged wood, and there's the sense that you're holding a piece of history. It means a lot to me that Christian Martin himself had his hands on this guitar.

'Course, I've had my share of Martins over the years, since having at least one Martin guitar in the band is ordained by the Laws of Bluegrass. I have one called Red, my trusty 1961 Martin D-28. The guy who owned it before me was a local character who went by the stage name of Panama Red. He thumped around Nashville for years playing for tips in clubs and bars. He hit hard times, so he sold his guitar. I snapped it up.

I didn't have Red too long before I ended up selling it to pay some

bills. Then a few years later, I got a call from the guy who bought Red off me, and he said it was "way too much guitar" for him and that I could have it back for the same price I sold it to him for. Nowadays I keep Red at the studio. I save him for special projects, like the album I did in memory of my dad.

When I recorded *Songs My Dad Loved* in 2009, it was a labor of love, my tribute to all those beautiful old-timey country songs Dad and I used to sing and play together when I was first learning. It was very emotional and healing and a great musical adventure, too. It was the first solo album I'd ever done. I played every instrument and sang all the vocal parts, overdubbing and double-tracking and having a ball. I was like a kid again, exploring instruments I'd always wanted to use on a record, like the mandocello, which has a huge, low-end mandolin sound.

I also played a big fretless banjo like the kind the minstrels had after the Civil War. The huge head and thick strings give it a real deep and low funky sound. I played a clawhammer banjo as well, since my dad had always loved that style. You can hear it rumble on "The City That Lies Foursquare." I even got out the old '42 Martin my Dad had bought new more than seventy years ago. When I was making the album, I could hear my dad saying, *Son, I never thought all them instruments would sound good together.* I really do think he would have liked it. I got my old fiddle out again, which I hadn't played in years, and I got to feature it on the old Santford Kelly tune "Colonel Prentiss" and a few others.

Now, sometimes you get a call out of the blue and it just feels right. I mean, you can either be a fuddy-duddy stick in the mud always making solo records, or you can collaborate and make something great. I always loved the collaboration aspect of music, and when a musician like Jack White calls, you say yes! The more times you say yes, the more people will discover how powerful the old music is.

I met Jack backstage at the Opry one night. I told him how much I loved the Loretta Lynn album he produced in 2004, *Van Lear Rose*, on

which he gave her a loving environment and let her be herself and sing her own songs. He asked me about the analog recording machines at my studio, and we talked about ribbon microphones and vintage gear. Jack loves talking shop, and so do I. He also has a deep love and respect for bluegrass and old-time country, so I was happy when he invited me to play mandolin on a tune with his band the Raconteurs. We did a bluegrass version of their song "Old Enough" with Ashley Monroe singing, and it was a real collaboration, not just a guest spot. Jack said, "Just play what you feel," so it was an easy fit for me. I had a great time, and they were very respectful to the old guy Skaggs!

I just try to keep my heart open to those "God moments," as I call them, where you come out of your comfort zone. You never know who's gonna call, and you never know what magic comes out of the mix when musicians from different genres meet up. That's what makes it so interesting. Sometimes it happens with a pairing that you wouldn't necessarily think of. Look at what happened when Alison Krauss and Robert Plant got together. Sparks flew, and it was one of those musical unions that was meant to be.

Same with me and Bruce Hornsby. I love working with Bruce; he's one of the most creative talents I know. He can play any kind of music and make it come alive. When he sits in with Kentucky Thunder, it sounds as if the piano has always been a part of bluegrass. He has an adventurous spirit, and hopefully we can keep making music together well into our years.

I still love to be a sideman when the project calls for it. I worked on the great jazz bassman Charlie Haden's *Rambling Boy*, which showed him returning to his roots growing up in his own family band in the Midwest. I got a chance to pull out my big ol' fretless banjo again, and also to sing some old heart songs with his daughters, Petra, Tanya, and Rachel, and his son, Josh.

One of the most enjoyable and flat-out fun collaborations I've ever done is the gospel album *Salt of the Earth* with my family, the Whites. We've played together off and on since the 1970s; I've recorded on their albums, and they've sung and played on mine. But this was the

first CD we'd done just us together singing great old gospel songs, and it was such a blast. I know I'm a little biased when it comes to Buck and the girls, but they are some of the finest people I know anywhere, and some of the most talented, too.

Now, I've talked for a while about collaborators I've worked with through the years, but my favorite collaborator and musical partner ain't a person. It's the 1922 F-5 Lloyd Loar mandolin that I call Pee Wee. I've only had him since 2010, but it's like we've been together forever. I'm so emotionally attached that I could hardly think of going anywhere without him. I sort of brought him out of retirement, and I'm gonna keep him till my dying day. They'll have to pry him outta my cold hands.

There are certain instruments that you feel a spiritual connection to, and once you hear the sound they make, you just know. Some musicians search for it their whole lives, and I was lucky to find my Holy Grail, the mandolin that I was supposed to have in my hands, and to share with the world.

I named him Pee Wee after the man who made him legendary, Pee Wee Lambert. Like I told you earlier in the book, he was the "third Stanley Brother" in the late '40s, the short guy with the big smile who could sing to the moon on the high trios, the one who played all those incredible mandolin breaks that set my young bluegrass soul on fire.

Let me brag on this instrument a little. I'm sorry, but I can't help it. Me and Pee Wee have a special connection. He's the best-sounding mandolin I've ever owned. He's also the prettiest one I own. The incredible thing is that I never went looking for him. He found me!

A few years ago, I got a call from a good friend, the mandolin virtuoso David Grisman, and he said, "Ricky, I'm looking to sell Pee Wee's old mandolin, and you get the first chance at it, 'cause you're the man to have it and carry on the tradition." Now, this came as a total surprise to me. I knew David had bought it, but I didn't think he'd ever want to sell it.

Truth was, I didn't know much more about this legendary mandolin than what most hardcore bluegrassers knew: that Pee Wee had accidentally broken the neck on it at a gig at a beer joint called Hillbilly Heaven in Columbus, Ohio, in 1961 and had thrown it away in a huff—and that mandolinists Frank Wakefield and Dorsey Harvey fished it out of a big trash can and rigged the neck with a splint made from a spoon handle and screws. After some major fixing, it went back onto the bluegrass circuit for a while, changing hands about a half dozen times over fifty years. Eventually, it made its way to David. Nobody's more serious about mandolins than David Grisman is, so this was a serious offer. Fate was calling, and I wasn't about to hang up. Could it really be possible that I could own the same Loar that Pee Wee used on all those classic Stanley Brothers recordings and held so proudly in those old black-and-white photos standing with Carter and Ralph?

I told Sharon about the phone call from David. Normally she wouldn't get too excited about me wanting to buy another mandolin, but her response really surprised me. She said, "You need to go out to David's and play that mandolin. He might be right; you may really be the one who is supposed to have it." You know, it was just so strange for her to say that, and I really took it as a confirmation from God.

So I called David the next day, and we set a date for me to fly out to California and spend a day with Pee Wee. I got to David's house, and he brought the mandolin out still in the case. When I opened the case and saw it lying there, it took my breath away. Then I played the intro to "Lonesome River." It sounded the same as it did in 1947, honest to goodness. Here I was at the ripe old age of fifty-six falling in love with an instrument for the first time. I truly know how Pee Wee must have felt when he dropped the mandolin by mistake and broke it. Or how Mr. Monroe felt when a vandal smashed his F-5 Loar with a fireplace poker. Those instruments were true musical partners.

About six months after I bought Pee Wee, I went on a pilgrimage

to Columbus to have a visit with Hazel Lambert, Pee Wee's widow. I hadn't seen Hazel since the show with Ralph at Frontier Ranch when I was sixteen. We reminisced for a while, and I wanted her to know how much I idolized Pee Wee. He was such a good soul, and a peacemaker, too, according to Ralph. Many a time he had to step in between Carter and Ralph to keep 'em from coming to blows! I told her that in all my years in bluegrass, I'd never heard anyone say a word against Pee Wee.

Hazel said that Pee Wee never quit playing music in the years after he left the Stanley Brothers. He worked his day job and raised his family, and after hours he worked the bluegrass bars in Columbus, where he mentored a lot of young musicians.

After we'd sat on the couch talking and catching up, I pulled the mandolin out of the case and showed Hazel how it had been restored to its original 1922 condition and look. She noticed that the refinishing work must have rubbed off Pee Wee's pick marks on the top, and it almost seemed like she was disappointed. But when I played a few of Pee Wee's intros, she got a big smile and said, "Yep, that's the sound! That's it!" Then she told me, "I think Pee Wee would be glad you have it."

It felt so good to hear her say that! "You know, Miss Hazel," I told her. "When I was a kid listening to Pee Wee on those old records, I never dreamed that this mandolin would be mine one day. I never even prayed for it. So I really don't know why God would send this to me."

Hazel had a concerned look, and she said, "Honey, you don't know?"

"Know what?"

"Honey, your mother called me in 1970 when you went to work with Ralph, and she said, 'Hazel, do you have Pee Wee's old mandolin? I want to buy it for Ricky and give it to him. He loved that mandolin, and he loved Pee Wee so much.' And I told her, 'Miss Dorothy, I don't know where that mandolin is, I ain't seen it since 1961.' We talked a little while, and I wished I could've helped her."

"My mother never told me a word about that!" She had died with that in her heart.

I pictured Mama on the phone, hoping to surprise me. She was ready do whatever it would take just to get me the mandolin that was now in my lap forty years later. The precious heirloom hanging around my neck every time I go on stage. Here was something about my mama I didn't know, and what a wonderful revelation it was. Getting Pee Wee's mandolin wasn't an answer to *my* prayer; it was an answer to my mother's prayer. Well, I lost it right there in Hazel's living room and just started crying like a three-year-old.

It's taken me a lot of years to find my true purpose as a "musicianary," a term I first heard from a great friend of mine, Ray Hughes, who taught me the true meaning of that word. Those Free Will Baptist preachers up in eastern Kentucky who prophesized over me, they sure were right when they said, "Son, God is gonna use you someday for His purposes." It just took a while for me to realize just how He'd do it.

My heart beats for the marketplace and the lost souls who are out there in the world. I want to bring joy to people with the music I play, but I also want to bring life-changing truth in some of the songs I sing.

And I can take the gospel to the marketplace, and I can be a musician in the world without being of the world. I want to bring such a truth through the music that it can bring conviction, so that the songs can help people to know God. That was the main reason I recorded my album *Mosaic*. Not exactly bluegrass and not exactly country, just some worship music from the heart and lyrics that are full of truth.

'Course, no matter what side roads my musical journey takes, I'll always be playing bluegrass. I feel even more of a mission now than I did when I returned to the fold fifteen years ago. With the passing of Earl Scruggs last year, the old fathers of bluegrass from that "Fab Five" have all gone home.

I feel like I need to be as good a father to the new generation as the elders were to me. Every man was born to be a father, either natural or spiritual. Sometimes, though, I think I've got some pretty tough acts to follow between my dad, Mr. Monroe, and the others who came before me. I think to myself, *I'm just a plain ol' country boy.* But then I realize that's what all the old bluegrass elders were, too, and that was all they needed to start a revolution.

Recently, when I celebrated my thirtieth year on the Opry, I thought about all those fathers and mothers again. But now I was the elder statesman, with the gray hair and the senior moments. (But I'm not as forgetful as Grandpa Jones just yet!) With age comes certain privileges, I'm happy to say, so I got to choose my own special guests for the show. I felt like, *It's my party and I'll pick if I want to!*

It was truly an unforgettable experience, with family and friends joining me for a night of celebration. Little Jimmy Dickens came out and represented the old-guard elders of the Opry. Jimmy is past ninety now, but still as ornery and salty as ever. He told a few jokes (often not G-rated), and then he turned the show over to me.

I couldn't help but take a deep breath and just let the moment sink in: a lifetime full of music, and now to be able to stand here and reminisce, so full of gratitude and joy I was ready to bust! I was so thankful. I felt the presence of the people who had helped me along the journey that brought me to the Opry when I was twenty-seven, and I thought how I'd love to tell them, one more time, thanks for their faith in me, and for keeping me on the right path so I could soldier on and do Mr. Acuff and Miss Minnie and Mr. Monroe proud by staying loyal to the Opry all these years.

I knew that out in the audience there were folks just like Hobert and Dorothy Skaggs with the same hopes and desires for their kids to be on the Opry that Mom and Dad had all those years ago. It was pretty overwhelming to think that fifty-two years ago, when the Opry was still held in the Ryman Auditorium, I had sat in the audience in those hallowed wooden pews and dreamed that one day I'd be on that stage—and now I was here. It was almost more than I

could handle, and luckily I had my guests to help me get through it by singing and playing.

First I had the Whites come on stage and win the crowd over with their special brand of country and gospel music, while I sat in with them, just like we did when we first started working shows together back in the late '70s. "Here's a family group from Texas," I told the audience. "You can always tell a Texan—you just can't tell 'em very much." And Mr. Buck said, "Ricky, you don't have to. We already know it!" It's so great to be a part of the Opry with my family, the Whites. I kinda know a little bit how Johnny Cash must have felt marrying into the Carter Family—like country music royalty.

Then I welcomed an up-and-coming group, Edens Edge. This young trio from Arkansas represents the modern sound of country music, and I joined them for a couple of songs, including their huge single "Amen." Then it was time for me and Kentucky Thunder to take a trip down memory lane with three of my country hits from the early '80s. With "Honey (Open That Door)," we had the audience singing along, and that was only the first hour!

Next I introduced Dailey & Vincent, and we sang the Stanley Brothers classic "A Lonesome Night." I've known Darrin Vincent since he was a kid in his family band, the Sally Mountain Show, back when he stood up on a chair and played the bass with his mom and dad and his sister Rhonda. Darrin spent ten years in my band, and since he started his own group with James Dailey, they've carried on that spirit of evangelization to take bluegrass and the Gospel out to the people. They kinda symbolized the seed I planted and the fruit of that seed, and they've done very well for themselves and for bluegrass music.

Then my buddy Josh Turner, one of country's brightest young talents, came out and did a few songs, and I joined him in a duet on "Me and God," the hit single he sang with Ralph Stanley a few years ago. Josh and his wife, Jennifer, used to be in our home Bible-study group.

Next was my good friend Alison Krauss. She didn't bring her band Union Station; she just wanted to sing harmony with me and Kentucky Thunder. She told me she didn't want to do any songs that featured her. She said, "I'm here to celebrate with you tonight." That's the way Alison is. She likes to stay in the background when it's about somebody else.

Well, I knew the fans would want to hear a few that spotlighted her voice, so I insisted that she pick something to sing lead on. After all, I told her, it was my night! So after some friendly arm-twisting, she agreed to do "Down in the Valley to Pray" if I would sing it with her. The audience loved it.

I'm so glad Alison came to help celebrate. It means so much to me to see how she's grown as an artist, and how the country and bluegrass fans love her. She has fans from all over the world. Pretty much anybody who loves good music loves her. Whatever stage she's on, all eyes and ears are on her, or whoever she's singing with.

The final guests of the evening were new friends: the modern-day hymn writers Keith and Kristyn Getty, a married couple who compose and perform gospel music for the twenty-first century. I just recently recorded a song with the Gettys called "Simple Living." They represent my old, old family roots from ancient days. They hail from Belfast, Northern Ireland, where the Skaggs forefathers had lived before immigrating to America.

For the finale, I had everybody come out and sing a song together, the way they used to do at bluegrass festivals back when Bill Monroe or Carlton Haney would round up as many musicians as they could fit on the stage to serenade the crowd with one last hymn before everybody had to go home. It was a song the Gettys had written called "In Christ Alone." It was an anthem for me on that night, for a special reason.

Before we started, I took a moment to try to sum up what I had learned on my journey from Brushy Creek to the Grand Ole Opry. I told the audience that when I'd come to the Opry thirty years before, I was full of myself, puffed up with the pride of youth, and

all that. It was all about me and my career, my talent, my show, me, me, me!

I got very emotional, and I don't remember all that I said that night. But I do remember talking about how God had changed my heart those thirty years, and how my life is now so about Christ. And Him alone. There's nothing I can add to His sacrifice. Salvation is a one-time experience, but sanctification is a lifelong journey. I can add nothing to His finished work on the Cross. All I can do is accept it by faith and believe it in my heart (Romans 10:9). That's what the Father expects us to do.

The hymn the Gettys had written expressed what I was trying to say better than I ever could. That's the beauty of music. We projected the lyrics to "In Christ Alone" on the big screens, and I had everybody in the house singing with me. We had church for a little while at the Grand Ole Opry. What a way to celebrate thirty years of God's Grace! The ending of thirty years, and the beginning of thirty more! Why not? We got a lot of young kids to inspire and pour our lives into.

You know, none of the other awards and honors mean quite as much to me as my membership in the Opry does. It may well be the greatest achievement in my career, and the thing is, I didn't achieve it! It was bestowed on me, as a gift. When you've been given a gift, like the mandolin my dad gave me, or the musical ability God gave me, or the privilege to be an Opry member, you appreciate how precious it is, because it's a gift, and you can't bargain for that, as much as you might like to. It's God's grace and a blessing that I never take for granted.

I couldn't have asked for a better celebration. That night I was surrounded by my family, my friends, and that great cloud of witnesses written about in Hebrews 12:1. When I came off the stage, I remember apologizing to Pete Fisher, the Opry's general manager, telling him I was sorry for taking so much time talking about the past thirty years and how much it had meant to me. "Ricky," he said, "that's why we love you here at the Opry. You're real, and you say what's in your heart. You don't ever have to apologize for that."

That night I was also thinking of the great young Opry performers who are coming up. Brad Paisley, Keith Urban, Carrie Underwood, and others in country music. They are the future, and they look up to me. Am I living up to the promise of pouring into the newcomers, and giving them the welcome that Minnie and Grandpa gave me? I hope so. And in bluegrass, too, there's a whole new crop with talent to burn. The Punch Brothers, Sarah Jarosz, Sierra Hull, and so many others.

I try my best, and I try to always remember the warmth and good humor Miss Minnie and the rest showed to me. I remember when Keith Urban became an Opry member. I couldn't make it to his induction, 'cause I was on the road. I knew how much joining the Grand Ole Opry family meant to Keith. So I sent him an e-mail to tell him how proud I was of him, and then I offered some advice: "Just a word of warning: Don't ever park in Jean Shepard's parking space. I've felt the force of that wrath, and it's not worth taking that chance."

I have as much a debt to these new generations as I do to the departed. It's a blessing to have the chance to mark a special event in your life, as I had the honor of doing on my anniversary night, but it's the future that I'm most excited about.

I want to go out and play music where the people are, out in the real world. I love playing, and I think God made me to take my gifts as a musician and bring people some joy. This ol' world could sure use a lot more of that.

No matter what, I'm going to keep looking ahead and try to keep the music new and fresh and growing. Every spring on the ridge in the hills of Kentucky back home, you can see the greening of the mountains. It's that same feeling of rebirth and rejuvenation.

My grandpa told me one time, "Son, if you look back over your shoulder, you'll plow a crooked row!" Now that's the gospel truth! Always look up, not down. Keep your eyes on the Lord. His eyes are always on us (Psalms 33:18). I have so much more to do—more places to see, more music to play—and a lot of young people to inspire and pour my life into!

ACKNOWLEDGMENTS

Ricky Skaggs

I'd like to personally thank and acknowledge my wife, Sharon White, for her help with this book. Sharon, you're a tremendous blessing in my life.

To my dear cousin Pat Hodges for going through boxes of keepsakes and not giving up on finding that first picture of me playing mandolin, which ended up being the photo on the front cover. Thank you, Pat.

To my brother Garold Skaggs for helping me with some dates and times. Thanks, brother.

To all my staff at Skaggs Family Records, you've been incredibly helpful. Charlotte Scott, Barbara Kimes, Tammy Carver, and Lee Groitsczh, thanks for your hard work.

To David Dunham, who brought the idea for a book to Harper-Collins.

To everyone at HarperCollins for making a dream come true for me. To Cal Morgan, who had faith in this project from day one. To Carrie Thornton, Brittany Hamblin, and a very patient and professional staff that helped me so much.

And to my cowriter, Eddie Dean, who did an incredible job getting my very long life story down on paper so that everyone who wants to read it can. Thanks to your wife and children for all the long hours you spent on this book. God bless you.

Eddie Dean

I would like to thank: Ricky Skaggs, for his inspirational story; our editors, Carrie Thornton, for her guidance and encouragement, and Cal Morgan, for his faith in the project, and the team at Harper-Collins, especially Chris Goff and Brittany Hamblin, for their hard work; my agent, Chris Calhoun, for his friendship and advice; my wife, Maria Carmen Allende, for inspiring my love of Argentine tango and sharing with equal fervor my affection for Patsy Cline and the Statler Brothers, and for making our home a place of music; and our children, Sophie and Pablo, for their joy and light; and in memory of my mother, who shared her passion for music and showed me "Heaven in a Wild Flower."